Gift of the

Museum of Biblical Art

New York 2005 - 2015

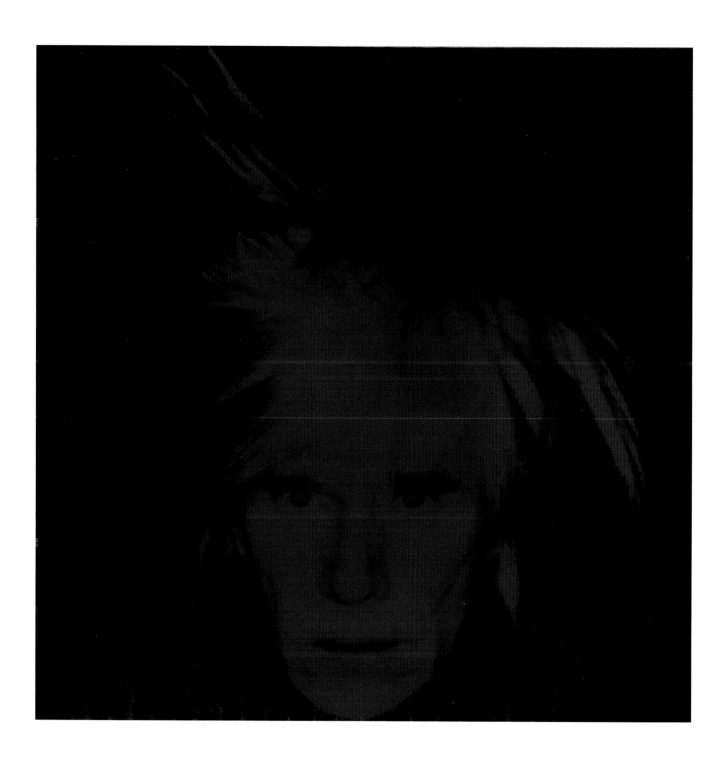

POP LIFE

Art in a Material World

Edited by
Jack Bankowsky, Alison M. Gingeras and Catherine Wood

Tate Publishing

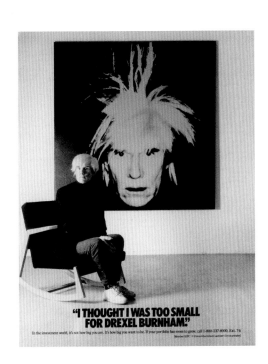

First published 2009 by
order of the Tate Trustees
by Tate Publishing, a division
of Tate Enterprises Ltd,
Millbank, London SW1P 4RG
www.tate.org.uk/publishing

on the occasion of the exhibition
Pop Life: Art in a Material World

Tate Modern, London
1 October 2009 – 17 January 2010

Hamburger Kunsthalle, Hamburg
15 February – 9 May 2010

The National Gallery of Canada, Ottawa
11 June – 19 September 2010

A catalogue record for this book is
available from the British Library

ISBN 978 1 85437 833 0 (hbk)
ISBN 978 1 85437 920 7 (pbk)

Hardback distributed in the United States
and Canada by Harry N. Abrams, Inc.,
New York

Library of Congress Control Number
applied for

Designed by Rose
Printed in Great Britain by
St Ives Westerham Press

Front cover: Jeff Koons, *Rabbit* 1986
The Eli and Edythe L. Broad Collection, Los
Angeles
Exhibited version: Museum of Contemporary
Art, Chicago. Partial gift of Stefan T. Edlis and
H. Gael Neeson
Title graphic by
The Studio of Fernando Gutiérrez

Frontispiece: Andy Warhol, *Self-Portrait*
1986. Tate. Presented by Janet Wolfson de
Botton 1996

Title page: *Andy Warhol for Drexel
Burnham* 1985–7. The Andy Warhol
Museum, Pittsburgh. Founding Collection,
Contribution The Andy Warhol Foundation
for the Visual Arts, Inc.

Measurements of artworks are given
in centimetres, height before width

Contents

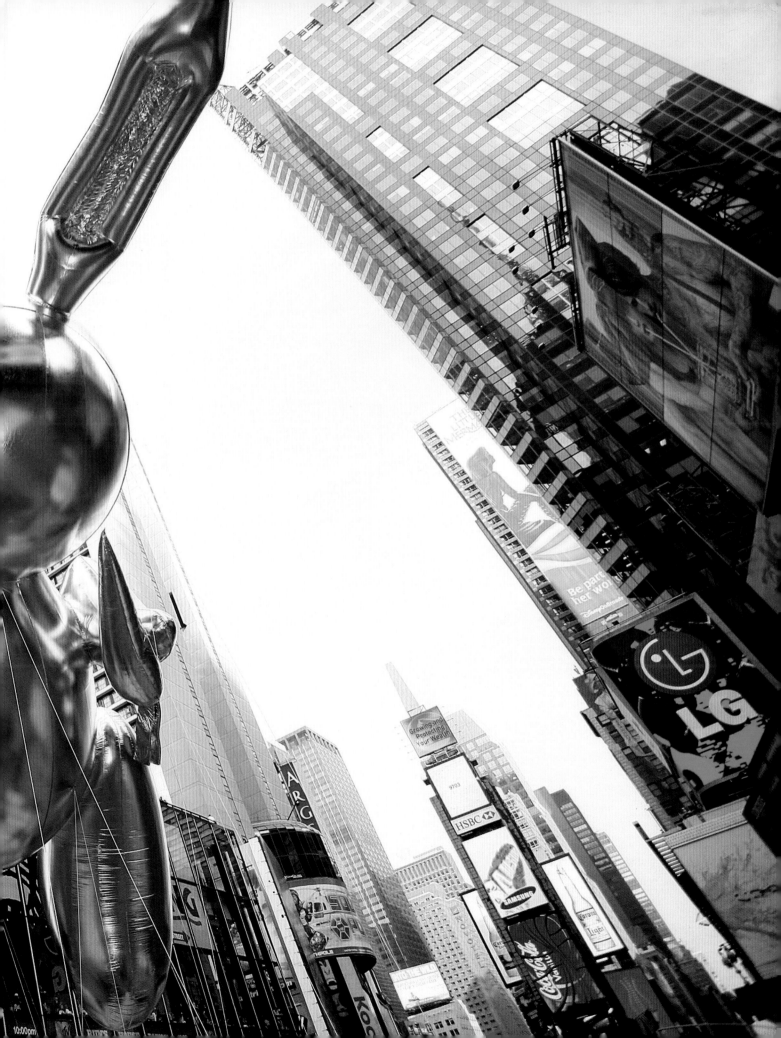

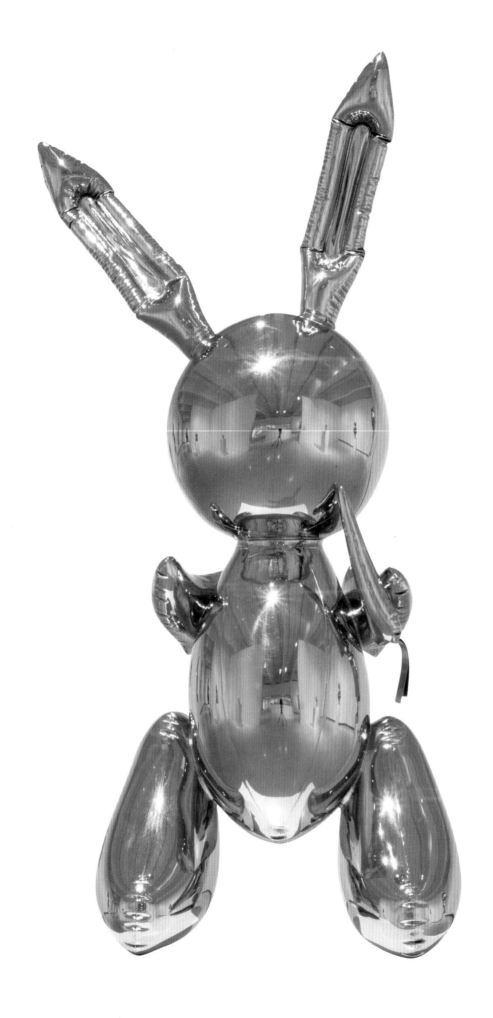

Foreword

Jeff Koons
Rabbit 1986
Stainless steel
104.1 x 48.3 x 30.5 cm

Previous pages:
Still from 2007 Macy's
Thanksgiving Day Parade®,
Featuring Jeff Koons's *Rabbit*
Flying, 29 November 2007
Balloon created by Macy's
Parade Studio in collaboration
with the artist
DVD, colour, sound, approx.
90 seconds

Pop Life: Art in a Material World proposes a rereading of the genre of Pop art as it played out through the 1980s and 1990s, taking a cue from the late work of its chief protagonist, Andy Warhol. Warhol's notorious provocation that 'good business is the best art' serves as a starting point as *Pop Life* looks ahead to the various ways that artists since the 1980s have engaged with mass media and the market and cultivated artistic personas, creating signature 'brands'. The exhibition's examination of this recent period in art history covers much territory that has, until now, been relatively little explored at Tate Modern.

Pop Life: Art in a Material World contends that Warhol's most radical lesson is reflected in the work of artists of the subsequent decades who, rather than simply represent or comment on our mass-media culture, have infiltrated the publicity machine and the marketplace as a deliberate strategy. Harnessing the power of the celebrity system and expanding their reach beyond the art world and into the wider world of commerce, these artists exploit channels that engage audiences both inside and outside the gallery. The exhibition's key themes – the persona as a facet of an artist's practice, engagement with the market, and the artist's strategies for gaining visibility – are explored in a series of installations and group rooms that reprise key exhibitions in these artists' careers as they illuminate the curatorial conceit.

First and foremost, I would like to extend our warmest thanks to the artists whose works make up this exhibition: Ashley Bickerton, Maurizio Cattelan, Bob Colacello, Jack Early, Tracey Emin, Cosey Fanni Tutti, Andrea Fraser, Damien Hirst, Jeff Koons, Sarah Lucas, Patrick McMullan, Christopher Makos, Takashi Murakami, Peter Nagy, Richard Prince, Rob Pruitt, David Robbins, Reena Spaulings, Sturtevant, Gavin Turk, Piotr Uklański and Meyer Vaisman. We are also immensely grateful to the artists' estates, who have been essential to the realisation of this exhibition: Jean-Michel Basquiat Estate; Joel Wachs, Claudia Defendi, Tim Hunt, and Sally King-Nero at the Warhol Foundation; Tom Sokolowski, Geralyn Huxley, Matt Wrbican, Heather Kowalski and Amber Morgan at The Andy Warhol Museum; Julia Gruen and Annelise Ream at the Keith Haring Foundation; and Gisela Capitain, Regina Fiorito and Lisa Frantzen for the Estate of Martin Kippenberger. We would also like to extend our thanks to the artists associated with Kippenberger included in the exhibition: Bernard Buffet, F.C. Gundlach, Valeria Heisenberg, Albert Oehlen, Perschalla, Stephen Prina, Tobias Rehberger, Daniel Richter, Chéri Samba and Jörg Schlick, and to those involved with Murakami's special commission for the exhibition: Visvim Kiefer, McG, Issey Miyake, Kanye West and Pharrell Williams.

In addition to the artists, there are many others whose help, support and advice have helped to make this complex group exhibition possible: Rhea Anastas; Lucy Askew, Managing Curator of Artists Rooms; Oliver Barker, Cathriona Powell and Lisa Dennison at Sotheby's; Eric Banks; Rosalie Benitez at Barbara Gladstone Gallery; the Blavatnik Family; Bruno Bischofberger, Gabriella Bachmann, Tobias Mueller and Daniel Susanne at Galerie Bruno Bischofberger; Irene Bradbury and Susan May at White Cube; Joshua Brentan at *Interview* magazine; Gavin Brown and Alex Zachary at Gavin Brown's enterprise; Dawn Chan; Malgorzata Bakalarz and Jerzy Kosnik from Piotr Uklański studio; Sadie Coles, Pauline Daly and Rebecca Heald at Sadie Coles HQ; Douglas Cramer; Thomas Crow; Carolyn Dalton at Macy's; Anton Sawicki, Daniel Dean and Eddie Jump at Ramboll Buildings and Design; Jeffrey Deitch; Anthony d'Offay; Larry Gagosian, Emily Florido, Mark Francis, Victoria Gelfand, Melissa Lazarov and Robin Vousden at Gagosian Gallery; Vincent Fremont; Jay Gorney; Bruce Hainley; Ryan Hart; Alexandra Hill and Julia Holdway at Tracey Emin studio; William Katz; Kazuyuki Kawamoto, Manager, Corporate Communications Dept., TDK Corporation; John Kelsey; Knight Landesman, Tony Korner and Charles Guarino at *Artforum*; David Maupin and Rachel Lehmann at Lehmann Maupin; Gary McCraw, Lauren Rothstein and Elizabeth Hull at Jeff Koons studio; Richard Milazzo; Andry Moustras and Mary Gould and the team of technicians at Science; Alberto Mugrabi; Gregor Muir; Bob Nickas; Glenn O'Brien; Jude Palmese; Ginger Reeder at Neiman Marcus; Anthony Reynolds; Stephen Rose, Cora Rosevear; Lola Toscani at Oliviero Toscani studio; Craig Barnes, Shin Kitahara, Idia Masako, Daniel Rappaport, Marika Shishido, Tomomi Tanikawa and Sayaka Toyama for Murakami studio, and the staff of Kaikai Kiki LLC; Emily Sundblad; Jacqueline Tran; Peter Wise, Director, Christopher Makos archive; Brett Zerger at l.a. Eyeworks; and Lucio Zotti.

This exhibition would not have been possible without the vital support of our sponsors. We are extremely grateful to James Chanos for his generosity towards this exhibition and his important role as a Trustee of the American Patrons of Tate. Our thanks also go to American Airlines for support-in-kind.

Gratitude for the curatorial conception and rigorous selection of this exhibition goes to Jack Bankowsky, Editor at Large of *Artforum*; Alison M. Gingeras, Chief Curator of the Pinault Collection; and Catherine Wood, Curator of Contemporary Art and Performance at Tate Modern, who have, over a period of three years, developed the thought-provoking themes and shape of this exhibition. In this they were aptly assisted by Nicholas Cullinan, now Curator of International Modern Art at Tate Modern, who contributed both organisational support and creative thinking to the project. Fiontán Moran and Flavia Frigeri, curatorial interns at Tate Modern, and Ted Turner, assistant to Jack Bankowsky, provided meticulous and much-valued additional support. We would like to add a special note of dedication to Robert Rosenblum, who was creatively involved at the start of this project and without whose input and inspiration this exhibition would not have been possible.

The accompanying catalogue will provide a lasting legacy of this exhibition. Alongside essays by the curators, we are delighted to include a text by Scott Rothkopf. For the elegant and eye-catching page design, credit is due to Rose Design as well as to the Tate Publishing team: Emma Woodiwiss, Roz Young and Melissa Larner, all coordinated under the exacting and proficient direction of Judith Severne, project editor.

We are delighted that the show will travel, first to Hamburger Kunsthalle, where we thank Director Hubertus Gaßner and Daniel Koep, and then to the National Gallery of Canada, where our thanks go to Director Marc Mayer, Karen Colby-Stothart, Christine Minas Heise and Jonathan Shaughnessy.

We are grateful all to our colleagues, too many to name individually, for their continuous dedication and enthusiasm. In particular, we would like to mention Sheena Wagstaff, Chief Curator, Tate Modern, who has championed this project from its outset. Our gratitude also goes to Nicholas Serota, Director of Tate, for securing key loans. Heartfelt thanks are also due to Caroline McCarthy and Hillary Taylor, Exhibition Registrars, for their skilful handling of the complex exhibition logistics; and equally to Stephen Mellor, Exhibitions Coordinator, for his input into all aspects of contractual, logistical, and design work, as well as to Helen Sainsbury, Curatorial Programme Manager. Thanks, as ever, go to Phil Monk and Marcia Ceppo for planning and implementing the complex installation process with Tate's experienced team of technicians and conservators.

Exhibitions rely on the trust and generosity of their lenders and we are greatly indebted to the institutions and private individuals who have agreed to part with much treasured works from their collections for an extended period of time. To all of them we express our deepest appreciation.

Vicente Todolí
Director, Tate Modern

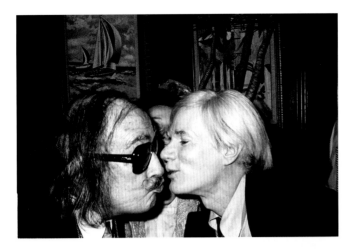
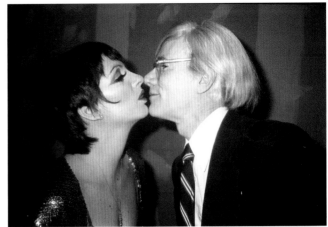
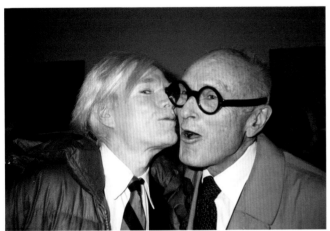
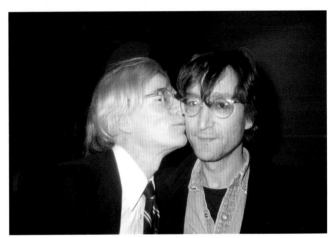

Christopher Makos
Dali Kissing Andy
1978
Vintage gelatin silver print
40.6 x 50.8 cm

Andy and Liza Kissing
1978
Vintage gelatin silver print
40.6 x 50.8 cm

Dali Kissing Architect Philip Johnson
1979
Vintage gelatin silver print
40.6 x 50.8 cm

Andy Kissing John Lennon
1978
Vintage gelatin silver print
40.6 x 50.8 cm

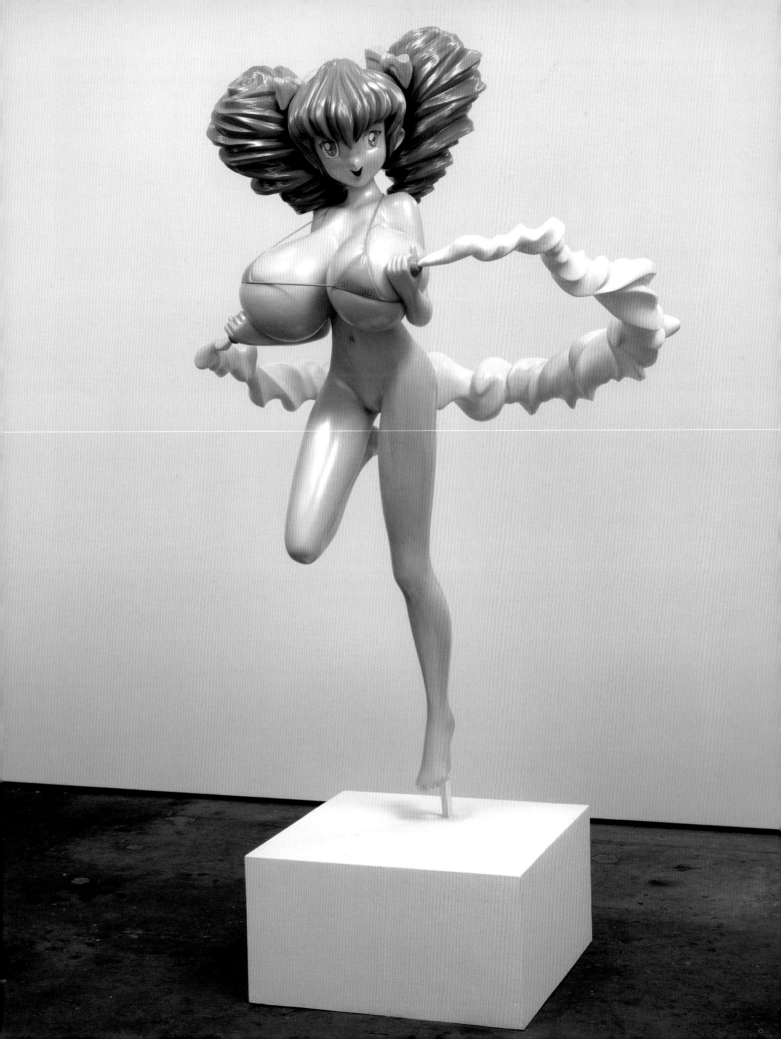

Introduction: Pop Life Is ...

Pop life is an artwork in the crowd. Millions tilt their heads back to look skyward as a gigantic silver rabbit floats down New York's Fifth Avenue. It is the same inflatable *Rabbit* that Jeff Koons exhibited as a forty-one-inch-tall sculpture in 1986 – only this time the rabbit stretches fifty feet and is a star of Macy's 2007 Thanksgiving Day Parade.

Pop life is a sculpture inside a box of gum. An *otaku* exits a convenience shop in Tokyo, opens the package of her *shokugan* ('snack toy'), pops the treats in her mouth, and turns the tiny figurine over in her hands. It is an exact miniature replica of one of Takashi Murakami's most famous sculptures, and it came 'free' with the purchase of two pieces of gum.

Pop life is the gavel falling on the last lot of Damien Hirst's 2008 mega-auction of his own work, *Beautiful Inside My Head Forever*. The latest versions of his signature spin-art tondi, embalmed bovine idols, and polka dot canvases (reprised in gold for the occasion), racked up a record single-artist auction total of £111,576,800 on the eve of the global stock market crash.

And Pop life is Andrea Fraser selling her body (literally) to a collector. The artist and writer-spokeswoman for institutional critique steps over the inviolable line that separates right-minded critical art from the seamy realms of spectacle and the marketplace – and into the risky, tangled territory that pop life is.

Pop Life: Art in a Material World charts the borderland where art crosses out of the frame and into everyday life, where art no longer 'tells' or 'shows' but rather 'does', where aesthetic distance gives way to performed immediacy. An exhibition of twenty-three artists, most of whom came to prominence in the 1980s and 1990s, *Pop Life* begins with Andy Warhol and his famous proclamation that '"business" [is] the best art'. The exhibition examines the full range of the Pop artist's long-contested late-phase endeavours – as publisher, gadabout, TV producer, model for hire, paparazzo, court portraitist to café society, and, as ever, a maker of art objects. *Pop Life* sees this network not as the falling off from Warhol's Pop art triumph that many perceived it to be in the 1970s and 1980s, but rather as its logical – and uniquely generative – conclusion. As such, *Pop Life* proposes a reconsideration of historical Pop art's legacy in relation to what is arguably the most significant tendency in art making since the 1980s.

Warhol's late network of activities, his 'next step after art', was already anticipated in his 1960s Factory, but it was

Takashi Murakami
Hiropon 1997
Oil, acrylic, fibreglass, and iron
223.5 x 104 x 122 cm

not until his near-fatal shooting by Valerie Solanas in 1968 that he fully entered the worlds of commerce and publicity – redefining the notion of art to encompass the full complexities of modern life and to operate directly in the world as we know it. For Warhol, the marketplace and the publicity machine became his mediums, and this can be said of each artist in this exhibition, or at least of those moments in their oeuvres here highlighted.

Pop Life takes us off the pedestal and into spheres of activity, which, while bound to the objects each artist exhibits in the conventional spaces of art, exceed them. An exhibition such as this is inevitably a challenging proposition. In documenting and bringing these 'extra-artistic' movements into the museum, one inevitably domesticates the very expansiveness one hopes to celebrate. How, for instance, does one capture the real-life carnival of Takashi Murakami's GESAI art fair in a gallery? How does one exhibit the replica of the fabled Hollywood sign that Maurizio Cattelan constructed on a peak of landfill in Palermo, Sicily? Even a photograph could not capture the fact that an integral component of the work was the way it lured a gaggle of art-world dignitaries from the opening festivities of the 2001 Venice Biennale to a garbage dump in Italy's hard-scrabble underside. How does one transpose to a museum the arm of Richard Prince's art that includes, for example, *Second House*, a modest tract-style home atop a hill in upstate New York filled with his own art and artifacts, a work whose very meaning depends on the obscurity of its locale and on a mystique artfully cultivated in books, photographs and citations in other works?

Perhaps it goes without saying that for those artists under consideration here the traditional spaces and systems in which art circulates are not taken as neutral givens. Indeed, such sites and systems – whether magazines, art fairs, galleries, auctions or museums – are themselves an integral part of these artists' tool kits, and even a deceptively simple show of paintings must be understood as a work of living theatre. In this respect, the mise-en-scène itself became a central organising principle for the exhibition. Installations are created or recreated (in full or in part) to anchor the show. These include Warhol's *Gems*, a 1979 series of paintings of jewels that are presented under glowing phosphorescent light, just as the artist originally conceived them; Richard Prince's *Spiritual America* 1983, a photograph of a naked prepubescent Brooke Shields, which was first exhibited in a faux gilt frame in a dim storefront on New York's Lower East Side, and is once more given its own room; and Jeff Koons's epochal *Made in Heaven* 1990–1 which is substantially reassembled here

along with the billboard that announced it. Also on view are reconstructions of Keith Haring's Pop Shop, the Lafayette Street boutique he inaugurated in 1986 to merchandise his wild-style branding triumph; the opening room of Martin Kippenberger's 1993 self-curated retrospective, *Candidature à une rétrospective*, originally presented at the Centre Georges Pompidou, as well as Tracey Emin and Sarah Lucas's shop in the East End of London, in which the artists performed as its proprietors selling customised ashtrays, keyrings and T-shirts in 1993.

When *Pop Life* was initially conceived some five years ago, the impulse to inhabit and theatricalise the art machine was ubiquitous. Artists responded to the new centrality of the art fair by making work that infiltrated its mechanisms – and mocked its rule. Murakami's handbag designs for Louis Vuitton had – it was a first – recently turned 'Business Art' into big business. And the fictive New York it-girl Reena Spaulings had just set up shop on Grand Street, even as the broom closet-size gallery-cum-*gesamtkunstwerk* The Wrong Gallery closed its door – and entered Tate's permanent collection. Fast forward and the pendulum has swung: Hirst's auction as total work of art (or rather, the market crash with which it magically coincided) turned our topic into instant art history. Today, as this exhibtion opens in the uncertain calm after the storm, we can already see this sequence in art-making – the pressures that engendered it and the impulses those pressures provoked – with new eyes. We can sort out its braver intensities from its merely rote iterations. And we can ask ourselves where it has left those artists ambitious enough to rise to the challenges of their time.

Jack Bankowsky · Alison M. Gingeras · Catherine Wood

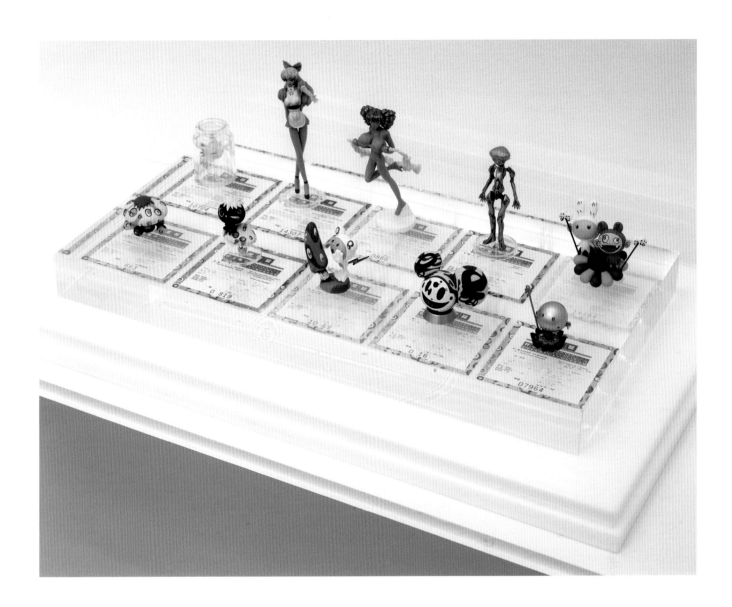

Takashi Murakami
Superflat Museum:
Los Angeles Edition 2003
Plastic figures and figure
assembly kits: packaged with
gum, brochures, and certificates
Box: 13 x 90 x 40 cm
Planning and production of figures:
Takashi Murakami, Kaiyōdō Co.,
Ltd, and Kaikai Kiki Co., Ltd
Prototype modelling: Bome
and Enoki Tomohide
Released by Takara Co., Ltd
Distributed by Dreams Come True
Co., Ltd

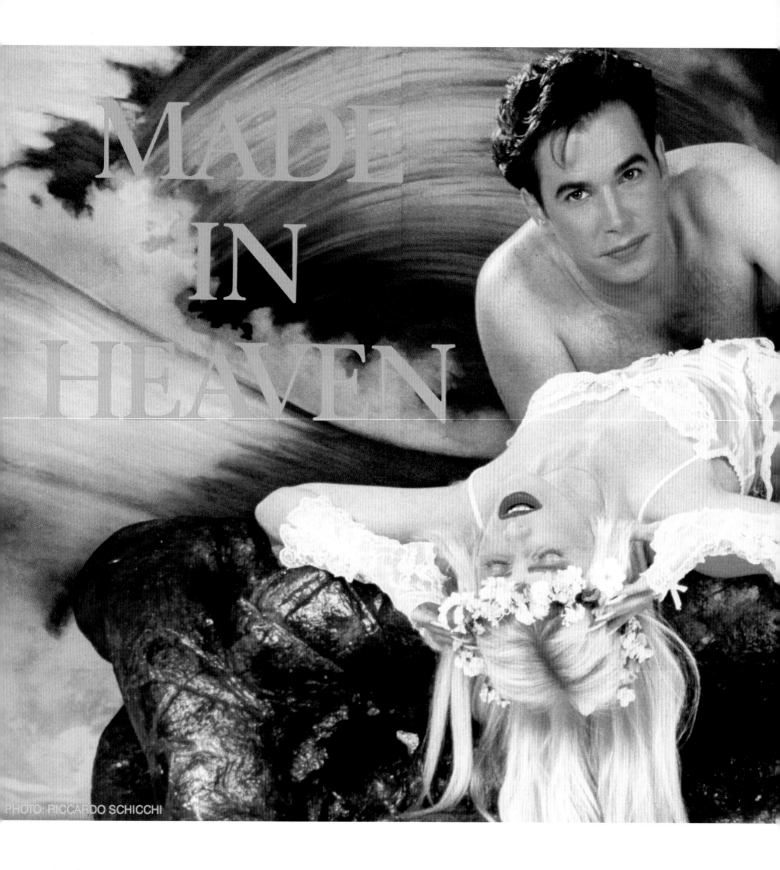

MADE IN HEAVEN

Detail
Jeff Koons
Made in Heaven 1989
(p.134)

But, I don't think of myself as evil – just realistic.
Andy Warhol[1]

Interviewer: *Can you give more to the public
than you are doing right now?*
Jeff Koons: *I would say yes, because I believe in
becoming. Jeff Koons is interested in becoming
Jeff Koons.*[2]

How Like a God

Jeff Koons, buck-naked and noticeably gym toned,
stares up at a fully dressed, female media professional.
'So how are you feeling right now?' coaxes his inquisitor,
Swedish-accented and brandishing a microphone.
'I feel fine', replies the almost *very* famous artist, perhaps
a touch too eagerly. 'Do I seem nervous, or something?'

This sequence, identifiable to anyone familiar with
Koons's oeuvre as a PR opportunity captured on or
around the occasion of his now epochal 1990–1 series
'Made in Heaven', showed up one day on YouTube
and vanished as suddenly the next. Compared to the
brazenness of the sculptures and paintings in the series,
which famously (and flagrantly) celebrate the artist's
nuptials with the Italian porn star and politician La
Cicciolina, the clip is tame. In fact, what made my
internet encounter so arresting had less to do with
the online fun of stumbling upon a favourite celebrity
parading about in his birthday suit than with the
unexpected peek this errant footage afforded behind
the self-creation that is Jeff Koons. Here we glimpse the
suburban-bred thirty-something – renowned by then in
New York but not yet the cartoon demigod that 'Made
in Heaven' would make of him – for whom getting naked
for Swedish television was but one small act of bravery
in a feat of artistic self-determination that would, in due
course, secure his status as arguably *the* representative
artist of his moment. Iconic works of art are often difficult
to see through the thick veil of their own notoriety, but
thanks to a 'terms of use' violation (duly noted in the
suddenly empty YouTube slot), the out-of-left-field
particularity – the marvel, really – of Koons's gesture
was restored to me.

What in the world inspired an artist brought up on the
bookish negations of Conceptual art to imagine the
ritual consummation of his love for a platinum-blond porn
star as the next and necessary step in American art?
And what does this three-ring *amour fou* say to us today

about the singular demands our period has made of its art – and the responses that have proved most adequate to them?

For answers, we look to Andy.

The Late Show

Beginning in the 1970s and lasting more or less until his death in 1987, just about everyone mistrusted Andy Warhol – even Andy.[3] By virtual consensus, the Pop master was washed up, his muse expired with the decade to which his art had lent its most indelible images. This is not to suggest that Andy stood idle; on the contrary, the nineteen years that followed on his near-fatal shooting by Valerie Solanas in 1968 saw the fabled Factory in more or less constant production, but as each new batch of pictures rolled off the assembly line, the tsk-tsking of the sceptics grew louder. From the commissioned portraits hustled by a cleaned-up and fully functional Factory crew at $25,000 a pop (with a discount on a second if you took two), to the 'Retrospectives/Reversals', paintings that recycled his signature soup cans and Marilyns of the 1960s in seemingly pointless repetition and combination, Andy's output appeared to confirm that the world's most famous artist *had* given up the ghost – in spirit if not in flesh. Add to the mix his gad-abouting in café society (chronicled in his in-house social-climbing vehicle *Interview*), coupled with the occasional modelling gig for the Zoli agency or a cameo for the popular television series *The Love Boat*, and the spectacle of Pop art's prime mover sinking to his own level was greeted with I-told-you-sos by those naysayers who from the very outset had thought the emperor to be a bit scantily clad.[4]

Blink hard and look again.

Today, Andy's late-phase circus of product and self-promotion looks less like the debilitated aftermath of his Pop-art fifteen minutes than his 'next step after art' – the 'Business Art' phase he prophesied in the most famous of his famously vatic pronouncements.[5] From the far side of 'Made in Heaven' (or, for that matter, the fully operational Louis Vuitton boutique at the heart of Takashi Murakami's 2007–8 MoCA retrospective, or Damien Hirst's auction as artwork, or the real 'live' fictions of Reena Spaulings), Andy looks like a father-figure for more than one generation of artists – and on the strength not just of the soup cans or avant-garde films but of his whole embattled, post-lapsarian output. Andy the publisher, Andy the gadfly, Andy the model and ad man and TV producer and star: today the full compliment of his excessive enterprise seems not only inevitable but uniquely generative in our time.

Andy Warhol
Self-Portrait 1963–4
The Andy Warhol Museum, Pittsburgh. Founding Collection, Contribution The Andy Warhol Foundation for the Visual Arts, Inc.

Andy Warhol
Four Multicoloured Self-Portraits (Reversal Series) 1979
(p.104)

Zoli modelling agency
promotional poster c.1981
(featuring Warhol, top right)
The Andy Warhol Museum,
Pittsburgh. Founding
Collection, Contribution
The Andy Warhol Foundation
for the Visual Arts, Inc.

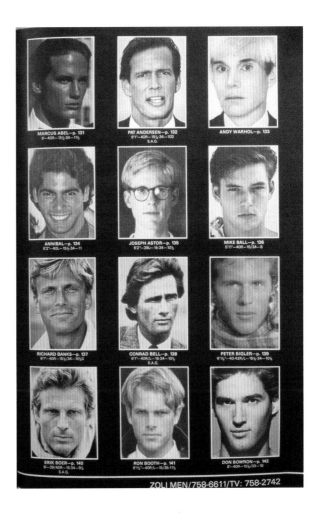

Live the Dream[6]

The year is 1986, and the talk of the New York art season an exhibition dedicated to the work of four fast-rising stars: Ashley Bickerton, Peter Halley, Meyer Vaisman – and, of course, Jeff Koons.[7] Freshly plucked from the DIY art scene then raging in Manhattan's East Village, this band of former outsiders found themselves at the boom-time centre of the New York art establishment. The address was 420 West Broadway, and the gallery the august Sonnabend, where the proprietress of legend was known to dazzle this upstart posse by clipping a piece of Warhol cow wallpaper from a roll stashed in the back office and bestowing it as anointment – and bait.

The Sonnabend exhibit marked both the end of the colourful and multifaceted East Village scene of the early 1980s and the consolidation of a new mood in art-making embodied in the work of the show's four protagonists.[8] SoHo, at the time, was an art ghetto divided. The 'Pictures generation' canonised in Douglas Crimp's 1977 show encamped at Metro Pictures on Greene Street; the New York Neo-Expressionists around the corner at Mary Boone on West Broadway.[9] The upstart East Village that produced the 'Sonnabend Four' (it was in this show that Koons exhibited his now iconic Rabbit 1986; p.8) owed an appreciable debt to the media-savvy musings of the 'Pictures' group – and next to nothing to their ribald rivals. But at the same time the rising generation registered an ultimately decisive impatience with the art-about-art aridity of Crimp's 'representation as such' and the broader lineage of intention that links the efforts of the Pictures group to the rarified negations of the Conceptual art that preceded them.[10] Koons spoke to the state of art-making as he saw it: 'Artists', he said, 'somehow develop this moral crisis where we are fearful of being effective in the world; we were the great seducers, we were the great manipulators, and we have given up these intrinsic powers of art, its effectiveness'.[11] But how to gain the upper hand, particularly when the real competition (such

was Koons's ambition) takes the form not of the art of one's peers or precursors but of a barrage of bad-breakups and death-defying diets that daily assault us in the checkout line? If the Pictures artists bodied forth the spectacle suppressed under the twin iconoclasms of Minimalism and Conceptual art (the 'return to representation', of course, linked their efforts to historical Pop art and even to Surrealism), they did so sceptically – to tease out the ruses of publicity. By contrast, for this rising generation (or better, half generation) who, in one key early show, rallied under the banner 'Infotainment', our 'image world' (or the cultural industry that props it up) was no longer a beast to be slain but an inevitability to be lived with and through – to be used (and abused) and finally taken for a ride.[12]

Dream the Life

By the early 1980s, Pop art meant not just canvases painted with comic strips or silkscreened with soup cans; for artists coming of age in that decade the bewigged spectre was an everyday fact of life on the New York scene(s), and the lessons of his embattled 'next step after art', whether taken as a cautionary tale or an enabling example, were part of the local DNA. Nowhere were the permissions of Warhol's business-art multitasking more conspicuous than in the figure of the 'artist/dealer', the much-discussed period posture embodied in the personages of Meyer Vaisman and Peter Nagy. Vaisman was not only an artist and a member of the Sonnabend Four but also a dealer of some renown – and, it turns out, retrospective import. As co-proprietor of the Seventh Street gallery International with Monument, he originally represented the other members of the famous foursome, mounting the run of early shows that secured, for example, Koons's spot on the art-world map, and presented significant solos by the likes of Richard Prince, to name another artist central to this discussion.[13]

By the middle years of the decade, the 1980s were living up to their cliché. The market was booming, and the doings of the heretofore-cloistered world of art suddenly held the glossies in thrall. Vaisman's point-of-purchase catbird seat proved an ideal perch from which to monitor the new game in the making. *The Morgue Slab* 1987 (p.114), a multi-canvas construction in which the still baby-faced artist caricatured himself as a cigar-chomping fat cat, winks at his double-dealing role as artist and gallerist – tweaking our received suspicions about a creator who mixes it up with commerce. Nagy, who, with his artist/partner Alan Belcher, tended shop a few blocks away at Nature Morte

on Tenth Street, wore his twin hats with an equally pointed nonchalance. Nagy's own *Hypocrite Sublime* 1984 (p.115), the title of which posits the 'double standard' or 'sell out' as the site of latter-day *terribilità*, sends up his two-timing role even as he offers it as the moment's privileged locus of artistic truth-telling.

If the dealers spoofed their double identities as backstage operatives and front-room talent, David Robbins worked his twin role as an artist and writer, theatricalising in a 1986 tour de force the rise to prominence of the generation of which he was the most able spokesman. Comprising a suite of standard-issue celebrity headshots depicting his almost-famous peers, including Nagy, Bickerton, Koons and – with perfect period pitch – himself, *Talent* not only writes large the affinities between the art system and the star system but functions as real-life PR for the artist and his peers, whose faces he splashed across the gallery's walls and (such was the work's success) the pages of the international art press.[14]

Hypocrite Sublime

The impulse to come at the system from the inside, to get under the skin of our image world by, well, getting under its skin, was captured by painter and critic Thomas Lawson, whose Trojan-horse approach to the art system was tagged by critic Craig Owens with the purposeful oxymoron 'subversive complicity'.[15] Chronologically, Lawson belongs to the Pictures generation, but, at a moment when the photograph had all but displaced the painting as a fitting medium to get a bead on Modern Life, he turned the tables, arguing that the old-timey convention of the canvas was a hidden-in-plain-sight secret weapon. The new generation took Lawson's intuition and ran with it. 'After years of pulling the object off the wall, smearing it across the fields in the Utah desert, and playing it out with our bodily secretions, the artwork has … asserted itself back into the gallery context – the space of art – but this with an aggressive discomfort and a complicit defiance.'[16] The words are Ashley Bickerton's, and they nail the attitude that produced this new breed of highly self-conscious, almost parodically commodified art objects. If historical Pop art read to 1960s eyes like direct dictation from Madison Avenue, twenty years' hindsight revealed its hand-painted patina, a register of mediation all but poignant when measured against the work's ambitions to match the immediacy of the brave new world of publicity. This new wave of New York art-makers made good on the deficit, burnishing Pop art's bling factor to an all but vengeful sheen.[17]

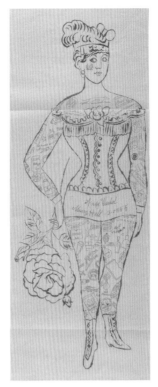

Ashley Bickerton
Tormented Self-Portrait
(Susie at Arles) 1987–8
(p.110)

Andy Warhol
Tattooed Woman
Holding Rose c.1955
The Andy Warhol
Museum, Pittsburgh.
Contribution The Andy
Warhol Foundation for
the Visual Arts, Inc.

In Bickerton's formulation, these high-octane distillates were at once complicit (they fill the bill for gallery-ready goods) and defiant (if only in that they made virtually everyone who thought they knew better squirm). Indeed, one could all but feel the artist bristling within these wall-bound objects. Composed entirely of the logos from the products he consumes, Bickerton's *Tormented Self-Portrait (Susie at Arles)* 1987–8 is an inspired emblem of our inevitable bondage to our culture of consumption (the titular Susie was Bickerton's alter ego – and his brand name) and, as such, a late, great Pop art icon. But his *Commercial Piece No.2* 1990, the next and last in the series of Logo pieces, jumps off the wall – and into the contextual swim. In his will to grapple with the complications of life (and art) in our everyday image world, Bickerton literally peddled space on the surface of the work to a select group of paying advertisers (including Mr Koons!).[18]

Made in Heaven

If the self-conscious objects of a Nagy, a Vaisman or a Robbins gestured in the direction of Warhol's late-phase performance of self and the network of extra-gallery initiatives he developed as his vehicle (even as, like the master himself, they held tight to the conventions of the artwork and gallery), Koons's 1988–9 series of meticulously styled ads for the four major art magazines of the period (*Artforum, Art in America, Arts, Flash Art*; pp.116–17) forsook the frame to ply the networks in which the art object circulates.[19] Like Bickerton's *Commercial Piece No.2*, these full-page tableaux, brazenly embellishing the artist's controversial persona, spoke to the condition of art in our publicity-driven commodity culture by diving into the deep end. The ads, on the one hand, served as announcements for Koons's forthcoming 'Banality' series, but they also counted as a set piece, and an essential one, in this latest offensive in the artist's bid for art-world domination. In perfect Warholian – or should I say Koonsian? – fashion, he not only fully inhabits the charges of his critical antagonists, effectively cutting them off at the knees, but also anticipates the worst sort of market-driven bad faith, adopting it with a festal glee. 'Banality' opened in identical, simultaneous incarnations in three venues (Donald Young in Chicago, Galerie Max Hetzler in Cologne, and Sonnabend). But the real kicker to this carefully plotted short-circuiting of the art machine with its commodifying recuperations is his subsequent packaging of these 'transgressive' ads as a deluxe edition of photolithographs in a specially designed box.[20]

One of the perplexities of Koons's art, it must be said, is that the same practice that includes that imponderable of compression, *Rabbit*, should also encompass the unruly theatricality of the two-continent, three-gallery, four-

Jeff Koons
Spread from
Baptism: A Project
for Artforum 1987
Artforum, November 1987

magazine offensive that is 'Banality'. And yet the line in his art that exceeds the object in order to exploit the networks in which it circulates is far too dominant ever to be plausibly repressed. Indeed, the marshalling of context so clearly seen in the 'Banality' ads runs, in various ways, through much of Koons's work. It appeared demonstratively again, when, invited to contribute an artist's project to the November 1987 issue of *Artforum*, he presented a seven-page sequence of Rococo chapel interiors (including a porcelain Don Quixote figurine, presumably representing the artist himself), emblazoned with the words 'to be forever free in the power, glory, spirituality, and romance, liberated in the mainstream, criticality gone'. Koons's flamboyant farewell to the default position of modernist criticality, served up no less in the house organ of the art world, was nothing if not a theatrical deployment of the apparatus to trumpet his generational message – in deed as well as in words. It must be insisted, however, that his sentiments had nothing to do with the familiar cranky refrains of those rearguard defenders of Art with a capital A, forever thumping their chests about the evils of 'critique' and the good of art as we once-upon-a-time knew it. What Koons was bucking against, rather, was a received, and, to his mind, implicitly domesticating, model of criticality that he felt certain had sidelined the art of his immediate past as a merely academic vocation.

His answer to this deadlock came, perhaps most unequivocally, in the form of the great *Puppy* of Arolsen, that masterwork of public art but, more important, 'Social Sculpture', that, in its astounding populist appeal, delivers on Koons's profound desire to break out of the rarified conversation of art in favour of a kind of immediate carnivalesque.[21] For *Puppy* is every bit the 'contextual' tour de force that the ads are. Conceived for and inspired by

Documenta 9, the 1992 version of the agenda-setting blockbuster in which he had not been invited to participate, *Puppy* exacted Koons's revenge in the form of a forty-and-a-half-foot tall, flowering topiary puppy, erected in the courtyard of the nearby castle at Arolsen. Koons's *cause célèbre* became an obligatory stop on the Documenta pilgrimage (and a rival to the exhibition's draw), which is to say, Koons – implausibly – won! Still, the masterwork in this sequence remains *Made in Heaven*, Koons's self-portrait as publicity coup (or is it the other way round?) that he previewed at the 1990 Venice Biennale.[22]

Super Stars and Art Stars

'Made in Heaven' is a suite of paintings and sculptures, but it was also a breathtakingly theatrical (and altogether ingenious) launch of the artist's purpose-crafted self at the art world's most visible conflagration. The Koonsian achievement consists in the fact that with 'Made in Heaven' he not only seized a leading role on the international art stage, but catapulted his star into the tabloid firmament – an altogether rarer feat where an artist is concerned, Warhol being one of the few to anticipate Koons's tabloid self-evidence.[23] Curiously, Koons's obsession with cracking the Hollywood nut – and his failure to do so – mirrors Andy's own. 'Made in Heaven', it must be understood, includes both the New York billboard that preceded the work's Venice debut (p.42) and the major motion picture by the same name that was, significantly, never to be made. Andy, of course, anticipated Koons's motivating obsession with mainstream exposure, and the ecology that connects Warhol's fixation with Hollywood and the artistic residue it leaves in its thwarted wake are amusingly detailed in Bob Colacello's *Holy Terror*, where he called

the artist's 1972 movie *Heat* (directed by Paul Morrissey and starring Joe Dallesandro and Sylvia Miles) 'his no-thank-you note for the invitations he never received from MGM and Paramount, Columbia, Warner's, and Twentieth Century-Fox'.[24] What binds Koons to Warhol in this respect (both of whom, from what I can guess, were singularly ill-equipped to make a convincing Hollywood-style movie) is just how deeply encoded this lust for 'mainstream' relevance is in the genetic makeup of their art. The notion that the 'fine artist' could or should 'cross over' into the sphere of popular entertainment conjures images of second-rate movie ventures and overblown performance spectacles, but it also registers an important anxiety about

the role, perhaps really the predicament, of artists and art-making in our contemporary pop-cultural universe, and one that becomes, in its failure as much as in its success, a kind of inversely enabling trope in the case of a Warhol or a Koons.[25] If Koons did not make his movie, the expectation it created figured in the theatricalisation of his rise to visibility vis-à-vis the systems that enabled it – and by systems I mean not just the international biennial and the gallery or museum world. Rather, what is put into play in 'Made in Heaven' is the full freight of our expectations with respect to scandal and its recuperations, as well as the sweep of modern art history, which Koons folds into his effort with an almost unthinkable audacity.[26]

Jeff Koons
Puppy 1992
Installation at Arolsen,
1992

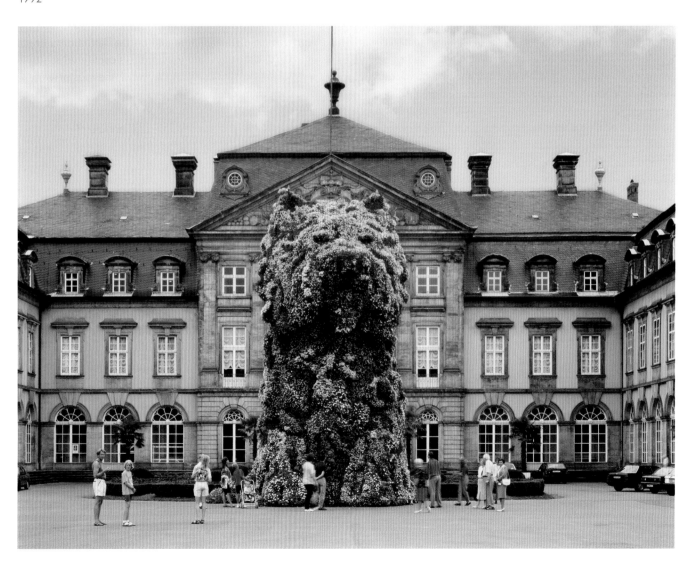

Warhol's obsession with celebrity in all its incarnations – super stars, art stars and, that holy grail, 'real' (read: Hollywood) stars – is in many ways the motor of his late achievement. It explains, for instance, his fascination with a triumvirate of art stars – LeRoy Neiman, Andrew Wyeth and Salvador Dalí – whose popular visibility (in Neiman's case, perhaps only in the US) vastly exceeded their stature in the art world.[27] And it casts his choices of more conventionally celebrated artist-subjects in revealing – sometimes amusing – relief. An outsize figure like Joseph Beuys, who, during Warhol's critically embattled later years, was widely deified in the art world, shows up in several late series: diamond-dusting the shaman was one way of having the last word. (p.103)

There was a long moment when Neiman was much more famous than either Beuys or Warhol, and it is just one instance of the consistency with which Warhol followed his heretic intuitions that he agreed to exhibit alongside the king of schlock – and against the good counsel of some of his advisers.[28] Warhol's business-art network is riddled with like crimes of which his own work as a paparazzo, collected in three prosaically packaged volumes (*Exposures*, 1979, *America*, 1985, and *Andy Warhol's Party Book*, 1988), must count as among his most audacious jabs at received expectations regarding the appropriate comportment for an artist.[29] Dalí, Warhol notes in *Exposures*, 'worships Andrew Wyeth, and so do I', and Andy counted Dalí (who showed up in a screen test and later on the cover of *Interview*)

among his favourite artists, because 'he is so big', Warhol explained. 'It's like being with royalty or circus people', he added, flaunting his animus towards the small-potatoes world of art. 'He wouldn't be caught dead in a loft.'[30]

The expanded field of Andy's 'next step after art' is a kind of pulsing heart of darkness (or light, depending on where you stand), in which social climbing, shopping, cruising and collecting are bound up in a roving social sculpture held together by art – which is to say business. Consider for instance Warhol's well-articulated dance with the publicity machine, a dance in which the artist figures as both paparazzo and as quarry/subject of the paparazzi.[31] You can start almost anywhere in this six-degrees-of-separation network: Warhol is the missing link between Farah Diba and Farrah Fawcett; between the three prosaically packaged volumes of his paparazzi photographs and the commissioned portraits that range from a generic middle-American society matron to Joseph Beuys; between – to lift a line from Robert Hughes's famous dismissal of the late Warhol – 'assorted bits of International White Trash'[32] and his aging Slovak-American mom with whom he shared his Manhattan home until her death in 1972, or anyone who could afford the $35,000 price tag 'for a portrait', as advertised in the 1986 *Neiman Marcus Christmas Book*: 'As a Neiman Marcus exclusive, Aramis has arranged for you to join the ranks of other celebrities from Marilyn to soup cans by becoming artist Andy Warhol's latest (and

Cover and pages from *Interview* magazine, May 1973, featuring Salvador Dalí
Courtesy Interview Enterprises Inc.

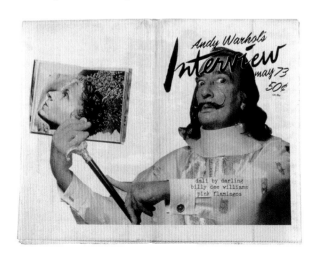

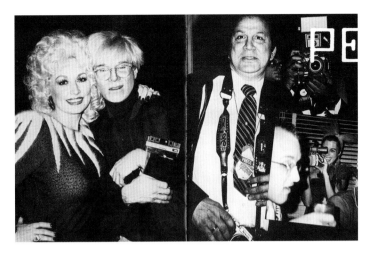

Cover and spread (featuring Warhol with singer Dolly Parton, and photographer Ron Galella) from Andy Warhol, *America*, New York 1985

possibly greatest) subject for a painting.' Warhol's art was a social sculpture, a *gesamtkunstwerk* for the age of the photo op, but it was also a business, and that is what made it art. 'Have you popped the question, Bob?', was Warhol's late-phase mantra, by which he meant, had Bob Collacello or Fred Hughes or whichever Factory lynchpin, sealed the deal with their next portrait victim, that counted as both payday and the exchange that converts the wining and dining into hard artistic currency.[33]

But what, as Koons's Swedish interlocutor put it, is this kind of art communicating to the audience? Where, in other words, is the payoff in these gilded acts of exhibitionism and social high anxiety? Koons's replies are disarming – but also illuminating when Warhol's own 'suspect purposes' are read back from the younger artist's vantage point. In his coaxing, messianic way, Koons answers that he wishes to show us 'that an individual can achieve anything they want, that they don't have to live with unfulfilled desire'. The 'achieving', if one takes him at his word (which, as with Warhol, I find a reliable policy), would include making one's self into a world-class artist – and one with an unusually nuanced grasp of the media machine. This lesson makes for a curious sort of artistic 'surplus' – a surplus, in its way, directly linked to that magnanimous act of expenditure (and declaration of war with Documenta 9 for column inches), the *Puppy* of Arolsen.[34] Compared to Koons's lust for recognition, Warhol's public worrying of his personal and artistic self-determination is obviously scored in a minor key, but the dividends – or maybe I really mean the way they are generated – are of a kind. Warhol's art is never merely 'about' fame or the famous. He never simply dissects the star-maker machinery; nor, for that matter, does he succumb to its spell from afar. Rather, he 'works' it, and, in

the process, leaves a trail to mark his progress that makes strange the whole human comedy, or, at any rate, a particular urban facet of it. It is this MO that links him not only to Koons and the East Village milieu from which he emerged but to a cross-section of artists who came of age in the 1980s and yet are not typically grouped together when the art of the decade is parsed. Indeed, when it comes to exhibiting the nuts and bolts of his social and mercantile manoeuvring, it is Warhol's unstinting honesty, cited by Murakami as the bedrock of the master's inspiration for him, that makes Andy's 'compromised' late practice seem today like such a deep well and balm. By staying true to his exhausted muse (and the bottom line), Warhol, in his intuitive but unwavy consistent way, so fully internalised the operations of the culture industry in his art and exploits that what looked, in the moment, like mere capitulation to the marketplace and the PR machine was, while certainly both these things, also a uniquely accurate road map of our condition.

Other Networks

So what does Koons's feat of stagecraft performed before a bloated-to-bursting international art audience have to do with Prince's *Spiritual America*, that single, pirated photograph of a naked Brooke Shields hidden away in a dimly lit storefront on New York's then-derelict Lower East Side? And what does either have in common with Keith Haring's Pop Shop, the Lafayette Street boutique that the artist opened in 1986 to merchandise his wild-style branding triumph, or with Martin Kippenberger's infamous Berlin artists' watering hole-cum-theatre of cruelty, the Paris Bar?

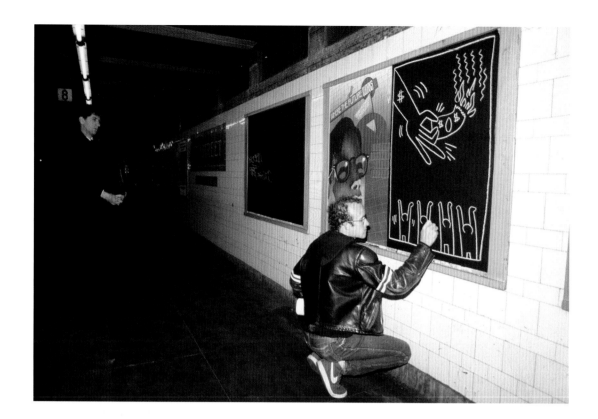

Keith Haring
drawing
in the subway,
New York 1985
Photo: Tseng
Kwong Chi

What these works and the artists who made them share – and share with Warhol – is a will to 'perform' their embeddings in the universe of public relations and the art system, an impulse that has led them, in each case, to step outside the frame and into the social flow that surrounds the artwork. Publicity was not just Warhol's great subject; it was also his medium, or, along with the art system – and himself! – one of his media, and the same, in various ways, can be said of each of these artists. Indeed, as we begin the gradual task of historicising art since the 1970s, it is this step – really a leap – from an art satisfied to comment on or represent its condition in our mass-mediated present to one that insists on commandeering the systems of which art is inevitably a part that has proved Warhol's most significant legacy.

In 1980, when Keith Haring, for example, put his chalk to the unsold advertising marquees papered over in black that once dotted the walls of New York City subway stops, his intent was no more to denounce the ruses of advertising than was Koons's or Warhol's: Rather, Haring was making an advertisement for himself.[35] 'The whole thing' he recalled:

> was a performance. When I did it, there were
> inevitably people watching – all kinds of people.

After the first month or two I started making buttons because I was so interested in what was happening with the people I would meet. I wanted to have something to make some other bonding between them and the work. People were walking around with little badges and the crawling baby with glowing rays around it. The buttons started to become a thing now, too.[36]

'The Radiant Child' (Haring's signature crawling baby surrounded with radiating chalk lines) was, of course, Haring – Haring as an absolute beginner – and his drawings were becoming 'a media thing … the images started going out into the rest of the world via magazine and television'.[37]

Haring's remarks recall Koons's rapturous populism – the same thrill of being swept up in the media machine, the same will to play to an audience beyond the confines of the art world. If Haring's populism seems more authentic, more gentle than Koons's lust for tabloid self-evidence, or, for that matter, than Warhol's passive-aggressive drive to scale the heights of café society, it is revealing that for Haring, Warhol 'was the *only* figure that represented any real forerunner of the attitude about making art in a more public way and dealing with art as part of the real world'.[38]

Shop Talk

The 'real world' for Haring is the world outside the realm of art (whether the terra firma of retail or the imperium of the glossies), and to speak to these worlds – this was Andy's lesson – one must do so in their own language. Though Haring left behind a Whitney Museum retrospective full of paintings, what made those paintings count – what, one might even say, made them art – is the trajectory of a career that literally, if, of course, conditionally, cut art out of the deal at both ends. Haring did this first by writing himself into the daily life of the city with the subway drawings. And he did it again (this time from the far side of his conquest of the gallery world) by extending what had become an established art brand into the realm of retail, with his merchandising masterwork, The Pop Shop.

'I was scared', Haring recalled. 'I knew I would be attacked', but '[Andy] was a big supporter of the Pop Shop', and Andy's blessing meant more to the younger artist than the tut-tutting of the critical rank and file.[39] Haring and Warhol both fretted about their shaky status with the art-critical establishment, but both stayed true to their heretic intuitions, and both crossed the line between art and commerce, art and publicity, art and, well, life as we know it today.

Nicholas Moufarrege, a savant on the scene in the East Village heyday, remarked that if 'the sixties brought pop into art, the eighties are taking art to pop', which was a catchier way of saying that artistic endeavour as such had entered the flow of mass-mediated life.[40] The upshot is that the most powerful artists made this a factor in their art. Julian Schnabel, for instance, an outsize figure if ever there was one, does not have a place in this lineage because his abundance and swagger stay local to an abiding romantic model of the fecund artist daddy. It is not that he is a less canny student of public relations than, for instance, a Koons or a Haring, but that his instinct for publicity is never the fibre of his art. Even for Cindy Sherman, whose vivid masquerade might seem one of the great ongoing performances of our time, the self remains safely on the observing side of the critical gaze that she casts on the types she inhabits. Despite the incisiveness of her art, Sherman never really crosses the line between Cindy and Sloane Ranger, self and Five Towns carpool mom. However resonant her embodiments, they are donned, in keeping with her Pictures pedigree, as problems of representation. She remains the critically distanced observer, probing her adopted postures, never a figure whose own movements through the world are a part of her project.

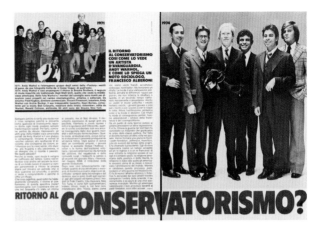

'Ritorno al Conservatorismo?' fashion feature with Fred Hughes, Vincent Fremont, Andy Warhol, Ronnie Cutrone, Bob Colacello and Sean Byrnes modelling Brooks Brothers clothing. Photographed by Oliviero Toscani. *L'Uomo Vogue*, February/March 1974

Warhol's whole late-phase performance can of course be seen as a slap in the face to art, a bid to upstage art by stepping into the flow of life. 'Business art', Andy famously remarked, 'is the best kind of art',[41] and the celebrated pronouncement is not just a naughty dig at modern art's foundational pieties. Mark Francis sees in the artist's early multimedia nightclub spectacles (and the Factory itself) a model for a kind of social sculpture, 'a total theatre in which the audience or spectators' lives and bodies were intrinsically engaged.'[42] Of course, with Andy's shooting in 1968 came a practical level of protection, which spelled the end of the Factory's open-door policy with respect to the demimonde, and with it a move to a more business-like demeanour reflected in the tailored suits donned by the Factory team as pictured in a *L'Uomo Vogue* feature headlined 'Ritorno al Conservatorismo?' (p.29).[43] Warhol's widely perceived fall from grace is, of course, coincident with a number of moves to the right, or at least up the social ladder, but a quarter-century's hindsight makes it plain that the party was not over; it had simply moved uptown.

All Tomorrow's Restaurants

Francis has remarked that 'Warhol attempted to restore traces of the childlike, the exotic, the ecstatic, and the grotesque to the various worlds he entered', and those worlds included, of course, the art world, which time has shown that he, like Haring and Koons and Kippenberger, played (to resort to the cliché) like a fine instrument.[44] The Paris Bar may not have much in common with Studio 54, the disco that Warhol immortalised with a series of paintings of VIP admissions tickets. But the restaurant was a nexus for Kippenberger's performance of self – or better, selves – that would animate the mythos-making machinery of the art world, mapping the convergence of the promotional and social mechanisms undergirding the institutions of art with a specificity unique to his endeavour.

Kippenberger captured the imagination of New York artists in the 1980s as no other European figure did, and, if his purposes were initially difficult to divine for audiences prepped on the antithetical intentions of German New Expressionism, for both Koons and Prince the ecology that binds Kippenberger's paintings to his theatrical antics was an enabling example. The affinity between Kippenberger and Koons is explicitly signalled in this exhibition by the portrait poster that the German artist commissioned the young American to make of him in 1990, titled *Martin Kippenberger Is Great, Tremendous, Fabulous, Everything* (p.128). The likeness would hang at the entrance of his 1993

Andy Warhol
The New Portrait 1984
ARTIST ROOMS Acquired jointly by Tate and the National Galleries of Scotland through The d'Offay Donation with assistance from the National Heritage Memorial Fund and The Art Fund 2008

Centre Georges Pompidou exhibition, *Candidature à une retrospective*, the first gallery of which is reprised for the current exhibition, complete with a wall-size oil painting of the infamous artists' haunt by Daniel Richter (p.130), commissioned by Paris Bar owner Michael Wurthle to fill the spot on the wall of his establishment left vacant when he sold off the by then valuable original. The gesture was altogether in keeping with the artist's own subversive gaming with the mechanisms of value and validation on which the institutions of art rely.[45] The Pompidou show was Kippenberger's characteristically provocative reply to the museum's invitation to exhibit, and as ever the proceedings burlesque the validating politics of the museum even as they exploit them. Resonances both explicit and implied between Koons or Kippenberger and the Warholian total art work are legion of course, though it is a selection of Warhol's late

(and, in fact, great) series, the 'Retrospectives/Reversals' (pp.104–7, 109) – paintings that literally cannibalise his own early Pop art icons – that make for our most showy slide-lecture comparative.

It is curious that Prince – an artist who has remarked that 'I don't see any difference now between what I collect and what I make. It's become the same' – numbers Warhol first and Kippenberger second in terms of the artists most generously represented in his private library-cum-self-portrait in the tiny town of Rensselaerville, New York.[46] Warhol's 'Time Capsules', the cardboard boxes in which he deposited samples of the massive detritus of his busy life – invitations, clippings, bills, etc. – and sealed them up for posterity, are as much a precedent here as the history of house museums as artworks from David Ireland to Donald Judd. Finally, to round out this promiscuous game of artistic Chinese whispers among the four central protagonists of the 1980s component of this show, it is Warhol's relationship to, and collaboration with, both Haring and his East Village comrade-in-arms, Jean-Michel Basquiat, that constitutes one of the most unexpected episodes in Warhol's last-phase oeuvre (pp.69, 121).

Once one exits the frame and enters the expanded landscape of extra-gallery endeavour, collaboration becomes a privileged procedure, a microcosm of the 'next-step-after-art' social sphere.[47] On the one hand, Warhol's relationship with these young artists was enabling (Haring has expressly acknowledged this), and yet, like all interpersonal relationships, Warhol's attachments were inevitably 'interested', which is what makes of these performed instances of intergenerational agon, if, that is, one will allow the inclusion of interpersonal manipulation in the business-art tool kit, an altogether resonant facet in Warhol's multitenticled social sculpture. That Warhol, in the fraught twilight of his Pop-art statement, pursued these rising art stars like a vampire hungry for fresh blood cannot go uncommented upon. That his portrait of Basquiat, *Jean-Michel Basquiat* 1982 (p.102), is in fact the only oxidation painting in his vast body of portraits, which is to say, the only portrait pissed on, is, one can be sure, a meaning that was not unintended by this most alert observer of the intersocial landscape.[48] Few, I hazard, would attempt to grapple with such an overdetermined image without acknowledging the permissions that the mediation of art allows, but I equally hope no one would miss the performed relationship between the young black artist and the embattled white star, the fraught bond between the institutions of art and the subcultures on which they feed, which Warhol has gone at with a too-hot-to-handle poker.

This is perhaps the place for a look at another collaboration (and a masterful performance), that between Sturtevant and the artists to which, she, like Warhol, both pays homage and cannibalises. Sturtevant's underrated art remains senseless outside the frame of these performed artistic relations. What she has done is to paint fairly exact replicas of the work of mostly male masters with deadpan aplomb and a mind-bending consistency that, with each passing year, makes her performance and the objects it yields more uncannily powerful. She is selective in her choices, and if Warhol is the artist to whom she has given the most attention, beginning in the mid-1960s and on and off into the 1990s, Haring also played a starring role in her oeuvre in the 1980s. Hung for this exhibtion next to the Warhol/Basquiat collaboration *Sweet Pungent* 1984–5 (p.121), her *Warhol Gold Marilyn* 1973 tondo (p.119) and four *Haring Tags*, all 1986 (p.120) will not fail to resonate – or to complicate our sense of the altogether unexpected way in which these paintings operate in our expanded field of endeavour.

Being Brooke

One of the downsides of an effort such as this exhibition is that it runs the risk of reducing the artists examined to so many chips off the Warholian iceberg, and yet (at least in the case of these four key figures) what proves altogether more surprising than the constancy of the ripples that Warhol's long-demonised late production continues to send into the future are the wholly unexpected ways in which his example resonates in the work of artists who have followed him. Nowhere is this truer than in Prince's art, particularly *Spiritual America* (p.123) his 1983 landmark work that inaugurates the 1980s sea change with which we are concerned in this essay and in the show it accompanies as decisively as 'Made in Heaven' caps it.

Spiritual America is not just a photograph of a bath-damp and decidedly underage Brooke Shields lifted from the sketchier side of commercial photographer Gary Gross's oeuvre. It is also the elaborate faux-gilt frame in which it was presented – and the off-the-beaten-track locale on New York's pre-gentrified Lower East Side where it was displayed. It is the work's title, a reference to a 1923 photograph by Alfred Stieglitz of a gelded workhorse, just as much as it is the creepy particulars of the image's soft-core mise-en-scène. And it is the modest furor that the presentation of the provocative image willfully incited in the critical climate of the moment – a moment in which the male gaze was more often the subject of determined criticism

Richard Prince
Untitled (Publicity) 2000
(p.122)

than the sort of no-comment, indeed, pointedly fetishised, display on offer here. *Spiritual America*, in short, includes the whole artful theatre with which Prince brought the image into the world – as well as the time-release aura it has bestowed on the artist's practice retrospectively. It was, like Kippenberger's Paris Bar, a vehicle for performing Prince's own artistic mystique, a work of self-promotion as much as an analysis of the fraught image.

When Prince invites us to ogle Brooke Shields in her prepubescent nakedness, his impulse has less to do with his desire to savour the lubricious titillations that it was shot to spark in its original context (the Playboy publication *Sugar n' Spice*) than with a profound fascination for the child star's story; by the time he lifted the photo, her celebrity had fully blossomed, making this early indiscretion of her over-eager manager mom an episode that all concerned parties were anxious to forget. Feminist critics at the time were quite right to point to the ambivalence of Prince's posture. This was no indictment of the masculinist gaze, and it never pretended to be. Prince wanted to dilate on Shields's status as victim – but also eventually victor – of the star-maker machinery, and the deep imbedding of this 'compromise' in the nature of celebrity more generally, of which the child star can be such an uncanny embodiment. Being Brooke may or may not be

better than flipping burgers in a greasy spoon, but what Prince wanted to think about – wanted to make us think about – was this stranger-than-fiction all-American journey, and how it relates to the theatre of his own under-construction persona.[49]

Coda: This Ain't No Fluxus

Where do paintings – those old-fashioned art objects – fit into all of this?

Those privileged reliables catch your eye as you cross the threshold of the fully operational Louis Vuitton boutique at the heart of Murakami's MoCA retrospective, ©MURAKAMI – tidy swaths of the company's famously monogrammed fabric, customised by the artist for his limited-edition handbags and stretched up as cash-and-carry canvases.

Or they go unnoticed, still a twinkle in the eye of Reena Spaulings, at the dinner celebrating the same exhibition's New York opening – tablecloths from all outward appearances, wine-spotted and scattered with crumbs – until, at evening's end, she discreetly steals away with one and stretches it up as an impressive tondo.

Sometimes they are simple ciphers – this seems true of Damien Hirst's dot paintings, that longtime standard in his repertoire. Reprised in gold to mark the occasion of his 2008 Sotheby's megasale, *Beautiful Inside My Head Forever*, the paintings are both witnesses to and stars of the marketing tour de force that broke all records on the eve of the stock-market crash and, in so doing, became the artist's masterwork (p.172).

At other times – in Richard Prince's case – they are 'Nurses': sex-crazed man-eaters but also caretakers and healers watching over an oeuvre that encompasses a Guggenheim Museum retrospective full of paintings and sculptures as well as a range of equally key interrelated endeavours, including the by now obligatory Louis Vuitton artist's designed purse and the nurse fashion show that accompanied its launch.

I have to admit that I've never really liked these 'Nurses', but I'm convinced I understand them. Part of understanding them is understanding that you can't understand them, that their ironies cut in several directions at once, that you will be every bit as much the butt of the joke if you call their bluff or suck it up. Like Warhol's 'Gems' (pp.94–7) or 'Torsos', the 'Nurses' are fetishes, paintings

about fetishes – and about painting-as-fetish – and they offend and flatter simultaneously. They take a fetish – comical, camp, yet still faintly potent, especially if you (like some of Prince's customers, undoubtedly) share the predilection – and serve it up without apology. There is a nurse for every collector's taste – if not perhaps pocketbook.

Painting is dead; long live painting! Bob Colacello, a key figure in Warhol's late-phase enterprise and an early and long-time editor of *Interview*, the magazine that Warhol started (as the story goes) to get into screenings and premiere parties, observed: 'Sometimes I wonder if Andy wanted it to work. I wonder if any of it – the video projects, *Interview*, even the movies, anything other than the art and the selling of the art – was meant to be serious.'[50] Having toiled for a dozen years (on Warhol's notoriously mean wages) to build the publication into a going concern, Colacello should know from whence he speaks. The myriad of Factory offensives may have been part of the art, but it was the paintings that called the carnival to order, that served as the 'control' against which a night out at Mortimer's or the Mudd Club might be counted as an 'action' in the expanded arena of Warhol's art. If he subtly hijacked his own entrepreneurial initiatives (or simply didn't feel their success in the larger ecology of his art need be measured by the same exacting accounting standards as the portrait commissions), this willful anti-professionalism may well have supplied the infra-thin, but necessary, difference that assured his 'next step after art' would remain legible as art and not simply business. To be sure, Warhol was ever on the make for the fresh venture – and he

tirelessly courted the mainstream – but when it comes to the extra-artistic endeavours, we had to wait for another generation, for a Murakami or a Hirst, to make the cash registers go cha-ching.[51]

The point of this essay, and the show that provides its occasion, is not to make a sequence of artists, bracketed by two all-time auction record holders, the misunderstood heirs to Fluxus. Indeed, if one avant-garde leitmotif is to disappear the conventions of art – and one's self – into the everyday demotic, a Koons, a Murakami, or a Haring does the opposite. Like Andy, who was famously always quitting painting but never actually doing so, Koons is keenly alive to painting's status as *the* vehicle synonymous with art's privilege.

Consider, for instance, his explanation for why he would want to turn the staged photographic images from 'Made in Heaven' into paintings: 'A photograph for me does not have a sense of spiritual seduction, it does not have an essence.'[52] But then when asked what makes a painting more 'eternal' than a photograph– here comes the zinger – he explains, 'For one thing you have the support of the museum. And the framework of painting, and the support of the institution of museums, is in everyone, it's in the subconscious mind.'[53] This is a fully instrumental understanding of painting's aura, and it says a lot about the way the medium has been deployed – and reinhabited – in the art we are concerned with here. The art object is only one part of the network that these artists animate, but it is an essential one, and it is a certain lucidity about how it functions in the broader economy of art that motivates these artists to step outside the art system, to turn its conventional vehicles back into art.

To succumb to the mass media and the marketplace is to break one avant-garde law. To succumb to art, or rather art's conventions and institutions, violates another, subtler protocol: the one that requires art to unmake itself, to make it new. To give in to both the culture industry and the art system at once – willfully, strategically, exultantly – lands one in the mainstream of pop life. The payoff comes when these systems are not only played, but played with a little 'art', played for some slim but decisive disturbance that occasions the eureka 'I see!' What counts as decisive is, as ever, elusive. Every business-art multi-tasker or media-happy showman does not a Koons or a Murakami make. *Pop Life* puts forth a sequence of artists who have, in their art – or at some moment in their art – not only made this double wager, but, it seems to us, made it count. In so doing the exhibition inevitably opens a still fresh wound – and it proposes a first-draft account of an already historical phenomenon.

Richard Prince
Man-Crazy Nurse
2002–3
Courtesy the artist

Notes

1. Andy Warhol and Pat Hackett, *Popism: The Warhol '60s*, New York 1980, p.108.

2. This quote comes from a Jeff Koons interview with a Swedish television reporter about his 'Made in Heaven' project. Available on YouTube for a short time (http://www.youtube.com/watch?v=ddjZjG_RxVw) on 9 March 2009, the interview was subsequently removed.

3. Wayne Koestenbaum writes, 'The endless art he made after Valerie Solanas shot him could not assuage his morbid fear that he had run out of ideas. He told his diary in November 1978, "I said that I wasn't creative since I was shot, because after that I stopped seeing creepy people."' (Koestenbaum, *Andy Warhol*, New York 2001, p.159.)

4. In one of the richer ironies of Warhol's reception, an unprecedented convergence of the critical left and the fusty majority occurred when a glibly turned diatribe penned by Robert Hughes showed up in, of all places, *Art after Modernism*, a compendium otherwise dedicated to packaging the 'post-Modern turn' in the neo-Marxist- and Structuralist-derived parlance of the moment. See Robert Hughes, 'The Rise of Andy Warhol', in Brian Wallis (ed.), *Art after Modernism: Rethinking Representation*, New York 1999, pp.45–58. (Reprinted from the *New York Review of Books*, 18 February 1982, pp.6–10.)

5. 'Business art is the step that comes after Art. I started as a commercial artist, and I want to finish as a business artist. After I did the thing called "art" or whatever it's called, I went into business art. I wanted to be an Art Businessman or a Business Artist. Being good in business is the most fascinating kind of art.' (Andy Warhol, *The Philosophy of Andy Warhol*, New York 1975, p.92.)

6. This section title (and the next) is borrowed from a pair of works by Meyer Vaisman. *Live the Dream* 1984, a cheeky send-up of artistic self-determination, perfectly conjures the have-cake-and-eat-it-too temperature of the time: a canvas silkscreened only with an enlarged pattern of its own weave and fitted with a pair of working clock arms, this empty sign of itself deploys the down-market sound bite of its title to mock the artist's own barbarian's knock on the closed gates of culture – even as he barges through them.

7. Peter Halley, whose practice remains largely confined to the two-dimensional support, was nonetheless a significant voice in the discussion around the developments explored here, and his work has important affinities and resonances with our subject that would benefit from examination in a fuller treatment of the period. Halley, it is interesting to note, felt Warhol to be a formative influence, and he founded *Index* magazine with curator and critic Bob Nickas in 1996, a publication that he has discussed in relationship to Warhol's *Interview*. Halley continued to publish *Index* until 2006, and relaunched the publication as a web-only enterprise in 2009.

8. It is crucial to note that this exhibition, which focuses on a tendency in art and not a period or movement, crosses conventional parsings of the period. The narrative in this and the following sections focuses on two of the fifty-plus galleries in the rich but short-lived East Village scene. One conditionally useful period cliché opposed the establishments I am concerned with here, which focused on Conceptual and Pop-influenced work, with another mood that coalesced around colourfully named galleries like Fun, Civilian Warfare and Gracie Mansion. Keith Haring and Jean-Michel Basquiat, who also figure in this exhibition, emerged from this latter side of the East Village scene.

9. See Douglas Crimp, 'Pictures', in *Pictures*, New York 1977, and Crimp, 'Pictures', *October*, no.8, Spring 1979, pp.75–88. Crimp's 'Pictures' essay first appeared in the catalogue of the eponymous exhibition of work by Troy Brauntuch, Jack Goldstein, Sherrie Levine, Robert Longo and Philip Smith that he curated at Artists Space in New York in 1977. A revised version of the essay appeared two years later in *October*, which, Crimp wrote in his introduction, took 'its point of departure from the catalogue text' and addressed 'an aesthetic phenomenon implicitly extending to many more artists than the original exhibition included'.

10. None of this, it should be noted, was quite as simple as it appears in this compressed narrative. The Neo-Expressionist impulse was broad-based, with both Italian and German counterparts to the New York phenomenon. And the work of an artist like David Salle, at that time a key figure in Boone's stable, has as much in common with the Pictures-generation mindset as with a Neo-Expressionist like Julian Schnabel, as his inclusion in the recent exhibition by that title at the Museum of Metropolitan Art New York suggests. Salle was also a model for and protagonist in Thomas Lawson's essay 'Last Exit: Painting' (see n.15).

11. Dorothea von Hantelmann has quoted Koons in her discussion of the artist vis-à-vis the related paradigms of 'celebration' and 'performativity', whereby he 'sets himself aside from the "cultural limit" of critique'. See 'To Celebrate, a Displacement of Critique', in Suzanne Pagé et al., *Pierre Huyghe: Celebration Park*, exh. cat., Tate Modern, London 2006, p.127. (Originally published in Burke and Hare's interview with Koons, 'From Full Fathom Five', *Parkett*, no.19, 1989, p.47.)

12. David Robbins captured the generational mood in his essay for the exhibition *Infotainment*, a text that became a kind of manifesto for the artists who congregated around the gallery Nature Morte. Organised at the gallery by artist and proprietor Peter Nagy in 1985, the exhibition included, in addition to works by Nagy and Robbins, pieces by Alan Belcher, Sarah Charlesworth, Peter Halley, Steven Parrino, Laurie Simmons and Haim Steinbach, among others. See *Infotainment*, exh. cat., Nature Morte, New York 1985, with texts by Robbins, Nagy, George W.S. Trow and Thomas Lawson.

13. Vaisman and his partners Kent Klamen and Elizabeth Koury founded International with Monument in 1984 on East Seventh Street between First Avenue and Avenue A in Manhattan's East Village. In 1985 International with Monument hosted the first one-person gallery exhibitions of Peter Halley and Jeff Koons. The gallery also showed the work of Ashley Bickerton, Sarah Charlesworth, Richard Prince and Laurie Simmons, before Vaisman sold his share to Koury and Eelan Wingate and it relocated to SoHo in 1988 as Koury-Wingate. See Dan Cameron, 'Dan Cameron on International with Monument', *Artforum*, vol.38, no.2, Oct. 1999, pp.127–8.

14. It is telling to note that the current work of both Bickerton and Robbins, which a fuller examination of our subject would certainly include, has evolved in a performative direction. Bickerton's recent work takes the form of a managed personal mythology in which the life the artist leads in the 'tropical island paradise' of Bali, Indonesia, is elaborately burlesqued in the paintings and mise en scène he sends back to civilisation. Recent work by Robbins, including projects such as *Ice Cream Social* 1993–2008, and his video/project *Lift* 2007–9, has also taken on an overtly performative dimension first seen in *Talent* 1986, a work that literally performed himself and his peers into the art system. *Ice Cream Social* began in New York when Robbins decided to display a dot painting he had made using Baskin-Robbins's trademark pink and brown colors at a local Baskin-Robbins ice-cream parlour, and grew to include events in other cities, a TV pilot, a feature film script, and a novella. *Lift* includes a video portrait of a personal trainer that invites us to consider the subject's vocation as an artistic activity. The video was exhibited in a gallery with three paintings based on the video made by assistants, a video of a conversation between Robbins and the trainer, and a brochure with a text by Robbins, and was also broadcast on a Milwaukee television station.

15. In 'Last Exit: Painting' (*Artforum*, vol.20, no.2, Oct. 1981, pp.40–7), his defence of painting's viability as an art form in the 1980s, Thomas Lawson elaborated a position whereby painting could follow 'a strategy of infiltration and sabotage, using established conventions against themselves in the hope of exposing cultural repression' (p.42). Although Lawson used the words 'subversive' and 'complicity', his theory may not have been referred to by the moniker 'subversive complicity' until Craig Owens, in his critique of Lawson's defence of painting, called him 'the author of the theory of subversive complicity'. (See Owens, 'Back to the Studio', *Art in America*, Jan. 1982, p.107.)

16. Ashley Bickerton in Peter Nagy, moderator, 'From Criticism to Complicity: *Flash Art* Panel', *Flash Art*, no.129, Summer 1986, p.49.

17. In the preceding Pictures generation only the work of Jack Goldstein and Robert Longo hinted in the direction of these high-glamour objects.

18 Ashley Bickerton's logo series comprises *Tormented Self-Portrait (Susie at Arles)* 1988, *Commercial Piece No.2* 1990 (discussed in the text), and *Le Art (Composition with Logos)* 1987, which featured the logos of the products Bickerton used in the making of the piece.

19 It's interesting to note that in the case of Nagy, his signature early means took the form of the infinitely reproducible Xerox affixed to the simplest canvas support, as if to highlight the comical duet of the convention of art writ large in the standard-issue stretcher and its undoing at the hands of reproductive technology.

20 My take on Jeff Koons's 'Banality' advertisements is indebted to Andrew Renton's prescient reading of the performative aspect of Koon's work as well as to Alison Gingeras's more recent consideration of performed personas in modern art: see Renton, 'Jeff Koons and the Art of the Deal', *Performance* no.61, Sept. 1990, p.28; Gingeras, 'Lives of the Artists: Public Persona as an Artistic Medium', *Tate Etc*, no.1, Summer 2004, pp.24–33.

21 I am indebted to Dorothea von Hantlemann's discussion of *Puppy* as central to her reading of Koons's work via the twin paradigms of performativity and celebration.

22 Koons debuted his 'Made in Heaven' series in the Aperto section of the 1990 Venice Biennale, showing three paintings and one sculpture. He unveiled the full series of works, including pieces that were much more sexually explicit, at his 1991 show at Sonnabend in New York. A billboard had appeared in 1989 on Broadway in New York, featuring a nude Koons embracing a swooning, lingerie-clad Cicciolina on what appears to be a rock outcrop or mass of gnarled tree roots. The sign, which listed Koons and Cicciolina as the stars of *Made in Heaven*, has the look of an advertisement for a B-movie (p.42).

23 I am indebted to Scott Rothkopf for conversations during the preparation of his essay for this catalogue regarding the degree of Koons's penetration of the tabloid press on the occasion of *Made in Heaven*.

24 Bob Colacello, *Holy Terror*, New York 2000, p.130.

25 On Laurie Anderson, for example, Robert Palmer wrote in the *New York Times*, 'Miss Anderson isn't just getting a chance to test her art in the mass marketplace; her progress is bound to be followed closely by other avant-garde and performance artists who would like to expand the audience for their recorded work. "The success of 'O Superman' did kind of come out of the blue", Miss Anderson conceded. "But I'd been aware for the last couple of years that different people were starting to come to my performances – kids, art people, rock-and-roll people. And I liked that a lot. I had always thought that would be a good direction, because in the United States artists tend to live and work in such a rarefied world. It's really sort of been my fantasy about American artists to see what could happen when they enter their own culture."' (Robert Palmer, 'The Pop Life', *New York Times*, 21 April 1982.)

26 Koons himself has referenced Courbet's *The Origin of the World* in discussing *Made in Heaven*, and one painting in the series, entitled *Manet*, references that artist's controversial *Le Déjeuner sur l'herbe*.

27 While Dalí's place in the popular imagination is formidable, his artistic reputation is certainly secure and of a different order from that of Wyeth and certainly of Neiman. Recent scholarship regarding Dalí's various activities in the years following the Second World War, when he expanded his artistic focus beyond the canvas to explore his interests in areas such as film and design, has considered his extra-painting endeavours as a direct precedent for the multifarious practice of Andy Warhol. The curator Michael R. Taylor writes, 'Dalí had provided Warhol with a role model for the successful, publicity-oriented artist whose knack for self-promotion ensures that every exhibition of his work is a sensational event. Warhol rarely acknowledged the debt his work owed to Dalí, but one can gauge how much he learned from his example by comparing the older artist's pioneering ventures into commercial art, filmmaking, fashion, advertising, commissioned society portraits, and religious iconography with Warhol's activities at the Factory.' (Michael R. Taylor, 'The Dalí Renaissance', in Michael R. Taylor (ed.), *The Dalí Renaissance: New Perspectives on his Life and Art after 1940*, exh. cat., Philadelphia Museum of Art 2008, p.24.)

28 In November 1981 the Los Angeles Institute of Contemporary Art mounted an exhibition, underwritten by Playboy Enterprises, of sports-star portraits by LeRoy Neiman and Andy Warhol. Robert Hughes, writing in the *New York Review of Books* in 1982, ranked Neiman as the second most famous artist in America, behind Andrew Wyeth and ahead of Warhol, and described him as 'Hugh Hefner's court painter, inventor of the Playboy femlin, and drawer of football stars for CBS.' (Robert Hughes, 'The Rise of Andy Warhol', *New York Review of Books*, 18 Feb. 1982, p.6.)

29 *Andy Warhol's Party Book* was completed just before his death but not published until shortly afterwards, in 1988.

30 Andy Warhol, *Andy Warhol's Exposures*, New York 1979, pp.128–9. It is interesting to note that Koons shares Warhol's obsession with Dalí (and indeed collects his work), and Dalí's living circus is of course a serious precursor for Warhol's 'next step after art', even if Dalí's artistic production and the carnival of his court fail to achieve the unity that to me seems decisive in Warhol's example.

31 Hubertus Butin has written suggestively on Warhol's use of self-promotion in his work. See 'Andy Warhol in the Picture: Self-Portraits and Self-Promotion', in Eva Meyer-Hermann(ed.), *Andy Warhol: Other Voices, Other Rooms*, Rotterdam 2007, pp.47–55, and '"Oh when will I be famous; when will it happen?": Andy Warhol's Society Photos', in *Andy Warhol: Photography*, Zürich 1999.

32 Hughes 1999, p.56.

33 Colacello 2000, p.168.

34 Koons had not been invited to participate in the megashow, held once every five years in Kassel, Germany.

35 The same thing might be said of graffiti art more generally, but Haring's choice of the unused marquees (and of ephemeral chalk as opposed to indelible spray paint) set him apart from the then-thriving subculture even as he conveyed its excitement. As he mused: 'Well I was arrested, but since it was chalk and could easily be erased, it was like a borderline case. The cops never know how to deal with it.' Indeed, the chattering classes recognised from the instant the Radiant Child showed up in their local subway stop that a new game was afoot; the question is, what kind of game?

36 David Sheff, 'Keith Haring: An Intimate Conversation', *Rolling Stone*, 10 August 1989, p.63.

37 Ibid., p.64.

38 Ibid.

39 Ibid.

40 Moufarrege quoted in Bernard Gendron, *Between Montmartre and the Mudd Club*, Chicago 2002, p.308. Gendron, writing about how large art exhibitions in the 1980s, such as P.S.1's 'New York/New Wave' in 1981, were becoming more and more like mass-culture spectacles akin to sporting events or fashion shows, quoted Moufarrege's article 'Another Wave, still more Savagely than the First: Lower East Side', which appeared in the September 1982 issue of *Arts*.

41 See n.5.

42 Francis 2004, p.14.

43 Warhol and associates such as Fred Hughes and Vincent Freemont modelled Brooks Brothers clothing in the fashion editorial shot by Oliviero Toscani in the February/March 1974 issue of *L'Uomo Vogue*.

44 Mark Francis, 'Horror Vacui: Andy Warhol's Installations', in Mark Francis (ed.), *Andy Warhol: The Late Work*, Munich 2004, p.12.

45 Kippenberger had already made his own copy when Wurthle was loath to remove the painting from its spot at the bar to loan it to the Paris show. Kippenberger's version depicted the painting in situ with a row of tables visible in front of the original work, a move altogether in keeping with the artist's Chinese-box approach to the network of affiliation on which cultural recognition is premised.

46 Karen Rosenberg, 'Artist: Richard Prince', *NYMag.com*, 25 April 2005, accessed on 25 July 2009 <http://nymag.com/nymetro/arts/art/11815/>. A central aspect of Prince's art includes both exhibitions in which he curates his own work like *Woman* in Los Angeles and *Man* in Zurich, and buildings he commandeers and arranges with his own art as well as artifacts he collects. These include First and Second houses (1993 and 2001–4, respectively).

47 In this respect artists such as Gilbert & George, and their New York counterparts McDermott & McGough, have a place in our story, both for the ecologies they sustain in their art between frame and 'real world' manoeuvre and the 'performed personas' that serve as their currency brands.

48 Warhol's other portrait, or rather cluster of portraits, of Basquiat depicts the artist posed in a jock strap and segmented into pieces, while perhaps their most memorable collaborative venture features a series of real punching bags printed with images of the martyred Jesus decorated in Basquiat's distinctive hand.

49 If Prince, in our line-up, is the sole survivor among his Pictures peers, it is for this reason. By 1983, he was already testing the limits of the appropriative academy, cognisant that it was hardly an infinitely renewal resource, and the wager in our grouping, of course, is that when the lens is pulled back, the ribbon that connects Prince to Koons – and both of them to Kippenberger (and all three to Haring) – is a good deal stronger than the one that binds him to Sherrie Levine, Cindy Sherman or Jack Goldstein.

50 Colacello 2000, p.141.

51 In his essay in the ©MURAKAMI catalogue, Scott Rothkopf discusses Murakami's interest in actually turning a profit in his endeavours (in disregard of the conventional divide between art and commerce) and cites a *Business Week* article that puts the gross earnings of Murakami's handbags for Louis Vuitton at more than 300 million dollars in their first full year of production. See Rothkopf, 'Takashi Murakami: Company Man', in Paul Schimmel (ed.), ©MURAKAMI, exh.cat., The Museum of Contemporary Art, Los Angeles 2007, pp.130, 156–8; Carol Matlack, 'The Vuitton Money Machine', *Business Week*, 22 March 2004, accessed on 25 July 2009 <http://www.businessweek.com/magazine/content/04_12/b3875002.htm>.

52 Andrew Renton, 'Jeff Koons: I Have my Finger on the Eternal', *Flash Art*, Summer 1990, p.111.

53 Ibid.

Made in Heaven: **Jeff Koons and the Invention of the Art Star**

Scott Rothkopf

On 19 May 1991, the *Fresno Bee* ran a short item announcing the impending nuptials of the 'American sculptor Jess Coon'. Coon, the unsigned text reported, was to marry 'a former Italian legislator who does a porn act as La Cicciolina' in Budapest on 1 June, according to the fiancée's mother Tibor Nogradi. The Reverend Zoltan Szirmai confirmed that he would administer the vows, having extracted from the bride-to-be a promise to cease her work in sex shows, films and videos, along with what the Lutheran minister delicately termed her 'advertising of free love'.[1] That the *Bee* quaintly misidentified the man who over the course of the previous year had arguably become the most famous artist in the world was perhaps less surprising than the fact that it was announcing the nuptials of any artist whatsoever – hardly the type of event that would ever have attracted much notice in the press. Yet with this brief item the central California paper joined the ranks of the hundreds of media outlets around the globe that would publish more than a thousand articles devoted to the engagement and marriage of Jeff Koons, adding a few more drops to the oceans of ink that would fundamentally transform the public status of artists for years to come.

By now, we take for granted the rightful place of artists alongside actors, athletes, rappers and scantily clad heiresses in the vast dominion of celebrity culture, yet their position within that universe was not always so secure. Certainly figures such as Pablo Picasso, Marcel Duchamp and even Jackson Pollock made cameos in the mainstream American press, the latter famously appearing in a 1949 issue of *Life* wearing paint-splattered dungarees above the headline, 'Is he the greatest living painter in the United States?'[2] Throughout the 1950s and 1960s, periodicals such as *Vogue*, the *New Yorker* and even *Seventeen* (showcasing the work of the eighteen-year-old Eva Hesse) introduced their readers to artists of every stripe, whether in profiles, special projects or elegant photographs like those shot by Francesco Scavullo of Ellsworth Kelly and Donald Judd alongside their nattily attired lady friends.[3] Yet during this period artists were treated less like bold-face personae in their own right than as passing objects of curiosity who might impart hip cachet or intellectual credibility to the pages in which they appeared. Ciphers from a rarified foreign realm, they were usually supplanted in subsequent issues even more quickly than were their counterparts from the worlds of literature, entertainment and sports.

There were exceptions to this rule, of course. By mid-century, Andrew Wyeth was an American household name, but he never achieved any traction in avant-garde circles and, at least until the headline-grabbing revelation

Jeff Koons
The New Jeff Koons 1980
Courtesy the artist

of the nude Helga pictures, few of those households would have had much interest in the vicissitudes of a cloistered life lived between grey skies and fallow fields. Salvador Dalí, more aptly, created his own international brand name, crossing from the avant-garde into the mainstream as early as 1936 with his appearance on the cover of *Time*, a point after which his renown as a celebrity grew in inverse proportion to his declining reputation as a serious artist.[4] With a love of the limelight and a distinctive look to etch into the minds of an art-wary public, Dalí masterfully plied his wares and himself across the post-war media landscape of print, TV and film. He leveraged the potent mixture of his name and his handiwork to help sell everything from a Hitchcock film and seats on a plane to brandy, perfume and lithographs bearing his (sometimes dubious) signature – the trademark of an outsize persona assiduously cultivated in autobiographies, TV appearances and photo ops, the likes of which no artist had ever previously conceived.[5]

If Dalí inserted himself promiscuously into every existing channel of mass marketing and popular entertainment, he did so as something of a clown, a mustachioed visitor from a distant surreal planet, and the scope of his celebrity would ironically be limited by the very attributes that gave it rise. Celebrity culture, as it developed over the final decades of the past century, for the most part required more pedestrian objects of fascination, people who despite their fame did ordinary things like going to a disco, putting on weight or running out for a latte. And in this regard, Andy Warhol's everyman mien left him perfectly poised to become a new kind of art star – not a lunatic or a snob or an untouchable Olympian, but a talented eccentric from Pittsburgh who worked hard to reach the top. (And in this regard, as well, he provided his fellow Pennsylvanian, Koons, with a perfect archetype.) Despite Warhol's avant-garde credentials, drug-addled friends and trademark wig, he liked Campbell's soup, shunned high-minded discourse, and was just as amused and amazed by the stars he courted as everybody else was, even as they figured more prominently in the company he kept. Warhol was a famous artist who could be written about in the way that other famous people could, and by the early 1980s he very often was.

To take a measure of Warhol's – or anyone's – growing celebrity around this time, one might, perhaps counterintuitively, look not at magazine covers or international reports but at local gossip pages, where unremarkable tidbits about rather more remarkable people suggest just how remarkable their followers believed them to be. For example, a survey of Page Six,

the *New York Post*'s trusty social barometer, reveals that in the early 1980s Warhol was quite literally the only visual artist to score any prominent mentions, alongside subjects such as Frank Sinatra, Donald Trump, Brooke Shields and other assorted socialites, politicians and movie stars. Between 1980 and 1983, the Pop master made thirty-five cameos in the column, as the gossipmongers tracked his peregrinations from the Upper West Side to Louisville to the Great Wall of China.[6] A few of these items made explicit mention of his art (such as the ceremonial unveiling of portraits of jockey Willie Shoemaker and soccer star Franz Beckenbauer before the Governor of Kentucky and the Culture Minster of Bavaria, respectively), but most concerned Warhol's appearances at various plays, restaurants and clubs in the company of pals like Halston, Liz and Liza. More interesting, perhaps, are those mentions that confused the distinction between Warhol's social stature and his ever-expanding professional activities, which would only later be understood as legitimate components of his oeuvre, whether an item trumpeting an *Interview* chat with Madame Mitterand, a backstage report on his *Love Boat* guest spot, or news that the artist would prowl the catwalk for mega-collector Rolf Hoffmann's upscale fashion line Lady van Laack.[7]

If Warhol could boast the distinction of being the sole artist tracked by Page Six in the early 1980s, his monopoly weakened around 1984 when visual artists (and the art world more generally) flooded the mainstream media as never before, ushering in a new breed of artist celebrities that thrives to this day. Suddenly Page Six introduced art dealer Mary Boone and Julian Schnabel, a 'stellar young painter in Boone's stable', and just as suddenly, readers learned of Schnabel's defection uptown to Pace, and of Jean Michel Basquiat taking his place.[8] Keith Haring opined at length on the opening of his Pop Shop and was reported to have supped at Mr Chow or the Odeon in the company of Warhol, Schnabel and Basquiat, whose Hawaiian holiday even merited a mention.[9] Much of the attention was driven by the mutually affirming embrace of the art scene and nightclubs, in particular Area and the Palladium, which hosted rotating (and competing) exhibitions of downtown artists, so that by 1986 even less glamorous personalities like Jenny Holzer and Vito Acconci could ride Warhol's long shirttails into the tabloids.[10] The nature of this coverage was unlike any that had preceded it; the general public was now instructed not just in what an artist showed but *where* he showed, as well as where he vacationed, dined and danced, preferably alongside the likes of Bette Midler and Calvin Klein. These details were regularly magnified and mirrored in the glossy pages of

national titles like *Vanity Fair, Esquire* and *Vogue*, which in 1985 went so far as to run a profile not on Julian Schnabel but on his beguiling, Belgian-born wife. As Studio 54 founder Steve Rubell succinctly put it, 'Artists are the rock stars of the eighties.'[11]

It should not be surprising that as artists gained a greater toehold in the popular imagination, they would seek to expand their share of it, and none did so more vociferously and cannily at the end of the 1980s than Koons. Although his renown had grown steadily during the early part of the decade, he was a relative latecomer to the broader cult of celebrity that I have been describing (which is to say that the mainstream media was slow to get to him, and when it finally did, it tended to focus more on the outrageousness of his work and its prices than on his personal affairs). He first gained broad media traction in 1986, alongside Ashley Bickerton, Peter Halley and Meyer Vaisman, in the flurry of reports on the 'Sonnabend Four' or, as *New York* magazine bluntly called them, 'The Hot Four' (better that than 'The Four Brushmen of the Apocalypse', as *Esquire* dubbed Schnabel, Robert Longo, David Salle and Eric Fischl the following year).[12] Yet Koons separated himself from the pack with his 1988 show *Banality*, which garnered his first Page Six mention on, appropriately

enough, his now-iconic porcelain sculpture of Michael Jackson, whom Koons repeatedly hailed in interviews at the time as a major inspiration.[13]

Koons's fixation on Jackson's communicative power and the radical nature of the performer's physical self transformation was already evident in a series of art-magazine ads for *Banality* in which the artist tellingly styled himself as pop star with the help of fashionable photographer Greg Gorman and David Bowie's hairdresser. Although the ads ostensibly announced a triple-bill of gallery exhibitions, they in fact promoted the artist himself as a new kind of celebrity, seen preaching to adoring children or surrounded by bikini-clad babes – a mode of self-presentation that perfectly emblematised the social status that artists had only lately attained (pp.116–17). These images have been incisively analysed by Andrew Renton as a kind of performance art in their own right, and they also drew on a long lineage of advertisements in which artists exaggerated and spoofed their own sex appeal, whether Ed Ruscha lolling in bed with two girls, Lynda Benglis wielding a dildo, or Robert Morris and even Kenny Scharf posing as muscle men.[14]

Koons, however, would not be content to play a star in the art journals when he could play – or better *be* – one

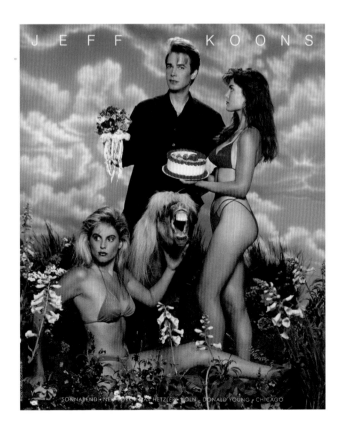

Jeff Koons
Advertisement
Art in America,
November 1988
(p.117)

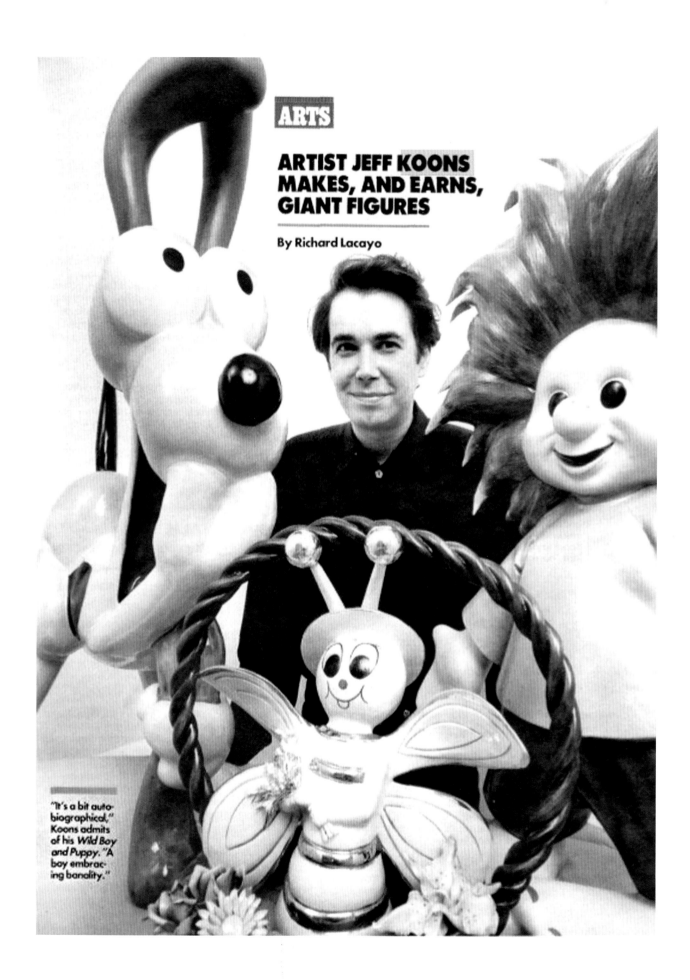

ARTIST JEFF KOONS MAKES, AND EARNS, GIANT FIGURES

By Richard Lacayo

"It's a bit auto-biographical," Koons admits of his *Wild Boy and Puppy.* "A boy embracing banality."

in real life. A form of self-fulfilling prophecy, his paid announcements were followed in less than a year by his appearance on the cover of the *Wall Street Journal* and in the pages of *People Weekly*, as he grew increasingly preoccupied with reaching an even greater audience than had the artists who had crowded the media spotlight before him.[15] 'How effective are art stars?', Koons asked interviewer Matthew Collings in 1989, before answering his own question, 'Their glamour is pretty limited … The only way artists can find their own glamour is to incorporate aspects of systems other than "art" and to be creative and confident enough to really exploit what they have'.[16] Only a few months later, Koons struck upon a way both to demonstrate that confidence and to engage a 'system' far beyond the art world: he would hatch a project entitled 'Made in Heaven', co-starring the world-famous, Hungarian-born porn star and Italian parliamentarian Ilona Staller, aka La Cicciolina.

The concept evolved slowly at first. Koons initially spied Staller in 1987 – the year she was elected to public office – in *Stern* magazine, and he used her mesh-covered torso as the model for his 'Banality' sculpture *Fait d'Hiver* of 1988. He encountered her image again several months later on the cover of a porn magazine, and he recalls being captivated by her beauty and 'innocence', his sense that her total public acceptance of her sexuality made her 'the eternal virgin'.[17] Koons was invited by the Whitney Museum to create an outdoor billboard for *Image World*, an exhibition exploring the relationship between art and the media, and he arranged a meeting with Staller to propose that they be photographed together for an advertisement announcing the as yet unrealised film *Made in Heaven*. The pair was shot in Rome against

a tempestuous aquatic backdrop, which had featured previously in Staller's work, by none other than Riccardo Schicchi, Staller's promoter and frequent lensman. Dressed in skimpy lingerie and silver heels, she reclines on a fake boulder, her head thrown back in ecstasy or alarm. Clutching her lithe body, Koons stares out at the camera and, he seems to imagine, his legions of adoring fans. Seen from the streets of downtown Manhattan, the billboard represented a particularly brazen form of self-promotion (and even self-portraiture) (p.42). Neither a spokesperson nor a hired hand, as Warhol and Dalí often were in the realm of advertising, Koons cast himself as a bona fide pop star, claiming his proper place in the network of publicity and mass attention that many artists had long coveted while pretending to scorn. If not quite in heaven, Koons was literally and figuratively borne on high.

With this indelible image, Koons launched both a media blitz and a body of work that would over the next two years grow increasingly entwined and, ultimately, indistinguishable. Captivated by his muse and the implicit promise of his new project (to say nothing of his own burgeoning celebrity), Koons returned with Staller to the studio to make more photographs, the first four of which would be photo-mechanically printed at large scale in oil-based inks on canvas and given their public debut in the Aperto section of the 1990 Venice Biennale. The vernissage was also a public debut of sorts for the personal relationship that had developed between Koons and Staller, who arrived daily at the installation in Vegas-worthy getups to smile or tongue kiss for the legions of paparazzi that snapped pictures of the lovers posing before their graven doppelgangers and an enormous sculpture of the pair embracing atop a rock formation encircled by a menacing golden snakes. Had Koons

Page from profile of Jeff Koons, *People Weekly*, 8 May 1989

Jeff Koons and Ilona Staller photographed in Koons's installation during the opening of the 1990 Venice Biennale. Spread from *Art* (Hamburg), July 1990

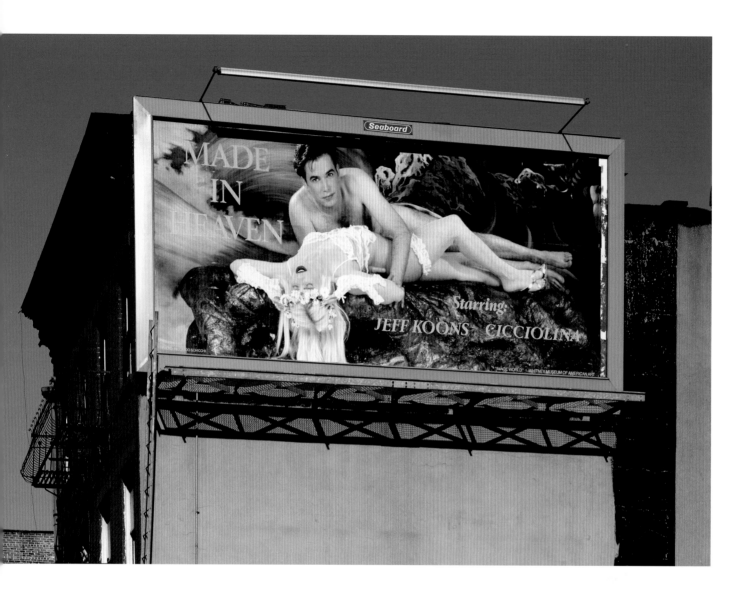

merely taken up with an infamous porn star, he would no doubt have caused a stir; and had he merely revealed himself alongside a naked model, he would have likely caused an even greater stir. But the fact that this naked model was both a world-famous porn star *and* his lover blurred the lines between art, life and the media to such an extent that the then-ubiquitous theorising on the 'relationship' between them suddenly seemed at best beside the point.

Although Koons's Venetian outing was not the most politically scandalous work on offer (that honour would go to the AIDS activist collective Gran Fury, whose installation juxtaposed images of an erect penis and the Pope), it easily became the most talked-about contribution to the show. Koons himself was happy to do plenty of talking, and over the summer he was quoted at length

in numerous publications, discussing his relationship and the Hollywood film he now intended to make with his new paramour. Koons spun the project with the consistency and precision of a first-rate salesman, which at one point he actually was. He and Cicciolina were the contemporary Adam and Eve; their lack of shame in making public their sexual activities would help remove the shame of their bourgeois audience, who would thus be more equipped to accept themselves and achieve their dreams, just as Koons had done in forming a union with the object of his greatest desire.[18] His other, perhaps more urgent, desire was to communicate with the broadest possible audience, as he remarked repeatedly, and Staller was extremely helpful in this regard. Indeed, it was the notoriety of her profession that paired so potently with the putative nobility of his to launch a thousand headlines around the globe.

Jeff Koons
Made in Heaven (Billboard),
Lower Manhattan, New York, 1989

Jeff Koons and Ilona Staller
on their wedding day, 1 June
1990 (AP press agency
photograph)

'Porn Star to Marry Sculptor', proclaimed the *Buffalo Gazette* in a typical if uninspired headline from the nearly 200 international gossip items that announced Koons's engagement in the autumn of 1990.[19] (Staller, it should be noted, was more often referred to by name and usually led the story, suggesting that while she rode Koons's fame into the art world, he rode hers into the world beyond.) The wires burned from Helsinki, Finland, to Akron, Ohio, with news of the imminent union, which appeared alongside other AP items detailing an MTV injunction against the latest Madonna video or Carrie Fisher's insistence that her housekeeper receive cameos in all her films. In January of 1991, word leaked that the marriage was off, but by May it was on again, with a UPI story quoting Staller's desire to have 'many bambinos', while Koons proclaimed in the *San Jose Mercury News* that 'the wedding, by any standards, is unique in the annals of history'.[20] That the 19,800 denizens of Sedalia, Missouri were deemed to have sufficient interest in the story provides some measure of the depth of Koons's penetration into the popular consciousness. Although he may not (yet) have boasted a name as recognisable as Warhol's, the newsworthiness of his personal affairs and the extent of their coverage propelled Koons into a media sphere inhabited not by Pop artists but pop stars.

The long engagement finally met its overdue end in a wedding in Budapest on 1 June. Although only fifty guests attended the ceremony, over the next fortnight official pictures and word of the proceedings reached millions of readers via 600 news outlets worldwide. Major European tabloids, such as British *Hello!* and *Paris Match*, ran multi-page pictorials of the blessed day, dwelling on details like the bride's pearly diadem with the breathless ardor usually reserved for the nuptials of minor Spanish nobility. Of particular interest were images of the three-tired, heart-shaped cake, crowned with a nude likeness of the couple in amorous embrace, although ironically these paled in shock value when compared to a two-page spread of the pair kneeling piously before the officiant, his hand raised in solemn benediction.[21] Adam and Eve had returned to the Lord's house, fully clothed (Koons in an Armani tux and Cicciolina in white, of course).

Koons, one must concede, was not the first post-war artist to stage his own wedding as a semi-public spectacle, a distinction belonging to Yves Klein, who in 1962 married his own art-world princess, a pregnant Rortraut Uecker, daughter of Günther, a charter member of the German Zero group. This ceremony was preceded not by a flurry of tabloid reports but by a lavish invitation bearing various coats of arms and silhouettes of the knights of the Order of St Sebastian, whose presence at the event was promised in the fine print. A master of pageantry and disguise, Klein did not disappoint his guests, who cheered outside Paris's church of Saint-Nicolas des Champs as the couple exited beneath the raised sabers of Klein's fellow chevaliers, dressed, like the groom, in the order's cape and plumed bicorn hat.[22] That Klein would tragically be dead within a year of his wedding

Yves Klein and Rortraut Uecker on their wedding day,
21 January 1962. Photo: Harry Shunk

and Koons divorced within two years of his only adds an eerie veneer of authenticity to these fairytale events, which could thus more rightly claim their pages in the endless album of doomed celebrity weddings.

Koons's short-lived marriage represented a high-water mark in the broader coverage of the *affaire* Cicciolina, though he would once again dominate New York art talk in the autumn, when the full fruits of his collaboration with his new wife were revealed in a solo exhibition at the Sonnabend Gallery. There, throngs of curiosity-seekers confronted sculptures in plastic, marble, glass and wood, many featuring the couple celebrating their recent conjugal union and the remainder depicting panting puppies and lavish bouquets crafted with a botanical precision that lent them obvious sexual overtones. The walls were lined with paintings of the lovers similar to the four unveiled in Venice, but crucial differences could be discerned. For one, Koons's body had changed dramatically, no doubt due to the daily gym regimen he was fond of describing in the press and to his obvious efforts at grooming and depilation.[23] Taking a cue from his hero Michael Jackson or a movie star facing onscreen sex, Koons had endeavoured to transform his physique, so that it might serve, as he often put it, as a 'vehicle for greater communication' – and what he was communicating was not just love or lust but a story of personal ambition and attainment, spiced with the vanity that such narratives often entail. The most significant turn in the work, however, was the fact that what was left implicit in the Venetian pictures had become explicit in every sense

of the term. In the Aperto images the *inamorati* abstained from actual intercourse and Koons sported a limp member, which strangely prompted much snickering in the press. Those pictures suggest that he had not yet fully achieved his self-professed freedom from shame, and he must have sensed that he needed to 'go all the way' to accomplish this goal. The paintings at Sonnabend thus depicted graphic vaginal, anal and oral penetration, allowing Koons to consummate not just his marriage but the full implications of his staggering project.

Much remains to be written about these paintings themselves, which manage to retain their charge more than fifteen years after their premiere – an estimable feat given that the vast majority of boundary-breaking art demonstrates a far shorter half-life. With hindsight, it becomes clear that the resilience of their shock value depends less on their disputable status as pornography than on their indisputable status as self-portraiture. Pictures of sex, after all, are often less troubling than demonstrations of extreme exhibitionism and narcissism, though in this case the vulnerability engendered by the former syndrome may complicate our diagnosis of the latter one. Koons's willingness – and even need – to reveal so much of himself physically took his decade-long examination of the dark heart of bourgeois taste to its unpredictable if logical conclusion. While the 'Made in Heaven' pictures clearly did not succeed in definitively emancipating Koons or his viewers from the embarrassment of sex (even today they are often exhibited with parental warnings and their maker has returned to a more stable and clothed domestic life), their truer achievement was the removal of the last vestiges of shame that long cloaked the avant-garde's tortured courtship of celebrity.[24] Looking at otherwise uncompromising characters like Donald Judd and Ellsworth Kelly flogging dresses in *Bazaar*, you can't help but feel a twinge of mortification behind their steely eyes. This, not the shame of sex, is the guilt that Koons absolves. He blew the lid off Warhol's soup can, and the publicly discussed antics and sales of a Damien Hirst or a Takashi Murakami might not be possible without his precedent, nor might the scores of profiles and 'art issues' peddled by glossy periodicals or the now common appearance of artists in the mainstream press and social swim. Koons did not create this condition, of course, but he responded to and helped shape the zeitgeist by abrading the distinction between the content of his work and the media spectacle it inspired. His bid to achieve a broader audience and a new form of artistic celebrity while maintaining his art-world credentials was a far greater gamble than his other forms of self-exposure, and in this he certainly succeeded like no artist ever before.

Notes

I wish to thank Hannah Hoffman for her assiduous and insightful research assistance in the preparation of this text.

1 'Wanna Bet?', *Fresno Bee*, 19 May 1991.
2 Dorothy Seiberling, 'Jackson Pollock: Is he the Greatest Living Painter in the United States?', *Life*, 6 August 1949.
3 'Its All Yours', *Seventeen*, September 1954, pp.140–1, 161; 'On the New York Art Scene', *Harper's Bazaar*, July 1966, pp. 94–5.
4 *Time Magazine*, 4 December 1936.
5 These projects, among others, are discussed in Fèlix Fanés, *Dalí: Mass Culture*, exh. cat., Fundación 'la Caixa', Barcelona 2004.
6 James Brady, 'Andy's Deal', Page Six, *New York Post*, 28 September 1982,; James Brady, 'Hi Yo, Andy', Page Six, *New York Post*, 3 November 1981; James Brady and Mary Murphy, 'Detour', Page Six, *New York Post*, 10 November 1982.
7 James Brady, 'Andy Who?', Page Six, *New York Post*, 23 September 1981; Susan Mulcahy and Richard Johnson, 'Warhol Wants To Be in Pictures', Page Six, *New York Post*, 28 March 1985; James Brady, 'Andy Warhol: Run Away', Page Six, *New York Post*, 17 September 1981.
8 Susan Mulcahy, 'Critic Sticks a Pin in the Art World and it Bleeds', Page Six, *New York Post*, 21 March 1984; Mulcahy, 'Defection', Page Six, *New York Post*, 8 April 1984; Mulcahy, 'Next', Page Six, *New York Post*, 28 April 1984.
9 Susan Mulcahy, 'Haring's Atomic Babies Going Legit', Page Six, *New York Post*, 21 November 1984; Susan Mulcahy, 'Fun Night', Page Six, *New York Post*, 25 April 1985; Susan Mulcahy, 'Uboyquitous', Page Six, *New York Post*, 24 January 1985; Richard Johnson, 'Love Bird', Page Six, *New York Post*, 20 April 1985.
10 Richard Johnson, 'Gold Mine', Page Six, *New York Post*, 15 May 1986.
11 André Leon Talley, 'Portrait of the Artist's Wife: Jacqueline Schnabel', *Vogue*, March 1985, pp.511–15, 560; Steve Rubell quoted in Joan Juliet Buck, 'Dealer's Choice', *Vogue*, February 1989, p.339.
12 Paul Taylor, 'The Hot Four', *New York*, 27 October 1989, pp.50–6; Lynn Hirschberg, 'The Four Brushmen of the Apocalypse', *Esquire*, March 1987, pp.76–87.
13 Richard Johnson, 'Artist Defends Jackson-Chimp Work', Page Six, *New York Post*, 17 December 1988.
14 Andrew Renton, 'Jeff Koons and the Art of the Deal: Marketing (as) Sculpture', *Performance*, September 1990), pp.18–29.
15 Meg Cox, 'Feeling Victimized? Then Strike Back: Become an Artist', *Wall Street Journal*, sec. A1, 13 February 1989; Richard Lacayo, 'Artist Jeff Koons Makes, and Earns, Giant Figures', *People Weekly*, 8 May 1989.
16 Matthew Collings, '"You Are a White Man, Jeff …": Matthew Collings Talks to Jeff Koons', *Modern Painters*, vol.2, no.2, Summer 1989, p.63.
17 Ibid., p.62.
18 These themes are discussed at length in many interviews from 1990. See for example, Sarah Morris, 'Interview with Jeff Koons', *Galeries Magazine*, no.36, April 1990, pp.126–33; and Andrew Renton, 'Jeff Koons: I Have my Finger on the Eternal', *Flash Art*, vol.23, no.153, Summer 1990, pp.110–115.
19 Associated Press, 'Porn Star to Marry Sculptor', *Buffalo News*, 5 December 1990.
20 Jim Jeffress, 'People', *San Jose Mercury News*, 1 May 1991.
21 'Cicciolina and Jeff Koons', *Hello!*, 8 June 1991, pp.56–7; Pierre Delannoy, 'La Cicciolina: Je prends le deuil de tous les cicciolini', *Paris Match*, 13 June 1991, pp.40–3.
22 Thomas McEvilley, 'Yves Klein: Conquistador of the Void', in *Yves Klein (1928–1962): A Retrospective*, exh. cat., Institute for the Arts, Rice University, Houston pp.74–5.
23 Koons, for example, claimed to work out three hours daily, in addition to taking a two-hour acting class (these figures varied slightly among interviews). See, for example, Richard Johnson, 'Bizarre Start for '90s on Art Scene', Page Six, *New York Post*, 3 January 1990.
24 In her provocative and insightful essay 'Lives of the Artists', Alison M. Gingeras noted Koons's freedom from guilt in this regard. Although critics in the early 1990s certainly understood Koons's performative persona in relation to the precedents of Warhol and Dalí, Gingeras was the first to elaborate a fuller treatment of Koons in this lineage, which she traces from Francis Picabia to Martin Kippenberger. See Alison M. Gingeras, 'Lives of the Artists', *Tate Etc.*, no.1, Summer 2004.

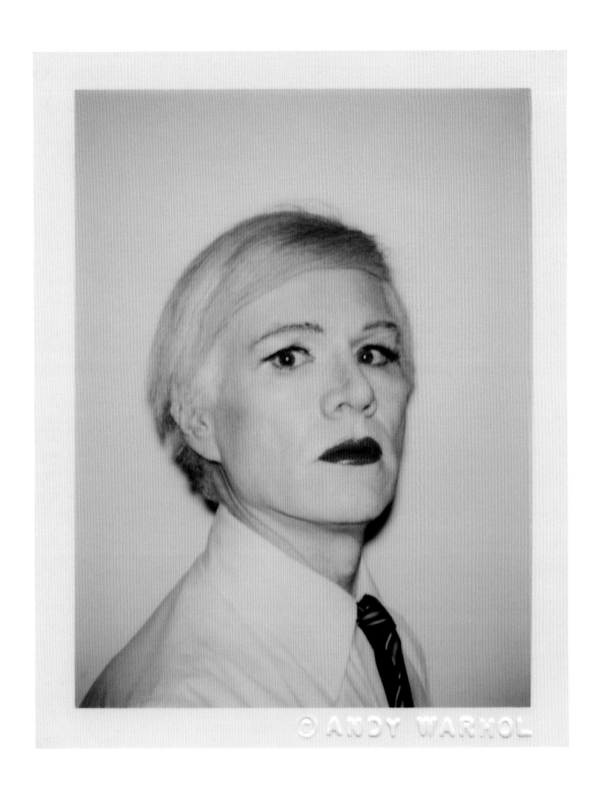

Andy Warhol
Self-Portrait in Drag 1980
The Andy Warhol Museum,
Pittsburgh. Founding Collection,
Contribution The Andy Warhol
Foundation for the Visual Arts, Inc.

Passing

'Executive Realness' is one of the categories featured in *Paris Is Burning* (1991), Jennie Livingston's documentary about drag-ball competitions in New York during the late 1980s. In order to 'pass' as a successful city financier or legal executive, the competitors – typically poor African American or Latino, gay or transgender – strut sharp, boxy suits and buffed leather shoes, parading smart briefcases or feigning casual engagement in a conversation on a mobile phone. The 'drag' that Livingston captures in this film is revealed not to be what might commonly be understood by this term: an attempt by a man to appear, credibly, as a woman. It is an altogether more complex endeavour that is to do with a subcultural minority 'passing' as a part of the affluent mainstream.

Alongside 'Executive Realness' and 'Opulence' (fabulous diamante and flowing gowns), there are categories such as 'Military Realness', 'Butch Queen Realness', or 'The Boy who Robbed you a Few Minutes before Arriving at the Ball'. These mimes begin to reveal how the whole social order is in fact a construct. Instead of the night-time balls appearing as fantastical inversions of the daylight 'real' (cut into the documentation of the balls are shots captured by Livingston of wealthy New Yorkers shopping, or going to work), they begin to appear as its underlying truth. By mimicking everyday roles so convincingly (and thus potentially inhabiting those roles in the everyday), 'Realness' disrupts our comprehension of the signals and codes that indicate apparent facts. Notions of inner essence or origin are traded against a pervasive sense of masquerade.

The ambiguous blend of simulation, aspiration and parody that constitutes 'Realness' opens up a way for thinking about the strategy adopted by a number of artists working since the 1980s, and their apparent complicity with the laws of the market. To use Judith Butler's interpretation of the laws of gender as analogy, 'drag is subversive to the extent that it reflects on the imitative structure by which hegemonic gender is itself produced and disputes heterosexuality's claim on naturalness and originality'.[1] Operating in the same social and economic context as Livingston's subjects, the artitsts have transgressed the boundary separating commerce or entertainment from the traditionally counter-cultural sphere of 'fine art'. Such an approach opens up a way to not only infiltrate and inhabit, but *survive* within the ravenous cultural economy of the mainstream. As Alison M. Gingeras has observed, 'The invention of bohemianism in nineteenth-century France provided an efficient means to prevent artists from contaminating everyone else'.[2] Instead,

then, by imitating the techniques of seduction and the systems of distribution that drive the capitalist economy, artists in the 1980s and 1990s invented new ways of participating in, perhaps contaminating, society again. By doing so, they both replenished the visual language available to the artist and – often by stealth – expanded art's reach. This strategy has hinged, also, upon a shift in attitude towards the role of the artists themselves: away from a concern with a romantic narrative of authenticity, towards a deliberate manipulation of self-image. As Andy Warhol put it of his own self-image, 'You should always have a product that's not you.'[3]

Warhol's affected 'look', aura-for-hire, and writings that reveal a deliberately shallow sense of self, often gleaned from clippings in magazines, flaunted a constructed persona whose emphasis on surface hinted at the existence of a masked 'beneath' whilst simultaneously barring access to it. His diaries (which one would assume to reveal the writer's innermost thoughts) are written in the same lively monotone of pure surface. There is a clear sense that Warhol was made up in 'drag' well before he made the late Polaroids that show him literally wearing

face-powder, eyeliner and lipstick (p.46). Though by the end of his career he was mixing in celebrity circles, Warhol's scene did not simply replicate the mainstream Hollywood glamour that inspired it. The Factory, and later endeavours such as Warhol TV, comprised a mix of real stars and those – like Warhol – who were self-confessed 'freaks'. The idea of assimilating into the glamorous world of the media as a two-pronged attempt to blend in and to hide was explicitly acknowledged in Warhol's frequent use of the camouflage motif.

Capitalist Realness

Against Warhol's persona, freakish and fright-wigged, one can invoke the 'straight' performance at play in the persona of Jeff Koons. With his ordinary, suit wearing style and friendly manner his camouflage within the everyday working world is discreet. Koons's straight act positions him as, arguably, the pivotal figure in an understanding of the unfolding of Warhol's legacy and its virulent potential to dissolve the segregation from society that was demanded of the 'bohemian'. In the

Still from *Paris Is Burning* (directed by Jennie Livingston, 1991)

image that we have of Koons, via interviews and appearances in both the work and the media, there are no quotes around what he says, no indication of 'drag' in any explicit sense.

His mix of boyish charm, ex-Wall Street-trader smartness and childlike wonder is a feat of 'Realness', perhaps. It is impossible, in Koons's case, to unpick his constructed persona from his 'self'. In his art, there is a pervasive narrative of being 'born again'. This can be seen in his early photo-lightbox showing himself as a young boy sitting at a table with a box of coloured crayons, *The New Jeff Koons* 1980 (p.36) – a work that was a part of a series that presented pristine domestic vacuum cleaners in vitrines, and appropriated advertisements as a form of 'readymade'. It is also evident in the suite of works with certain titles invoking the Garden of Eden,[4] included in his show *Made in Heaven* (1989), depicting the consummation of his marriage to Illona Staller (the porn star La Cicciolina) with what he describes as 'prelapsarian innocence', interwoven with sculptures of flowers and puppies. In both cases, the artist appears as though he has been born into the life of the consumer dream, rather than pointing to it from an outside position. This narrative involves a deliberate conflation of Christian and capitalist ideologies. Whilst early on in his career there was some acknowledgement of the strategies behind the work, in interviews and statements made in the years since, Koons has persistently stayed 'in character' with a consistently a-critical tone, expressing a desire to make work that is beautiful, sublime and spiritual. 'I want the viewer to feel that they are perfect'[5] he has said.

Made in Heaven also deliberately invokes the work of Eduard Manet. In making this reference explicit (not only do the pictures recall Manet's compositions but one is actually titled *Manet*), Koons invokes and radically reclaims the historic artist who has been pinpointed as the founder of modernism. He hereby triples the staging of his own originary myth. Manet's *Olympia* 1863 depicts a naked prostitute lying on a bed, as though ready to receive a client. She stares directly into the eyes of the painting's beholder, blurring the beholder/client position. But if the seeds of rebellion, proposing the painting as an object for sale, and the presence of the nude model as a crassly transactional encounter, was already there in *Olympia*, Manet's presentation of his later painting *Nana*

Eduard Manet
Nana 1877
Kunsthalle,
Hamburg

1877 makes his perception of things clear. When *Nana* – a painting of a courtesan applying make-up at her mirror, with a sideways glance towards the viewer, and a client waiting behind her – was rejected for exhibition in the Paris Salon, Manet arranged to have the painting displayed instead in the large glass window of one of the city's recently built shopping arcades. Tamar Garb points to this act as a scandal of 'double commodification', in which Manet deliberately drew the attention of his audience (and his critics) to the fact that both the female subject and the work of art itself were for sale.[6] What is relevant here is that Manet was stepping beyond even a straightforward and 'critical' depiction of modern life, such as the one that Courbet's realism put forward, and knowingly implicating himself as pimp, client and salesman of wares.

Koons, after Manet, drags to the foreground the relations that underpin his work. He himself plays the lead protagonist. But where Manet points – critically – to Nana as a prostitute for hire (as artists' models might have been at the time), in June 1991 Koons 'rescues' Staller by transforming acts of pornography into the sacred consummation of their real-life marriage.[7] In Koons's work, then, unlike in Manet's, both model and artist are ostensibly redeemed. By injecting the sexual acts depicted with a conservative form of 'kinship'[8] he legitimates them so that they are, in a certain sense, beyond criticism. Koons's *Made in Heaven* billboard poster, shown in a prominent location in downtown Manhattan,[9] was identical to a Hollywood film campaign (p.42). A couple of years earlier, in 1987, when invited to contribute a project to *Artforum* magazine, he created an insert in the form of an advertisement in which he pictured himself as porcelain figurine of Don Quixote, standing among the trappings of a rococo church. The caption for the piece read: 'To be forever free in the power, glory, spirituality and romance, liberated in the mainstream, criticality gone' (see p.24). Both projects signalled a transition for art from the avant-garde into the blinking lights of mass publicity. But does this gesture strip his art of its capacity for any kind of oppositional or agitational stance? How and why does that matter?

Art historian Dorothea von Hantelmann suggests that Koons's attitude breaks through the 'cultural limit' of critique to engage in 'celebration' as a potent alternative.[10] Part of the power of this approach is the defiance that it presents towards the avant-garde establishment itself. His apparent complicity with the market, with advertising imagery, with spectacle culture in general, makes for work that rubs abrasively against the conventions of modernism. In

particular, his work challenges the persistently influential class-based assumptions about taste, and about what constitutes fine art set out by Clement Greenberg in his writings since 'Avant-garde and Kitsch' (1939).[11] Such views certainly persisted among the *October*[12] critics such as Rosalind Krauss who, writing in the *New York Times* in 1991, derided Koons's work at the time because of its perceived lack of critical subtext: 'Koons … is not exploiting the media for avant-garde purposes. He is in cahoots with the media. He has no message. It's self-advertisement, and I find that repulsive.'[13]

Koons's straight act might be linked back to a 1963 performance by Gerhard Richter, Sigmar Polke and Konrad Lueg titled *Living with Pop: A Demonstration for Capitalist Realism*, staged within Berges, the largest furniture store in Düsseldorf, the city in which they lived. The artists, who at that time declared themselves as 'The German Pop Artists',[14] dressed in suits and ties, sat for the duration of the performance in armchairs that were elevated on plinths , presenting both themselves and the furniture as a kind of consumer readymade. Richter, Polke and Lueg were reacting in part against the teachings of Joseph Beuys at the Düsseldorf Academy, and the bohemian and shamanistic associations that he lent to the role of the artist. Instead, they conjured an image of the artist as white-collar worker relaxing in a comfortable modern home, as such a scene might be pictured in an ad on television.[15] Building upon Warhol's legacy, but with a note to these European forebears, Koons opened up the provocative possibility of 'passing' his own transgressive practice in the mainstream without a 'message'. As Peggy Phelan has observed,[16] the aim of the walkers in *Paris Is Burning* was, indeed, to pass 'unmarked': to simulate what was normative whilst living in a way that in fact rewrote patriarchal structures of kinship and norms of heterosexual society. Despite the machismo of the 'Made in Heaven' series, Koons does not regress to an older and more familiar model of the heroic artist in a reactionary way. Instead, his apparent lack of extraordinary status as a 'working artist', the lack of message in his attempt to pass 'unmarked' by harnessing the laws of the market economy, might be what constitute his own evolution of the attitude initiated by Warhol into a new form: 'Capitalist Realness'.

Certain of the manifold possibilities that this attitude engenders have been played out to an extreme, on the one hand, in the ambitious and high-profile practices of Damien Hirst and Takashi Murakami. Each of these artists has gone further still than Koons in colonising market terrain and

grasping the mechanisms of self-promotion. Both have taken control of elements of the art world usually seen as being outside the concern of the artist. As Scott Rothkopf observes, Murakami, along with his multinational corporation Kaikai Kiki, 'In addition to churning out finely crafted artworks coveted by collectors … is busy producing related merchandise; running an art fair; managing the careers of seven young Japanese artists; planning exhibitions and their accompanying catalogues; hosting a radio show and penning a newspaper column; pursuing commercial "collaborations" in the form of product tie-ins, advertising commissions and corporate branding projects.'[17] Murakami's began as a practice in which, from the very start, he challenged the conventional notions of authorship according to which the art world operates: creating videotapes that were presented as historical Japanese avant-garde performances (in fact fakes that he had made) as a knowing intervention into then current market demand for Japanese art. Hirst's embrace of this terrain is evident in his

decision to bypass the traditional dealer circuit (or keep them on their toes) by hiring his own independent agent Frank Dunphy (formerly agent to Coco the Clown), as well as by opening his own shopfront for his merchandising line, Other Criteria on New Bond Street, and by selling a huge body of new work at auction.

All three of these artists pass with convincing performances of Capitalist Realness in that they appear as straightforward modern businessmen ('while Henry Kravis may look rich in a bespoke suit, Murakami [who professes to spend his nights in a cheap sleeping bag] knows his hero Bill Gates looks even richer in a pair of Dockers', as Rothkopf observes),[18] sell work for record sums, engage in merchandising collaborations (Louis Vuitton, Levis) and are popularly known in the press. Each of the artists utilises an attitude of Realness to take control of the terms by which the artist is usually controlled, by the intermediaries in charge of money and the establishments in charge of taste.

Gerhard Richter and Konrad Lueg
Living with Pop: A Demonstration for Capitalist Realism in Berges furniture store, Düsseldorf, 1963.
Photo: Reiner Ruthenbeck

Overidentification

In his essay 'Horror Vacui: Andy Warhol's Installations', Mark Francis described Warhol's transgression into the forbidden territory of entertainment and commercialism as an attempt to:

> create a kind of 'social space', an atmosphere which subverted the pristine vacuity of a conventional modern gallery space, and at the same time reconnected the museum with its repressed or forgotten siblings, the department store, the supermarket, the dance club, the discotheque, the attic and the basement ... [T]he prototypical modern museum, which is to say those founded with the educational and ordering principles of the eighteenth century and after, has tended to excise the phantasmagoric, the wondrous, and the grotesque aspects of culture, and banish them to the vagaries of the commercial (hence 'low') marketplace, or the (nocturnal) pleasures of leisure time.[19]

Within this compelling observation about the nature of Warhol's transgression, it is useful to differentiate further between the 'commercial market place' and the 'nocturnal pleasures' of leisure time. These can be read as two different kinds of economies in themselves, which – like Livingston's contrast between the drag balls and 'real' New York – reflect upon each other's construction.

The concept of 'Realness', as I have discussed, provides an image of how apparent complicity might in fact be subversive in its transgression of the limits of the acceptable avant garde, as well as being potent in its ability to mimic the spectacles with which visual art competes for attention. But the image of 'Realness' embodied in the work of Koons, Hirst, and Murakami mimics more or less legitimated rules for 'playing the game' in capitalism (albeit bringing to light rules that are often obscured in the art world). Elsewhere, it has been given a more transgressive application, invoking the phantasmogoric and the grotesque.

In the 1980s, Slovenian theorist Slavoj Žižek coined the term 'overidentification' to denote an extreme form of 'Realness' or 'passing' used as a strategy to reveal the 'obscene or hidden reverse' of a legitimate system. He did so in order to explain the apparently 'fascist' attitudes of the Slovenian artist/music group, Laibach, popular in Eastern Europe in the 1980s. Provoking suspicion from the authorities for their actions, Laibach famously underwent a 'trial by television' in 1983 in which, dressed in military uniforms, they were interrogated by a political reporter. The artists transformed this ostensibly 'live' discussion into a piece of theatre by pre-scripting their answers to his questions and delivering them in an inexpressive tone, which – whilst the views that they articulated were not in tune with the accusations against them – only served to heighten distrust. Žižek's conjecture was that their simulation of complicity with totalitarianism was more provoking and powerful than an attitude of scepticism or critique would have been. Laibach was operating within a wholly different ideological context from that of the artists in this exhibition: under communism rather than capitalism. Nevertheless, even to consider 'free-market capitalism' as an ideological construction, rather than as the 'common sense' evolution of social economics (such that the normative idea of the 'laws of the market implies'), is important is in understanding how and why the artists in this exhibition operate as they do (Richter's Capitalist Realism was in part an answer to the official art of East Germany that he grew up with: Socialist Realism).

'Overidentification', states Žižek, exposes the 'obscene superego' of the system, making visible the '"nightly" law that necessarily redoubles and accompanies, as its shadow, the "public" law'. Žižek takes as an example of this 'nightly law' Code Red in the film A Few Good Men (1992; directed by Rob Reiner). When two US marines are tried for carrying out a clandestine night-time beating of a colleague who had been planning to expose them for military misconduct, it transpires that they were only following the orders of their superiors, who have invoked Code Red in order to punish the whistle-blower. This secret code, writes Žižek, 'condone[s] an act of transgression – an illegal beating – and reaffirms the cohesion of the group ... Such a code must remain under the cover of night, unacknowledged, unutterable', while 'in public everybody pretends to know nothing about it, or even actively denies its existence.'[20]

It is helpful to consider two broad (though not wholly separate) tendencies in this exhibition – one that operates in the mainstream economy, and the other that operates within the unregulated, illegitimate underside. Whilst certain artists take positions that simulate identification with what in the art world remains hidden – i.e. the mechanisms of the market – to effect 'Realness', other artists overidentify with these mechanisms and in doing so reveal something of their 'hidden reverse'. In the latter group, the artists produce work that also finds visibility in a popular or mainstream context, but via channels that would ordinarily be considered against its laws. These repressed aspects can be thought about in terms of the 'counterfeit', of 'exploitation', or of 'prostitution'.

Laibach
Still from *Trial*
by Television 1983

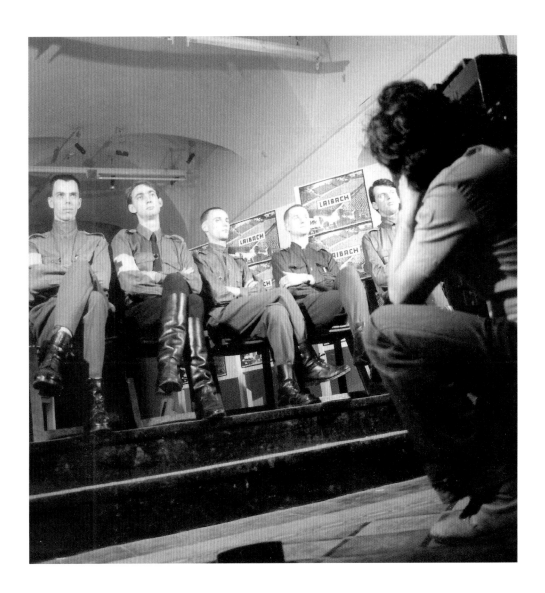

Counterfeit

An important commodity in the art market is the originality of the work for sale – both in the sense that it is a unique expression, and that it is genuinely by the artist that its signature (or signature style) claims. Since her first solo show at the Bianchini Gallery in New York in 1965, Sturtevant has worked on the 'reproduction' of iconic contemporary paintings, sculptures and installations. She is credited with marking the beginning of the 1980s 'Simulationist' movement, but unlike certain of her peers such as Mike Bidlo and Richard Pettibone, her work is not appropriation art, and nor is it homage. Whilst Louise Lawler or Sherrie Levine appropriated other artists work via forms of mechanical reproduction, Sturtevant intricately remade works by hand: collapsing any distance between her work and the original by fully inhabiting the process in order to create apparently legitimate substitutions for those works. 'The brutal truth … is that it's not a copy', Sturtevant has said.[21] She overidentifies with the idea of the 'signature style' in order to reveal the hidden reverse of the legitimate art economy. Where the artist's genius ought to be is a hollow brand that shifts and identifies with different works at different times in a performative manner. By 'passing' as originals by Frank Stella, Keith Haring or Andy Warhol, her works make manifest the myths of originality and authenticity that the art system does its best to mask (pp.119, 120). The artists she

fakes have sometimes themselves been complicit in the process. Warhol, always one step ahead, allowed her to make her *Gold Marilyn* on his own silkscreening press. And when Sturtevant met Marcel Duchamp and showed him an early 'Duchamp' that she had made, as the artist recounts, he did not bat an eyelid, and played the game by simply asking, 'Well, where did you get that?'

Bernard Blistene has commented:

> Sturtevant's project … takes the form of an analysis of the myth of the artist from an age of the exchange value and the free circulation of goods. So why therefore pay less for a Sturtevant than for all those she recyles? And why then this schizophrenia, which Deleuze demonstrated was pushing the capitalist system to bankruptcy? By mixing up artistic codes, by destabilizing its fetishist function, Sturtevant aims to undermine art as absolute merchandise in the circulation of signs and values that knows no place.[22]

In challenging the very notion of the 'original' she also challenges ideas of copyright or counterfeit, and so disturbs the basic tenets of the art market.[23] (By way of contrast, Murakami's recent touring retrospective, which included

Cover of *Reena Spaulings: A Novel by Bernadette Corporation*, New York 2004

Sturtevant
Warhol Gold Marilyn 1973
(p.119)

Sturtevant
Beuys La
Rivoluzione
Siamo Noi
1988
Courtesy the
artist and
Anthony
Reynolds
Gallery,
London

a shop selling Kaikai Kiki products, as well as large-scale product displays, was titled © *MURAKAMI*; p.78).

Even Sturtevant's name alludes to the idea of a brand whilst maintaining a kind of genderless anonymity for the artist. Paradoxically, she performs her brand-identity while perpetually assimilating any sense of signature style into the 'signature styles' of others. But Sturtevant's work projects not just the success of individual 'passes', but her entire system of language and all that it encompasses. Her doubling of iconic works creates a virus in the system, a multiplication of cells that – via an excessive form of complicity – corrodes and destabilises the very foundations of its belief.

Rather than being a sibling of the appropriation artists of the 1980s, then, Sturtevant in her practice looks forward to contemporary attitudes in art. In particular, her work chimes with the corrosive endeavour of the artists' collective Reena Spaulings. Reena Spaulings is a fictional character, now 'artist' and 'gallerist', who evolved within the context of a multi-authored novel by the Bernadette

Corporation in 2004. Bernadette Corporation is a collaborative project, begun in 1994, of which Bennett Simpson has written, 'In a cultural landscape littered with "alternatives" (grunge, heroin chic, Bill Clinton), BC were quick to see identity as a fallacious term usurped by capital – and so they sought to undermine it from within, in their words, by, "emulating a corporate image through 'joke' forms of business that are serious".'[24] The existence of Reena Spaulings, a cipher whose nominal identity serves as an anchor for the practices of a number of different artists, and simultaneously plays the gallery dealer, exposes the inverse of Sturtevant's revelation of lack so far as the marketable individual is concerned: there is no face, no singular life narrative to be matched with the artist's output. Or, rather, an excess of narratives, an excess of faces, and of artistic styles that cannot satisfy the shape of cultural demand for their commodification. Both Sturtevant and Reena Spaulings cleave apart assumed relations between persona, product and biography as extreme exaggerations of the Warholian adage about having 'a product that's not you'.

Detail
Piotr Uklański
The Nazis 1998
(pp.164–5)

Exploitation

One of the particular criticisms of free-market capitalism that is raised by Karl Marx in *Capital* (*Das Kapital*, 1867, 1885, 1895) is the notion of the 'exploitation' of labour. He argues that the greater the 'freedom' of the market (i.e. the less it is regulated), the greater the power of capital, then the greater the 'rate of exploitation'. This rate can be measured as the ratio between necessary and surplus labour; in other words, the rate at which somebody in power is profiting from that excess. The 1960s and 1970s saw the emergence of a genre of film that was known as 'exploitation' because it was promoted by exploiting, for publicity purposes, the sensationalism of certain kinds of subject matter – nudity, violence, horror, and other taboos. Subjects in the genre included cannibal films, biker films, sexploitation and even Nazi-sploitation. The last, such as *Love Camp 7* (1969) or *Ilsa, She Wolf of the SS* (1974), were often a conflation of soft-porn with scenes of torture based on historical images.

The position taken by Piotr Uklański in relation to the market, and to the realm of publicity, might be explored with both fiscal and populist notions of 'exploitation' in mind. In his series *The Nazis* 1998 (pp.164–5) he deliberately utilises a subject that connotes horror, in combination with the glamour and seductiveness of Hollywood styling, to provocative effect. This series of works was made not in the context of a practice rooted

in exploring other 'political' issues but alongside pieces such as *Dancefloor* (a Studio 54-style light-up dance floor, originally installed at Gavin Brown's gallery, Passerby) or a project for the group show *Casino* in Ghent in 2001, in which 'he lit up the vast imperial facade of the neighboring Museum voor Schöne Kunsten. Strings of beaded lights described the building's entire architectural profile, threading along the edges and planes, columns and cornices, so that by night the slightly pompous Neoclassical building was transformed into an illuminated edifice flashy enough for Las Vegas'.[25]

Uklański has described[26] how he had become fascinated by an *Arena* magazine fashion issue about the Nazi uniform that ambiguously celebrated the glamorous appeal of Dirk Bogarde and Marlon Brando acting the parts of SS officers. The artist was intrigued by the enthralling and repellent translation of this image of ultimate horror (Nazism) into a seductive fashion context. Rather than distancing himself from the culture that could effect this transformation, though, Uklański chose to foreground his own implication in it (as a maker of images), and even to profit from it by engendering scandal. The work – a series of 164 photographs of actors playing the roles of Nazi soldiers in feature films – makes manifest his attempt to keep the horrific

Piotr Uklański
Dancefloor 1996
Installed at Passerby, New York

implications of the subject and the seductiveness of its presentation in suspension). In this sense, the work relates to Richard Prince's rephotographed image in *Spiritual America* 1983, which exploited – to the artist's own ends – the provocative power of a photograph, originally taken by Gary Gross, of a naked pre-adolescent Brooke Shields (p.123). As Jack Bankowsky notes, 'Brooke Shields posed for [Gary Gross] both as a normal young girl and in the nude, her body heavily made up and oiled, receiving a fee of $450 from Playboy Press, Gross's partner in the project. Her mother signed a contract giving Gross full rights to exploit the images of her daughter.'[27]

What distinguishes Uklański's attitude from the use of marketing strategies by his 'Capitalist Realness' predecessors and peers operating on the usual lines of economic labour and surplus value is his exaggeration of the economic structures that are appropriated. This form of 'exploitation' uses minimal labour in combination with highly inflammatory or seductive material to generate maximum effect. It works on the formula that a single inflammatory work might – and indeed did – generate a huge amount of attention, controversy and press coverage, even being attacked by one of the actors depicted in the work when it was exhibited in a Warsaw museum. In this way his work performs the mechanics of capitalism to simultaneously profitable and critical ends. Notably, another work by Uklański made at this time was *Untitled (The Full Burn)* 1998, of a stunt man performing the spectacle of self-immolation.

Uklański's express political stance is deliberately withheld in interviews, but a conversation he recorded with Roman Polanski in his 2004 Basel catalogue[28] might be turned back upon his own practice to suggest a position whose flagrant apathy as regards activism nevertheless contains a critical dimension that pushes against established notions of agitation or transgression:

> PU: I want to talk to you about your participation in May 1968.
> RP: I am not sure what you mean. But I was in the South of France that spring. They invited me to be part of the official jury of the Cannes Film Festival …
> PU: '[You] had your red Ferrari Berlinetta shipped from Los Angeles over to the South of France for the occasion … You were cruising around the Côte flashily attired in Rodeo Drive gear! You must have looked like a head-to-toe Hollywood success story … Was your deliberate lack of modesty simply ill timed? An act of bad judgement? Or were you staking a position?

Prostitution

One of Richard Prince's joke paintings reads: 'A man walking out of a house of questionable repute, muttered to himself, 'Man, that's what I call a business … you got it, you sell it, and you still got it.' Prostitution is, on the one hand, defined as the act of accepting money in return for sexual intercourse, and intercourse as a commodity is the joke that Prince makes. But the primary dictionary definition of the verb 'to prostitute' is 'to devote to, or offer or sell for an unworthy, evil or immoral use'.[29] Prostitution is defined as 'devotion to unworthy or shameful purposes'. The concept of prostitution can be taken as a metaphor by which the relationships between the 'legitimate' economies of art might be measured against the illegitimate, marking the boundary between simply selling and selling one's soul or 'selling out'. Like the notion of exploitation, it represents a step beyond the performance of self for PR purposes towards lending the most intimate reaches of human contact utilised for profit-orientated ends. Within the field of Capitalist Realness, it is in the area of 'overidentification' that the underworld economy of prostitution comes into play. Where Warhol's 'good business' involved the marketing of 'a product that's not you', Prince's joke points to the threat of a potential merging of self and product. Particular artists in the exhibition have played on this threat in a provocative way.

Between 1973 and 1980, the artist Cosey Fanni Tutti (born Cosey Newby, 1951) appeared as a model in more than forty pornographic 'magazine actions', within titles including *Playbirds*, *Exposure*, *Park Lane* and *Sex Fantasy*. In Fanni Tutti's own words:

> My express intention with the project was both to infiltrate the sex market to create (and purchase) my own image … and to gain first hand experience of being a genuine participant in the genre. To achieve my aim, I couldn't adopt the approach of a voyeuristic or analytic artist viewing from the outside because that wouldn't provide me with a true experience. What was required for me was to become 'one of the girls'.[30]

Richard Prince
Untitled (jokes) 2008
Courtesy the artist

In the context of feminist art and performance at the time, this 'industrial' attitude to selling images of her naked body was an aggressive and challenging move. Rather than criticising ideals of sexuality and allure peddled by the pornographic industry, Fanni Tutti set out to inhabit them, shifting persona within each shoot from the early faux-naïve character 'Tessa from Sunderland' (p.147) to the playful later work where Fanni Tutti is posed in a lesbian love 'painting and decorating' scene in *Knave* magazine. Fanni Tutti's attempt to 'pass' within the industry was sincere. She did indeed become 'one of the girls', making and distributing the commonly used 'Z-Cards' bearing her photograph and vital statistics. She entered into the community, and competition, of the business in order to get work. At the time of the ICA exhibition *Prostitution* in 1976 in which these actions were first shown, the *Sunday People* reported that industry insiders had confirmed Fanni Tutti's place in the scene: 'One leading Soho porn merchant reckons that Fanni Tutti has made "several grand" in the past two

years – because in her work anything goes … "Fanni Tutti has been on the scene for years, everybody knows her" said Mr Graham Baker, publisher of a series of sex magazines. "She is a good worker and will do anything …This week alone she is appearing in at least five of our magazines because she is always hungry for work."'[31]

So on one level, until the ICA exhibition exposed her as an artist, Fanni Tutti 'passed' in this world as 'unmarked'. But as an artist, her work presented a riposte to the typical positioning of the naked female body as represented in art history. If Manet, and later Koons, drew attention to the hierarchies of gender and class often taken for granted, in classical painting, Fanni Tutti tipped that attention further through her own overidentified position within it – a position that did not sit comfortably in either the classical or the critical feminist camp of the time. The naked female body was being represented in very different ways in the work of Gina Pane, Marina Abramowic or Carolee Schneeman,

Cosey Fanni Tutti
Single-sided B/W Model
Z Card 1977
(p.147)

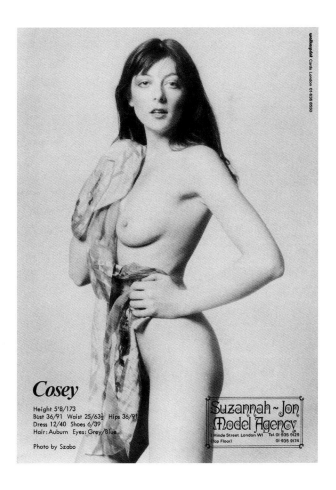

Cosey

Height 5'8/173
Bust 36/91 Waist 25/63½ Hips 36/91
Dress 12/40 Shoes 6/39
Hair: Auburn Eyes: Grey/Blue

Photo by Szabo

Suzannah~Jon
Model Agency

for example, who used themes of endurance, aggressiveness and masochism. Fanni Tutti seduced her viewers with images of desire and glamour, and made good money out of it – a radical inversion of the traditionally ephemeral sphere of performance as 'body art'.

The poster for the *Prostitution* exhibition pictured Fanni Tutti in S&M gear lying on a couch in such a way that made an obvious visual reference to Manet's *Olympia* painting. In the Fanni Tutti, or COUM (the group of which she and Genesis P-Orridge were a part) remake, however, the artist defiantly performed the soliciting position of the prostitute, rather than taking the role of the client, as did Manet or Koons. In the statement written across the bottom of the image, the artists described the work as a 'deliberate policy'[32] in which 'different ways of seeing and using Fanni Tutti with her consent, produced by people unaware of her reasons, as a woman, and as an artist, for participating'.[33] The text on the poster stated: 'Everything in the show is for sale at a price, even the people.' The exhibition caused a scandal in the national press, generating over a hundred 'outraged' articles in newspapers ranging from the *Evening Standard* to the *Sun* to the *Daily Telegraph*, and – a the same time – creating a buzz around the show that led to huge queues

of people waiting to see the exhibition. As Simon Ford writes, 'COUM were persuaded by the ICA, The Crown Commissioners (who owned the ICA's lease) and the Arts Council of Great Britain to desist from hanging Tutti's works from magazines on the walls. Instead the "offending" images were stored away in white containers and could only be viewed one frame at a time.'[34] As a response both to the scandal and to the censorship of their exhibition, Fanni Tutti and P-Orridge created a space within the exhibition upon which they pinned the ever-growing flurry of daily news clippings. They described their stance as a comment on the reality of the material and economic conditions under which the artist in London at that time had to work within.

Almost thirty years later, the American artist Andrea Fraser again raised the concept of 'prostitution'. Fraser's long-term project has, since the late 1980s, involved the artist 'passing' as a number of different art-world characters of her own invention, from the prim, suit-wearing docent Jane Castleton (*Museum Highlights* 1989) to the louche artist-celebrity, after Kippenberger (*Art Must Hang* 2001). Fraser's drive has been to analyse the 'social field' that makes up the culture of art. In 2003, however, her project went beyond the simultaneously parodic and aspirational 'Realness' of these inhabited subject positions towards a form of

Andrea Fraser
Still from *Official Welcome*
2003
Courtesy the artist

October 19th-26th 1976

SEXUAL TRANSGRESSIONS NO. 5

PROSTITUTION

COUM Transmissions:- Founded 1969. Members (active) Oct 76 - P. Christopherson, Cosey Fanni Tutti, Genesis P-Orridge. Studio in London. Had a kind of manifesto in July/August Studio International 1976. Performed their works in Palais des Beaux Arts, Brussels; Musee d'Art Moderne, Paris; Galleria Borgogna, Milan; A.I.R. Gallery, London; and took part in Arte Inglese Oggi, Milan survey of British Art in 1976. November/December 1976 they perform in Los Angeles Institute of Contemporary Art; Deson Gallery, Chicago; N.A.M.E. Gallery, Chicago and in Canada. This exhibition was prompted as a comment on survival in Britain, and themselves.

2 years have passed since the above photo of Cosey in a magazine inspired this exhibition. Cosey has appeared in 40 magazines now as a deliberate policy. All of these framed form the core of this exhibition. Different ways of seeing and using Cosey with her consent, produced by people unaware of her reasons, as a woman and an artist, for participating. In that sense, pure views. In line with this all the photo documentation shown was taken, unbidden by COUM by people who decided on their own to photograph our actions. How other people saw and recorded us as information. Then there are xeroxes of our press cuttings, media write ups. COUM as raw material. All of them, who are they about and for? The only things here made by COUM are our objects. Things used in actions, intimate (previously private) assemblages made just for us. Everything in the show is for sale at a price, even the people. For us the party on the opening night is the key to our stance, the most important performance. We shall also do a few actions as counterpoint later in the week.

PERFORMANCES: Wed 20th 1pm - Fri 22nd 7pm

Sat 23rd 1pm - Sun 24th 7pm

INSTITUTE OF CONTEMPORARY ARTS LIMITED
NASH HOUSE THE MALL LONDON S.W.1. BOX OFFICE Telephone 01-930-6393

Cosey Fanni Tutti
Prostitution exhibition poster
Institute of Contemporary Arts,
London 1976
(p.146)

overidentification with the art world culture's economic underpinning. *Untitled* 2003 is a work in which the artist had sex with a collector in return for a payment of $20,000. Fraser is an artist who became associated with 'institutional critique' after the late 1980s, has taught on the Whitney programme and published numerous articles in *October* and other art magazines. This act was too close to the line not only for the outraged mainstream press who labelled her, among other things, as a 'whore'[35] but also for many of her supporters in the art world. The work's fulfilment of that marketable desire for intimacy with the artist peddled to collectors via the transgression of real sexual intimacy was seen as a step too far. As Alexander Alberro wrote: 'as with all successful exercises in verisimilitude, Fraser's "performances" risk being confused with reality and being received as affirmative rather than critical'.[36]

In her text 'The Artist as Service Provider' Fraser takes the ideal of the collector's 'access' to the artist to an absurd degree. '*Untitled* is merely one step beyond this observation isn't it?', she writes, continuing:

We are demanding fees as compensation for work within organisations. Fees are, by definition, payment for services. If we are, then, accepting payment in exchange for our services, does that mean we are serving those who pay us? … Studio practice conceals this condition by separating production from the interests it meets and the demands it responds to at its point of material or symbolic consumption. Because a service can be defined, in economic terms, as a value that is consumed at the same time that it is produced, the service element of project-based practice eliminates such separation.[37]

Fraser challenges this idea of access as a literalised pun – she is 'in bed with the collector' – in a gesture that exaggerates the hidden 'deal' behind collectors' investment in contemporary art. She has said:

If prostitution is evoked as a metaphor for the reduction of all human relationships to economic exchange, then I think *Untitled* works in the opposite direction. Buying and selling art is, in fact, an economic exchange. *Untitled* turns it into a very human relationship. The collector had to 'pay' much much more than money; he paid with his body and his image in the video and with his presence.[38]

Whilst Fanni Tutti boldly occupied the position of the prostitute by authoring a remake of Manet's *Olympia*, Fraser goes one step further, even, and performs as artist, prostitute and client (she actively sought out the collector who would participate in this work with her, sleep with her and pay her the money). Her comment about what the collector had to 'pay' brings our attention to her deliberate reversal of conventional power relationships by exaggerating the strength of her own position; insisting that whilst the act may appear to have been 'bought' in a conventional way, the artist's exposure of the act created a transaction that was two-way in a real emotional sense. By bringing this notion of prostitution to the fore via the agency of their respective female subject positions Fanni Tutti and Fraser perform different kinds of implication in the market, radically making visible attitudes of complicity with it and with the art world, at the same time as refuting the logic of that world and many of its assumptions. By means of their respective strategies, they each problematise the ideal of artistic autonomy upon which the art market hinges, and expose the existence of limits to the artist's freedom to transgress.[39]

Key Performance Indicators

Capitalist Realness and its phantasmagoric siblings – counterfeiting, exploitation, prostitution – challenges both our understanding of popular culture and the traditional sphere of the avant-garde by bringing to light new kinds of spaces in which art can operate. Revolutionising the notion of the 'underground', this attitude drags everything to the surface plane, teaching us to look right there for potential transgression. All the artists in this exhibition use forms of 'passing' or 'overidentification' to test their existence in the world via the degrees of visibility that they can gain. From Warhol to Fanni Tutti to Fraser there is a post 1980s sensibility that understands that in order to exist as a valid subject, or to participate, even, one must situate at least part of one's practice within an active relationship to the mainstream.

Traditional ideas of authenticity, originality and intimacy are traded for exposure as artists inhabit this terrain in ways that go beyond straightforward reflection or representation. In contemporary business management, a product is weighed according to Key Performance Indicators – financial and non-financial measures used to help an organisation to define and evaluate how successful it is. Borrowing this notion and applying it to the realm of art that derives from Warhol's 'good business' model, an idea of 'performance' thus becomes as important as the very idea of existence: as a way of measuring the artist-subject's relevance and validity. This take on 'performance' is a far cry from the body-centred practices of artists making work in the 1960s and 1970s whose live presence was a simple register of their palpable existences. Instead it has become a notion that is inextricably tied to the notion of success.

The Key Performance Indicators for artists in this exhibition include Warhol's scrapbook of gossip column clippings, Fanni Tutti's collected actions published in magazines, or the persistence of Reena Spaulings's richly fabricated and multi-authored mythology. All of these approaches register and problematise the extent to which late capitalism understands the idea of the self as commodity, and the extent to which, in turn, the commodity might be a conceptual entity as much as an object for sale.

Hirst, Murakami and Koons perform the normative laws of the market, Sturtevant, Fanni Tutti, Fraser and Uklański or Reena Spaulings produce forms of its hidden reverse. But what the artists in this exhibition have in common is that the complex terrain of the late capitalist economy itself is treated as a grand 'readymade' in which they might generatively intervene; producing a meta-level of awareness about its machinations and its effects. It is a way of rewriting our understanding of the realm of representation, and the power it holds, via its basis in economics. Instead of commenting on the market and mass culture from an apparently removed position, and instead of displacing elements of that culture into the rarified frame of the gallery or museum – as classic Pop art did – the works in *Pop Life* collapse the subjectivity of the artist into the material world of transactional exchange. In doing so this work risks two-way contamination: not only of society by the artist, but of the artist's ideals by vested or pecuniary concerns. At the same time, such an approach radically challenges the notion of the society of spectacle as an alienating and immovable condition of contemporary life, reinventing it as a space that can be agitated by contestation.

Notes

I would like to thank Mark Godfrey and Kathy Noble for their insightful comments on the text of my essay.

1 Judith Butler, *Bodies that Matter: On the Discursive Limits of 'Sex'*, New York 1993, p.125.

2 Alison M. Gingeras, 'Lives of the Artists: Public Persona as an Artistic Medium', *Tate etc*, no.1, Summer 2004, pp.24–33. She continues, 'Derived from the name of a region in the Czech Republic inhabited by nomadic gypsies, the modern notion of bohemia designated a place where artists and disillusioned members of the bourgeoisie could intermingle with the poverty stricken, foreigners, racial minorities, homosexuals and anyone else on the margins of society.'

3 Andy Warhol, *The Philosophy of Andy Warhol*, San Diego and New York 1975, p.86.

4 One of the works is titled *Jeff in the Position of Adam*.

5 Jeff Koons in conversation with Hans Ulrich Obrist and Julia Peyton Jones at the Victoria and Albert Museum, London, 2 July 2009.

6 Tamar Garb, *Bodies of Modernity: Figure and Flesh in Fin de Siecle France*, London and New York 1998, p.140.

7 Koons originally met La Cicciolina because, having seen her work in pornographic magazines, he wanted to hire her to feature in this work. The project soon turned into a real-life love affair and marriage. See pp.41–4, above.

8 Gayle Rubin, 'The Traffic in Women: Notes on the 'Political Economy' of Sex', in Rayna Reiter (ed.), *Toward an Anthropology of Women*, New York 1975, p.161: 'Capitalism is a set of social relations – forms of property and so on – in which production takes the form of turning money, things and people into capital. And capital is a quantity or goods or money which, when exchanged for labor, reproduces and augments itself by extracting unpaid labor, or surplus value, from labor and into itself.' Kinship systems 'are made up of and reproduce concrete forms of socially organised sexuality'.

9 The billboard was originally made for the Whitney Museum exhibition *Image World* in 1989.

10 Dorothea von Hantelmann, 'Jeff Koons, MoMA, Oslo', *Frog*, no.1, Spring 2005, pp.63–5.

11 In 'Avant-garde and Kitsch', first published in *Partisan Review*, vol.6, no.5, 1939, pp.34–49, Clement Greenberg describes the way in which the 'first settlers of bohemia' necessarily defined themselves against the 'bourgeoisie' so as to create a stronger united position. 'Courage indeed was needed for this, because the avant-garde's emigration from bourgeois society to bohemia meant also an emigration from the markets of capitalism, upon which artists and writers had been thrown by the falling away of aristocratic patronage.' 'Kitsch, using for raw material the debased and academicized simulacra of genuine culture, welcomes and cultivates … insensibility. It is the source of its profits. Kitsch is mechanical and operates by formulas. Kitsch is vicarious experience and faked sensations.'

12 Lynda Benglis's infamous *Artforum* advertisement picturing herself naked with a dildo appeared in 1974. *October* magazine was founded in spring 1976 following the departure of *Artforum*'s associate editors Rosalind Krauss and Annette Michelson, in protest at the Benglis ad.

13 Brian Wallis, 'We Don't Need Another Hero: Aspects of the Critical Reception of the Work of Jeff Koons' in *Jeff Koons*, exh. cat., San Francisco Museum of Modern Art 1992, p.28.

14 That these artists were looking towards American Pop at the time was evident in Richter's recollection, 'we went to Ileana Sonnabend [in Paris] to present ourselves with our portfolios as the German Pop Artists. That was when we first saw originals by Lichtenstein': 'Interview with Benjamin Buchloh' (1986), in *The Daily Practice of Painting: Gerhard Richter, Writings 1962–1993*, ed. Hans Ulrich Obrist, trans. David Britt, Cambridge, Massachusetts 1995, p.138.

15 This relates to Richter's claim that he was a bourgeois painter just as he was 'bourgeois enough to eat with a knife and fork'.

16 Peggy Phelan, *Unmarked: The Politics of Performance*, London 1993.

17 Scott Rothkopf, 'Takashi Murakami: Company Man', in *© MURAKAMI*, exh. cat., MOCA at the Geffen Contemporary, Los Angeles 2008, p.132.

18 Ibid., p.141.

19 Mark Francis, 'Horror Vacui: Andy Warhol's Installations', in *Warhol: The Late Work*, exh. cat., Museum Kunstpalast, Düsseldorf 2004, p.11.

20 Slavoj Žižek, 'Why Laibach and NSK Are Not Fascists' (1993), in Inke Arns (ed.), *IRWINRETROPRINCIP, 1983–2003*, Frankfurt 2003, p.21.

21 Quoted in Bernard Blistène, 'Label Elaine', in *Surtevant: The Brutal Truth*, exh. cat., Museum für Moderne Kunst, Frankfurt-am-Main 2004, p.37.

22 Ibid., p.42.

23 Sturtevant recounted in conversation that when she met Takashi Murakami at his exhibition opening at MMK in Frankfurt, titled *© MURAKAMI*, she told him she liked the work, but 'why the insistence on this medieval idea of copyright?'

24 Bennett Simpson, 'Techniques of Today: Bennett Simpson on Bernadette Corporation', *Artforum*, vol.43, no.1, September 2004.

25 Kate Bush, 'Once upon a Time in the East: Piotr Uklański', *Artforum*, vol.41, no.3, November 2002.

26 In conversation during discussions relating to the preparation of this exhibition.

27 See Jack Bankowsky's essay, pp.31–2 above.

28 '"Charging the Barricades in a Red Ferrari Convertible!": Piotr Uklański in Conversation with Roman Polanski', *Earth, Wind & Fire*, exh. cat., Kunsthalle Basel 2004, p.218.

29 *The Chambers Dictionary*, Edinburgh 1998, p.1321.

30 Cosey Fanni Tutti, 'Confessions' (unpublished manuscript supplied by Cabinet Gallery, London).

31 *Sunday People*, 24 October 1976.

32 ICA *Prostitution* exhibition poster, 1976, Tate Gallery Archive: TGA 955/7/772.

33 Ibid.

34 'Subject & [sex] Object: Simon Ford on Cosey Fanni Tutti and her Works for Magazines', *Make 80* global issue, June–August 1998, p.7.

35 As reported by Jerry Saltz in 'Critiqueus Interruptus: The Lady Is Not a Tramp: Andrea Fraser Replaces Sensationalism with Adoration', *Village Voice*, 13 February 2007.

36 Alexander Alberro, 'Introduction: Mimicry, Excess, Critique', in *Museum Highlights: The Writings of Andrea Fraser*, ed. Alexander Alberro, Cambridge, Massachusetts 2005, p.xxx.

37 Andrea Fraser, 'How to Provide an Artistic Service: An Introduction' (1994), in ibid., pp.153–62.

38 Miwon Kwon, 'What Do I as an Artist Provide?: A Conversation between Andrea Fraser and Miwon Kwon', *Documents*, no.24, Winter 2004.

39 See Lynn Hunt, 'Introduction' in Lynn Hunt, (ed.), *The Invention of Pornography: Obscenity and the Origins of Modernity 1500–1800*, New York 1993, pp.11–12: 'Early modern pornography … was linked to free-thinking and heresy, to science and natural philosophy, and to attacks on absolutist political authority. It was especially revealing about the gender differentiations being developed within the culture of modernity … In other words, pornography as a regulatory category was invented in response to the perceived menace of the democratization of culture.'

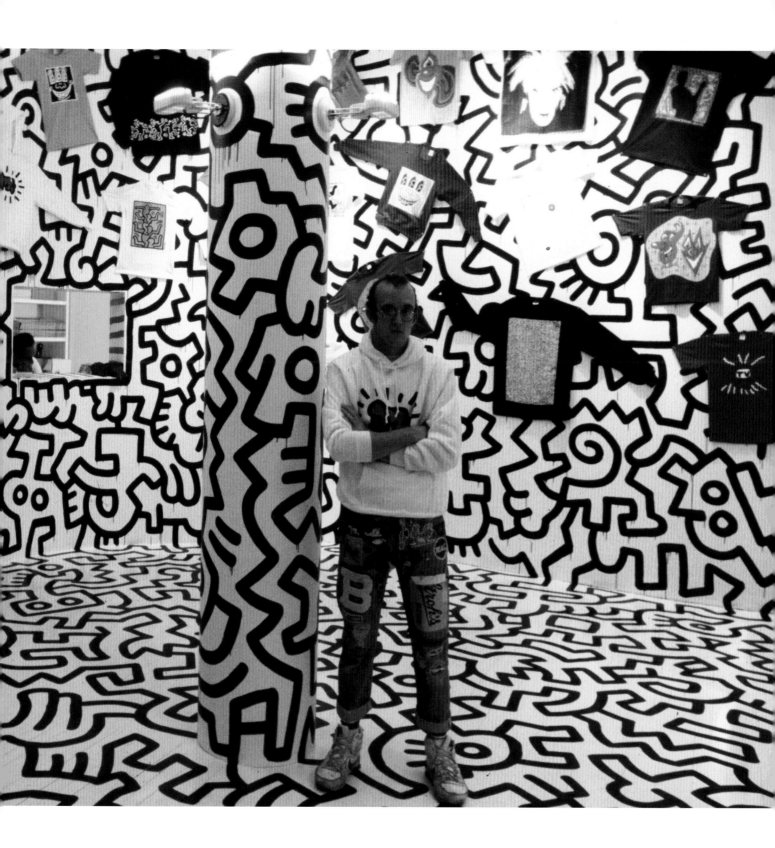

Keith Haring inside
the Pop Shop, 1986
Photo: Tseng Kwong Chi

Dreams That Money Can Buy

Nicholas Cullinan

The currency of desire is the subject of the 1947 film by Hans Richter that lends this essay its title, and ostensibly concerns a man who starts his own business selling tailor-made dreams to an assortment of frustrated clients. Each dream transaction comprises a vignette made by a variety of artists including Alexander Calder, Marcel Duchamp, Max Ernst, Man Ray and Fernand Léger. Richter's film offers both an allegory and a withering critique of America's (then) eager embrace of psychoanalysis as a service-orientated industry solution to mining imagination that perhaps is not there to be mined.

What, then, might Richter's caustic exercise in wish-fulfilment suggest about the artists discussed in this essay? Whilst other, seemingly more pertinent, precedents for their work might be found in Ben Vautrier's Fluxus *Ben's Shop* of 1958, Claes Oldenburg's *The Store* of 1961 and, of course Andy Warhol's solo exhibition of his *Brillo Boxes*, *Campbell's Soup Cans* and *Heinz Boxes* at the Stable Gallery in New York in 1965, whose installation aped supermarket modes of display, the overarching archaeological metaphor of surface versus depth in psychoanalysis, as dissected by Richter, is one that feeds into all these artists' parodic dabblings in the market.

The examples discussed here are Keith Haring's downtown New York Pop Shop of the 1980s, which opened in a city caught between the euphoric disco days of Studio 54 and the nightmare of AIDS; Tracey Emin's and Sarah Lucas's The Shop in the East End of London, which operated after the demise of Thatcherism and during the rise of the YBAs in the early 1990s; and Damien Hirst's Sotheby's auction of his grimly glittering objects in 2008, which perfectly mirrored an endpoint of late capitalism in its nihilistic embrace of the market. These present a range of very different ways in which to queer the market, offer a tacit critique of machismo posturing and the rigid British class system, and a blankly cannibalistic comment on their own systems of production and consumption. As the three examples show us, to 'sell out' rests on the paradox of commodifying subversion (or subverting commodification), and by apparently embracing success, to refuse to adhere to traditional and constricting notions of decorum and conservative ideas of taste.

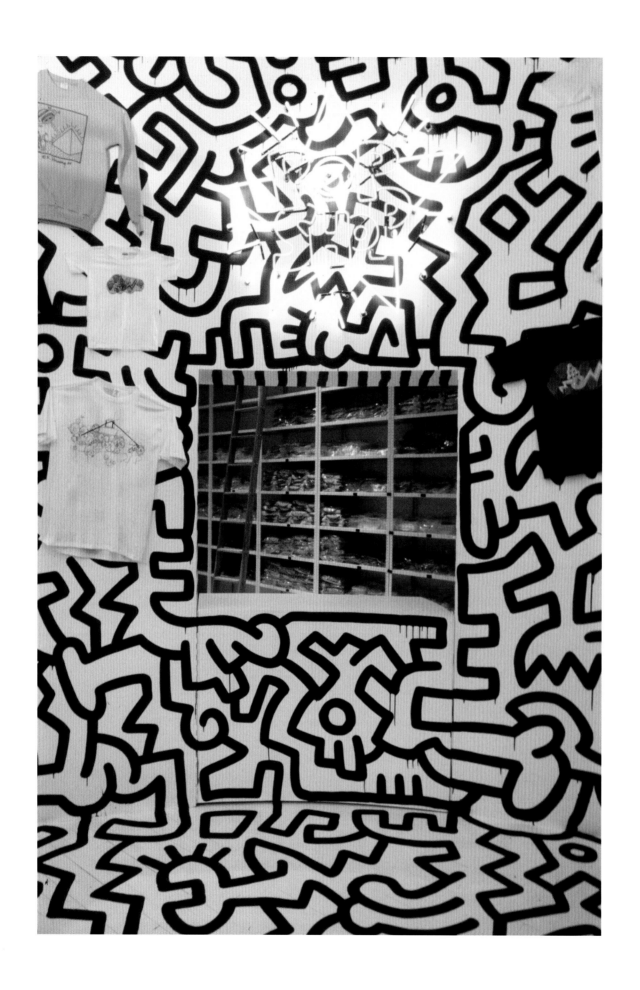

Two views inside
the Pop Shop, 1986
Photo: Tseng Kwong Chi

Libidinal Economy: Keith Haring's Pop Shop

I watched Keith come up from that street base, which is where I came up from, and he managed to take something from what I call Street Art, which was an underground counterculture, and raise it to a Pop culture for mass consumption. And I did that too. The point is, we have an awful lot in common. Another thing we have in common – and this happened quite early – was the envy and hostility coming from a lot of people who wanted us to stay small. Because we both became very commercial and started making a lot of money, people eliminated us from the realm of being artists. They said, 'OK, if you're going to be a mass-consumption commodity and a lot of people are going to buy your work – or buy into what you are – then you're no good.' I know people thought that about Keith, and they obviously felt that about me too. So Keith and I are sort of two sides of the same coin.
Madonna[1]

In 1986, Keith Haring crossed-over from the studio to the store (seemingly obviating the gallery system in the process) by opening his Pop Shop on 292 Lafayette Street in downtown New York. Customers were greeted by window displays featuring his signature mascots of inflatable babies or a barking dog in neon. Inside, Haring fashioned a hyperactive horror vacui by covering the curvilinear walls, floor and ceiling of the interior with his trademark all-over graffiti scrawl made of monochrome marks and interpenetrating abstract and anthropomorphic forms, before stocking the shop with a range of goods that gleefully exploited his branded signature and made these items accessible to a mass-market audience. His products included an array of badges, inflatable babies, 'amazing magnets', baseball caps, jigsaw puzzles, transistor radios, skateboards, Swatch watches, and a vast assortment of T-shirts with different designs emblazoned across them, all rendered in a rainbow of day-glo colours, and prominently featuring Haring's imprimatur. Soundtracked by blaring rap music, Haring's goods were purveyed to an eager audience as part of 'an extended performance' in an endeavour that was in essence akin to a designer's diffusion line, which expands the market reach and makes otherwise inaccessible items available to a younger and broader target audience who would risk being alienated.[2] The success of the Pop Shop in New York prompted another branch to open in Tokyo in 1988, which sold kimonos and fans decorated with Haring's trademark designs, a strategy of East-meets-West commerce that arguably may have influenced the young Takashi Murakami.[3]

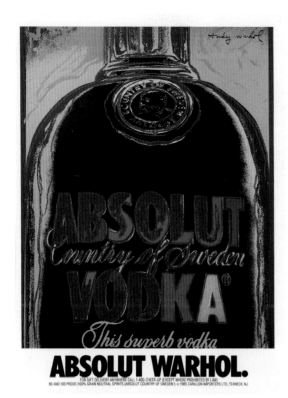

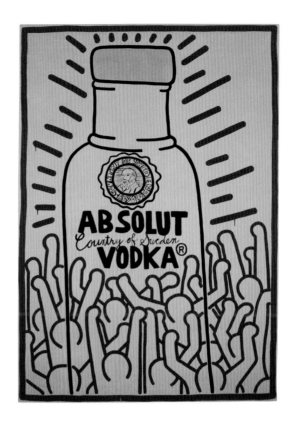

Andy Warhol
Absolut Vodka advertisement 1985
The Andy Warhol Museum, Pittsburgh.
Founding Collection, Contribution The Andy
Warhol Foundation for the Visual Arts Inc.

Keith Haring
Absolut Vodka advertisement 1986
Keith Haring Foundation, New York

Haring's early forays altering the posters on various stations of New York's subway were part of this effort to bring art into the daily lives of the city's commuters, a subversive gesture that didn't require access to a private gallery or admission to a public museum. Inspired by seeing an advertisement on the street for 'Chardon Jeans' from which someone had deleted the letter to 'C' to create the legend 'Hardon Jeans', Haring began to do the same with every poster he encountered. The cumulative effect of this rebranding enterprise was, as he observed, to hand over ownership of his works to the audience. As Haring stated: 'Here's the philosophy behind the Pop Shop: I wanted to continue this same sort of communication as with the subway drawings. I wanted to attract the same wide range of people, and I wanted it to be a place where, yes, not only collectors could come, but also kids from the Bronx.'[4] The Pop Shop represented an effort both to continue and extend this viral strategy, and conversely to reclaim his stake and control the way in which his work was being imitated and disseminated to a mass audience by the mid-1980s.[5]

The downtown milieu that nurtured Haring and in which he first emerged was one that fused the tropes of the utopianly aspirational with urban industry and manufacture from its very inception, like Warhol's silver-lined Factory before it.[6] A perfect exemplar of this was the underground nightclub Paradise Garage, where Madonna performed for Haring's birthday and Grace Jones's naked body was painted with graffiti by the artist for a gig. Under the auspices of Warhol, however, Haring took his, quite literal, underground guerrilla drawings to a new level of commerce.[7] Self-confessedly 'in awe of Andy', Haring met him in 1983, and they soon formed a close friendship, trading works and collaborating on projects; with Haring even posing for a portrait by the older artist (p.103).[8] Warhol's advice guided Haring to ignore the criticism that a commercial enterprise such as the Pop Shop would inevitably attract, as his protégé acknowledged:

Of course, I knew I'd get a lot of criticism for it, but I also knew that it was what some of the work called for – and *had* to become. Still, it meant I'd be walking an

incredibly fine line. It was a real tightrope, and dangerous on either side. You had to avoid crass commercialism and also keep hold of the art world.[9]

Haring also followed in the footsteps of Warhol's unabashed embrace of commerce by, like his mentor and at his suggestion, designing an advertisement for Absolut Vodka in 1986 and a subsequent one for Lucky Strike cigarettes the following year.[10] In 1985 Haring and Warhol also collaborated on a joint work celebrating the shamelessness of their mutual friend Madonna, who is namechecked and namedropped many times throughout their respective diaries, journals and interviews.[11] After the pop princess proved impervious to the potentially embarrassing release of some photographs of her modelling naked during her impoverished early years in New York in the late 1970s, the *New York Post* ran a cover story emblazoned with the headline: 'Madonna: "I'm Not Ashamed"' and the

nonchalant legend: 'Rock star shrugs off nudie pix furor'. Haring and Warhol upped the ante on Madonna's defiant attitude and immortalised her amorality by adorning the newspaper cover with an array of energetic graffiti markings and transforming the black and white photograph of the pop star into a Technicolor vision of blonde hair, green eyes, rosy skin and pink lips. Madonna's brazenness must have been of special attraction and significance for both Haring and Warhol, since the same accusations being levelled at her – unashamedly ambitious, money-grabbing and tasteless – were also being applied to them; all three tarred by the same airbrush.[12] If Warhol had originally been shunned by the art world for being too camp and crassly commercial (and would continue to be rejected for these reasons intermittently throughout his career), his example taught Haring to cut out this middleman and instead purvey tokens of aspiration back to the very audience that first supported him.[13]

Keith Haring and Andy Warhol
Untitled (Madonna: 'I'm Not Ashamed') 1985
Keith Haring Foundation, New York

Sarah Lucas and Tracey Emin
Complete Arsehole T-shirts 1993
Photo: Pauline Daly
Courtesy Sadie Coles HQ, London

Sarah Lucas and Tracey Emin in
the doorway of The Shop, 1993
Photo: Carl Freedman
Courtesy Sadie Coles HQ,
London

Class of '88: Tracey Emin's and Sarah Lucas's The Shop

If we were listed it would be under sell-out, in the shopping listings.
Tracey Emin[14]

If the aspirational yet affordable merchandise of Haring's New York downtown store was a barometer for the boom-and-bust era of Reagonomics, then The Shop, which was opened by Tracey Emin and Sarah Lucas in the East End of London in 1993 during a recession and the aftermath of Thatcherism in Britain, similarly reflects its social context perfectly. Both phenomena – despite their very different manifestations – are also perhaps linked by a common thread. In 1985, Charles Saatchi opened his eponymous gallery in St John's Wood, which exposed a new generation of young British art students to the ambition of their American peers. As Richard Shone recalls: 'To visit the exhibitions there was a point of duty for many of the students (group visits and private-view cards from teachers helped); illuminating and influential was the two-part *New York Art Now* (September 1987 – April 1988), which included work by Robert Gober, Ashley Bickerton and Jeff Koons. Here they could find confirmation of, or add to, their own preferences and direction.'[15]

The YBAs' subsequent tactic and market strategy was therefore composed of a two-pronged business plan. The first was to appropriate the model of slick professionalism and vaulting ambition from American Neo Geo artists of the 1980s that Saatchi had shown in London. The second was to then graft this onto a distinctly British vernacular and thus transform it from a negative into a marketable commodity and unique selling point, whether this was in the East End Docklands warehouse space where Damien Hirst's entrepreneurial exhibition *Freeze* was staged in 1988, which showcased his contemporaries from Goldsmiths including Gary Hume and Sarah Lucas, or events such as Joshua Compston's *Fête Worse Than Death* in 1993 and 1994, which aimed to create a 'capitalism of the avant garde' by parlaying an English provincialism into an international asset.[16] Emblematic in this respect is Gavin Turk's blue plaque *Cavey* 1991–7 (p.154), which recasts a recognisable symbol of English heritage into a self-promoting badge of honour, or his sculpture *Pop* 1993 (p.155), which rebrands Warhol's iconic painting of Elvis as a gun-toting American cowboy into Sid Vicious from the British punk band the Sex Pistols; an appropriational *mise en abyme* completed by the fact that the waxwork figure is

an effigy of the artist himself. Works such as this were eventually exported back to the US with exhibitions such as *Brilliant! New Art from London* at the Walker Art Center, Minneapolis, in 1995 and *Sensation*, which toured to the Brooklyn Museum of Art, New York, in 1999 and closed the circle on this reciprocal relationship.

When Emin and Lucas took out a short lease on a shop at 103 Bethnal Green Road in the East End of London, it marked both a continuation and a corrective of these strategies. As Lucas observed, shows such as *Freeze* may have been staged in old warehouses, but they were intended 'to copy or emulate something much more professional than that and much more flash'.[17] A reaction against this transatlantic model of go-getting and self-starting enterprise as exhibited in *Freeze*, is one that defines The Shop. As Matthew Collings has written:

> Although there were no exhibitions as such, it was a parody of a contemporary gallery: galleries were still 1980s-corporate style, white square lifeless and pretentious, run by intimidating zombies (as they mostly still are today); whereas nothing in the shop had a power look. Everything was tacky and small time … It was a kind of alternative souvenir shop, selling negative souvenirs of London instead of positive ones, and in the East End instead of the West End.[18]

The Shop was initiated by Lucas's suggestion that the artists get a studio together. Although Emin had no need of a studio at the time since she was not making art, they nonetheless scoured East London and found a shop with a six-month lease. If Haring's Pop Shop functioned as a way in which to radically expand the possibilities of the artist's multiple, Emin's and Lucas's shop collapsed various categories in on themselves: studio, shop, and salon-meets-flophouse, while the photographs of the artists posing on the threshold of the property deliberately toyed with the imagery of a brothel. Opening on 14 January 1993, the upstairs rooms were used as studios, while the ground floor became a shop purveying a quirky range of emphatically handmade items, from slogan T-shirts including 'I'm So Fucky' and 'She's Kebab' and vests bearing legends such as 'Sperm Counts', hats, clothes and ashtrays featuring the face of Damien Hirst to papier-mâché dildos. The Shop had all of the attributes of a low level, cottage industry enterprise, such as a bric-a-brac boutique or a haberdashery, with the proprietors performing the role of shopkeepers, complete with printed stickers for 'Lucas & Emin' with their address and telephone number. 'Out to Lunch' signs and a characteristically misspelled

proclamation by Emin – 'Public Notice: Be Faitful To Your Dreams' – completed the sense of an oddball shop. Emin's handwritten inventory of items from The Shop scrupulously lists all the objects produced alongside the prices they sold for, such as a 'Rothko comfort blanket' (£7), a 'set of bollocks plus photo of Cerith Wyn Evans' (£6), 'Bird Condoms (Featherlite)' (£2), 'The Earnest Eminway School of Art' (£4), and 'Crazy Tracey and Sensible Lucas' badges (£2). T-shirts were cannily priced thus: 'Prices start at £12 and increase with each sale – £12 – £15 – £20 – £25, etc.', in an inverse relationship to supply and demand from Warhol's pricing of his commissioned portraits, where a discount was available for multiple orders. They also staged events such as life-drawing classes, with a hand-drawn poster begging the question: 'Just Where Do you Draw the Line?'. Defying Warhol's famous dictum that 'Business art is the step that comes after Art', Emin therefore emerged on the art scene as a businesswoman (however

shambolic) before she had her first exhibition, in a manner not dissimilar to stockbroker-cum-artist Jeff Koons.[19] Emin's diary from the time of The Shop also revels that she expected a business-like attitude to punctuality and professionalism: 'Sarah took the day off. 20 mins late for 6 weeks = 24 hours.'[20]

What Emin's and Lucas's Shop and exhibitions such as *Freeze* really signify are not the ambition of a generation determined to achieve success at any cost, but the intrusion into a stolidly middle-class and left-wing British art world of artists with a defiantly working-class work ethic, and, worse still, one made possible by a détournement of Thatcher's emphasis on rampant capitalism and insistence on a classless society.[21] Artists who had success not inherited but *earned*, would of course count the fruits of their labour through its wages (mostly money and column inches), as Warhol had prophetically observed.[22]

Detail
Tracey Emin
Tracey Emin CV 1995
Tate

This Little Piggy Went to Market:

Damien Hirst's Auction

Art is about life and the art world is about money although the buyers and sellers, the movers and shakers, the money men will tell you anything to not have you realise their real motive is cash, because if you realise – that they would sell your granny to Nigerian sex slave traders for 50 pence (10 bob) and a packet of woodbines – then you're not going to believe the other shit coming out of their mouths that's trying to get you to buy the garish shit they've got hanging on the wall in their posh shops ... Most of the time they are all selling shit to fools, and it's getting worse. Damien Hirst[23]

On 15 and 16 September 2008, Damien Hirst sold 223 lots of his new work through an auction at Sotheby's in London for an estimated total gross of £111.5 million, marking, depending on your viewpoint, the absolute zenith or the nadir of the art-market boom. Bracketed by the bottom line and the highest bidder, Hirst's speculative and performative gesture in staging such a theatrical event updated the Minimalist mantra of 'it is what it is' to 'it is what it's worth', while the auction's record-breaking sales tally incontrovertibly placed it as a supreme artistic statement, according to Warhol's motto of 'making money is art and working is art and good business is the best art.'[24] Emboldened by the unprecedented success of the *Pharmacy* auction at Sotheby's in London in October 2004 and the sale in 2007 of his diamond-encrusted skull, *For the Love of God*, for an estimated fifty million pounds, beyond the statistics and superlatives that swirled around the sale (the largest amount ever grossed by a single-artist at auction, etc.), what was really at stake in Hirst's high-profile test of worth, apart from just an attempt to cut out his long-term dealers?[25]

Entitled *Beautiful Inside My Head Forever*, the auction consisted of glitzy new variations on familiar themes created over the preceding two years, including formaldehyde sculptures, butterfly, spot and spin paintings, and medicine cabinets. Hirst's retrospective tendency situated the auction as either a mid-career stocktaking or – if the claims made before the auction that he would discontinue or diminish the production line of spin, spot and butterfly paintings and formaldehyde animals were to be believed – a last hurrah. Now, Hirst found ways to gild the lily throughout – spin paintings were either heart-shaped or encrusted with butterflies,

skulls or manufactured diamonds (and in some case, all of these motifs). Hirst's Midas touch transformed all: his trademark pharmacological dot paintings were emblazoned upon a golden background and medicine cabinets metamorphosised into gilded display cases for diamonds rather than for pills. From the golden dot painting *Aurothioglucose* (p.172) to the mythological *The Kiss of Midas* (p.178), the self-referencing and retrospective tendencies endemic to late Warhol now proliferated in the profusion of skulls superimposed on the formerly abstract spin paintings, as more of a nod to Hirst's own diamond skull, *For the Love of God*, from the previous year, than to any form of memento mori. Religious references still littered the titles of the works, such as those named after psalms, but Hirst's move away from Catholic imagery to those of mythology acted as a marker of his own self-mythologisation. Not only were iconic animals from Hirst's stable such as sharks and lambs present in multiple, but these were joined by more exotic or even mythical members of the menagerie, including a winged piglet, a zebra and a unicorn. Only a golden goose was sadly absent from the otherwise perfect Noah's Ark of bling. The glittering centrepiece of the entire auction was of course the *Golden Calf* – which both baited its audience with its nod to the biblical cautionary tale against wealth and idolatry, and also flattered them with a knowing irony.

The myth of Midas which Hirst mined so heavily for the works included in the auction is, of course, as much about fossilisation as it is about fabulousness, and only the terminally humourless could have failed to spot the self-parody being flaunted throughout the golden lots. Perhaps the auction itself acted as a loss leader (albeit a wildly profitable one), since its remuneration in publicity and notoriety were possibly more important than the fiscal recompense. Such a successful gamble enacted Warhol's emphasis on the quantitative over the qualitative – Hirst could now weigh his reviews rather than reading them. As Hal Foster has observed of Hirst's alchemical transmutation of spectacle into revenue, 'with his courting of controversy, [he] is the champion of converting public attention into financial reward'.[26] The works arguably doubled as props for the performance that constituted the main artwork – the auction itself, as a kind of *gesamtkunstwerk*, given a further *fin-de-siècle* feel dramatised by the deals and hammers being struck as Lehman Brothers went bust and Merrill Lynch was bought in a fire sale. Even Hirst's dealers, who were being bypassed by the event and denied their usual cut, gave statements for the press release. They played their allotted parts beautifully, with Jay Jopling as

spurned but forgiving spouse opining that '8,601 flawless diamonds notwithstanding, ours has never been a traditional marriage', and the corporate entity of Gagosian Gallery pledging to be enthusiastic bidders, 'in the room with paddle in hand'.[27] In a particularly illuminating diatribe essay for the exhibition catalogue *In-A-Gadda-Da-Vida* at Tate Britain in 2004 titled 'Why Cunts Sell Shit to Fools', Hirst offers an arresting array of possibly pre-emptive clues as to the motivation for his auction four years later. He explains that as Houdini wrote: 'The easiest way to attract a crowd is to let it be known that at any given time and a given place someone is going to attempt something that in the event of failure will mean sudden death.'[28] If Hirst was gambling with the thrill of some form of career suicide through his sale, then the payoff was disappointingly a runaway success.[29] As Hirst's sell-out auction has demonstrated, putting Warhol's ideas into action, angst-ridden discussions of taste and aesthetics are outmoded. When it comes to the business of art, the bottom line is always the most beautiful.

Damien Hirst
False Idol 2008
(p.179)

Notes

I would like to thank Julia Gruen and Annelise Ream at the Keith Haring Foundation, Craig Barnes at Kaikai Kiki New York, Alexandra Hill and Julia Holdway at the Tracey Emin Studio, and Jon Lowe at the White Cube archive for their assistance during the research for this essay. I would also like to thank James Boaden, Xavier F. Salomon, Karsten Schubert, Richard Shone and Catherine Wood for their comments.

1 Madonna, quoted in John Gruen, *Keith Haring: The Authorized Biography*, New York 1992, pp.91–2.

2 Keith Haring, *Keith Haring: Journals*, with an introduction by Robert Farris Thompson; preface by David Hockney, New York and London 1996, p.116.

3 As Scott Rothkopf writes: 'Murakami visited [Keith Haring's Pop Shop] on his first trip to New York in 1989, just three years after it opened with Warhol's fabled blessing. Like Murakami, Haring had a stable of signature characters – the barking dog and radiant baby, to cite only the most iconic examples – that moved fluidly between his high-end paintings and sculptures and the T-shirts and magnets the filled Pop Shop's shelves. Also like Murakami, Haring's signature graphic style derived from vernacular sources and was instantly recognizable, lending itself to cross-branded collaborations, such as his series of Swatch watches, and occasional advertising commissions like those he undertook for Absolute Vodka and Lucky Strike. So aware was he of his brand's growing cachet that he permanently appended a hand-drawn copyright symbol to his signature as both an acknowledgement of its talismanic power and a mock threat to would-be forgers.' Scott Rothkopf, 'Takashi Murakami: Company Man', in Paul Schimmel (ed.): ©MURAKAMI, exh. cat., The Museum of Contemporary Art, Los Angeles 2007, pp.128–59, esp. pp.143–4. Murakami himself downplays this link: 'Although Keith Haring is an artist who I like, the nature of his Pop Shop has not much influence on my work.' See Carlo McCormick, 'Pop Killer: Takashi Murakami', *Spread*, issue 3, 2008, pp.88–91, esp. p.91.

4 Haring continues: 'I knew since almost '82, '83 the imitation thing starts springing up all over the world. Things had, sort of, entered the popular culture whether I wanted them to or not, because of doing the drawings in the subway and presenting them almost as a public gift to the world and presenting them as public art intended to be seen and used by the public.' Keith Haring, quoted in Gruen 1992, p.148.

5 Keith Haring interviewed by John Gruen, unpublished transcript.

6 For an excellent overview on this subject, see Marvin J. Taylor (ed.), *The Downtown Book: The New York Art Scene 1974–1984*, Princeton and Oxford 2006.

7 As Haring said: 'I discussed the Pop Shop many times with Andy Warhol, and he was totally supportive of my taking the plunge, and not caring what people thought, because as long as I knew why I was doing it, then that was what was the most important.' Gruen 1991, p.129. Haring paid tribute to his spiritual father through a range of T-shirts sold in the Pop Shop that either featured Warhol's iconic fright wig self-portrait of 1986, or portraits made by Warhol of Haring.

8 Keith Haring, in Gruen 1991, p.90.

9 Ibid., p.128.

10 See ibid., p.116.

11 See Andy Warhol, *The Andy Warhol Diaries* (ed. Pat Hackett), London 1989; Keith Haring, *Keith Haring: Journals*, with an introduction by Robert Farris Thompson; preface by David Hockney, New York and London 1996, and also Gruen 1991.

12 Haring: 'Of course, the Pop Shop was an easy target, and it was attacked from all sides. People could now say, "What do you mean Haring isn't commercial? He's opened a store!" But I didn't care, because it's still going strong – and it's an art experiment that works.' Keith Haring, quoted in Gruen 1991, p.148. The Pop Shop was successful for some time, but eventually closed in 2005.

13 'Andy's life and work made my work possible. Andy set the precedent for the possibility for my art to exist.' Haring, in *Keith Haring: Journals*, p.117. It is worth noting that all the artists who have sought recourse to the tactics of commerce and the mercantile as a mode of expression stress the democratic aspect of these enterprises – from Haring's stated desire to extend his brand into a trademark and business in order to sell affordable objects directly back to the downtown demographic that had nurtured him rather than just focus on his burgeoning uptown and upmarket audience, to the choice of Emin and Lucas to purvey emphatically tatty handicraft objects more akin to bric-a-brac. Even the stated aim of Hirst's record-breaking auction was to make the process of selling multi-million pound works of art as democratic as possible to whoever happened to be the highest bidder. As Hirst said: 'After the success of the Pharmacy auction, I always felt I would like to do another auction. It's a very democratic way to sell art and it feels like a natural evolution for contemporary art.' Sotheby's press release, 28 July 2008.

14 Pauline Daly and Brendan Quick, 'Crazy Tracey, Sensible Lucas', *Interview*, September 1993, pp.58–60, esp. p.58.

15 Richard Shone, 'From "Freeze" to House: 1988–1994', in *Sensation*, exh. cat., Royal Academy, London 1997, pp.12–25, esp. p.19.

16 See Jeremy Cooper, *No FuN Without U: The Art of Factual Nonsense*, London 2000, p.159.

17 Ingvild Goetz, 'The Work Is my Description of the World: Interview with Sarah Lucas', in *Art from the UK*, exh. cat., Sammlung Goetz, Munich 1998, p.135.

18 Matthew Collings, *Sarah Lucas*, London 2002, p.29. Collings also remembers 'the most striking feature of the Bethnal Green Road shop, besides the obscene things it sold, and its permanent atmosphere of drunkenness and hang-over, was its non-arty unpretentiousness … It was a joke in itself that money had so little meaning in the shop, at a time when society and especially the art world was obsessed by the stuff.' Ibid.

19 See Andy Warhol, *The Andy Warhol Diaries*, London 1989, p.92. For Emin, the passage from shop to museum was almost immediate: *The Shop 14 January to 3 July 1993* consists of a museological box containing the ashes of all the artworks burned after the shop closed down. Shortly afterwards, Emin's first solo show opened at White Cube titled *My Major Retrospective*, and grandiloquently laid claim to an eminent past, while The Tracey Emin Museum opened in 1995, allowing the artist to bestow instant museum status on herself.

20 Unpublished manuscript of Tracey Emin's diary. Emin's final entry in the diary reveals a more relaxed attitude to this work-ethic, however: 'At this point – everything got drunk – and wild – and I decided to keep a diary at home'.

21 A trashed dark blue Nissan Bluebird from the 1980s, doors open and windows smashed in and given the title *Islington Diamonds* by Sarah Lucas in a work from 1997, a slang term applied to the glittering shards of shattered glass from vandalised cars, is exemplary in this sense. Islington, the formerly working-class neighbourhood of London in which Lucas was born and raised, was at that very moment being overtaken by the ambitions of New Labour.

22 'you should always have a product that's not just "you." An actress should count up her plays and movies and a model should count up her photographs and a writer should count up his words and an artist should count up his pictures so you always know exactly what you're worth, and you don't get stuck thinking your product is you and your fame, and your aura.' Andy Warhol, *The Philosophy of Andy Warhol (From A to B and Back Again)*, New York 1975, p.86.

23 Damien Hirst, 'Why Cunts Sell Shit to Fools', *In-A-Gadda-Da-Vida*, Tate Britain, London 2004, pp.82–5, esp. p.82.

24 See Paula Feldman and Karsten Schubert (eds.), *It Is what it Is: Writings on Dan Flavin since 1964*, London 2004. See also Warhol, *The Philosophy of Andy Warhol (From A to B and Back Again)*, p.92.

25 Hirst's mercantile and autonomous sale was not, however, the first example of an artist bringing works directly to auction, as many of its commentators stated. On the 8 March 1926 Marcel Duchamp and Francis Picabia staged an auction of *Tableaux, aquarelles et dessins par Francis Picabia appartenant à M. Marcel Duchamp*, at the Hôtel Drouot, Paris. The sale contained eighty works by Picabia and featured a catalogue, that like Hirst's own tome, was a work of art in its own right, and was both designed by and featured a preface written by Duchamp and signed 'Rrose Sélavy'. The sale was well attended and a great financial success, with Duchamp purchasing several works for resale and taking roughly 10 per cent of the profits.

26 Hal Foster, 'The Medium Is the Market', *London Review of Books*, 9 October 2008, pp.23–4, esp. p.24.

27 Sotheby's Press Release, 28 July 2008.

28 Hirst, 'Why Cunts Sell Shit to Fools', p.85.

29 As early as 1990, Hirst had stated: 'I can't wait to get into a position to make really bad art and get away with it. At the moment if I did certain things people would look at it, consider it and then say "Fuck off". But after a while you can get away with things.' Hirst in an interview with Liam Gillick, in *Building One*, *Gambler*, London 1990, n.p.

Takashi Murakami at the Shuffle
Maid Café, GEISAI #11
Photo: Miget

Lost in Translation: The Politics
of Identity in the Work of Takashi Murakami

Alison M. Gingeras

Takashi Murakami is an unlikely hero when it comes to identity politics. One of the most commercially potent artists of our day, he has founded his creative empire as much on his dazzling array of extra-studio activities – curating a trilogy of museum exhibitions around his theory of the 'Superflat'[1]; orchestrating the burgeoning careers of his artistic protégés from his Kaikai Kiki studio; collaborating on music videos and album covers for hip-hop stars such as Kanye West; organising GEISAI, a spectacular biannual arts festival in Tokyo; or designing motifs for Louis Vuitton luxury goods – as on his more conventional activities as a painter and sculptor. While the combination of these pursuits has made him a 'star', they have also severely handicapped his critical credibility. In fact, his international celebrity, recognisable 'brand' name and financial success are used as evidence against him when the integrity of his artistic practice is called into question. How could his work retain any critical or socio-political meaning when it is so closely aligned with the market?

Yet if one considers identity politics as a means to advance the interests of an oppressed or marginalised group, then Murakami should be reconsidered first and foremost as a political artist. While his approach does not possess the hallmarks of political art – it in fact completely disavows oppositional critique – his entrepreneurial enterprise can be understood as a quest to rid Japanese national cultural identity of its inferiority complex vis-à-vis American pop-cultural hegemony and to understand the lasting trauma of the Second World War in the formation of post-war Japanese culture. As Murakami's friend and scholarly collaborator Noi Sawaragi attempts to explain regarding the overarching objective of his curatorial work:

> *The Superflat Manifesto* did not make the righteous claim that Japanese can produce high art just like Westerners; instead, [Murakami] aimed to recreate global art by changing the value system, proclaiming 'the time has come to take pride in our art which is a kind of subculture, ridiculed and deemed "monstrous" by those in the Western art world'.[2]

This nationalist/redemptive drive is not limited to Murakami's curatorial efforts. Reading his entire oeuvre, as well as the performance of his public persona, through his project of nationalist vindication opens up a broader understanding of his unique adoption of 'Business Art' strategies.

Yet because Murakami's Business Art DNA is shared with Andy Warhol, it is understandable why his critical intent

Installation view of ©*MURAKAMI* at
The Geffen Contemporary at MOCA,
Los Angeles 2007

and engagement with identity politics can become lost in translation when it comes to the mainstream reception of his work. On the surface, his modus operandi seems to come straight out of the Warholian playbook, with little variation from the original model: striving for mainstream celebrity; adopting corporate business structures; catering to our collective appetite for sensationalism; transgressing avant-garde hierarchies that separate high from low, commodity from art. Yet it is necessary to look beyond the apolitical connotations that plague any artist bracketed with Warhol in order to differentiate their approaches and uncover Murakami's skillful manipulation of Japanese signifiers as well as his dual performance of his national identity at home and abroad.

Imports and Exports

When Warhol opened the Pandora's box of Business Art, he did more than just sell out: he expanded the sphere of critical artistic agency by radically calling into question the hypocritical values and political pieties that have been projected on artists for decades. Donning his signature wig and with his *Interview* magazine tape recorder in hand – becoming an active protagonist in worlds of high society and pop culture – Warhol severed his ties with the avant-garde. While on the surface he cosied up to money and power, he also opened the door to a form of criticality while acknowledging that there is no 'outside' – artists could work the system without completely conforming to the model. Warholian affirmative critique amounts to creating slight disturbances or engendering unstable meanings within the mainstream. Murakami brought Warhol's model of affirmative criticality to Tokyo as the conceptual cornerstone of his studio-cum-cultural export business Kaikai Kiki Co. Ltd.

Importing this Warholian model to Japan as the validating example and conceptual motor of his enterprise, Murakami was also building on the lack of formal demarcation between fine art and popular merchandise that is a major characteristic of post-war Japanese society. Not only did the Japanese language not have a term for 'fine art' until after the start of the Meiji Restoration in 1868, most Japanese have experienced avant-garde art from the West in the 'museum floors' of department stores such as Mitsukoshi, Isetan and Seibu.[3] Like any savvy cross-cultural entrepreneur, Murakami fuses imported and domestic notions to create an export product range that retains the hallmarks of cultural exoticism without alienating the consumer. Even for the most provincial audience abroad, his work strikes a perfect balance between generating legible and seductive Japanese signifiers – derived from the familiar visual styles and subject matter of *anime* (animation) and *manga* (comic books) – while disembodying them from the deeper, perhaps more provocative meanings in a purely Japanese context. As cultural critic Dick Hebdige has noted: 'As for the current craze for Murakami in America, it seems probable … that Americans feel they understand Murakami without conducting research because they are reacting to a hyperstimulated and decontextualized Japan that looks a lot like their society.'[4]

This phenomenon is particularly evident in the success story of Murakami's 'Kaikai Kiki' product line. Over the past decade, his studio has developed an extensive range of merchandise – *shokugan* (snack toy) figurines, t-shirts, toys, posters, personal accessories and other sundry trinkets – that are emblazoned with Murakami's pantheon of invented characters or his signature visual motifs. Whether featuring his Mickey Mouse-like character Mr D.O.B., his open-mouthed smiling flowers, or his *manga*-inspired jellyfish eyes, these seductive wares are Murakami's first line of offence in his campaign to reverse the tide of Japan's post-war cultural inferiority complex. Unlike his paintings and sculptures with six-figure price tags, these products – by virtue of their accessibility and popularity – most effectively advance his campaign to overturn American pop hegemony by capturing both the Western market share and the popular imagination with indigenous Japanese forms and content.

By subliminally cultivating foreign tastes for the *otaku* aesthetic (the Japanese term for obsessive fans of *anime* and *manga*),[5] Murakami seeks to shift the terms of the discourse further away from dominant Western terms of appraisal. Reading the existing literature that has seriously analysed Murakami's involvement in *otaku* subcultures, it

Still from
Takashi Murakami
SUPERFLAT FIRST
LOVE 2009
Producer/Original
Script/Director:
Takashi Murakami
Music: Fantastic
Plastic Machine
Produced by:
Kaikai Kiki Co., Ltd.,
OLM Digital, Inc.,
Asahi Production
Supported by: Louis
Vuitton Malletier,
Louis Vuitton Japan
Time: 3 minutes
14 seconds
Format: Blu-ray

becomes clear that it has been widely acknowledged that his engagement goes well beyond visual and thematic appropriation. Unlike historical American Pop artists, who elevated low cultural signs into a high cultural icons, Murakami channels an *otaku* attitude in order to bypass these types of hierarchical distinctions and projects a radically egalitarian attitude towards visual culture (no qualitative distinction, for example, is made between different modes of expression whether in the form of street culture, film, literature or games). Thus, according to this alternative value system, Murakami is no 'sell-out' as would be said of an artist in the West; the white-cube art production, luxury fashion-brand consulting and Kaikai Kiki merchandising are all equally weighted in his radical cultural maelstrom. By popularising (and commercialising) this *otaku* sensibility for an international audience, Murakami works to further erode conventional cultural hierarchy. He is equally invested in recuperating the previously negative cultural associations projected on *otaku* communities in Japan. He does not try to suppress the negative underpinnings of the *otaku* stereotype – a socially dysfunctional, infantilised young man who lives in a fantasy world and often harbours perverse sexual predilections. In fact, he not only attempts to inhabit this persona but has used the figure of the *otaku* as the inspirational foundation for his new cultural paradigm of contemporary Japanese art. As art historian Midori Matsui explains:

> Murakami's uniqueness lay in his dialectical thinking, which inspired him to turn negative conditions of postmodern Japanese society into new methods of creating and interpreting a uniquely Japanese art ... Murakami utilized these negative conditions [embodied by *otaku* culture] – childishness and flat social structure – as vehicles to develop a unique aesthetic, a method of cultural interpretations and rules of artistic operation to bring a revolutionary change in the structure of Japanese art.[6]

Beyond Japan's borders, Murakami's *otaku*-inspired revolution continues to gain international momentum. With every purchase of a Superflat Vuitton monogram bag or a Kaikai Kiki plush toy – no matter whether the deeper references register with the shopper – the commercial validation and power of mass-market diffusion further fuels Murakami's campaign of cultural vindication.

One of the most powerful examples of this is his most recent animated short *SUPERFLAT FIRST LOVE* 2009, a three-minute film that he made in collaboration with *anime* master Mamoru Hosoda for Louis Vuitton. Inversing the power dynamic of big-business/artist relations, it is as if Murakami has instrumentalised the luxury brand as a vehicle for his subversive *otaku*-inspired agenda rather than the other way around. Behind the boy-meets-girl narrative cliché, the film is completely dominated by repulsive tropes (bodily discharge, orifices, apocalyptic explosions, monsters) cloaked in the *kawaii* (cuteness) aesthetic. The archetypal Tokyo schoolgirl in uniform (the *otaku* voyeuristic fantasy object par excellence) meets a magical panda on the street, only to be eaten by him. Post-consumption, girl and panda are transported into a floating netherworld populated by monsters and smiley flowers on a backdrop of LV monograms that themselves are regularly imploded or devoured by Murakami's characters or motifs. What is most striking about this hybrid of art and marketing is not the artist's seamless incorporation of a corporate brand in his work but the way in which Murakami uses the mainstream stature of the brand to legitimise his *otaku*-inspired practice. Even in this slick consumerist arena, Murakami never compromises the erotic or violent undercurrent in the *otaku* sensibility; instead, he knowingly capitalises on Louis Vuitton as a rubberstamp of cultural endorsement as well as a vehicle to indoctrinate a vast Western audience to his worldview. In Murakami's hands, the market becomes a medium for identity politics.

Takashi Murakami with Kanye
West and Marc Jacobs at
Brooklyn Ball, opening of the
©MURAKAMI exhibition, April
2008

Emperor of Signs

Takashi Murakami is the Emperor of Signs. With the
exception of Warhol, very few artists approach his skillful
manipulation of mainstream cultural signifiers, as well as his
seamless penetration of the mass media, as he performs his
artistic persona for a wide-ranging audience. For run-of-the-
mill newsstand titles – whether fashion glossies or lifestyle
monthlies like *W*, *Elle*, *InStyle* and *Uomo Vogue* – Murakami
offers a distinctly twenty-first century spin on the Warholian
Business Art model. Countless paparazzi photos have
captured him comfortably inhabiting the role of celebrity-
brand endorser, posing on the red carpet with other bold-
face names such as fashion designer Marc Jacobs or
entertainers Kanye West and Pharrell Williams.

While the Warhol comparison is certainly apt, the agency
that motivates these performances of celebrity endorsement
radically differs on closer inspection. Working for the Zoli
modelling agency at the end of the 1970s (p.21), Warhol
sold his image to any company willing to pay the price –
whether advertising for TDK videotapes, l.a. Eyeworks, or
the ill-fated Drexel Burnham Lambert junk bonds firm. When
it came to these endorsements, he performed disinterested
passivity and indiscrimination, famously noting: 'Some
Company recently was interested in buying my "aura".
They didn't want my product. They kept saying, "We want
your aura"… I never figured out what they wanted. But they
were willing to pay a lot for it.'[7] Far from this passive front-
man for hire, Murakami has acutely focused his PR

strategies – he retains several full-time consultants at his
Kaikai Kiki studio to handle his public image. Hyper-aware
of how the semiotics of his endorsements and celebrity
associations play into his overarching identity politicking,
he has a tight grip on his image in the same way that he
demands full artistic control of his corporate collaborations.
When caught in the paparazzi's lenses, he eschews the
bohemian or eccentric-artist cliché. Polished, polite and
smiling, he communicates a studied image to the general
public that combines two key messages: his 'Japaneseness'
(signalled by his long hair pulled into a Samurai bun, round
glasses and whispy goatee) as well as 'seriousness'. In a
chic suit and bowtie, Murakami looks especially sober
when posing next to more flamboyant superstars like blue-
haired Marc Jacobs or a bejewelled, couture-wearing
Kanye West. It is no accident, though, that each of these
frequent celebrity associates-cum-collaborators is
considered a maverick or iconoclast in their respective
fields. To reassure the art-phobic public, Murakami
harnesses their legitimising coolness into building his
own mainstream public image.

When it comes to the art world, Murakami's constructs
a less homogenous public persona. On one hand, he
completely 'performs the system' by reinforcing his
Warholian credentials – for example, by approvingly
walking the Sotheby's saleroom in May 2008 when one
of his most iconic *otaku*-inspired sculptures was being

auctioned. His validating presence in the temple of speculative capital was not lost on a group of art-world players in attendance. As Sarah Thornton reported for *Artforum*'s internet gossip page, Murakami's reactions were as studied as the price achieved was record-smashing:

> It wasn't until Lot 9, Takashi Murakami's naked and fully erect *My Lonesome Cowboy*, 1998, that mouths began to drop … The crowd delighted in a virile volley of bids between Philippe Ségalot on the aisle and Sotheby's Alexander Rotter, who was on the phone with someone who many suspected was Steve Cohen but others thought might be Viktor Pinchuk … Eventually, Rotter's client won the sculpture for $15.2 million, nearly four times its $4 million high estimate. Even Murakami, who was sitting at the back of the room with artist Chiho Aoshima, was wide-eyed with amazement.[8]

With his presence at Sotheby's, Murakami was not only bolstering consumer confidence on the highest end of the economic spectrum: a record-shattering auction price lends further authority to the entwinement of identity politics and brand that Murakami has forged for collectors as well as for sceptics at home in Japan.

Not all of his performances in a commercial arena are purely motivated by market affirmation. On the opening night of Art Basel Miami Beach in December 2008, Murakami took a much less conventional track. Directly referencing the *otaku* practice of costume role-play – *kosupure* or 'cosplay' – Murakami transformed himself into one of his own *Flowerball* sculptures, wearing a furry outfit worthy of an amusement park character. In the context of one of the most glitzy and financially flush commercial art fairs, Murakami took the act of self-promotion to seemingly absurd heights. Yet his antics were less aimed at winning

Takashi Murakami in front of *My Lonesome Cowboy* 1998, Sotheby's saleroom, New York, May 2008
Photo: David Valesco

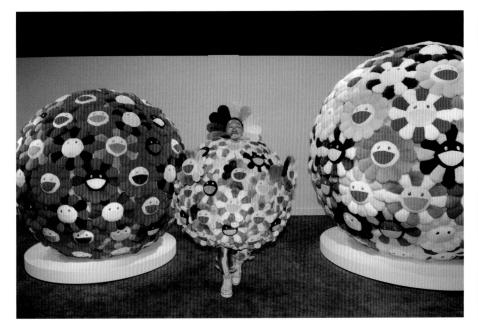

Takashi Murakami at Design Miami, 2008
Photo: GION

Takashi Murakami in *hakama*
at Gagosian Gallery, 2007
Photo: GION

over the support of 'serious' Western collectors than earning some credibility points from the 'real' *otakus* back home in Tokyo's Akihabara district, where such cosplay is an everyday part of the landscape. Just like the young women who wear French-maid costumes in broad daylight without the pretext of Halloween, Murakami dons *Flowerball* as a public badge of his *otaku* authenticity and obsessiveness.

If this interpretation of cosplay as a display of cultural authenticity was mostly lost on a Western audience, Murakami's most recent New York exhibition was designed to conjure the traditional Japan in the heart of Madison Avenue. Titling his show *Tranquillity of the Heart, Torment of the Flesh: Open Wide the Eye of the Heart and Nothing Is Invisible*, Murakami temporarily put aside his *otaku* pantheon to make a new series of monumental paintings honoring Daruma, the legendary patriarch of Zen art and founder of Zen Buddhism. Beyond this radical iconographic departure, Murakami pulled out all the stops by orchestrating a week-long series of traditional tea ceremonies for New York's A-list *culturati*. Museum curators, journalists, collectors and the odd celebrity were invited to partake in the lavish yet solemn ritual tea service that was presided over by So-oku Sen (a Kyoto tea master), Murakami wearing a traditional *hakama* robe (discreetly emblazoned with one of his smiling flowers)

and women wearing intricate kimonos. Like a sophisticated drag show, Murakami's presentation, trafficking in historical and traditional signifiers, was a new strategic tactic even if it was outside his quotidian life. As the *New York Times* reported: '"I wanted to bring something spiritually and culturally Japanese to a wider audience," Mr. Murakami said as a Japanese television crew filmed his every move. "This is only the second time in my whole life I've dressed up like this," he added. "The first time was when I was at the tea master's house."'[9]

Targeting this elite contingent of the cultural establishment, Murakami's carefully crafted, participatory spectacle aimed to lure sceptics who might otherwise be turned off by the Warholian facets of his practice or by the intricacies of the *otaku* subculture. As a good student of Roland Barthes, Murakami sets into motion this play of japonaiserie in order to feed our desire to construct a fictive Japan – that is, an amalgamation of Murakami's fantastical devising and our own.

Geisai University

With the provocative slogan 'Will you make art until you die?' calligraphically inscribed on the flap of his ceremonial *Happi* jacket, Murakami annually takes the stage in front of a rapt crowd of several thousand to inaugurate his biannual arts festival GEISAI. Initiated in 2002, and running nearly twice a year ever since, it is an unusual hybrid of the Western commercial art fair with traditional Japanese arts festivals. Delving deeper, the inspirational roots for GEISAI hark back to Murakami's deep desire 'to become a school teacher'[10] and his aim to found a school on the model of *terakoya*, or 'temple schools' of the Edo Period (1603–1868). Without any educational or professional prerequisites, artists apply for a miniature booth in which to display their works and be judged by a panel of distinguished jury members (from both international and Japanese circles). In addition to having to explain their works and meet the various demands of a 'professional' art environment, exhibiting artists are also encouraged to sell their work to GEISAI's visitors. As explained on his Kaikai Kiki website, Murakami states that GEISAI is not only a forum for practical artist training but a breeding ground for the feeble Japanese contemporary art market:

> After making their first sales, aspiring artists still have to face the major hurdle of whether they can find consistent work as professionals in the industry. While some places breed an active art market, Japan is not currently one of those places ... For its participants, having a booth in GEISAI is not only about selling work, but also about forging communication with visitors, talking about their work, and in general, undergoing practical training for a career as an artist.[11]

In the summer of 2009, Murakami created a spin-off of this convention in the form of an ongoing series of seminars entitled 'GEISAI Daigaku' (University). Under the promotional pitch 'Forget art school, come here!' Murakami dispenses with the need to confer an official degree to prospective students and instead opens a Tokyo classroom for 'people who want to learn about the principles that lie at the foundation of art. If you count yourself as one of these people, then here is your gospel.'[12]

Building on GEISAI's didactic ambitions, Murakami has engaged in other less-publicised activities to reach the ears of emerging artists and aspiring gallerists at home.

In 2005, he published an extensive volume uniquely for Japanese readership entitled *Geijutsu Kigyo Ron* (Art Enterpreneurship Theory, 2005). He hosts a weekly radio talk show called *Geijutsu Dojo* (approximately translating as 'Arts Seminar') to share his experiences and views, and generally expand the reach of his cultural tutelage.[13]

This nexus of educative activities in Japan has hardly been noticed in the West, though these endeavours have become the heart and focus of Murakami's current enterprise. Investing the profits, marketing savvy and media credibility gained abroad, Murakami strives to engender a new art system in Japan.[14] By performing the role of mercantile artist in the West, he is able to become a *Sensei* (master-teacher) in the East.

Takashi Murakami onstage at GEISAI #11
Photo: Miget

Shuffle Maid Café, GEISAI#11
Photo: Miget

J-Pop Idolatry

Despite his desire to serve as an edifying force, Murakami does not only cultivate a professorial image in Japan. Even at home, show business is undeniably in his blood and was acutely on display during the dense schedule of activities for GEISAI #11. Following its first incarnation as a rather low key educative platform, the September 2008 edition reached a spectacular pinnacle with Murakami investing several million dollars of his personal funds in the organisation of the art fair and its concurrent array of ancillary events. As the largest, single-day GEISAI to date – with over 900 artists participating in the main event – the art programme was peppered with elaborate staged concerts by Asian entertainers such as the J-Pop icon Yuzu and the Tawainese-born Mandopop star Ken Chu. But the centrepiece – Murkami's living, *otaku* masterpiece – was the School Festival Executive Committee, housed in a separate wing of the same Tokyo convention centre that hosted GEISAI. Murakami invited a number of groups to orchestrate a series of interactive environments that each catered to a specific *otaku* subcultural fetish. In addition to the Shuffle Maid Café – the classic *otaku* gathering place where visitors (addressed as 'Mistress' and 'Master') could order tea from a bevy of subservient young Japanese woman in 'Gothic Lolita' French-maid garb, there were other themed 'cafés' with elaborate sets animated by cosplay performers. The Edelestein Boys High School featured pretty young lads in camp uniforms and a garden-party themed decor, while the Samurai Café developed the *shogunate* motif down to the last historical detail. There was also a military-themed café run by a group of self-professed 'camouflage' fetishists, a hospital-themed café, populated by doctors in scrubs and nurses in short skirts, and even a 'principal's office', where the disciplinarian role-playing was enthusiastically acted out by school-uniform-clad bad boys and girls.

By granting these *otaku* troupes the support to create elaborate sets and costumes in such a prominent setting, Murakami not only became a generous patron to this sector of the *otaku* community but reframed their activities as a form of performance art for the non-Japanese, art-world professionals who found themselves at GEISAI #11. In his Welcome note in the GEISAI #11 programme, he promised, 'GEISAI implies how art shows shall be in the future. Or rather, it's a push to break through the limitations now. This is going to be a revolution of young artists.' GEISAI was conceived as a one-day *gesamtkunstwerk* with the School Festival Executive Committee as the living, beating heart of this revolution.

AKB48

This specific interest in enabling and reframing the performative side of the *otaku* subculture has continued with Murakami's increasing patronage of the group AKB48. More than just an all-girl pop band, AKB48 are *aidoru* or 'idols' – a term for a branch of Japanese pop culture that began in the 1980s. It promotes extremely young, mostly female stars who incarnate the *kawaii* ideal in their appearance, often adopting childlike behaviour and speech.[15] Made up of forty-eight performers in their late teens and early twenties, AKB48 are considered *otaku* idols because of their specifically honed brand of *kawaii* sensibility and because they are permanently based in their own theatre in the Akihabara district, the heart of the Tokyo *otaku* community.

Murakami formally initiated a relationship with AKB48 by inviting them to perform centre stage at the School Festival Executive Committee. Since then, he has commissioned AKB48's producer and lyricist, Yasushi Akimoto, to write the words for the soundtrack of his *SUPERFLAT FIRST LOVE* film and has created the art for the album cover of their most recent record *Namida Surprise!* – rendering portraits of the group's stars in a *manga* style over a backdrop of his signature smiling-flower motif.

Murakami's relationship with AKB48 is somewhat reminiscent of Warhol's involvement with the Velvet Underground. In addition to consolidating his countercultural credentials within the broader downtown

Takashi Murakami
CD cover artwork for
Namida Surprise! by
AKB48, released
2009

New York club scene, Warhol also creatively capitalised on the Velvet Underground's interdisciplinary energy, thus 'taking his interest in film to the next level by bringing together "all the different art forms into one thing"'.[16] Similarly, AKB48 provides Murakami with a 'real life' pop-culture vehicle to advance his aesthetic and theoretical agenda within the *otaku* world itself – while perhaps refuting some of the initial scepticism that the hardcore *otaku* community expressed in criticising his early *manga*-inspired works such as *Hiropon* 1997(p.12) and *My Lonesome Cowboy* 1998 for being either ironic or too much like caricature. As a promoter, patron and collaborator, Murakami has turned his public alliance with AKB48 into another artistic medium. His J-Pop 'Idolatry' is yet another

powerful, seductive means to assert his vision of contemporary Japanese identity. In an attempt to 'translate' his feverent involvement with the J-Pop scene for an international audience, Murakami is collaborating with the Hollywood director McG on a short film for *Pop Life*. This *court mettrage* is being filmed in the heart of the *otaku* neighbourhood of Akihabara and stars Kirsten Dunst as a magical princess.

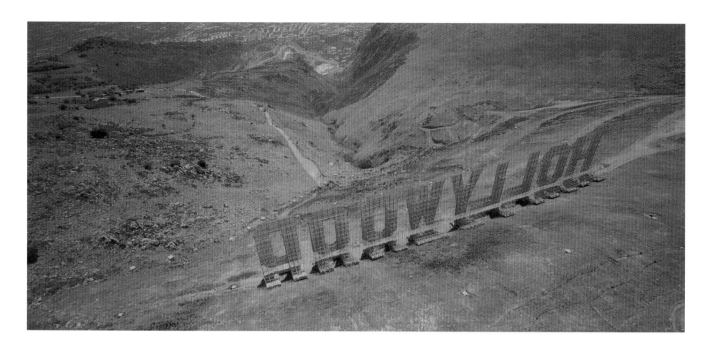

Maurizio Cattelan
Hollywood 2001
Courtesy the artist and Marion
Goodman Gallery, New York

The World Only Goes Round by
Misunderstanding (Charles Baudelaire)

The complexity of Murakami's work is more often than not misunderstood. In the worst-case scenario, he is vilified as an art-world sell-out. The spotlight of stardom and aura of commercialism that surround him often obscure the identity politics and cultural ambitions that drive his practice. But, to paraphrase Baudelaire, these misunderstandings are the productive motor that enables Murakami's world to turn. Without the global communications reach and mainstream presence engendered by his various market infiltrations, he would not be able to create a 'new value system' abroad or a 'revolution' at home. Thus he occasionally amplifies these misunderstandings, overplaying the role of market 'darling' in order to reap the benefits offered by Business Art tactics. The combination of a critical deployment of identity (politics) and knowing 'profiteering' from the employment of mainstream communications/marketing strategies is by no means limited to Murakami. While not necessarily embracing as 'pure' a Business Art model as Kaikai Kiki, a handful of other artists of Murakami's generation overlap in their strategic deployment of a public persona as the centrepiece of a practice revolving around identity politics.

One of the most overt examples of artists working this angle is Maurizio Cattelan. He actively plays on popular clichés

about his Italian origins, forging a persona straight out of the Comedia dell'arte tradition. His 'performance of the self' blends together Piero Manzoni's neo-avant-garde 'pranksterism' with mannerisms and humour derived from the cinema of Federico Fellini and Roberto Benigni. He even exploits his 'auspicious Roman nose'[17] in his numerous self-mocking portraits. Not only has he honed this disarming *Italiano* shtick to a perfect T, but his compelling persona regularly attracts the attention of the mainstream media. He has been featured in such magazines as *Vogue* and has even posed for a Gap clothing advertisement, effortlessly inhabiting the role of art-world celebrity. 'A jokester, a sensationalist, a troublemaker, a conceptual artist', is how Calvin Tomkins succinctly summarised Cattelan's frequent media labels when profiling him for the *New Yorker*.[18]

Deploying this well-established trickster reputation has given Cattelan licence to toy with the power structures of the contemporary art system without adopting the conventional methods of institutional critique. Two of his most successful projects that effectively 'performed the system', *Carribean Biennale* 1999 and *Hollywood* 2001, were enabled by his beguiling Manzoni-meets-Benigni routine. For the first project, Cattelan created the ruse of a 'serious' international

exhibition (taking out full-page ads in art monthlies, issuing a press release, hiring a reputable curator) as an elaborate excuse to invite ten high-profile artists from the international circuit to St Kitts Island in the British West Indies for a free vacation. Using his comic charms, he pulled a fast one on the public by not producing a show with objects, while cajoling the participating artists to break with their professionalised sphere and expose themselves in their leisure time (he later published an art book of their holiday snapshots). In June 2001, Cattelan likewise marshalled his fame and charisma to divert a plane-load of art-world power players from the main event at the Venice Biennale for a day trip to Palermo, where he had constructed a replica of the Hollywood sign atop a putrid Sicilian garbage dump. The crux of the work was not the highly visible frame for the event. Its manufactured 'exclusivity' exposed the vain desires of curators, dealers, journalists and collectors to be a part of this happening, no matter how preposterous. Cattelan has spent years cultivating this goofy impresario persona – heavily aided by playing up traits of his national identity – in order to allow him to get away with such devilish infiltration of the system without being thrown out of it.

Polish artist Piotr Uklański has also staked a large swath of his practice on an unorthodox brand of identity politics.

His work could be described as nationalist art projected through a sensationalist lens. To name but a few salient examples, he has created *The Nazis* 1998, a photographic archive of actors in Nazi regalia; *Untitled (Ioannes Palus PP. II Karol Wojtyla)* 2004, an aerial 'portrait' of the Polish Pope composed using the bodies of thousands of mulatto Brazilian soldiers; *Summer Love: The First Polish Western* 2006, a feature-length film that combined the Western genre with a disorienting mix of authentic Polishness (it was shot on location near Krakow with mainstream Polish film stars) and 'Polack' joke clichés (heavily accented English dialogues, a drunken sheriff, a slapstick cowboy posse). Uklański also regularly performs as the 'Polish Prince'[19] or 'Kielbasa Cowboy',[20] wearing flamboyant Eastern garb like a sheepskin *ushanka* hat or the national Eagle emblazoned on his chest, as demonstrated in a fashion spread for *Vogue*. Skewering the art world's compulsion to seek out and represent the 'Other', he theatricalises the outward signs of his ethnicity without conforming to the standard or 'authentic' narratives associated with Polish identity. In a review entitled 'Fist Full of Pierogis', film historian J. Hoberman writes: 'Uklański is adept at playing the angles, both in terms of camera placement and genre derangement.' Identity politics is one such genre. Courting controversy and engaging with potentially incendiary

Piotr Uklański
Summer Love: The First
Polish Western 2006
Courtesy the artist

Pruitt Early
The Artists in their Studio
early 1990s
Courtesy the artists and Gavin
Brown's enterprise, New York

stereotypes, Uklański has focused on deranging the politically correct orthodoxy that surrounds identity-based art. He makes politicised work that investigates the histories and iconography of his motherland while purposefully disappointing expectations of what an avant-garde Polish artist is supposed to embody (for example, a redemptive political artist à la Krzysztof Wodiczko) through his infiltration of mainstream media in shaping his ostentatious, provocative persona.

Playing with the political hotbed of identity politics in America has also been the lifeblood of the controversial artist duo Pruitt Early's practice. For their debut gallery outing in 1991, the then-couple (in real life and in art) created a series entitled *Artworks for Teenage Boys* – a show that aimed to conjure the tastes and preoccupations of working-class, heterosexual white American males. They made sculptures out of stacks of beer cans covered with stickers featuring references to soft porn, heavy-metal bands and drug culture. Foreshadowing Richard Prince's car-hood paintings, Pruitt Early also created freestanding cut-outs of muscle cars and motorcycles adorned with Playboy-bunny pinups. By inhabiting this un-PC subject position – rather than making redemptive art that investigated their own 'marginalised' identity as an openly gay couple – Pruitt Early immediately forged their persona as 'insouciant bad boys who courted controversy and reveled in bad taste'.[21] Despite accusations of sexism, the artists carried on their polemical role-playing of American archetypes, creating the sister series *Artworks for Teenage Girls*.

When their big 'break' came with an invitation to show at the prestigious Leo Castelli Gallery, Pruitt Early unleashed their infamous project *Red, Black, Green, Red, White and Blue* (pp.160–3). The installation consisted of store-bought posters depicting figures from Black American pop culture mounted on obelisk-shaped canvases that were either painted with the colours associated with the Black Liberation movement or covered in *kente*-like fabric. The paintings were grouped into clusters of various shapes and hung on gallery walls overlaid with shiny gold wallpaper and splattered with Pollock-style wisps of paint. Without proposing any cultural hierarchy, Pruitt Early indiscriminately juxtaposed the images of civil-rights martyrs Martin Luther King, Jr and Malcolm X, pop bands such as the Jackson 5, sports heros like Michael Jordan, cult Blacksploitation actor Pam Grier, and controversial rappers N.W.A. Black culture was presented as a single monolith. This flattening mise-en-scène was intended to evoke the way in which the white establishment instrumentalises black cultural signifiers. To quote the original press release, the artists intended to

'locate popular culture as a site for political intervention in the wake of neo-racism, in the discussion of both historical revisionism and the economic/political control being sought and leveraged by the African-American subject within the cultural confines of Red, White and Blue – America'. Yet with race relations being an incendiary battleground and with the tight grip that politically correct thinking had on the art world in the early 1990s, the show was denounced as cynical, degrading and racist. It was apparently impossible in this original context to 'read' Pruitt Early's work as a performative assumption of different identity positions – empowered in part by their own minority status. As Rob Pruitt retroactively reflected: 'We wanted to point out the commodification of black heroes by predominantly white-owned companies, but we didn't realize what a land mine it was.'[22] Not only did Pruitt Early transgress political and societal taboos, but they also infringed the models of criticality endorsed by the art establishment. How could artists who so overtly incite controversy and play to the peanut gallery make 'valid' political or critical work? How can artists who strategically construct personas through the PR machine – thereby intrinsically undermining our expectation of authenticity – explore the politics of identity?

These rhetorical questions apply to all the artists chronicled in this essay, who together form a very particular branch of the Warholian family tree. Picking up on the examples set by the 'postlapsarian Warhol', they have located their artistic agency outside the very hermetic sphere of art and inside a direct engagement with pop culture. Given the current anomic, totalising landscape of the mass media, it is increasingly difficult to define a critical, *outside* position. Unafraid to get their hands dirty, each of these artists has become a protagonist in this sphere as opposed to a mere commentator. Their practices implicitly call into question the whole notion of criticality. They ask whether it is possible to draw a model of criticality that is based on affirmation instead of distance, denunciation and familiar models of institutional critique. When Takashi Murakami creates the apparatus of Kaikai Kiki Co. Ltd, or Pruitt Early 'perform' marginalised subject positions to scathing reactions, these practices are not critical in the traditional sense – but they do destabilise our expectations of what an artist in society might be, turning the avant-garde model completely on its head. Looking closely at the desire of these artists to reach out into the mainstream as well as their specific engagements with identity politics, we see that subtle disturbances are built into their intent. Even at the risk of being misunderstood or dismissed, they leave behind the safety of sanctioned art-world and academic positions to fully inhabit the system, with all its complexities and moral compromises.

Notes

1 Takashi Murakami coined the term 'Superflat' in 2000, when addressing the specific condition of contemporary Japanese art and culture. His manifesto begins: 'The world of the future might be like Japan is today – super flat. Society, customs, art, culture: all are extremely two-dimensional. It is particularly apparent in the arts that this sensibility has been flowing steadily beneath the surface of Japanese history. Today, the sensibility is most present in Japanese games and anime, which have become powerful parts of world culture.' Takashi Murakami, 'The Super Flat Manifesto', *Superflat*, Tokyo 2000, p. 5. Murakami has built on this original theorisation, creating a trilogy of exhibitions and scholarly publications that explore the interrelationships between vanguard art, *manga* and *anime*, and their forerunner, *Ukiyo-e* woodblock prints and *nihonga* painting. The exhibition history is as follows: *Superflat* at the Museum of Contemporary Art, Los Angeles, in 2001; *Coloriage* at the Fondation Cartier de l'art contemporain, Paris, in 2002, and *Little Boy: The Arts of Japan's Exploding Subculture*, Japan Society, New York, 2005.

2 Noi Sawaragi as quoted in Takashi Murakami, 'Superflat Triology: Greetings, You Are Alive', *Little Boy: The Arts of Japan's Expoloding Subculture*, New Haven 2005, p.160.

3 For a discussion of the museum-in-a-department-store phenomenon that came to prominence in Tokyo during the mid 1970s, see Kerrie L. MacPherson, *Asian Department Stores*, Honolulu 1998, p.21.

4 Dick Hebdige, 'Flat Boy versus Skinny: Takashi Murakami and the Battle for Japan', in *©MURAKAMI*, New York 2007, p.41.

5 Sociologist Sharon Kinsella has authored several insightful studies into Japanese youth culture and its relation to identity formation. She writes about the 'Birth of the Otaku generation' as follows: 'Otaku, which translates to the English term "nerd", was a slang term used by amateur manga artists and fans themselves in the 1980s to describe "weirdoes" (henjin). The original meaning of otaku is "your home" and by association, "you", "yours" and "home". The slang term otaku is witty reference both to someone who is not accustomed to close friendships and therefore tries to communicate with this peers using this distant and over-formal form of address, and to someone who spends most of their time on their own at home. The term was ostensibly invented by dojinshi artist, Nakamori Akio, in 1983. He used the word otaku in a series entitled "Otaku no Kenkyu"(Your home investigations) which was published in a low-circulation Lolicom manga magazine, *Manga Burikko* (Manga Cutie- Pie). After the Miyazaki murder case [the infamous murderer Miyazaki was an obsessed manga fan], the concept of an otaku changed its meaning at the hands of the media. Otaku came to mean, in the first instance Miyazaki, in the second instance, all amateur manga artists and fans, and in the third instance all Japanese youth in their entirety. Youth were referred to as otaku youth (otaku seishonen), otaku-tribes (otaku-zoku), and the otaku-generation (otaku-sedai).' From an article entitled 'Amateur Manga Subculture and the Otaku Panic' in the Journal of Japanese Studies (Summer 1998). This quote comes from the author's website: http://www.kinsellaresearch.com/nerd.html

6 Midori Matsui, 'Murakami Matrix: Takashi Murakami's Instrumentalization of Japanese Postmodern Culture' in *©Murakami*, New York 2007, p.84.

7 Andy Warhol, *The Philosophy of Andy Warhol: From A to B, and Back Again*, San Diego and New York 1975, p.77.

8 Sarah Thornton, 'Bringing Home the Bacon', New York, 15 May 2008, http://artforum.com/diary/id=20200#readon20200

9 Carol Vogel, 'The Warhol of Japan Pours Tea', *New York Times*, 7 May 2007.

10 '"He wants to come a schoolmaster", the critic Midori Matsui said. "I think he's a very lonely person and he needs to create his own family." Once Murakami tried to establish a school. "Like a very small school, a *terakoya* school, like in the Edo era – one teacher with 10 students, very close." Murakami said.' Lubow, 'The Murakami Method', *New York Times Magazine*, 3 April 2005, p.64.

11 Mission statement of Geisai taken from the official Kaikai Kiki website: http://english.kaikaikiki.co.jp/whatskaikaikiki/activitylist/geisai/

12 Mission statement of Geisai University from the official Kaikai Kiki website: http://english.kaikaikiki.co.jp/news/list/season_1_of_geisai_university_is_set_to_begin_soon/

13 Murakami's radio show is available via podcast: http://www.tfm.co.jp/podcasts/dojo/

14 This assertion is corroborated by Murakami's official artist profile on the Kaikai Kiki website. It states, 'While proposing a rethinking of "Japan" to those both within and outside, Murakami maintains a strong commitment to promoting Japanese art throughout the world. Twice a year he holds the GEISAI festival in Japan for young emerging talent, and with his company Kaikai Kiki, supports and manages a group of young artists while preparing for his future endeavors. "To become a living example of the potential of art." This is the burning force behind Takashi Murakami's work.' http://english.kaikaikiki.co.jp/artists/list/C4/

15 'Kawaii style dominated Japanese popular culture in the 1980's. Kawaii or "cute" essentially means childlike; it celebrates sweet, adorable, innocent, pure, simple, genuine, gentle, vulnerable, weak, and inexperienced social behaviour and physical appearances. It has been well described as a style which is "infantile and delicate at the same time as being pretty"… Matsuda Seiko was to cute what Sid Vicious was to punk. Between April 1980 and 1988 she became the reigning queen and prototype for a whole new industry of "idol singers" that flourished in the 1980s. Matsuda was flat chested and bow-legged and on TV she wore children's clothes, took faltering steps and blushed, cried, and giggled for the camera. Following in Matsuda's footsteps most of the 1980s idols were released in time to become famous between the ages of fourteen and sixteen. The debut age of packaged pop-stars have in fact been getting progressively younger since 1974.' From Sharon Kinsella, 'Cuties in Japan', in Lise Skov and Brian Moeran (eds.), *Women Media and Consumption in Japan*, Honolulu 1995. This version cited from: http://www.kinsellaresearch.com/Cuties.html

16 Christoph Grunenberg, 'The Politics of Ecstacy: Art for the Mind and Body', in *Summer of Love: Art of the Psychedelic Era*, exh. cat., Tate Liverpool 2005, p.32.

17 Calvin Tomkins, *Lives of the Artists*, New York 2008, p.140.

18 Ibid., p.142.

19 Gavin Brown, 'The Incomplete Pole', *Biało-Czerwona*, Gagosian Gallery, New York 2008, p.9.

20 Nathaniel Rich, 'Kielbasa Cowboy', *Men's Vogue*, November 2007, pp.156–8.

21 Mia Fineman, 'Back in the Arms of the Artworld', *New York Times*, 17 June 2001.

22 Ibid.

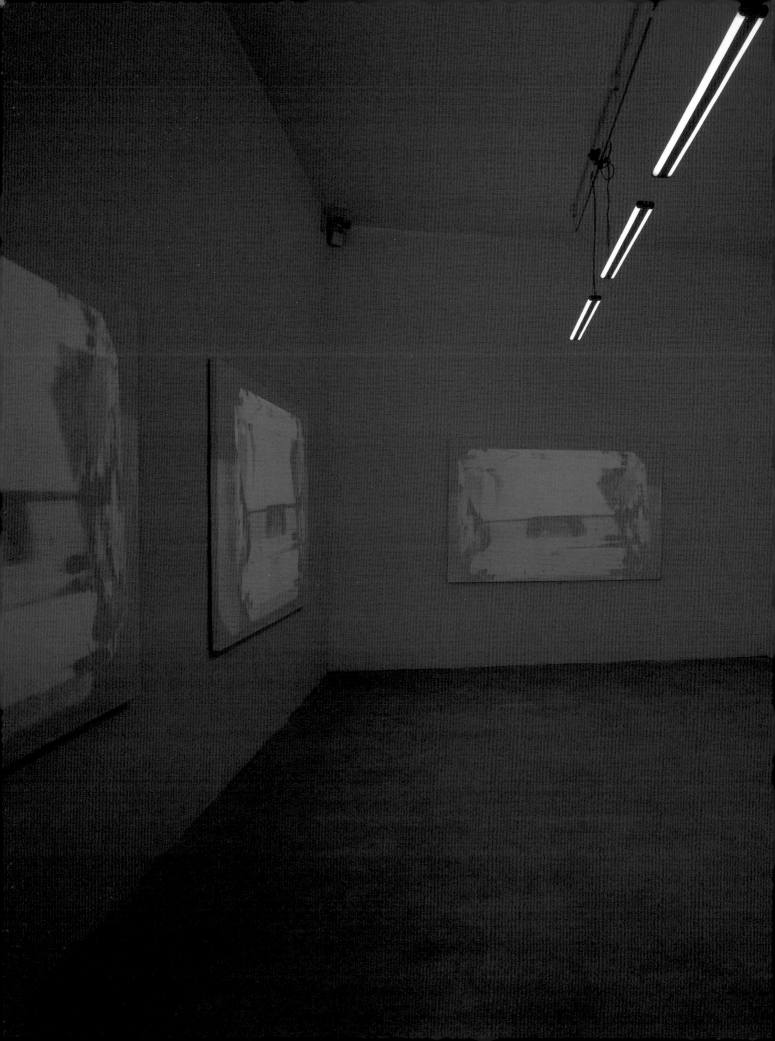

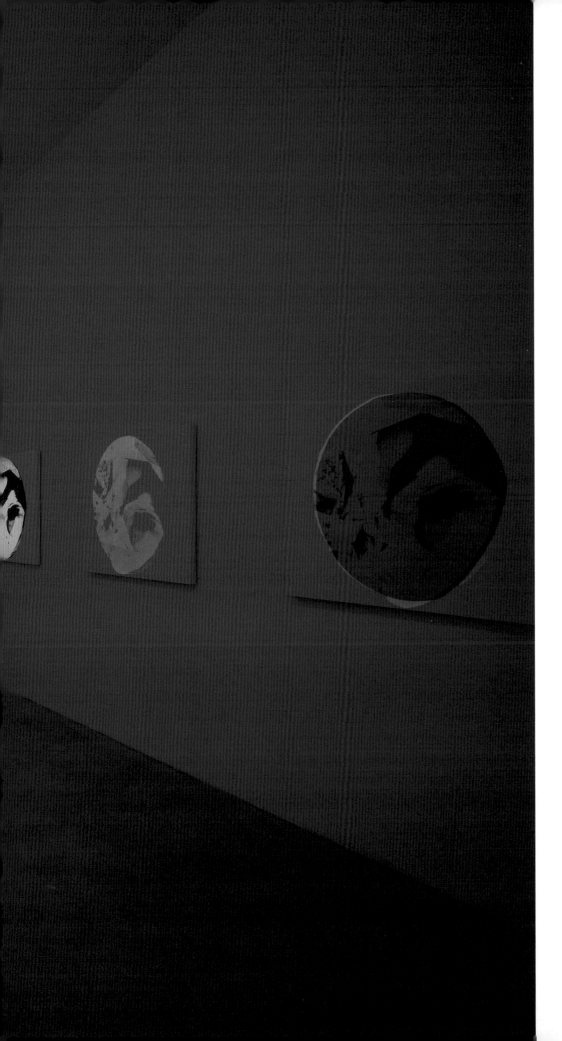

Andy Warhol
Gems 1979
Installed at Galerie Bruno
Bischofberger, Zürich

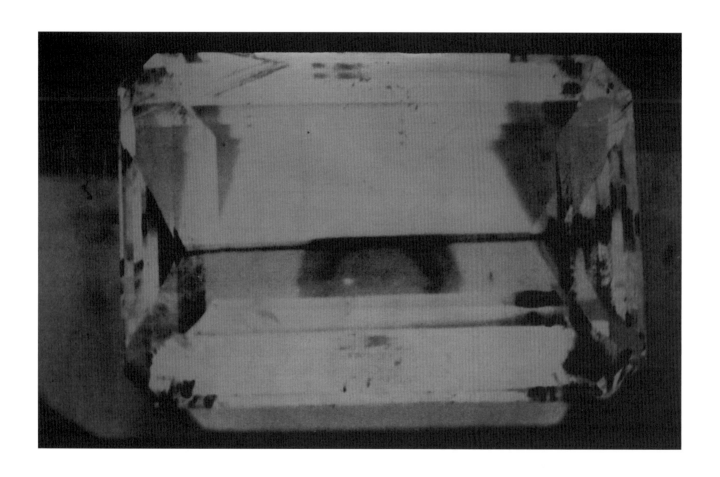

Andy Warhol
Gem 1979
(viewed under UV light)
Acrylic, diamond dust and
silkscreen ink on canvas
137 x 218 cm

Andy Warhol
Gem 1979
Acrylic, diamond dust and
silkscreen ink on canvas
81 x 107 cm

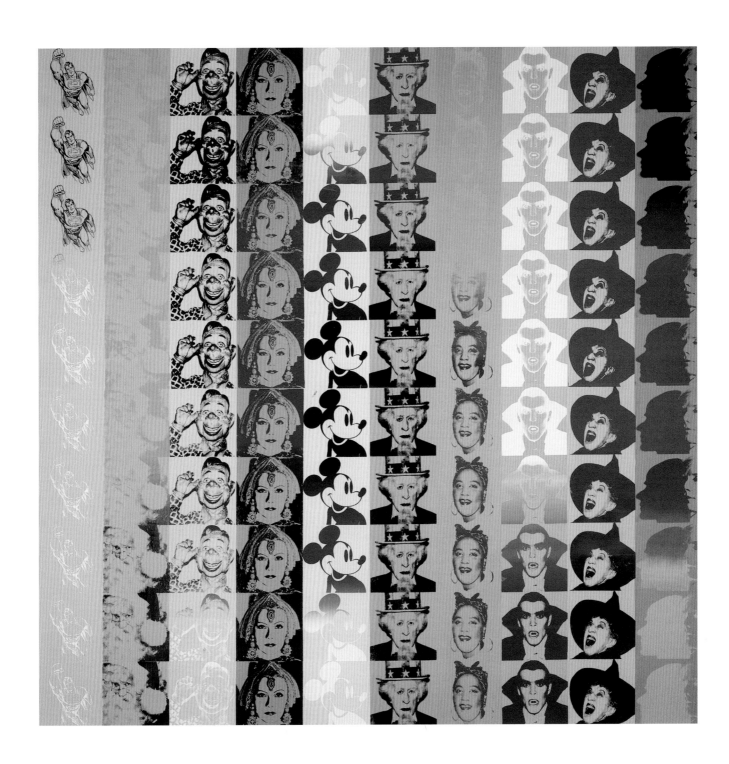

Andy Warhol
Myths 1981
Acrylic and silkscreen ink
on canvas
254 x 254 cm

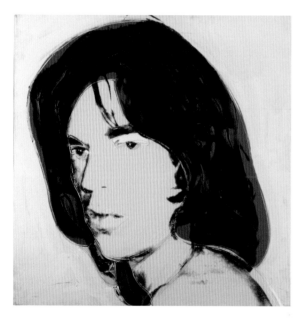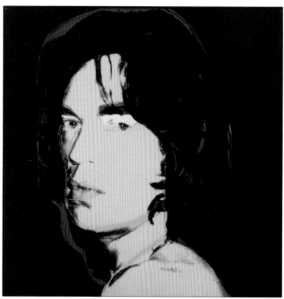

Andy Warhol
David Hockney 1974
Acrylic and silkscreen ink on canvas
Each 101.6 x 101.6 cm

Andy Warhol
Mick Jagger 1975
Acrylic and silkscreen ink on canvas
Each 101.6 x 101.6 cm

Andy Warhol
Gilbert and George 1975
Acrylic and silkscreen on canvas
Each 101.8 x 101.8 cm

Andy Warhol
Grace Jones 1986
Acrylic and silkscreen ink on linen
Each 101.6 x 101.6 cm

Andy Warhol
Jean-Michel Basquiat
1982
Acrylic, silkscreen ink
and urine on canvas
101.6 x 101.6 cm

Andy Warhol
Joseph Beuys 1980
Silkscreen ink and diamond
dust on acrylic on canvas
Each 101.6 x 101.6 cm

Andy Warhol
Keith Haring and Juan Dubose
1983
Acrylic and silkscreen ink
on canvas
Each 101.6 x 101.6 cm

Andy Warhol
Four Multicoloured Self-Portraits
(Reversal Series) 1979
Acrylic and silkscreen ink
on canvas
120 x 91.5 cm

Andy Warhol
Twelve White Mona Lisas
(Reversal Series) 1980
Acrylic and silkscreen ink
on canvas
202.9 x 202.9 cm

Andy Warhol
Black on Black Retrospective
(Reversal Series) 1979
Acrylic and silkscreen ink
on canvas
195 x 241.5 cm

Andy Warhol
Retrospective (Reversal Series) 1978
Acrylic and silkscreen ink on canvas
203 x 203 cm

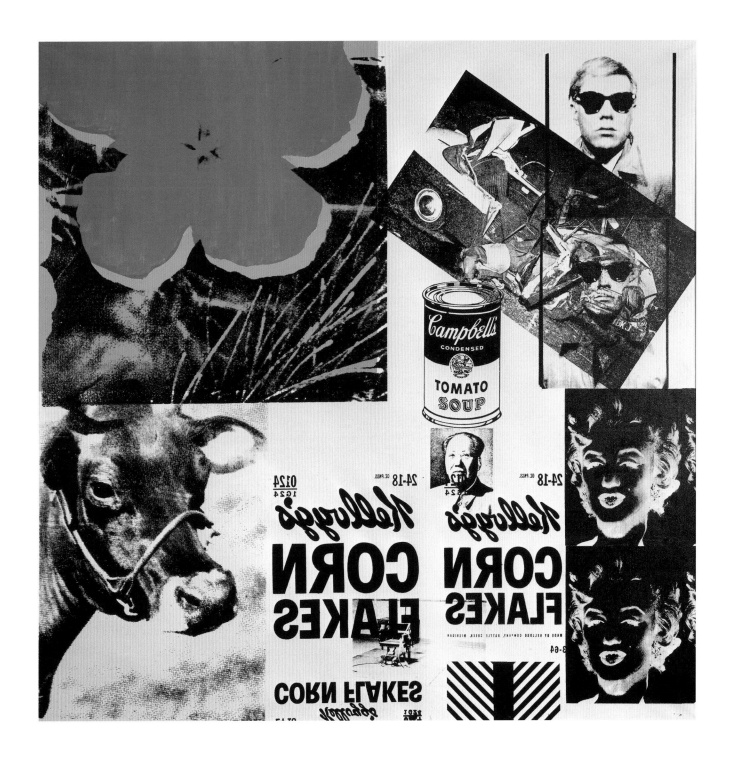

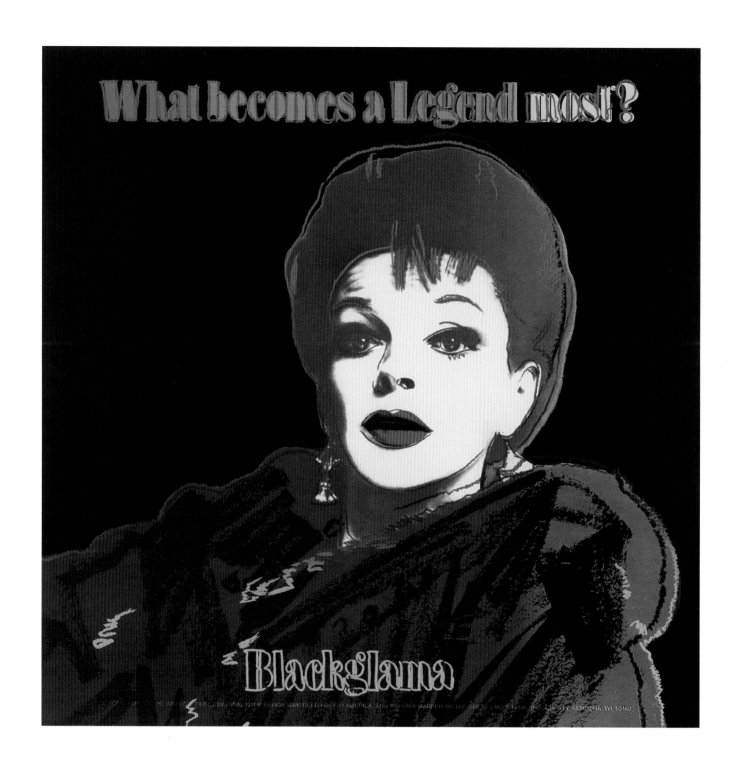

Andy Warhol
Blackglama (Judy Garland)
from the portfolio Ads 1985
Screenprint on Lenox Museum Board
96.5 x 96.5 cm

Andy Warhol
Four Multicoloured Marilyns
(Reversal Series) 1979–86
Acrylic and silkscreen ink
on canvas
92 x 71 cm

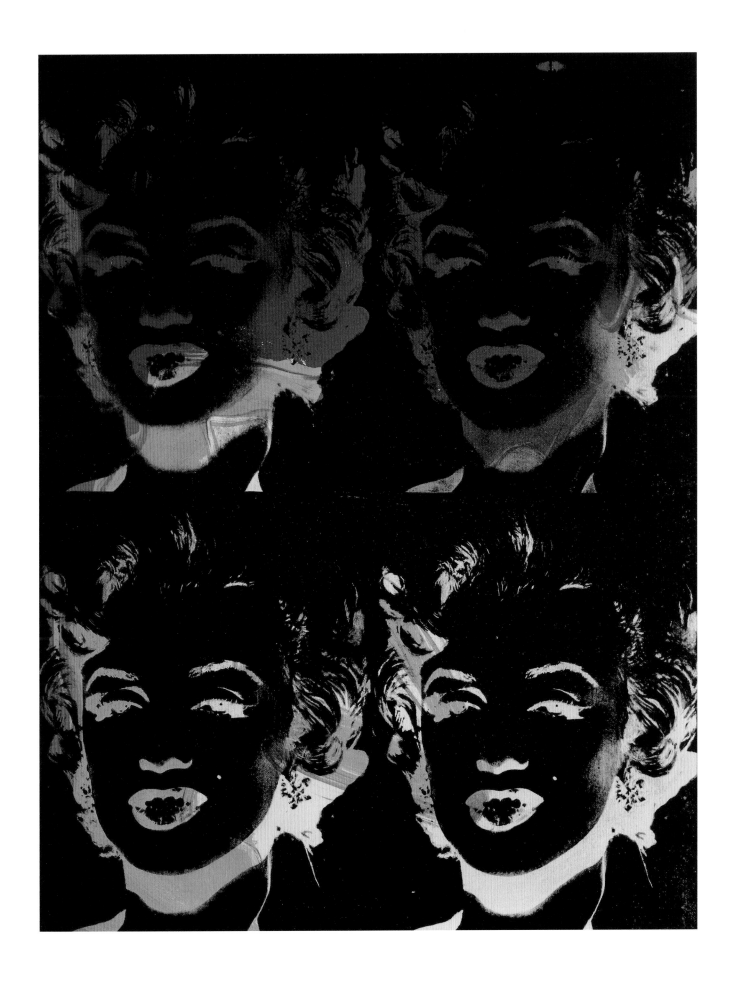

Ashley Bickerton
Tormented Self-Portrait
(Susie at Arles) 1987–8
Acrylic, bronze powder and
lacquer on wood, anodised
aluminium, rubber, plastic,
Formica, leather, chrome
plated steel, and canvas
227.1 x 174.5 x 40 cm

Ashley Bickerton
Still Life (The Artist's Studio
after Braque) 1988
Mixed media construction
with black leather covering
86.4 x 158.7 x 90.2 cm

111

David Robbins
Talent 1986
Portfolio of 18 black
and white photographs
Each 25.4 x 20.3 cm

Larry Johnson

Cindy Sherman

Allan M^cCollum

Thomas Lawson

Jeff Koons

Gretchen Bender

Peter Nagy

Jennifer Bolande

David Robbins

Meyer Vaisman
The Morgue Slab 1987
Process ink on canvas
249.5 x 351.8 x 21.6 cm
Hammer Museum, Los
Angeles. Gift of Patrick
Painter and Soo Jin Jeong
Painter

Peter Nagy
EST Graduate 1984
Photocopy and acrylic
on canvas
100.3 x 61 cm

Peter Nagy
Hypocrite Sublime 1984
Photocopy and acrylic on canvas
63.5 x 63.5 cm

Jeff Koons
Advertisement
Flash Art International,
December 1988

Jeff Koons
Advertisement
Arts, 1988

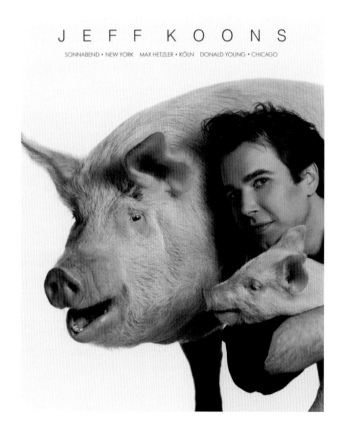

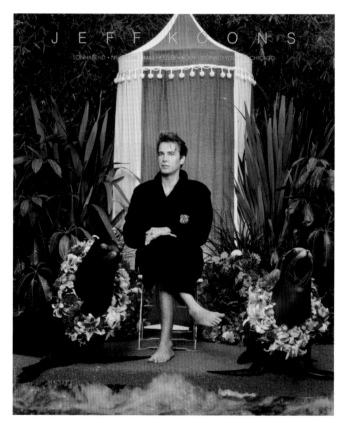

Jeff Koons
Advertisement
Art in America, November 1988

Jeff Koons
Advertisement
Artforum, November 1988

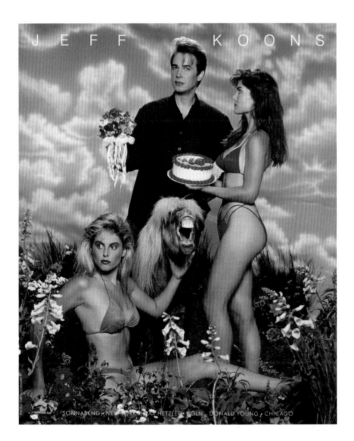

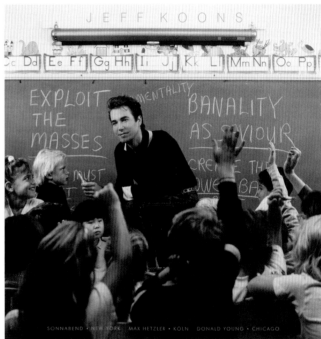

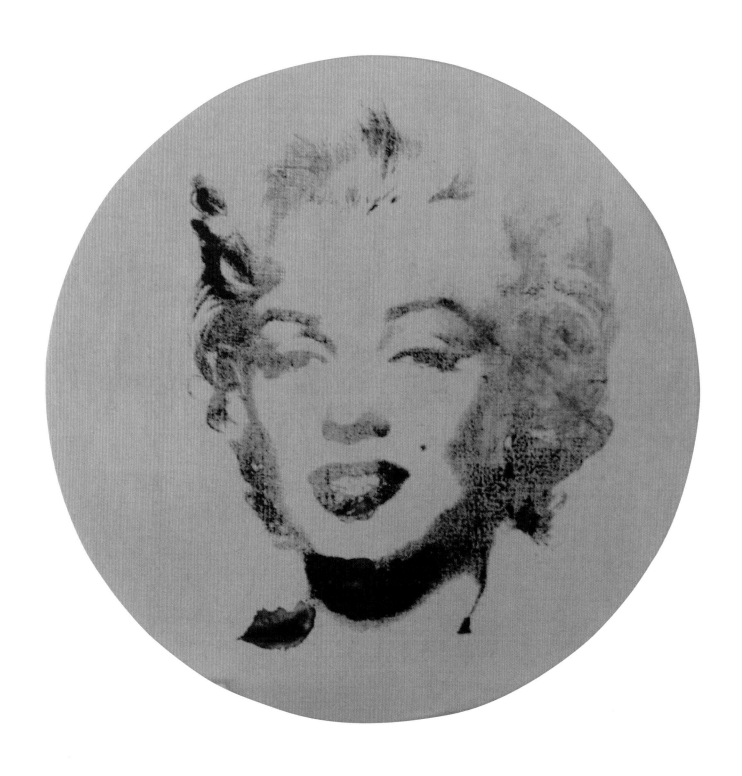

Sturtevant
Warhol Gold Marilyn 1973
Silkscreen ink and acrylic
on canvas
45.8 x 45.8 cm

Sturtevant
Haring Tag 1986
Sumi ink and acrylic on cloth
25 x 22.5 cm

Sturtevant
Haring Tag 1986
Sumi ink and acrylic on cloth
25 x 22.5 cm

Sturtevant
Haring Tag, July 15 1981 1986
Acrylic on canvas
25 x 22.5 cm

Sturtevant
Haring Tag, July 15 1981 1986
Sumi ink and acrylic on cloth
25 x 32.5 cm

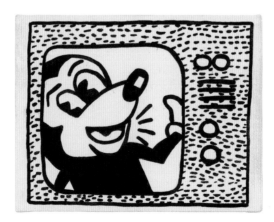

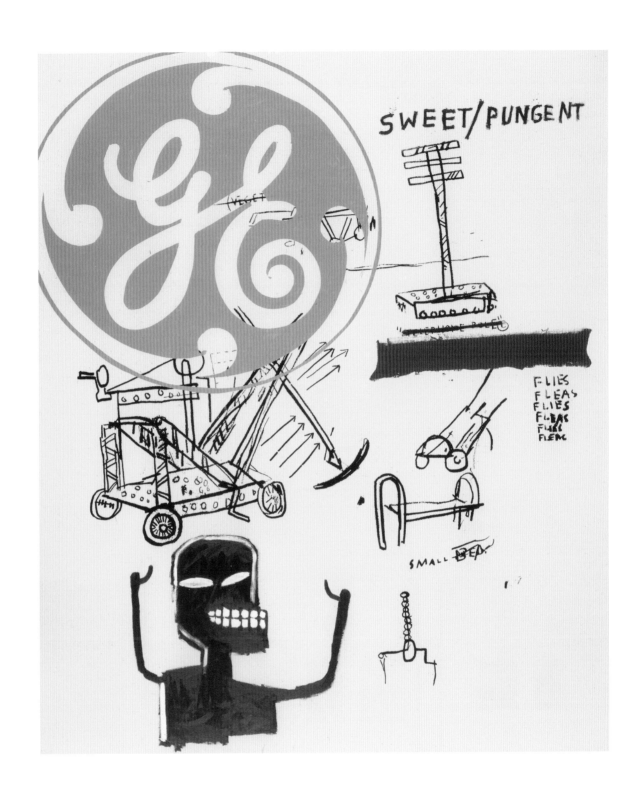

Jean-Michel Basquiat
and Andy Warhol
Sweet Pungent 1984–5
Acrylic and silkscreen ink
on canvas
244 x 206 cm

Richard Prince
Untitled (Publicity) 2000
1 publicity photograph and
1 photograph
104.8 x 84.5 cm
Courtesy the artist

Richard Prince
Spiritual America 3 2004
Ektacolor photograph
126.4 x 169.9 cm
Courtesy the artist

Richard Prince
Spiritual America 4 2005
Ektacolor photograph
229.9 x 182.9 cm
Courtesy Gagosian Gallery

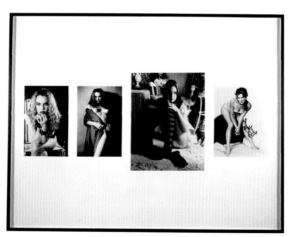

Richard Prince
Spiritual America 1983
Ektacolor photograph in
gold-painted frame
24.7 x 19.6 cm

Keith Haring
Pop Shop
Open 1986–2005, New York
Photo: Peter Cunningham

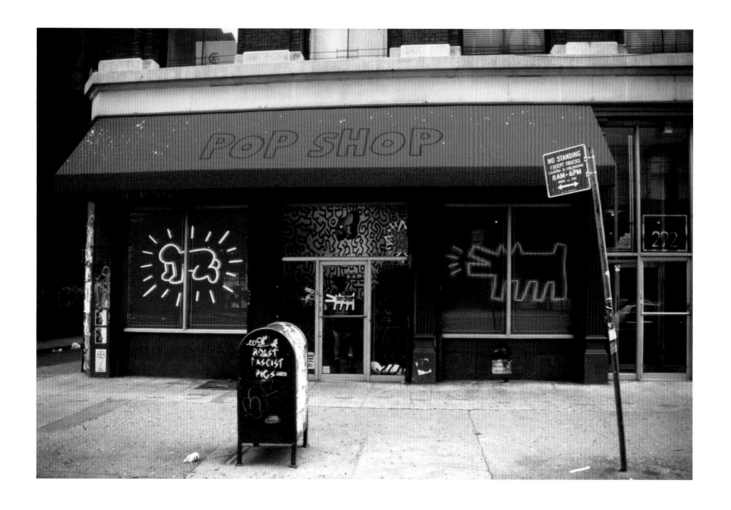

Keith Haring
Keith Haring inside the Pop Shop
1986
Photo: Tseng Kwong Chi

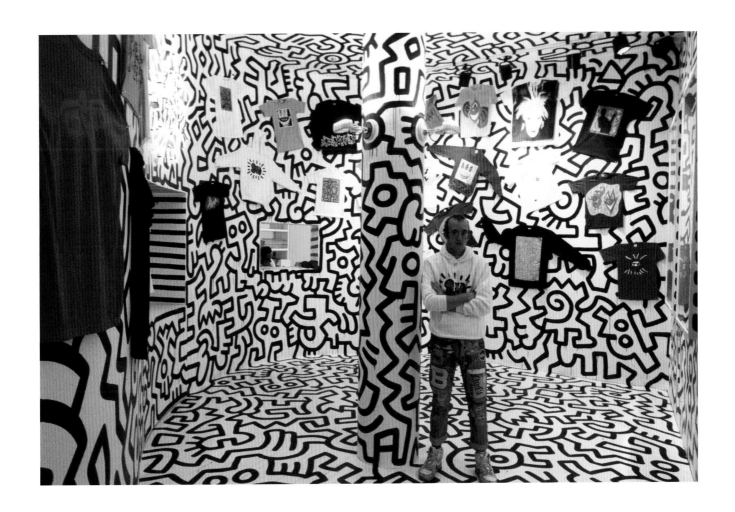

MARTIN

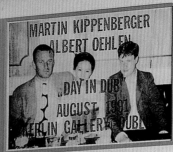

MARTIN
KIPPENBERGER
—
PUT YOUR EYE
—
IN YOUR MOUTH
—
13 June – 25 August
1991
SAN FRANCISCO MUSEUM
OF MODERN ART

HAND PAINTED
PICTURES
MARTIN
KIPPENBERGER

GALERIE MAX
HETZLER
VENLOERSTRASSE 21
5000 KÖLN 1
23 OKT. – 21 NOV.
1992

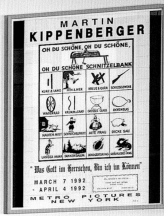

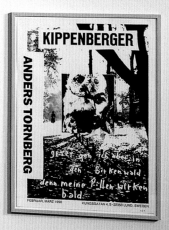

Martin Kippenberger
Pop It Out 1990
Portfolio of 30 posters
Overall dimensions variable
Installation view

Martin Kippenberger
Martin Kippenberger Is Great,
Tremendous, Fabulous, Everything
1990
Designed by Jeff Koons
Screenprint
94.7 x 68.8 cm

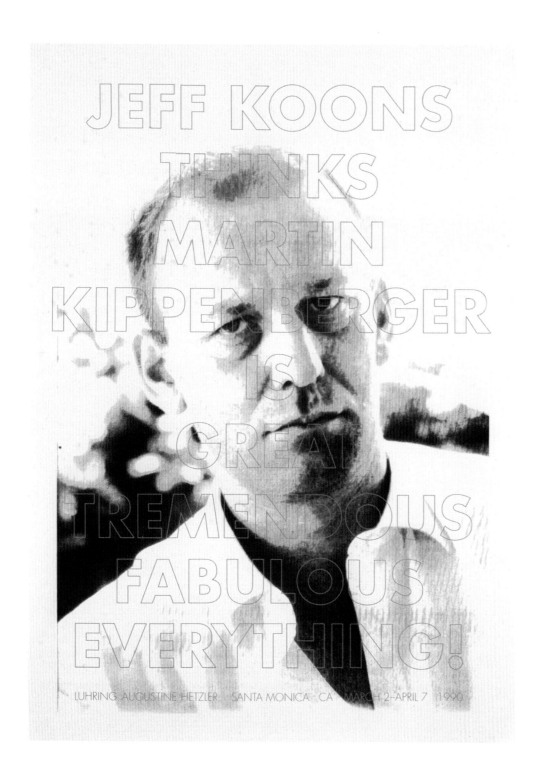

Martin Kippenberger
Bitte nicht nach Hause schicken
(Please Don't Send Me Home)
1983
Oil on canvas
120 x 100 cm

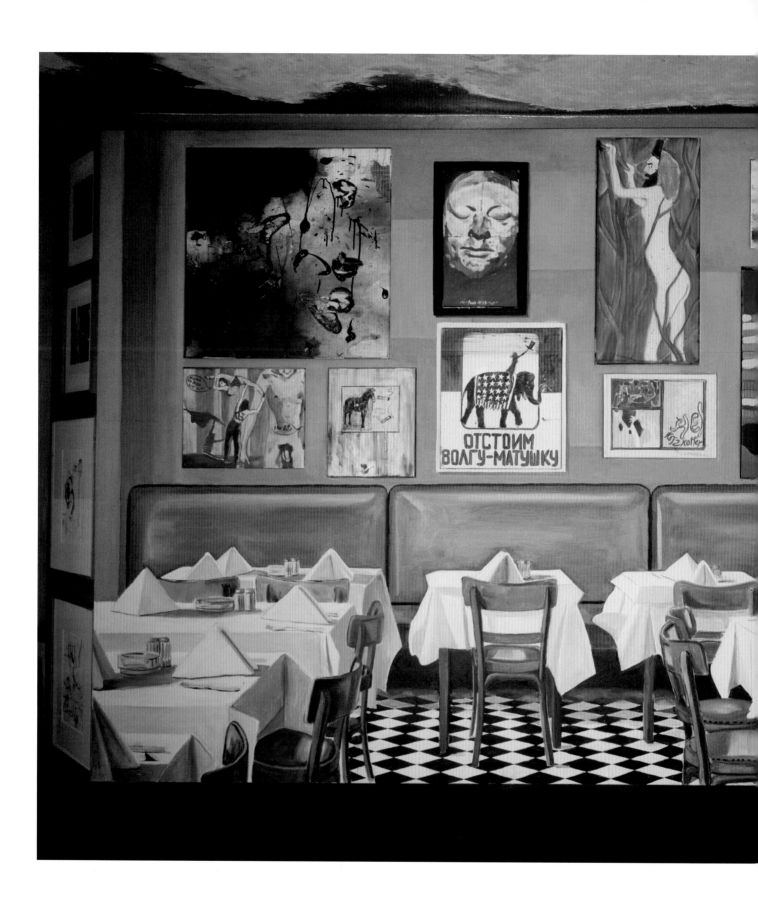

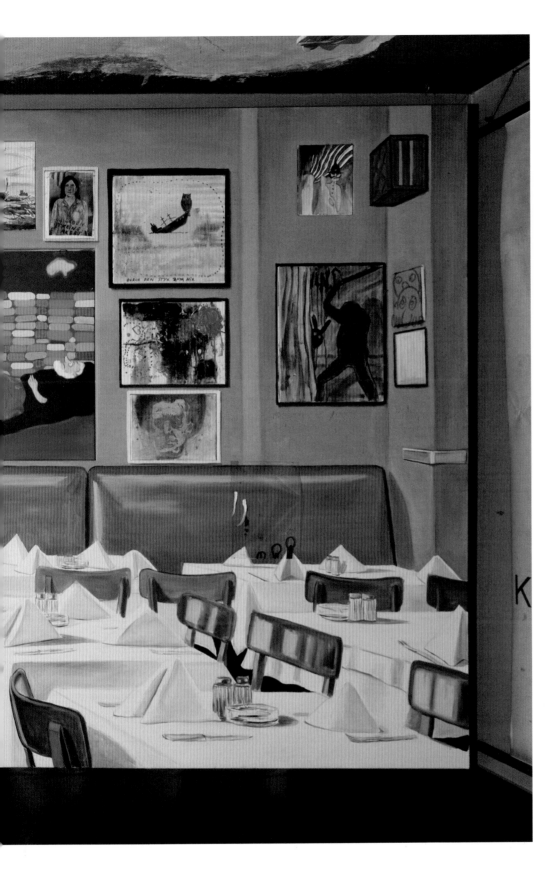

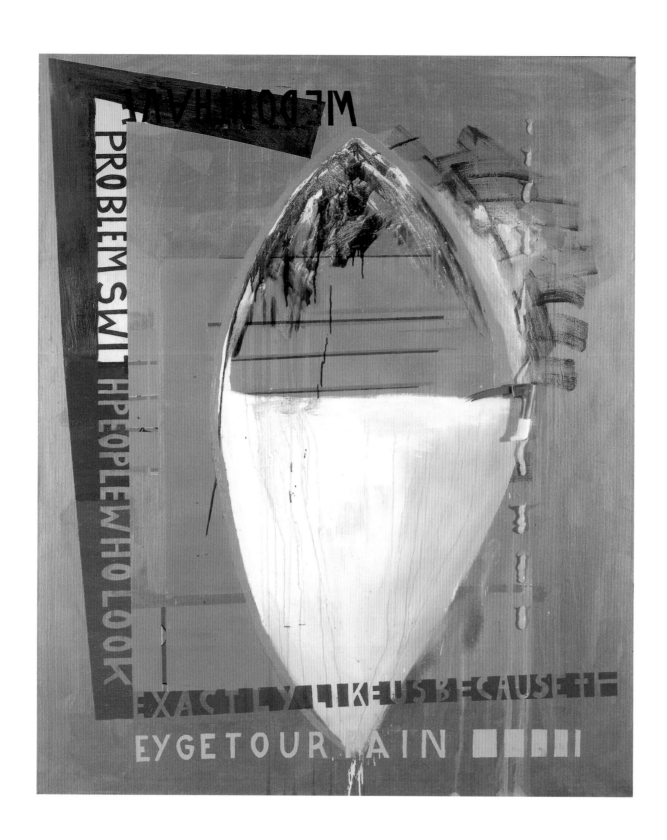

Martin Kippenberger
We don't have problems with
people who look exactly like us
because they get our pain 1986
Oil on canvas
180 x 160 cm

Martin Kippenberger
8. Preis 1987
Lacquer and denim on canvas
180 x 150 cm

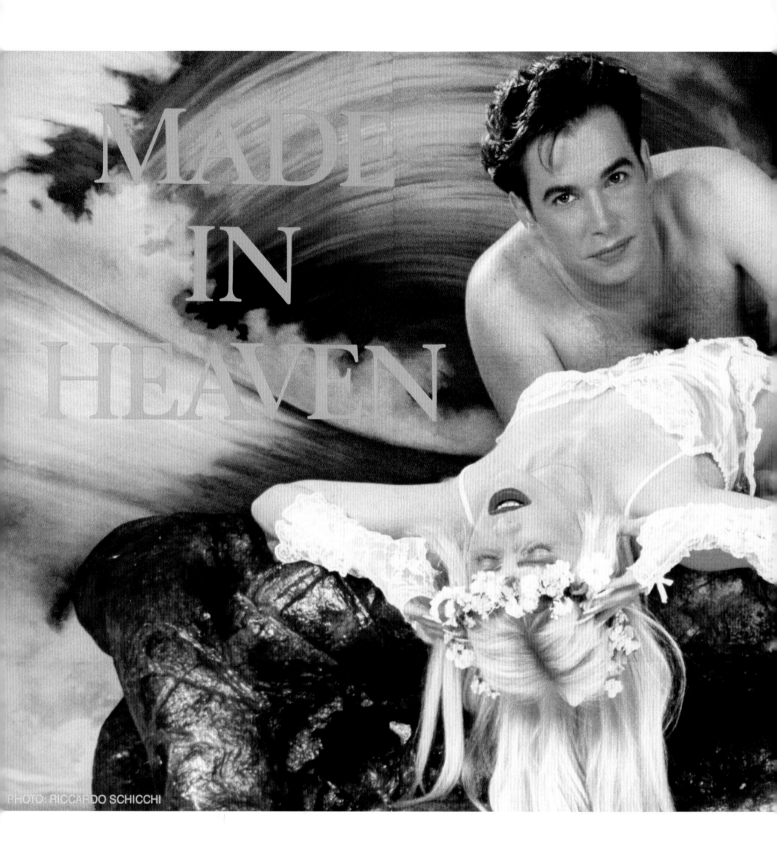

MADE
IN
HEAVEN

PHOTO: RICCARDO SCHICCHI

134

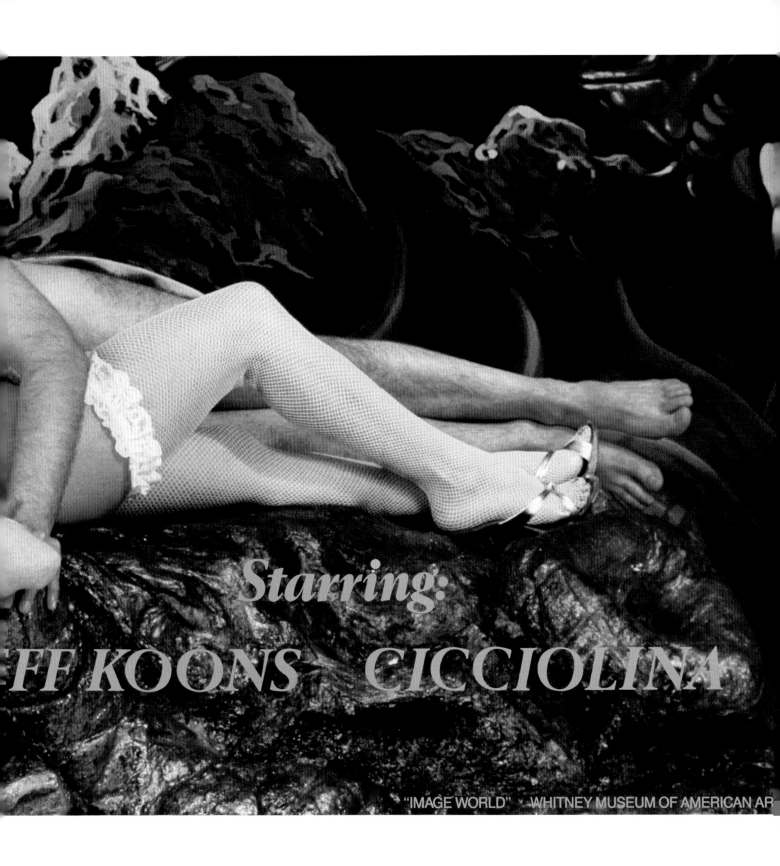

Starring:
FF KOONS CICCIOLINA

"IMAGE WORLD" WHITNEY MUSEUM OF AMERICAN AR

Jeff Koons
Made in Heaven 1989
Lithograph on paper on canvas
314.5 x 691 cm

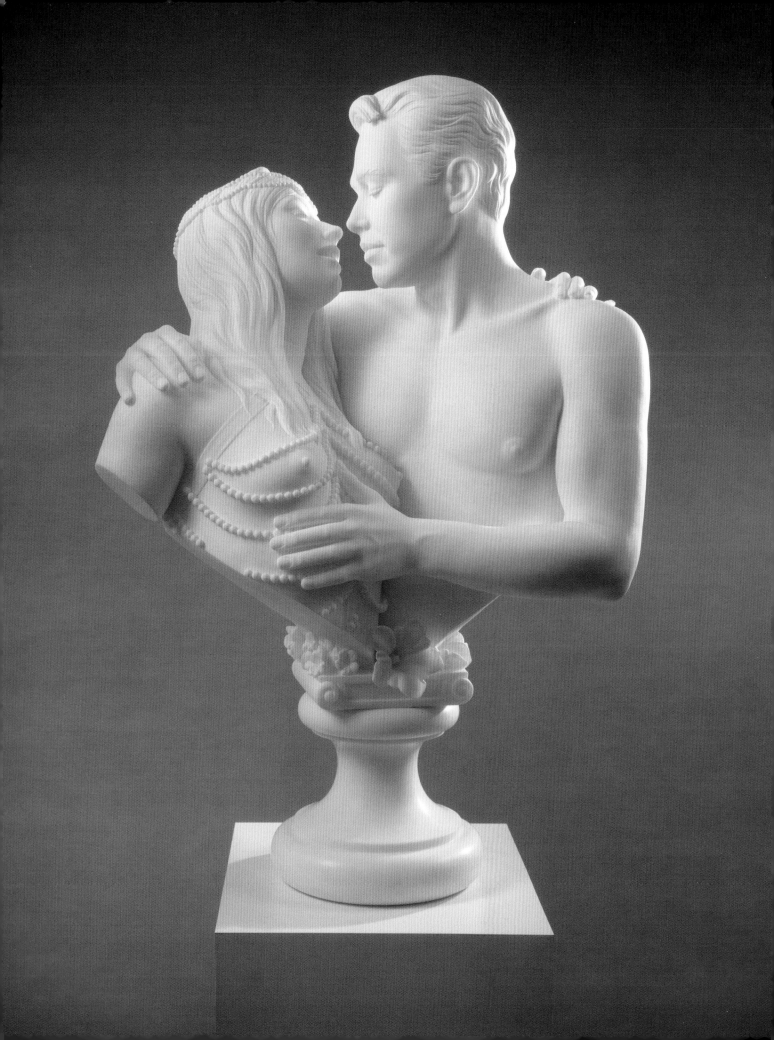

Jeff Koons
Bourgeois Bust –
Jeff and Ilona 1991
White marble
113 x 71.1 x 53.3 cm

Jeff Koons
Dirty – Jeff on Top 1991
Plastic
139.7 x 180.3 x 278.8 cm

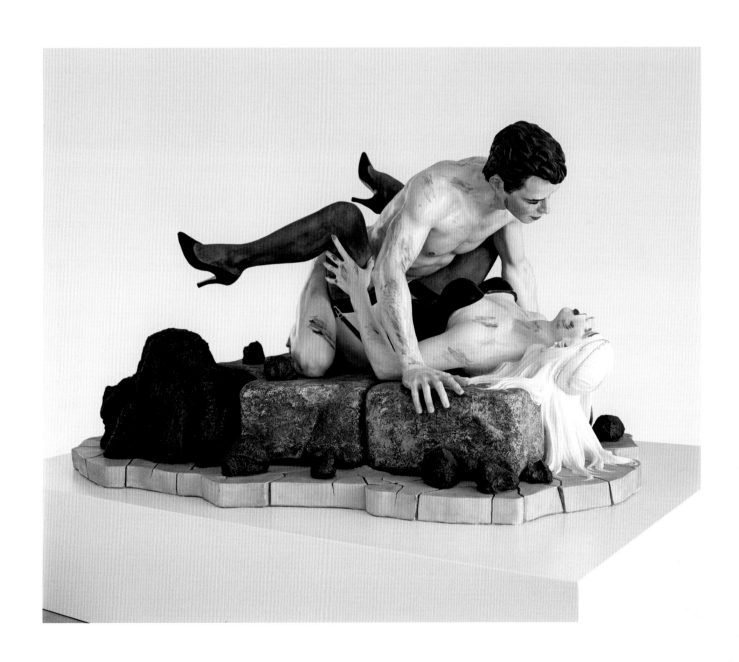

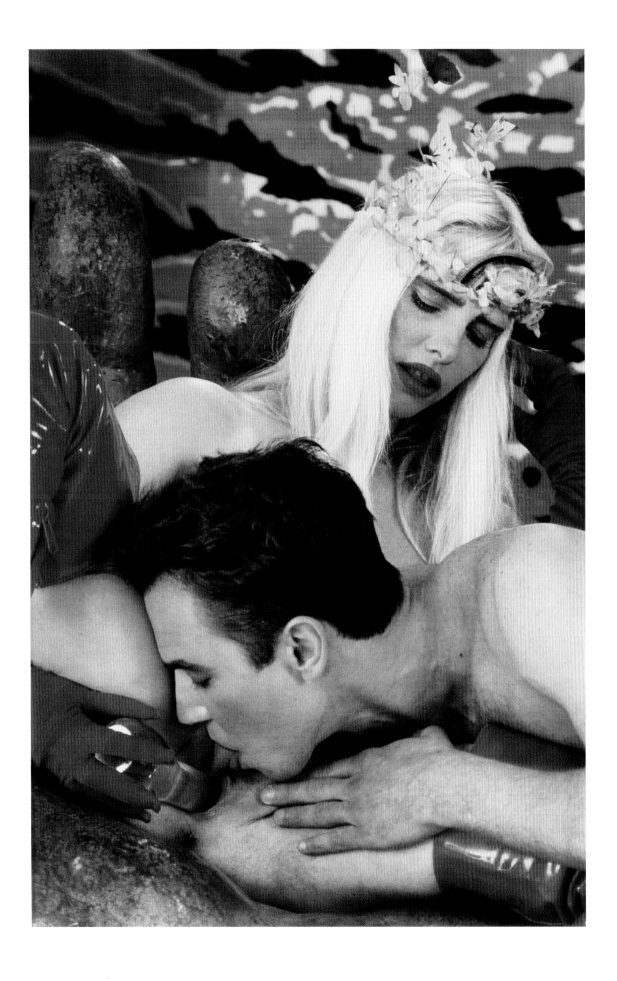

Jeff Koons
Glass Dildo 1991
Oil inks silkscreened on canvas
228.6 x 152.4 cm

Jeff Koons
Exaltation 1991
Oil inks silkscreened on canvas
152.4 x 228.6 cm

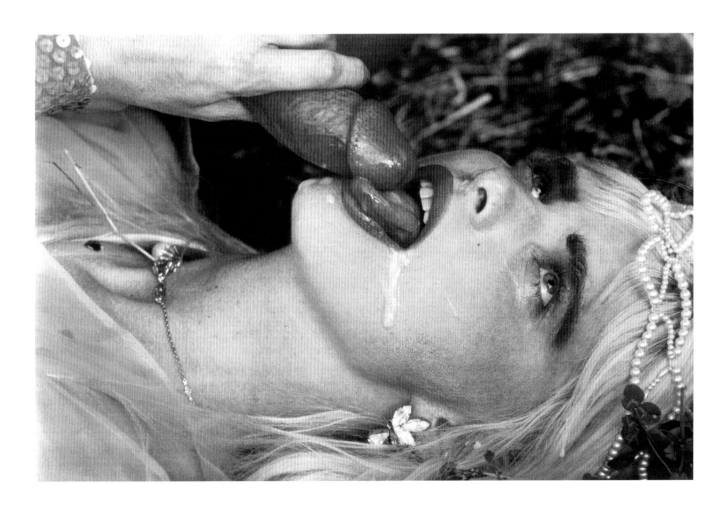

Jeff Koons
Wall Relief with Bird 1991
Polychromed wood
182.9 x 127 x 68.6 cm

Jeff Koons
Ilona's Asshole 1991
Oil inks silkscreened on canvas
228.6 x 152.4 cm

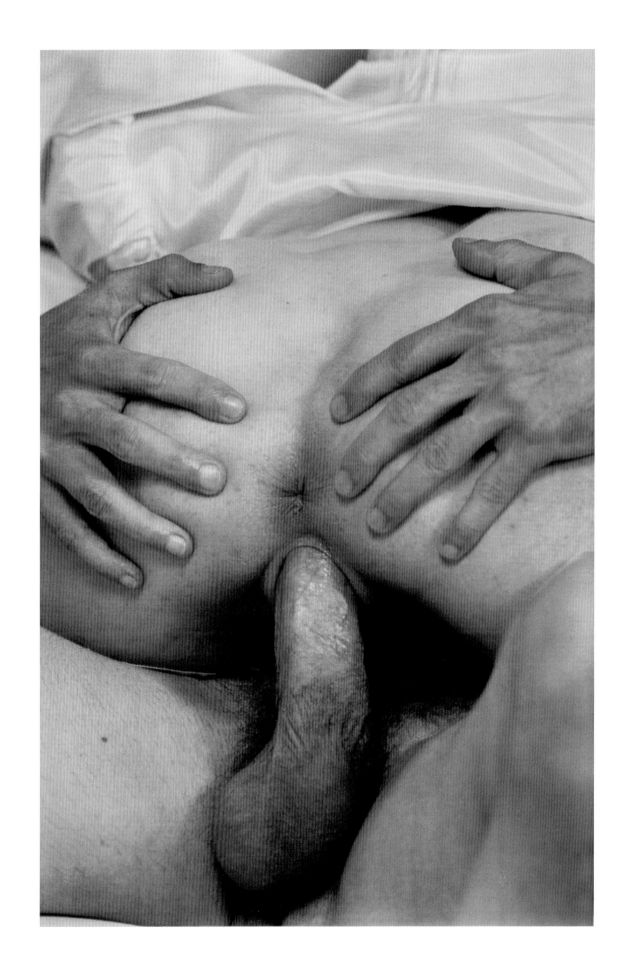

Jeff Koons
Couch (Kama Sutra) 1991
Glass
49.5 x 59.7 x 40 cm

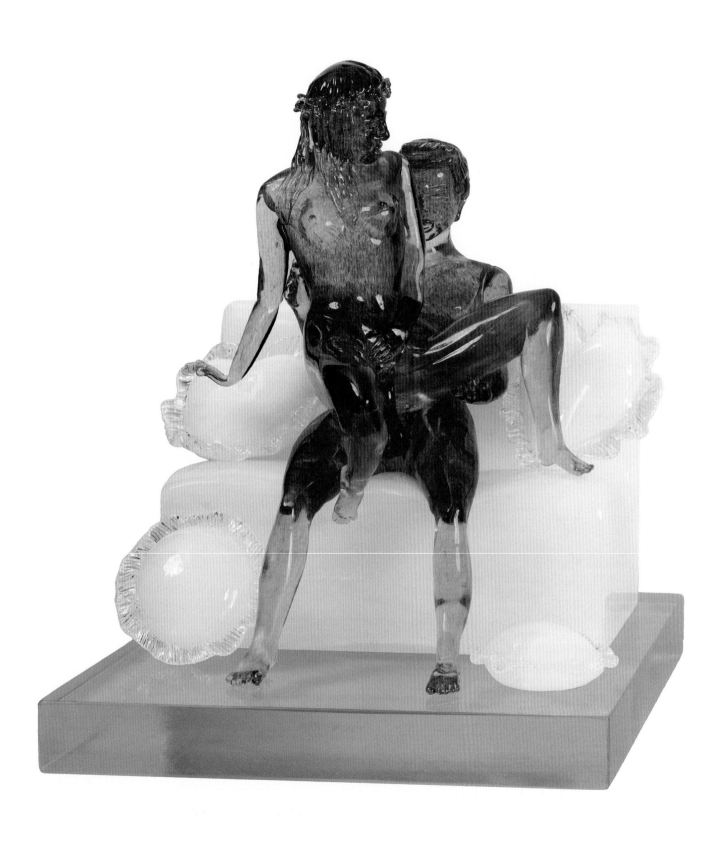

Jeff Koons
Violet-Ice (Kama Sutra) 1991
Glass
33 x 69.2 x 41.9 cm

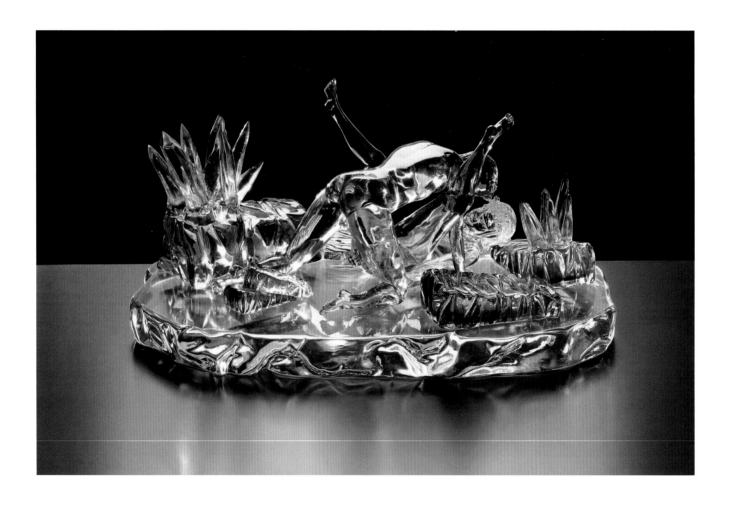

Jeff Koons
Manet 1991
Oil inks silkscreened on canvas
152.4 x 228.6 cm

October 19th – 26th 1976

SEXUAL TRANSGRESSIONS NO. 5

PROSTITUTION

COUM Transmissions:- Founded 1969. Members (active) Oct 76 - P. Christopherson,
Cosey Fanni Tutti,Genesis P-Orridge.Studio in London.Had a
kind of manifesto in July/August Studio International 1976. Performed their works
in Palais des Beaux Arts,Brussels; Musee d'Art Moderne, Paris; Galleria Borgogna,
Milan; A.I.R. Gallery, London; and took part in Arte Inglese Oggi, Milan survey of
British Art in 1976. November/December 1976 they perform in Los Angeles Institute
of Contemporary Art;Deson Gallery,Chicago;N.A.M.E. Gallery,Chicago and in Canada.
This exhibition was prompted as a comment on survival in Britain,and themselves.

2 years have passed since the above photo of Cosey in a magazine inspired this
exhibition.Cosey has appeared in 40 magazines now as a deliberate policy.All of
these framed form the core of this exhibition.Different ways of seeing and using
Cosey with her consent,produced by people unaware of her reasons,as a woman and an
artist, for participating.In that sense,pure views.In line with this all the photo
documentation shown was taken,unbidden by COUM by people who decided on their own
to photograph our actions.How other people saw and recorded us as information.Then
there are xeroxes of our press cuttings,media write ups.COUM as raw material.All of
them,who are they about and for? The only things here made by COUM are our objects.
Things used in actions,intimate (previously private) assemblages made just for us.
Everything in the show is for sale at a price,even the people. For us the party
on the opening night is the key to our stance,the most important performance.We
shall also do a few actions as counterpoint later in the week.

PERFORMANCES: Wed 20th 1pm - Fri 22nd 7pm

Sat 23rd 1pm - Sun 24th 7pm

INSTITUTE OF CONTEMPORARY ARTS LIMITED
NASH HOUSE THE MALL LONDON S.W.I. BOX OFFICE Telephone 01-930-6393

Cosey Fanni Tutti
Prostitution exhibition poster,
Institute of Contemporary Arts,
London 1976
23.4 x 65.5 cm

Cosey Fanni Tutti
Single-sided B/W Model Z card
1977
Print on card
21 x 15 cm

Cosey Fanni Tutti
'Tessa from Sunderland' from
Park Lane, no.12, 1975–6
Colour print on paper
44 x 119 cm

Above, and below right:
Cosey Fanni Tutti
'And I Should be Blue' from
Knave, vol.9, no.4, 1977
Print on paper
Page size: 164 x 120 cm

The girls' work rate isn't exactly startling—more of a nationalised industry pace than anything else—but what the hell, enjoy, enjoy. And it looks like they're having fun inventing the First Principle of Decorating: "Paint expands to cover the bodies allotted". For most people, paint is an acquired taste, but young Cosey seems to be lapping it up.

While a good bath would doubtless be a more efficient way of cleaning up, it would certainly be less stimulating.

When they've finished their colourful claspings, our two artistes will still be left with the problem of the wall. If they're smart, they'll leave it as it stands, and try and palm it off on the Tate for vast sums of money.

Tracey Emin
My Major Retrospective II
1982–92, 2008
Wire, canvas, card, pen,
photographs, wooden shelves
Overall dimensions variable,
each shelf 60 x 90 x 3.8 cm

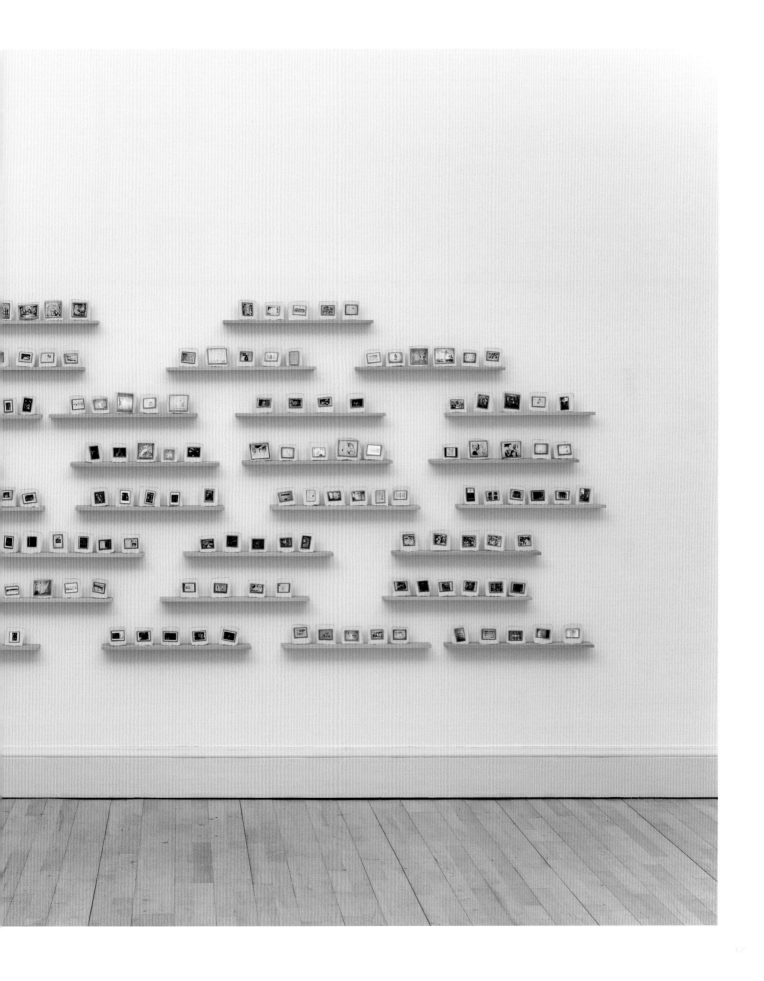

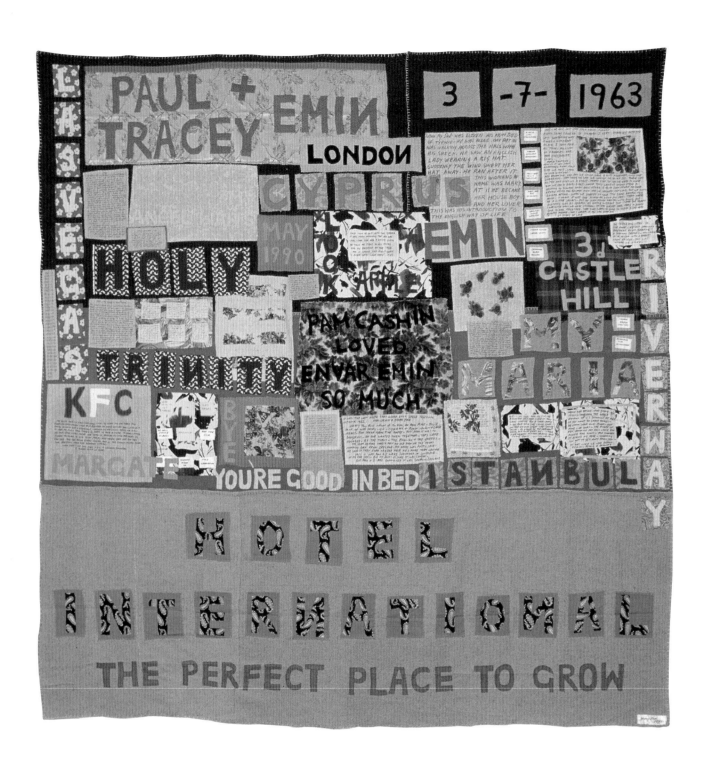

Tracey Emin
Hotel International 1993
Appliqué quilt
257 x 240 cm

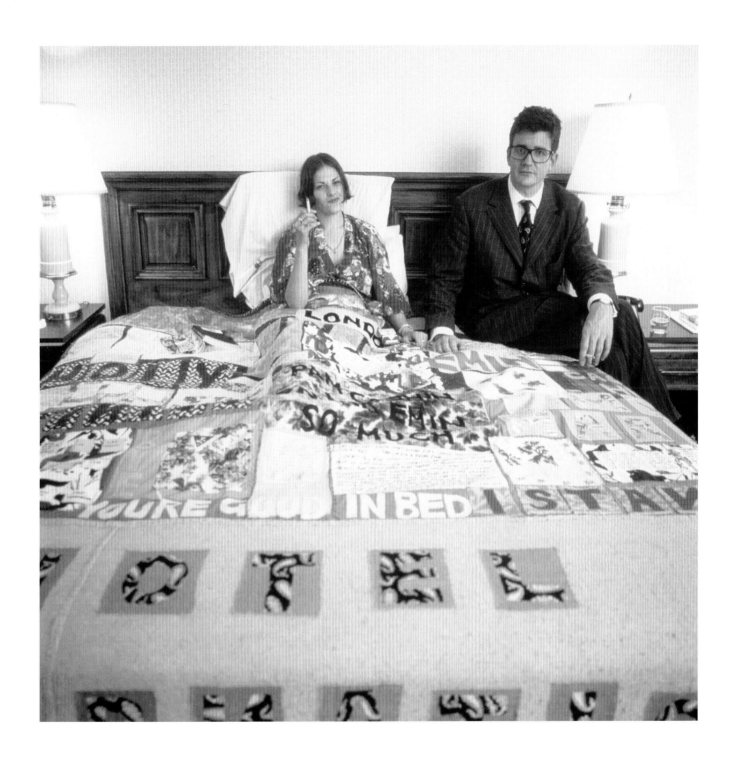

Tracy Emin in bed, lying under
Hotel International, with Jay Jopling
at the Gramercy Hotel, New York
1993

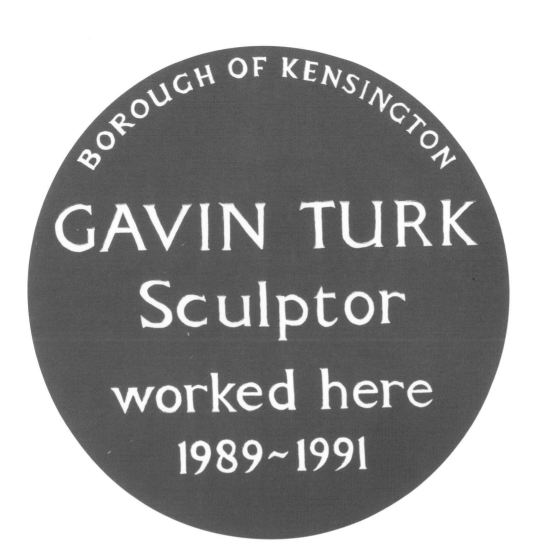

Gavin Turk
Cavey 1991–7
Ceramic laid on concrete
48.2 (diameter) x 5 cm

Gavin Turk
Pop 1993
Glass, brass, MDF, fibreglass,
wax, clothing, gum
279 x 115 x 115 cm

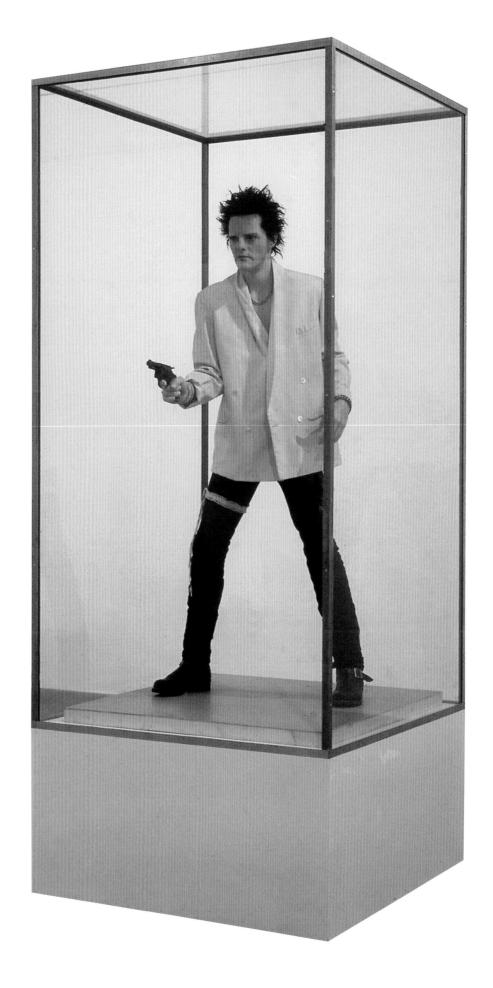

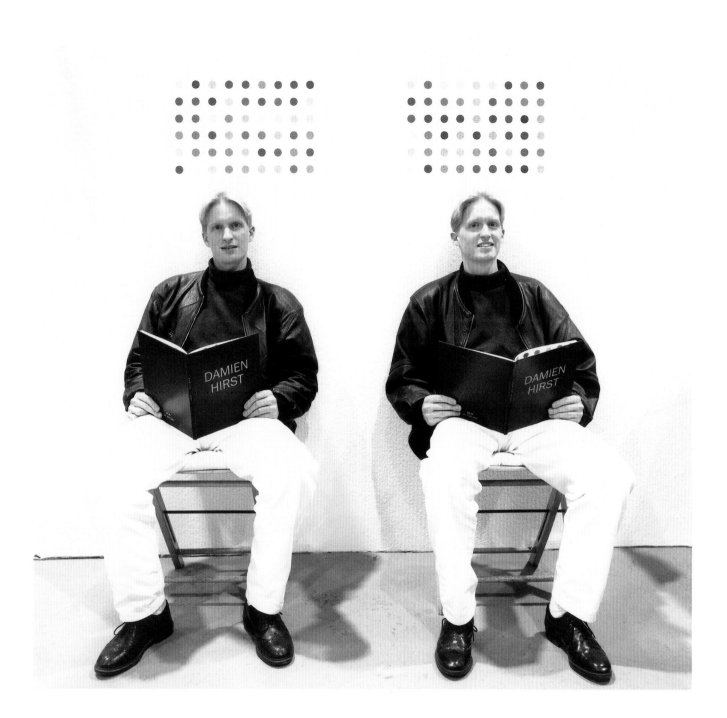

Damien Hirst
Ingo, Torsten 1992
Gloss household paint
on wall, chairs and twins
Dimensions variable
Original installation
at *Unfair*, Cologne

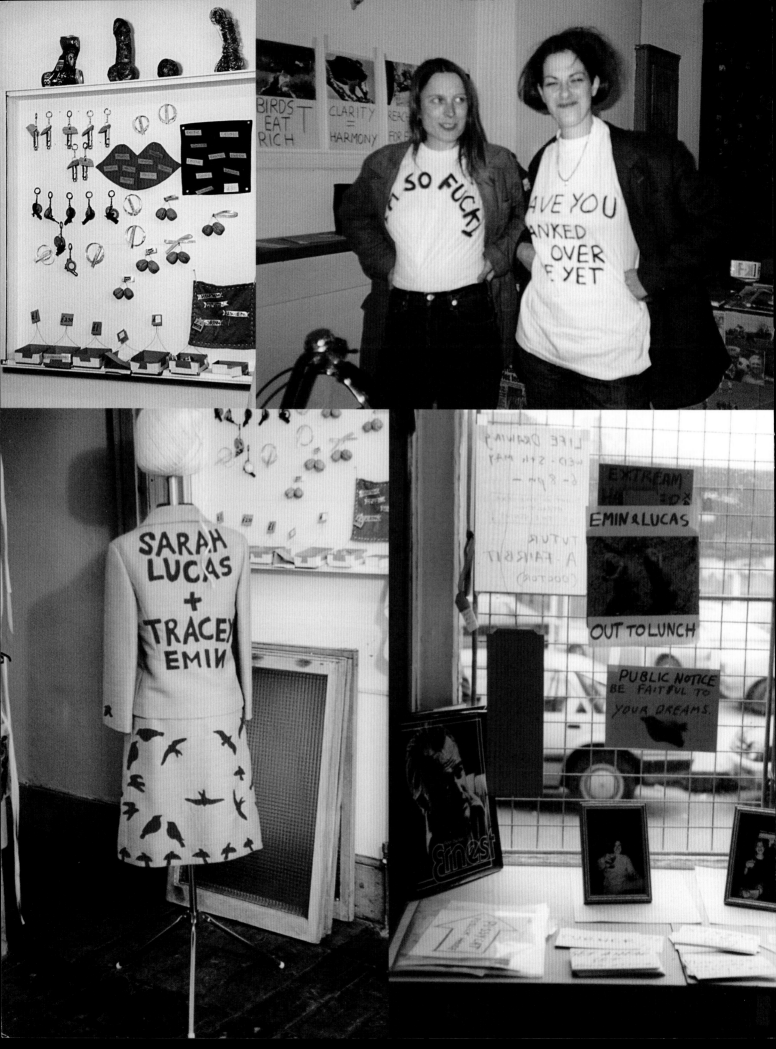

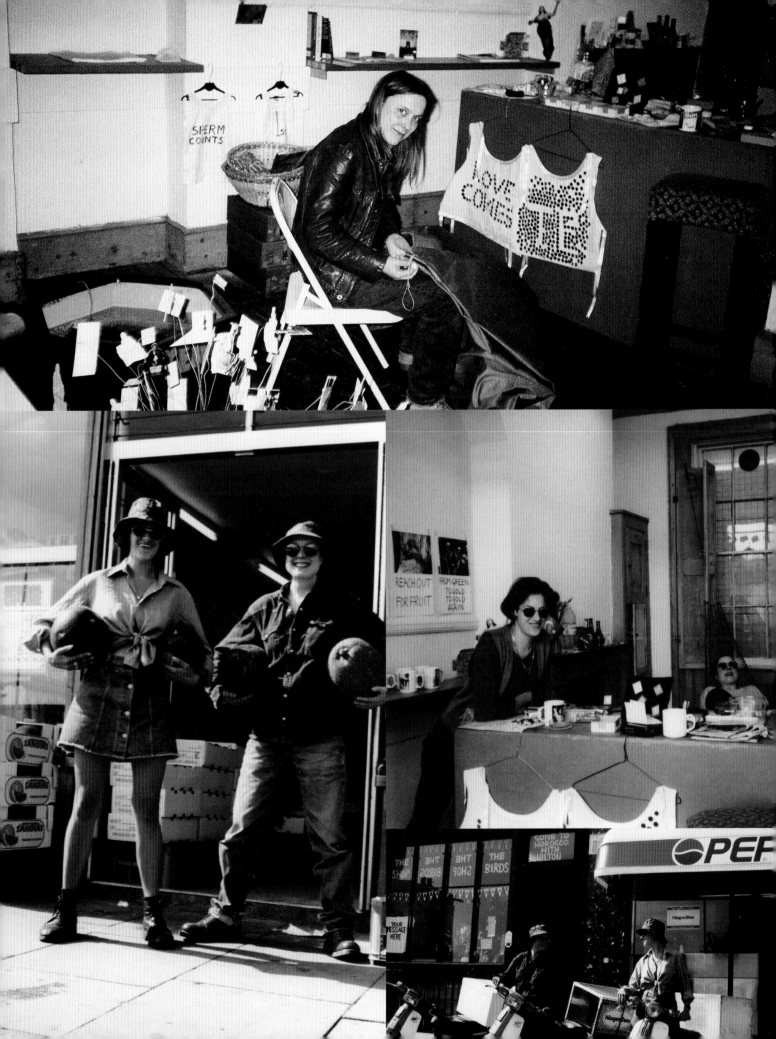

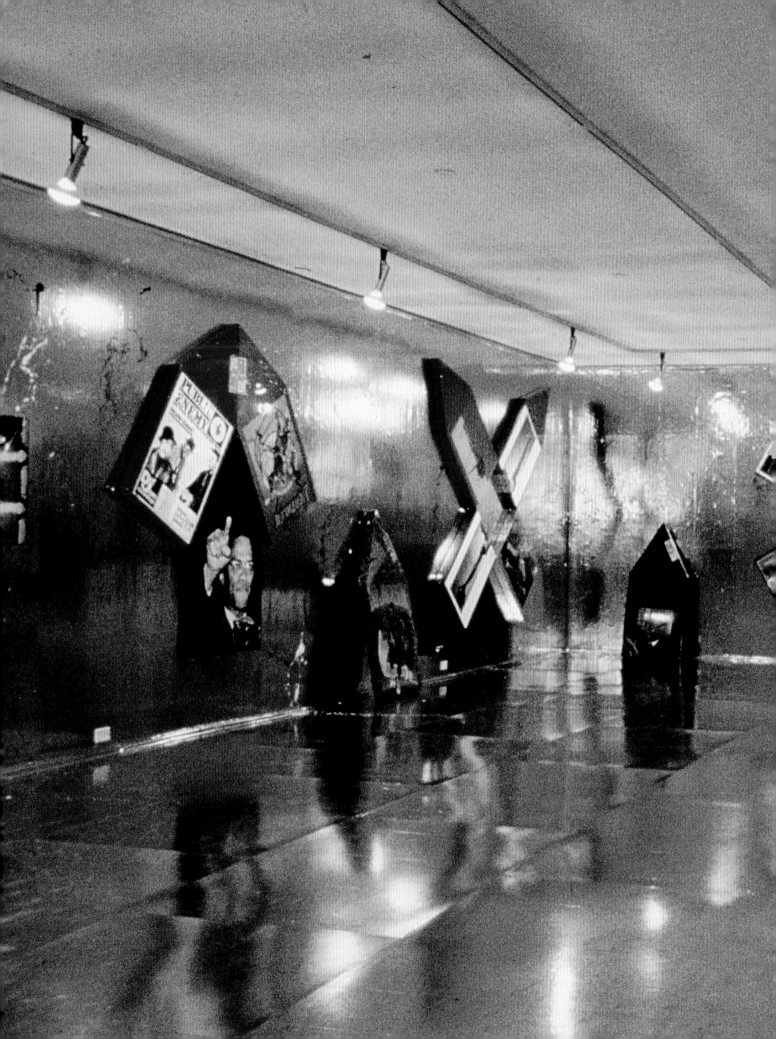

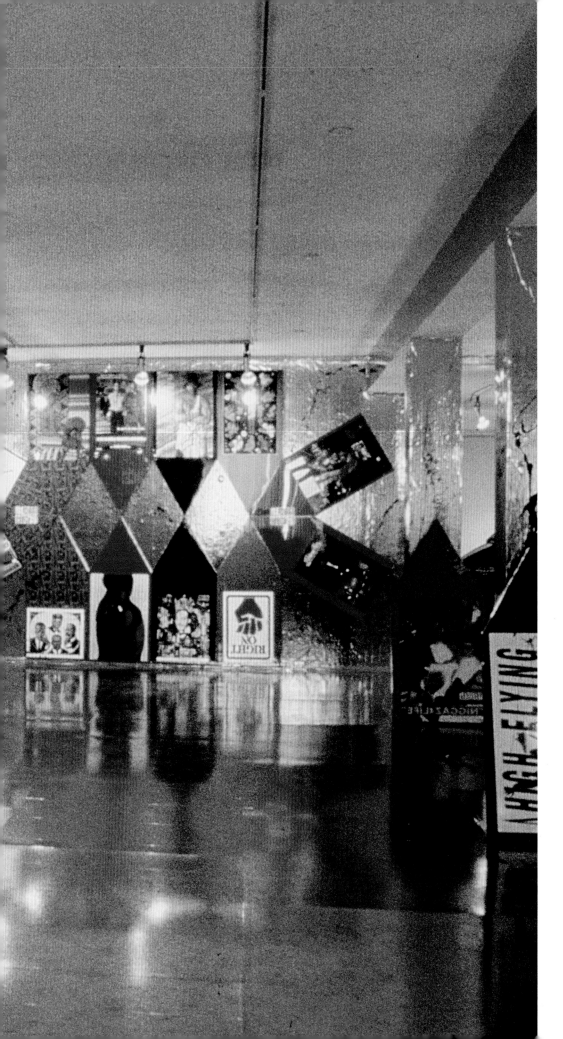

Pruitt Early
Red, Black, Green, Red, White
and Blue
Installation at Leo Castelli Gallery,
New York 1992

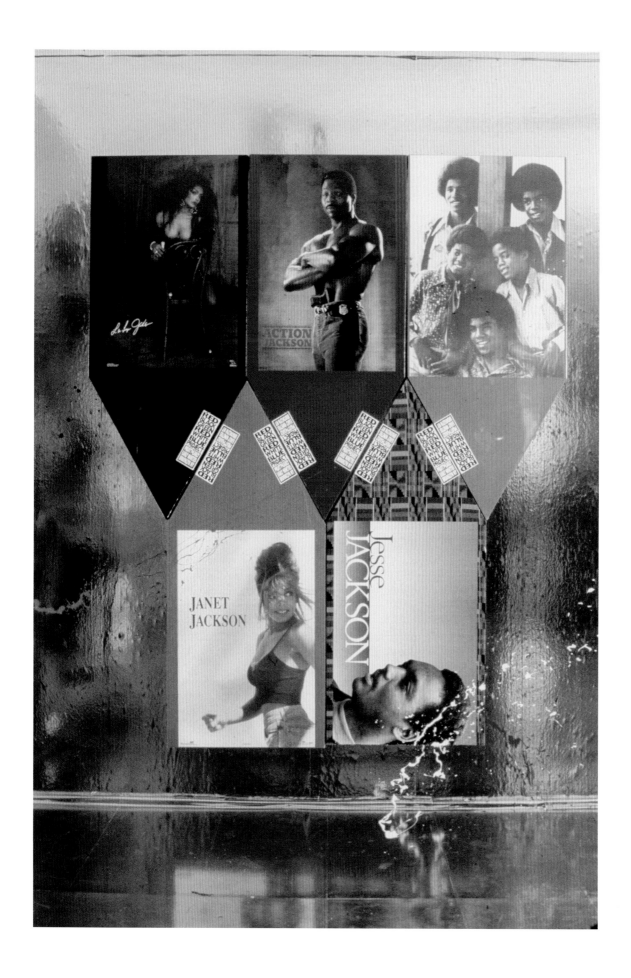

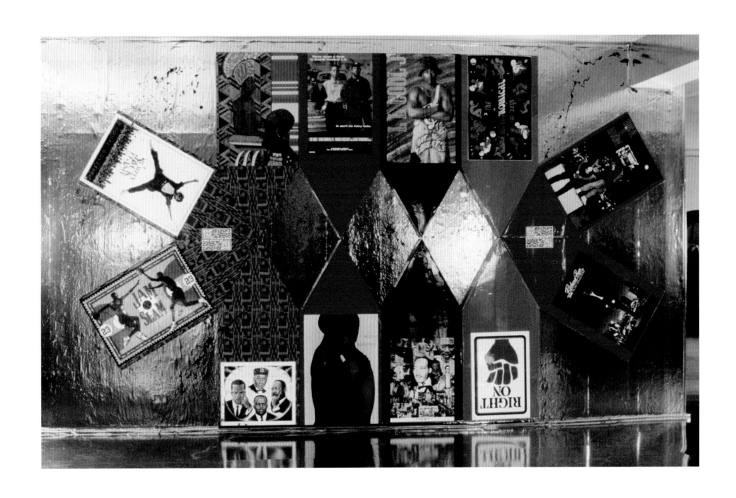

Pruitt Early
Jackson 5, early 1990s
Mixed media
241.3 x 200.7 cm

Pruitt Early
It Ain't No Fairy Tale, early 1990s
Mixed media
269.2 x 299.7 cm

Piotr Uklański
The Nazis 1998
164 chromogenic, black and
white and colour photographs
Each 35.5 x 25.4 cm

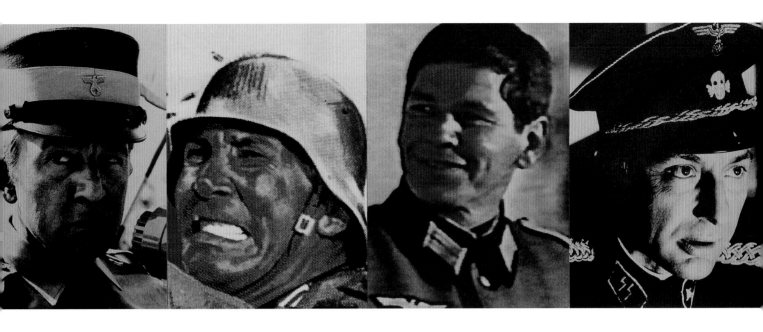

Piotr Uklański
The Nazis 1998
Installed at
Photographers' Gallery,
London 1998

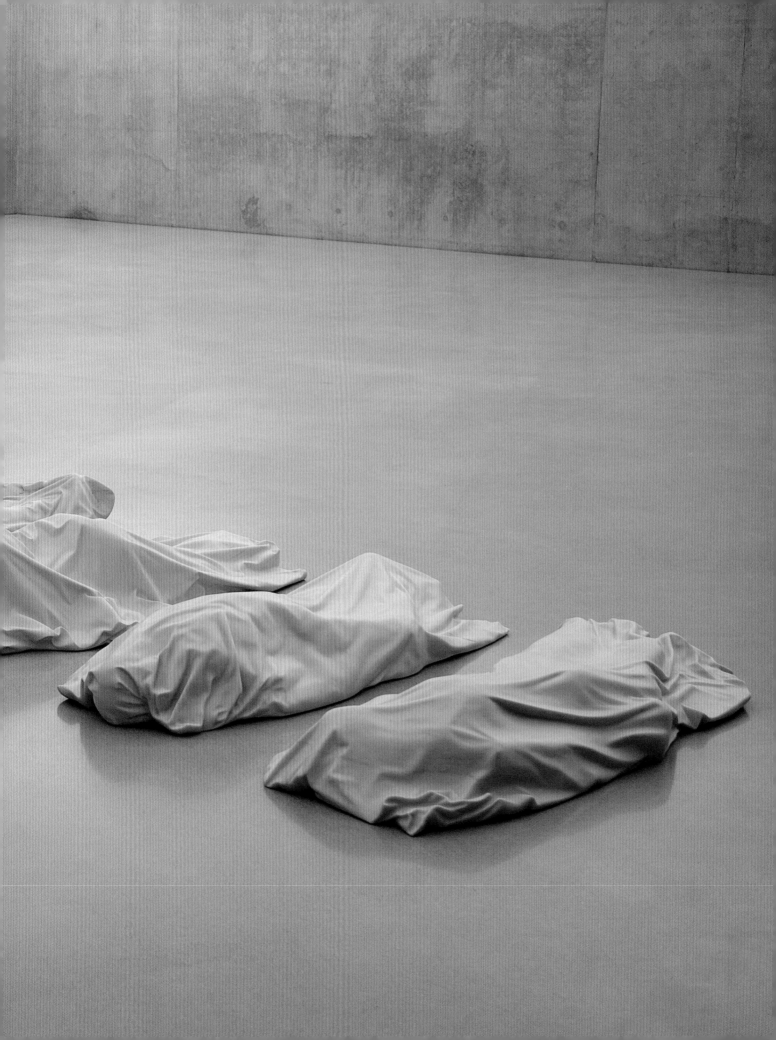

Previous page:
Maurizio Cattelan
All 2008
Carrara marble white 'P'
850 x 200 cm as installed
Installed at Kunsthaus Bregenz
2008
Private collection

Maurizio Cattelan
Ave Maria 2007
Siliconic rubber, clothes,
and steel
140 x 70 cm as installed
Installed at Tate Modern,
London 2007
Private collection

Maurizio Cattelan
Untitled 2007
Taxidermy with glass fibre
structure
160 x 90 cm
Installed at Museum für
Moderne Kunst, Frankfurt
2007
Private collection

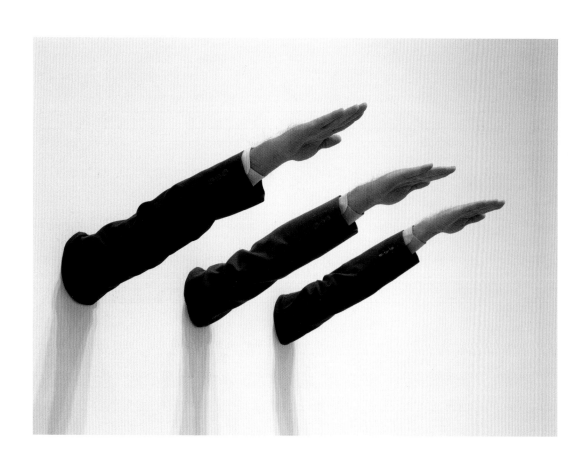

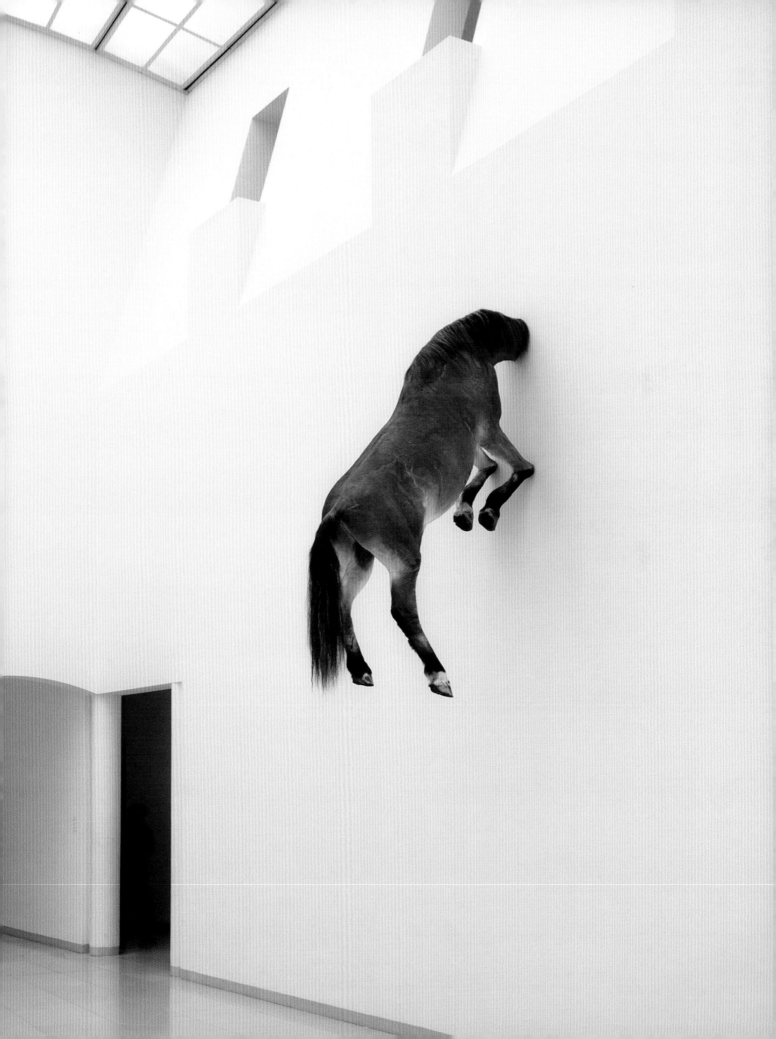

Maurizio Cattelan
Untitled 2009
Rubber
20 x 35 cm
Private collection

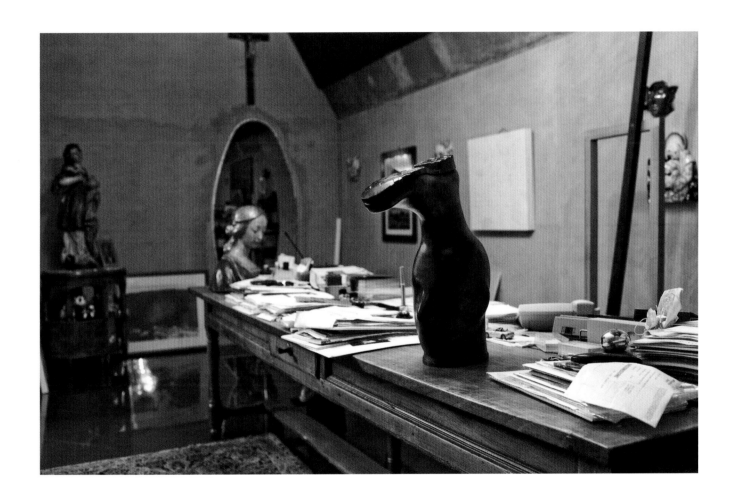

Damien Hirst
Memories of / Moments with You
2008
Gold-plated steel and glass
with manufactured diamonds
Diptych, each 91 x 137.2 x 10 cm
[Detail, right]

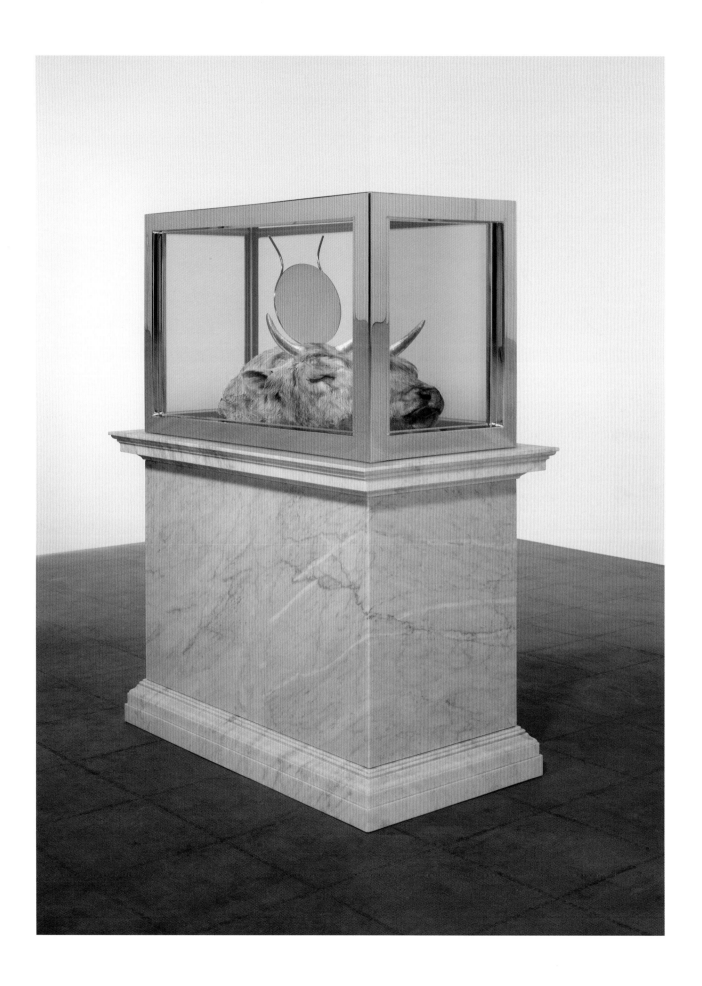

Damien Hirst
End of an Era 2009
Bull's head, gold, gold-plated
steel, glass, silicone, and
formaldehyde solution with a
Carrara marble plinth
213.4 x 170.9 x 97.2 cm

Damien Hirst
The Kiss of Midas 2008
Butterflies, manufactured diamonds
and enamel paint on canvas
152.4 x 152.4 cm

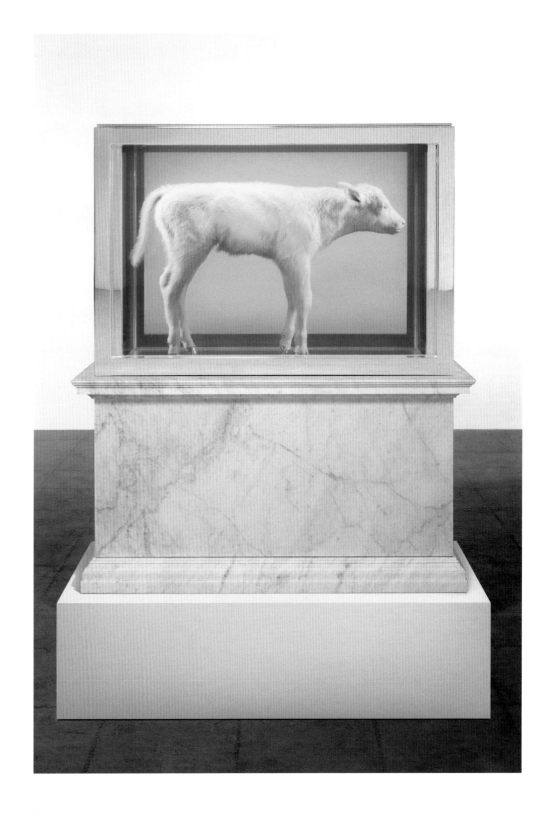

Damien Hirst
False Idol 2008
Calf, gold, gold-plated steel,
glass, silicone, and formaldehyde
solution with a Carrara marble
plinth and a stainless steel plinth
259.6 x 195 x 103.3 cm

Andrea Fraser
Untitled 2003
Project and DVD, colour,
no sound, 60 minutes
Installed at Friedrich Petzel
Gallery, New York 2004

Andrea Fraser
Still from Untitled 2003

Reena Spaulings
Untitled (Flag) 2009
Mixed media and aluminium
pole, bracket, plastic eagle
Pole 182.9 cm high,
flag 91.4 x 15 cm

Wallpaper
(after Merlin Carpenter)
2009
Ink on paper
Dimensions variable

183

Selected Bibliography

Compiled by Fiona Baker and Cindy Lisica

1. Books
2. Sections of books
3. Exhibition catalogues
4. Articles, reviews, etc.
5. Solo artists

An asterisk (*) indicates entries which derive from references in previous bibliographies, but which have not been seen by the compilers.

1. Books

Bracewell, Michael: *The nineties: when surface was depth*. London: Flamingo Publishers, 2002; 373p.

Chu, Petra ten-Doesschate: *The most arrogant man in France: Gustave Courbet and the nineteenth century media Culture*. Princeton: Princeton University Press, 2007; 238p.; bibl. pp.215–28.

Collings, Matthew: *BLIMEY! From Bohemia to Britpop: The London art world from Francis Bacon to Damien Hirst*. Cambridge: 21, 1997; 208p., col. illus.

Cork, Richard et al.: *Young British Art: the Saatchi decade*. London: Booth-Clibborn, 1999; 615p., col. illus.

Danto, Arthur C.: *After the end of art: contemporary art and the pale of history*. Princeton: Princeton University Press, 1997; 239p.

Danto, Arthur C.: *Beyond the Brillo box: the visual arts in post-historical perspective*. Berkeley and Los Angeles: University of California Press, 1992; 275p.

Higgie, Jennifer (ed.): *The artist's joke*. London: Whitechapel; Cambridge, MA: MIT Press, 2007; 237p.; bibl. pp.232–3.

Holzwarth, Hans Werner (ed.): *Art now*. Vol.3. Cologne and London: Taschen, c.2008; 591p., illus.; Cattelan pp.88–91, Emin pp.156–9, Hirst pp.248–51, Koons pp.280–3, Prince pp.384–7, Uklanski pp.480–3.

James, Jamie: *Pop art*. London: Phaidon Press, 1996; 126p., illus. (some col.); bibl. p.27.

Livingstone, Marco: *Pop art: a continuing history*. London: Thames & Hudson, 1990; 271p., col. illus.; bibl. pp.261–4, see 'Extinguished match: American pop 1965 and after' in ch.9, 'Pop's maturity', pp.195–220, and 'Eat dirt art history: neo-pop in the 1980s' in ch.10, 'Legacies of Pop', pp.221–48 (2nd ed., 2000).

Mattick, Paul and Katy Siegel: *Money*. New York: Thames & Hudson, 2004; 208p., col. illus.; bibl. p.203.

Morgan, Robert C: *The end of the art world*. New York: Allworth, 1998; 225p., illus.

*Russell, John: *Pop art redefined*. London: Thames & Hudson, 1969; 240p., illus. (some col.).

Salas, Charles G. (ed.): *The life & the work: art and biography*. Los Angeles: The Getty Research Institute, 2007; 162p., illus. (some col.).

Shanes, Eric: *The pop art tradition: responding to mass-culture*. New York: Parkstone, c.2006; 255p., col. illus.; bibl. p.253.

Spigel, Lynn: *TV by design: modern art and the rise of network television*. Chicago: University of Chicago, 2009; 392p., illus.

Taylor, Michael R. (ed.): *The Dalí renaissance: new perspectives on his life and art after 1940: an international symposium*. Philadelphia: Philadelphia Museum Distribution, 2008; 226p.

Taylor, Paul: *Post-pop art*. Cambridge, MA: MIT Press, 1989; 189p.

Thornton, Sarah: *Seven days in the art world*. London: Granta, 2008; 274p., illus.

Walker, John A.: *Art since pop*. London: Thames & Hudson, c.1975.

Welchman, John C.: *Art after appropriation: essays on art in the 1990s*. Amsteldijk: G+B Arts International, 2001; 306p., col. illus.

2. Sections of books

Hoffman, Barry: 'Advertising under the influence', in Barry Hoffman: *The fine art of advertising*. New York: Stewart, Tabori and Chang, 2003; ch.8, pp.110–23.

Hoffman, Barry: 'The greatest degeneration', in Barry Hoffman: *The fine art of advertising*. New York: Stewart, Tabori and Chang, 2003; ch.9, pp.124–40.

Karmel, Pepe: 'Oedipus wrecks: New York in the 1980s', in Stephanie Barron and Lynn Zelevansky: *Jasper Johns to Jeff Koons: four decades of art from the Broad Collections*. Los Angeles County Museum of Art, 2001; pp.103–41.

Lawson, Thomas: 'Nostalgia as resistance', in Lawrence Alloway et al.: *Modern dreams: the rise and fall and rise of pop*. New York: Institute for Contemporary Art; London and Cambridge, MA: MIT Press, 1988; pp.151–71.

Lucie-Smith, Edward: 'The heritage of pop' in Edward Lucie-Smith: *Art tomorrow*. Paris: Terrail, c.2002; ch.3, pp.50–75.

Mamiya, Christin J.: 'The legacy of pop art: the roots of post-modernism' in Christin J. Mamiya: *Pop art and consumer culture: American supermarket*. Austin: University of Texas, 1992; ch.8 pp.158–71.

Pearlman, Alison: 'Jean-Michel Basquiat, Keith Haring, and the art of subcultural distinction', in Alison Pearlman: *Unpackaging art of the 1980s*. Chicago: University of Chicago, 2003; ch.3, pp.69–104.

Pearlman, Alison: 'Peter Halley, Jeff Koons, and the art of marketing- and consumption-analysis', in Alison Pearlman: *Unpackaging art of the 1980s*. Chicago: University of Chicago, 2003; ch.4, pp.105–44.

Rothkopf, Scott: [Essay] in Yves Aupetitallot and Anne Pontégnie (eds.): *Kelley Walker*. Zurich: JRP Ringier, 2007; pp.105–27.

3. Exhibition catalogues

The pictures generation 1974–1984. Metropolitan Museum of Art, New York, 21 Apr. – 2 Aug. 2009; ed. Douglas Eklund; 350p., illus. (some col.).

Four friends: Jean-Michel Basquiat, Keith Haring, Donald Baechler, Kenny Scharf. Tony Shafrazi Gallery, New York, 25 Oct. 2007 – 12 Jan. 2008 (publication is also an exh. cat. for *Who's afraid of Jasper Johns?*, Tony Shafrazi Gallery, New York, 9 May – 12 July 2008); 45p., illus. (some col.).

Panic attack: art in the punk years. Barbican Art Gallery, London, 5 June – 9 Sept. 2007; eds. Mark Sladen and Ariella Yedgar; 223p., illus. (some col.); biogs., colls.

Re-object: Marcel Duchamp, Damien Hirst, Jeff Koons, Gerhard Merz. Kunsthaus Bregenz, 18 Feb. – 13 May 2007; ed. Eckhard Schneider; 187p., col. illus.; see 'Damien Hirst' by John Gray, pp.158–9, illus. pp.74–102; 'Jeff Koons' by Gudrud Inboden, pp.160–2, illus. pp.104–28.

In the mood for pop. Opera Gallery, London, [5–22 Dec. 2007]; 146p., col. illus; biogs.

Pop art is: popular, transient, expendable, low cost, mass produced, young, witty, sexy, gimmicky, glamorous, big business. Gagosian Gallery, London, 27 Sept. – 10 Nov. 2007; [202]p., col. illus; biogs.

Aftershock: contemporary British art, 1990–2006. Guangdong Museum of Art, Guangzhou, 15 Dec. 2006 – 4 Feb. 2007; Capital Museum, Beijing, 20 Mar. – 11 May 2007; organised by the British Council; 148p., illus. (some col.).

'Where are we going?': selections from the François Pinault Collection. Palazzo Grassi, Venice, 30 Apr. – 1 Oct. 2006; eds. Alison M. Gingeras and Jack Bankowsky; 272p., col. illus.; see Francesco Bonami on Cattelan, pp.50–3; David Rimanelli on Uklanski, pp.38–41; Robert Rosenblum on Hirst, pp.214–21; Scott Rothkopf on Koons, pp.28–9.

Pierre Huyghe: Celebration Park. Tate Modern, London, 10 Mar. – 23 Apr. 2006; Musée d'Art moderne de la Ville de Paris, 10 Mar. – 23 Apr. 2006; 142p. col. illus.; see 'To celebrate, a displacement of critique' by Dorothea von Hantelmann, pp.126–9.

Superstars: das Prinzip der Prominenz von Warhol bis Madonna. Kunsthalle Wien, Vienna, 4 Nov. 2005 – 22 Feb. 2006; 319p., col. illus.; colls.

Wade Guyton: Color, Power & Style. Kunstverein Hamburg, 29 Oct. 2005 – 8 Jan. 2006; eds. Yilmaz Dziewior and Janneke de Vries; 128p. col. illus.; see 'Modern pictures' by Scott Rothkopf, pp.65–84.

Monument to now: The Dakis Joannou Collection. DESTE Foundation for Contemporary Art, Athens, 22 June – 31 Dec. 2004, ed. Jeffrey Deitch; 445p., col. illus.

Love/hate: from Magritte to Cattelan. Museum of Contemporary Art, Chicago, 30 May – 7 Nov. 2004; 223p., col. illus.; see Cattelan, pp.51–3; Koons, pp.111–17.

Supernova: art of the 1990s from the Logan Collection. San Francisco Museum of Modern Art, 13 Dec. 2003 – 23 May 2004; ed. Madeleine Grynzstejn; 185p., illus. (some col.).

Pop: the continuing influence of popular culture on contemporary art. Logan Art Gallery, Queensland, 6 Aug. – 6 Sept. 2003 and touring to seven other Australian galleries until 5 Sept. 2004; 8 loose leaves, col. illus.

Pop thru out. Arario Gallery, Cheonan, 27 May – 20 July 2003; [91]p., col. illus.

Shopping: a century of art and consumer culture. Tate Liverpool, 20 Dec. 2002 – 23 Mar. 2003; eds. Christoph Grunenberg and Max Hollein; 269p., col. illus.; bibl. pp.263–6.

Blast to freeze: British art in the 20th century. Kunstmuseum Wolfsburg, 14 Sept. 2002 – 19 Jan. 2003; Les Abattoirs, Toulouse, 24 Feb. – 11 May 2003; 359p., col. illus.; bibl. pp.351–5, biogs. pp.328–49.

Remix: contemporary art & pop. Tate Liverpool, 25 May – 26 Aug. 2002; 95p., col. illus.

La Biennale di Venezia: 49. Esposizione internazionale d'arte: platea dell'umanità = Plateau of humankind = Plateau der Manschheith = Plateau de l'humanité; 10 June – 4 Nov. 2001 ; 2 vol., illus. (some col.); biogs., bibl., exhibs.; see Cattelan, vol.2, pp.324–5; Turk, vol.2, pp.379–80.

Apocalypse: beauty and horror in contemporary art. Royal Academy of Art, London, 23 Sept. – 15 Dec. 2000; 251p., illus. (some col.); bibl. pp.245–6; see Prince (with essay by Nathan Kernan, pp.34–49), Catellan (with essay by James Hall, pp.82–97), Koons (essay pp.226–43) et al.

Pop surrealism. The Aldrich Museum of Contemporary Art, Ridgefield, CT, 7 June – 30 Aug. 1999; ed. by Richard Klein et al.; 157p., col. illus.; list of works pp.138–57.

Epocale: pop art, graffiti art, cracking art. Galleria Pananti, Florence, 4 June – 4 Oct. 1998; 86p., col illus.; with text by Gianni Pozzi.

The great American pop art store: multiples of the sixties. University Art Museum, Long Beach, 26 Aug. – 26 Oct. 1997; 2nd ed., ed. by Constance W. Glenn, 1998; 115p., col. illus.

Sensation: young British artists from the Saatchi Collection. Royal Academy of Art, London, 18 Sept. – 28 Dec. 1997; 224p. col. illus.

Multiple Identity: Amerikanische Kunst 1975–1995 aus dem Whitney Museum of American Art. Kunstmuseum Bonn, 4 June – 7 Sept. 1997; 136p. illus. (some col.).

Material culture: the object in British art of the 1980s and '90s. Hayward Gallery, London, 3 Apr. – 18 May 1997; [32]p., illus.; see Lucas, p.18, and Turk, p.24.

Collaborations: Warhol, Basquiat, Clement. Museum Fridericianum, Kassel, 4 Feb. – 5 May 1996; Museum Villa Stuck, Munich, 25 July – 29 Sept. 1996; ed. by Tilman Osterwold; 127p., col. illus.

"Brilliant!" new art from London. Walker Art Center, Minneapolis, 22 Oct. 1995 – 7 Jan. 1996; [91]p., illus.

Virtual reality. National Gallery of Australia, Canberra, 10 Dec. 1994 – 4 Feb. 1995; 64p., illus. (some col.); see Ashley Bickerton, pp.20–1, Damien Hirst, pp.28–9, and Jeff Koons, pp.8–9.

Objects for the ideal home: the legacy of pop art. Serpentine Gallery, London, 11 Sept. – 20 Oct. 1991; 55p., col. illus.; biogs. pp.52–5.

The last decade: American artists of the 80's. Tony Shafrazi Gallery, New York, 15 Sept. – 27 Oct. 1990; 138p., illus. (some col.).

Artificial nature. DESTE Foundation for Contemporary Art, Athens, 20 June – 15 Sept. 1990; eds. Jeffrey Deitch and Dan Friedman; 152p., col. illus.

Infotainment. Nature Morte, New York, 1985; 63p., illus. (some col.); bibl. pp.62–3, biogs. pp.53–61.

**Pictures*. Artists Space, New York, 24 Sept. – 29 Oct. 1977; [31]p., illus.

4 . Articles, reviews, etc.

Artforum International. 'Art and its markets', vol.46, no.8, Apr. 2008.

Artforum International. 'Special issue: pop after pop', vol.43, no.2, Oct. 2004.

Artforum International. '40th Anniversary: the 1980s: part one', vol.41, no.7, Mar. 2003.

Artforum International. '40th Anniversary: the 1980s: part two', vol.41, no.8, Apr. 2003.

Artforum International. 'The East Village, 1979–1980: the rise and fall of an art *scene*', vol.38, no.2, Oct. 1999.

Bankowsky, Jack: 'Many happy returns: this is today', *Artforum International*, vol.42, no.9, May 2004, pp.170–1.

Bankowsky, Jack: 'Tent community', *Artforum International*, vol.44, no.2, Oct. 2005, pp.228–32.

Bankowsky, Jack: 'There's a party in my sculpture', *Artforum International*, vol.46, no.3, Nov. 2007 (on Jason Rhoades), pp.111–16, 400.

Bishop, Claire: 'Antagonism and relational aesthetics', *October*, vol.110, Fall 2004, pp.51–79.

Cameron, Dan: 'Dan Cameron on International with Monument', *Artforum International*, vol.38, no.2, Oct. 1999, pp.127–8.

Cameron, Dan : 'Against Collaboration', *Arts Magazine*, vol.58, Mar. 1984, pp.83–7.

Crimp, Douglas: 'Pictures' in *October*, vol.8, Spring 1979, pp.75–88.

Demos, T J: 'A matter of time', *TATE ETC*, no.9, Spring 2007, pp.96–103.

Foster, Hal : 'Signs taken for wonders' [the new quasi-abstract painters], *Art in America*, vol.74, June 1986, pp.80–91, 139.

Gingeras, Alison M: 'A sociology without truth = Eine Soziologie ohne Wahreit', *Parkett*, no.59, 2000, pp.50–9.

Gingeras, Alison M: 'Lives of the artists: public persona as an artistic medium', *TATE ETC*, no.1, Summer 2004, pp.24–33.

Gioni, Massimiliano: 'Touch me I'm sick: portraits of power' [reprinted from *Flash Art*, vol.34, no.218, May/June 2001], *Flash Art*, vol.41, July/Sept. 2008, pp.202–5.

Graw, Isabelle: 'When procedures become market tools: a conversation with Johanna Burton', *Texte Zur Kunst*, no.62, June 2006, pp.184–91.

Hall, James: 'Neo-Geo's bachelor artists', *Art International*, no.9, Winter 1989, pp.30–5.

Heartney, Eleanor: 'The hot new cool art: simulationism', *ARTnews*, vol.86, no.1, Jan. 1987, pp.130–7.

Holert, Tom: 'Performing the system', *Artforum International*, vol.43, no.2, Oct. 2004, pp.248–52, 303–4.

Kelsey, John: 'Man without qualities', *Artforum International*, vol.44, no.2, Oct. 2005, (on Michael Krebber) pp.220–7.

Lawrence, Thomas: 'Infotainment: Thomas Lawson on media moguls', *Artforum International*, vol.43, no.2, Oct. 2004; pp.93–4, 281.

Lee, Pamela M: 'The art of production', *Artforum International*, Oct. 2007, pp.338–43.

Malik, Suhail: 'A boom without end? Liquidity, critique and the art market', *Mute: culture and politics after the net*, Aug. 2007, vol.2, no.6, pp.92–9.

Nagy, Peter, moderator: 'Flash Art panel: from criticism to complicity', *Flash Art*, no.129, Summer 1986, pp.46–9.

Nilson, Lisbet: 'Making it neo' [young generation has taken center stage], *Art News*, vol. 82, Sept. 1983, pp.62–70.

Rimanelli, David: 'Pop life: los super elegantes', *Artforum International*, vol.44, no.2, Oct. 2005, pp.245–7, 298, 303.

Peters, Philip: 'In the middle of nowhere: Andy Warhol (and Jeff Koons)', *Kunst & Museumjournaal*, vol.4, no.3, 1992 pp.6–10.

Robbins, David: 'ABC TV', *Artforum International*, vol.38, no.2, Oct. 1999, pp.118–19, 160–1.

Rothkopf, Scott: 'Subject matters', *Artforum International*, vol.42, no.9, May 2004, pp.176–7.

Ruyters, Domeniek: 'Keith Haring/Jeff Koons, the most recent successors to Andy Warhol', *Kunst & Museumjournaal*, vol.4, no.3, 1992, pp.44–50

Smith, Roberta. 'Art: 4 Young East Villagers at Sonnabend Gallery', *New York Times*, 24 Oct. 1986.

Weiwei, Ai, Amy Cappellazzo, Thomas Crow, et al.: 'Art and its markets: a roundtable discussion', *Artforum International*, vol.46, no.8, Apr. 2008, pp.292–303.

Wood, Catherine: 'Horror vacui: The subject as image in Mark Leckey's "Parade" = 'Das subject als Bild in Mark Leckeys "Parade"', *Parkett*, no.70, July 2004, pp.157–63.

5. Solo artists

Ashley Bickerton

Sections of books
We love you both. London: Booth-Clibborn Editions; Candy Records, 1998; 'Ashley Bickerton', p.4.

Exhibition catalogues
Ashley Bickerton: recent wurg. White Cube, London, 3 Apr. – 9 May 2009; 35p., col. illus.; biog., exhibs.

La forma del mondon: la fine del mondo = The shape of the world: the end of the world. Padiglione d'Arte Contemporanea di Milano, Milan, 14 July – 15 Oct. 2000; 223p., illus. (some col.); see Ashley Bickerton pp.98–101.

Pollution: Ashley Bickerton, Enrica Borghi, Luigi Carboni et al. Galleria Gian Ferrari Arte Contemporanea, Milan, 22 Jan. – 28 Feb. 1998; 71p., col. illus.

Islas = Islands. CAAM Centro Atlántico de Arte Moderno, Las Palmas, 16 Sept. – 6 Nov. 1997 and touring to: Centro de Arte La Recova, Santa Cruz de Tenerife; Centro Andaluz de Arte Contemporáneo, Seville, until May 1998; 2 vol., [555]p., col. illus.; see 'Ashley Bickerton', vol.2, pp.138–9.

Some went mad, some ran away. Serpentine Gallery, London, 4 May – 5 June 1994; and touring to: Nordic Arts Centre, Helsinki; Kunstverein, Hanover; Museum of Contemporary Art, Chicago, until 12 Mar. 1995; 48p., illus. (some col.); bibl., biog., exhibs.

Articles
'Fluid mechanics: a conversation between Ashley Bickerton and Aimee Rankin' (an artists' dialogue), *Arts Magazine*, vol.62, Dec. 1987, pp.82–5.

Bankowsky, Jack: (Sonnabend Gallery, New York; exhibit.), *Artforum International*, vol. 28, no. 5, Jan. 1990, p.133–4.

Brooks, Rosetta: 'Ashley Bickerton: the unbearable lightness of art', *C Magazine*, 20 Dec. 1988, pp.14–17.

Caley, Shaun: 'Ashley Bickerton: a revealing exposé of the application of art' (interview), *Flash Art (International Edition)*, no.143, Nov./Dec. 1988, pp.79–81.

Frangenberg, F.: 'Ashley Bickerton: works from 1987–1996' (Galerie Philomene Magers, Cologne; exhibit.), *Kunstforum International*, no.141, July/Sept. 1998, pp.374–5.

*Gingeras, Alison: 'Divergent tropical zone', *Purple Fashion*, no.3, Spring/Summer 2005, pp.80–7.

Lafreniere, Steve: 'Ashley Bickerton talks to Steve Lafreniere', *Artforum International*, vol.41, no.7, Mar. 2003, pp.240–1, 281.

Leffingwell, Edward: Ashley Bickerton at Sonnabend' (exhibit.), *Art in America*, vol.93, no.2, Feb. 2005, pp.128–9.

Moos, David: 'Ashley Bickerton: eco-ego', *Artext*, no.69, May/July 2000, pp.62–7.

Phillips, Richard: 'Ashley Bickerton', *Journal of Contemporary Art*, Spring/Summer 1989, vol.2, no.1, pp.79–90.

Santacatterina, Stella: 'Ashley Bickerton: White Cube 2' (exhibit.), *Flash Art*, vol.35, no.222, Jan./Feb. 2002, p.98.

Swenson, Kirsten: 'Asley Bickerton: Lehmann Maupin' (exhibit.), *Art in America*, vol.96, no.11, Dec. 2008, pp.172–3.

Maurizio Cattelan

Books
Cattelan, Maurizio and Paola Manfrin (eds.): *Permanent food. 14.* [Dijon: Presses du Réel, 2006?]; c.[192]p., illus. (some col.).

Manacorda, Francesco: *Maurizio Cattelan* (Supercontemporanea series). Milan: Electa, 2006; 107p., col. illus.; bibl. pp.104–5, biog., exhibs.

Verzotti, Giorgio (trans. Marguerite Shore): *Maurizio Cattelan.* Milan: Edizioni Charta, 1999; 57p., col. illus.; bibl. pp.56–7.

Exhibition catalogues
Dionysiac (6 works). Centre Georges Pompidou, Paris, 16 Feb. – 9 May 2005; c.250p., col. illus. + booklet [12]p.

Maurizio Cattelan. Museum of Modern Art, New York, 6 Nov. – 4 Dec. 1998; 8p., illus.(col.); biog.

Maurizio Cattelan. Museo d'Arte Contemporanea, Castello di Rivoli, Milan, 1997; [32] leaves, col. illus.; biog., exhibs., perfs.

Articles
Bonomi, Francesco: 'The wrong way' (interview with Maurizio Cattelan, Massimiliano Gioni and Ali Subotnik), *Modern Painters*, Mar. 2006, pp.86–91.

Cavallucci, Fabio: 'Maurizio Cattelan', *Flash Art*, vol.41, May/June 2008, p.147.

Gayford, Martin: 'Shock value', *Modern Painters*, Autumn 2000, vol.13, no.3, pp.88–9.

Giancarlo, Politi: 'Killing me softly' [interview with Maurizio Cattelan; reprinted from Flash Art, vol.37 July–Sept. 2004], *Flash Art*, vol.41, July–Sept. 2008, pp.220–3.

Kontova, Helena: 'Maurizio Cattelan: no cakes for special occasions' (interview with Maurizio Cattelan), *Flash Art*, vol.40, Nov.–Dec. 2007, pp.74–6.

Tracey Emin

Books
Brown, Neal: *Tracey Emin.* London: Tate Publishing, 2006; 128p., col. illus.; bibl. pp.124–6, exhibs.; perfs.

*Emin, Tracey: *Tracey Emin.* New York: Rizzoli, 2006; 413p., col. illus.; bibl. pp.402–7.

Emin, Tracey: *Strangeland.* London: Sceptre, 2005; 212, [1]p.

Emin, Tracey: *Always glad to see you.* [London?]: Tracey Emin, 1996; [16]p.

Emin, Tracey et al.: *The phone box: art in telephone boxes London & Liverpool.* [S.l.]: Virginia Nimarkoh, 1993; 1 box, col. illus.

Merck, Mandy and Townsend, Chris: *The Art of Tracey Emin.* London: Thames & Hudson, 2002; 224p., illus.; filmog.

Exhibition catalogues
Tracey Emin: 20 years. Scottish National Gallery of Modern Art, Edinburgh, 2 Aug. – 9 Nov. 2008; and touring to: Centro de Arte Contemporaneo de Malaga; Kunstmuseum Bern, until 21 June 2009; 151p., col. illus.; awards, bibl. p.151, biog., colls., exhibs.

Tracey Emin: you left me breathing. Gagosian Gallery, Los Angeles, 2 Nov. – 22 Dec. 2007; 83p., col. illus.

Tracey Emin: borrowed light. Biennale di Venezia, 52nd Great Britain, Venice, 10 June – 21 Nov. 2007; 125p., illus. (some col.); awards, bibl. p.125, biog., exhibs.

Tracey Emin: when I think about sex … [I make art]. White Cube, London, 27 May – 25 June 2005; 23p., illus.

Tracey Emin: this is another place. Modern Art Oxford, Oxford, 10 Nov 2002 – 19 Jan. 2003; 99p., illus., facsims.

Ten years: Tracey Emin. Stedelijk Museum, Amsterdam, 19 Oct. – 31 Dec. 2002; 39p., col. illus.; bibl. pp.35–6, exhibs.

The Turner Prize 1999. Tate Gallery, London, 20 Oct. 1999 – 6 Feb. 2000; [14]p., col. illus.; see 'Tracey Emin' by Simon Wilson, pp.4–5.

Tracey Emin: sobasex. Sagacho Exhibit Space, Tokyo, 10 Oct. – 14 Nov. 1998; [6]p. folded card; illus.; awards, biog., exhib.

Tracey Emin: I need art like I need God. South London Gallery, London, 16 Apr. – 18 May 1997; 69p., col. illus.; bibl. p.67, biog., colls., exhibs.

Articles
Douglas, Scott.: 'What does Tracey Emin mean to you?', *Art Review*, no.12, June 2007, pp.110–15.

Durden, Mark: 'The authority of authenticity: Tracey Emin', translated by Colette Tougas, *Parachute*, no.105, Jan./Mar. 2002, pp.20–37.

Preece, Robert: 'Exposed: a conversation with Tracey Emin', *Sculpture*, vol.21, no.9, 2002, pp.38–43.

Cosey Fanni Tutti

Exhibition catalogues
Sympathy for the devil: art and rock and roll since 1967. Museum of Contemporary Art, Chicago, 29 Sept. 2007 – 6 Jan. 2008; Museum of Contemporary Art, North Miami, 31 May – 8 Sept. 2008; Dominic Molon; 287p., col. illus.; biogs., colls., exhibs.

WACK! Art and the feminist revolution. Museum Of Contemporary Art, Los Angeles, 4 Mar. – 16 July 2007; and touring to: National Museum of Women in the Arts, Washington, D.C.; P.S.1 Contemporary Art Center, Long Island City; Vancouver Art Gallery, until 18 Jan. 2009; ed. Lisa Gabrielle Mark; 511p.; illus. (some col.); biogs., colls., exhibs.

TATE Triennial 2006: new British art. Tate Britain, London, 1 Mar. – 14 May 2006; eds. Beatrix Ruf and Clarrie Wallis; 160p., col. illus.; biogs., exhibs.

The future has a silver lining: genealogies of glamour. Migros Museum für Gegenwartskunst, Zurich, 28 Aug. – 31 Oct. 2004; eds. Tom Holert and Heike Munder; 248p., illus. (some col.); biogs., colls., exhibs.

INDEPENDENCE. South London Gallery, London, 3 June – 3 Aug. 2003; [16]p., col. illus., map.

Protest & survive. Whitechapel Art Gallery, London, 15 Sept. – 12 Nov. 2000; 46p., illus. (some col.).

Live in your head: concept and experiment in Britain 1965–75. Whitechapel Art Gallery, London, 4 Feb. – 2 Apr. 2000; Clive Phillpot and Andrea Tarsia; 175p., illus.

Out of actions: between performance and the object, 1949–1979. Museum of Contemporary Art, Los Angeles, 8 Feb. – 10 May 1998; and touring to: MAK (Austrian Museum of Applied Arts), Vienna; Museu d'Art Contemporani de Barcelona; Museum of Contemporary Art, Tokyo, until 11 Apr. 1999; 407p., illus. (some col.); bibl. pp.391–406.

Articles
'Cosey Fanni Tutti: Questionnaire', *Frieze*, no.97, Mar. 2006.

'Up close and personal with Cosey Fanni Tutti', *Make, the magazine of women's art*, no.90, Dec. 2000/Feb. 2001, pp.22–3.

Fanni Tutti, Cosey: 'Cosey Fanni Tutti on independence', *Art Review*, no.13, July/Aug., p.36.

Ford, Simon: 'Subject and [sex] object', *Make, the magazine of women's art*, no. 80, June/Aug. 1998, pp.2–7.

Ford, Simon: 'Doing P-Orridge' (art, crime and the 1976 exhibit Prostitution at the Institute of Contemporary Art, London), *Art Monthly*, no.197, June 1996, pp.9–12.

Politi, Gea: 'Cosey Fani Tutti: self-remixes' (interview), *Flash Art (International Edition)*, vol.41, Mar./Apr. 2008, p.151.

Roberts, John: 'Bruce McLean and Cosey Fanni Tutti at the Hayward Annual 79' (exhibit.), *P.S.*, no.2, Sept./Oct. 1979, p.19.

Andrea Fraser

Sections of books

Fraser, Andrea: 'A museum is not a business. It is run in a business-like fashion' in *Art and its institutions: current conflicts, critique and collaborations*, ed. Nina Möntman. London: Black Dog Publishing, 2006, pp.86–98.

Exhibition catalogues

The world as a stage. Tate Modern, London, 24 Oct. 2007 – 1 Jan. 2008; 80p. col. illus; bibl., biog., exhibs.; see. 'Andrea Fraser', pp.46–7

Andrea Fraser: lecture. Cooper Union for the Advancement of Science and Art, New York, 19 Apr. 2004. 1 folded card, col. illus.

Andrea Fraser: works 1984 to 2003. Kunstverein Hamburg, 13 Sept. – 9 Nov. 2003; ed. Ylmaz Dziewior; 288p. col. illus; bibl., biog. pp.283–7.

Report: the EA – Generali Foundation: Andrea Fraser. EA – Generali Foundation, Vienna, 1 Apr. 1994 – 12 May 1995, 14 May – 30 July 1995; 87p. illus.

Articles

'Andrea Fraser: [Curriculum Vitae]' in 'Faculty 2008', Skowhegan; bibl., biog., exhibs. <http://www.skowheganart. org/materials/cvs/Fraser.pdf>

*Anastas, Rhea: 'The artist is a currency' (interview with G. Bordowitz, A. Fraser, J. Koether and G. Ligon), *Grey Room*, no.24, Summer 2006, pp.110–26.

Graw, Isabelle: '*Andrea Fraser*: Hamburger Kunstverein', *Artforum International*, vol.42, no.4, Dec. 2003, p.140.

Hofleitner, Johanna: 'Milan: Andrea Fraser: Metropol' (Galerie Metropol, Vienna; exhibit.), *Flash Art*, vol.26, no.173, Nov./Dec. 1993, p.121.

Meyer, James: 'The strong and the weak: Andrea Fraser and the conceptual legacy', *Grey Room*, no.17, Fall 2004, pp.82–107.

Miller, John: 'Icon II: Piero Monzoni's Merda d'artista: excremental value', *TATE ETC*, no.10, 2007, pp.40–3.

Keith Haring

Books

Celant, Germano (ed.): *Keith Haring*. Munich: Prestel-Verlag, 1992; 212p., illus. (some col.); bibl. pp.206–11.

Deitch, Jeffrey: *Keith Haring*. New York: Rizzoli, 2008; 522p.; col. illus.; colls., exhibs.

Gruen, John: *Keith Haring: the authorized biography*. New York: Simon and Schuster, 1991; 255p., col. illus.; bibl. pp.243–4, exhibs.

Kolossa, Alexandra: *Keith Haring, 1958–1990: a life for art*. Cologne: Taschen, 2006 (English trans.; originally published in German in 2004); 96p.; col. illus.; bibl. p.96, biog.

Exhibition catalogues

Keith Haring. Musée d'Art Contemporain de Lyon, 22 Feb. – 29 June 2008; ed. Gianni Mercurio; 366p. col. illus.; biog., colls., exhibs.

The Keith Haring Show. Triennale di Milano, Milan, 28 Sept. 2005 – 29 Jan. 2006; 404p., col. illus.; bibl. pp.398–404, biog., colls., exhibs.

Keith Haring: sculptures, paintings and works on paper. Ben Brown Fine Arts, London, 6 June – 28 Oct. 2005 (with a concurrent exhib. of five sculptures, Somerset House, London); 61p.; col. illus.; biog., exhibs.

Keith Haring, 1958–1990. Ludwig Forum für Internationale Kunst, Aachen, 29 Sept. – 26 Nov. 2000; 115p., col. Illus.; bibl. pp.109–15, biog., exhibs.

Keith Haring. Enrico Pedrini, Palazzo Lanfranchi, Pisa, 8 Dec. 1999 – 12 Mar. 2000; 119p.; bibl. pp.113–99, biog., colls., exhibs.

Keith Haring. Whitney Museum of American Art, New York, 25 June – 21 Sept. 1997; 295p.; col. illus.; biog., exhibs.

Keith Haring 1983. Galerie de Poche, Paris, 15 – 30 Jan. 1990; 40p.; illus.

Articles

Atkins, R: 'The strange case of Keith Haring', *Art in America*, vol.97, no.4, Apr. 2009, pp.43–4, 46–7.

Blinderman, B: 'Keith Haring's subterranean signatures' (interview), *Arts Magazine*, vol.56, Sept. 1981, pp.164–5.

Bousteau, Fabrice and Pierre Sterckx: 'Keith Haring ou l'art de la glisse', *Beaux Arts Magazine*, no.285, Mar. 2008, pp.82–5.

Caley, Shaun: 'Keith Haring' (interview), *Flash Art*, no.153, Summer 1990, pp.124–9.

Goodbody, Bridget: 'Affairs of the heart', *Art Review (International Edition)*, vol.2, no.6, part i.e.8, Sept. 2004, pp.90–3.

Haring, Keith: 'Keith Haring', *Flash Art*, no.116, Mar. 1984, pp.20–4.

Kerr, Merrily: 'Keith Haring's Pop Shop to close', *Art On Paper*, vol.9, no.6, July/Aug. 2005, p.16.

Perrone, J: 'Porcelain and pop', *Arts Magazine*, vol.58, Mar. 1984, pp.80–2.

Rubell, Jason: 'Keith Haring: the last interview', *Arts Magazine*, vol.65, Sept. 1990, pp.52–9.

Damien Hirst

Books

Fryer, Paul and Hirst, Damien: *Don't be so...* London: Trolly Ltd, 2002; 167p., col. illus.

Hirst, Damien: *I want to spend the rest of my life everywhere, with everyone, one to one, always, forever, now*. London: Booth-Clibborn Editions, 1997; 334p., col. illus.

James, Nicholas Philip: *Damien Hirst: the biopsy paintings and other works*. London: Cv Publications, c.2007; 28p.; biog.

Shone, Richard: *Damien Hirst: pictures from the Saatchi Gallery*. London: Booth-Clibborn Editions, 2002; 103p., col. illus.

Thümmel, Konstanze: '"Shark wanted": Untersuchungen zum Umgang zeitgenössisher Künstler mit lebenden und toten Tieren am Beispiel der Arbeiten von Damien Hirst...', Thesis (PhD.) Albert-Ludwigs-Universität zu Freiburg, 1997; 290p.; bibl. pp.253–90.

Exhibition catalogues

Damien Hirst: beyond belief. White Cube, London, 3 June – 7 July 2008; 182p., col. illus.

For the Love of God: Damien Hirst: the making of the Diamond Skull. White Cube, London, 3 June – 7 July 2007; 78p., col. illus.

In the darkest hour there may be light: works from Damien Hirst's Murderme collection. Serpentine Gallery, London, 25 Nov. 2006 – 28 Jan. 2007; [208]p. col. illus.; biogs.

Damien Hirst: 'Corpus: drawings 1981- 2006'. Gagosian Gallery, New York, 15 Sept. – 28 Oct. 2006; 408p., illus (some col.); awards., biog., colls., exhibs.

Damien Hirst: new religion. Paul Stolper Gallery, London, 13 Oct. – 19 Nov. 2005; 92p., col. illus.

Romance in the age of uncertainty: Damien Hirst. White Cube, London, 10 Sept. – 19 Oct. 2003; 143p., col. illus.

From the cradle to the grave: selected drawings: Damien Hirst. Tivoli Gallery, Ljubljana, 10 June – 28 Sept. 2003; 351p., col. illus.

Theories, models, methods, approaches, assumptions, results and findings: Damien Hirst. vol.1. Gagosian Gallery, New York, 23 Sept. – 16 Dec. 2000; 156p., col. illus.

Damien Hirst: no sense of absolute corruption. Gagosian Gallery, New York, 4 May – 15 June 1996; 124p., col.illus.; biog. pp.121–4.

Damien Hirst. Institute of Contemporary Arts, London, 13 Dec. 1991 – 2 Feb. 1992; 62p., illus. (some col.).

Articles

*'Damien Hirst: beautiful inside my head forever', *Sotheby's*, 15–16 Sept 2008.

Burton, Jane: 'Shark tactics: how Damien Hirst and his contemporaries became international art stars', *ARTnews*, vol.97, no.10, Nov. 1998, pp.137–9.

Ebony, David: 'Damien Hirst: to market, to market...', *Art in America*, vol.96, no.10, Nov. 2008, p.33.

*Jentleson, Katherine; Levine, Adam: 'After the Hirst-eria', *Art & Auction*, vol.32, no.5, Jan. 2009, p.96.

Lydiate, Henry: 'Beautiful inside my head forever', *Art Monthly*, no.321, Nov. 2008, p.37.

MacAdam, Alfred: 'Damien Hirst: Gagosian', *ARTnews*, vol.104, no.6, June 2005, p.117.

Morgan, Stuart: 'Damien Hirst: Stuart Morgan and Damien Hirst discuss life and death' (interview), *Frieze*, pilot issue, Summer 1991, pp.22–5.

*Restany, Pierre: 'Back into the pop era: Pierre Restany interviews Damien Hirst', *Domus*, no.806, July/Aug. 1998, pp.49–50.

Martin Kippenberger

Books

Martin Kippenberger: die gesamten Plakate 1977–1997. Zurich: Offizin Verlag Zürich; Cologne: Verlag der Buchhandlung Walther König, 1998. Catalogue raisonné of posters, published on the occasion of exhib. *Martin Kippenberger: Frühe Bilder, Collagen, Objekte, die gesamten Plakate und späte Skulpturen*, Kunstahus Zürich, 12 Sept. – 15 Nov. 1998; 222p., col. illus.; introductory essay by Bice Curiger.

Kippenberger, Martin: *Hotel hotel hotel*. Cologne: Verlag der Buchhandlung Walther König, 1995. c.[340]p.

Kock, Uwe: *Annotated catalogue raisonné of the books by Martin Kippenberger 1977–1997 = Kommentiertes Werk.verzeichnis der Bücher von Martin Kippenberger 1977–1997*. Cologne: Walther Konig, 2002; 335p., col. illus.

Muthesius, Angelika (ed.): *Martin Kippenberger: ten years after*. Cologne: Benedikt Taschen, 1991; 159p., col. illus.; bibl. pp.154–5, exhibs. pp.156–8.

Spiekermann, Heliod: *Kippenberger: frech und ungewohnlich am Beispiel = Kippenberger: fresh and unusual in mind*. Leipzig: Buchbinderei GmbH Grafik-Druck, 1994; 34p., illus.

Taschen, Angelika and Riemschneider, Burkhard (eds).: *Kippenberger*. Cologne and London: Taschen, 2003; 240p. col. illus.; bibl. and biog. pp.230–5, exhibs. pp.236–9

Würthle, Michel: *MK95: Martin Kippenberger 1995, Portraits: Albrecht Fuchs*. Cologne: Snoeck, c.2008; trans. Nicholas Grindell; [56]p., col. illus.

Exhibition catalogues

Martin Kippenberger: the problem perspective. Museum of Contemporary Art, Los Angeles, 21 Sept. 2008 – 5 Jan. 2009; 370p., col. illus.; bibl. pp.359–69, biog. pp.349–52, exhibs. pp.353–9.

Martin Kippenberger: Utopien für alle = Utopia for everyone. Kunsthaus Graz am Landesmuseum Joanneum, 15 Sept. 2007 – 6 Jan. 2008; ed. Peter Pakesch; 227p., col. illus.; biog pp.216–17, exhibs pp.218–21.

Martin Kippenberger. Tate Modern, London, 8 Feb. – 14 May 2006; K21 Kunstsammlung Nordrhein-Westfalen, Düsseldorf, 10 June – 10 Sept. 2006; eds. Doris Krystof and Jessica Morgan, 192p., col. illus; biog. pp.167–9, exhibs. pp.171–9.

Martin Kippenberger: The magical misery tour, Brazil. Gagosian Gallery, London, 23 Sept. – 4 Dec. 2004; 111p., col. illus.; biog. p.105, exhibs. pp.105–111.

Nach Kippenberger. Museum Moderner Kunst Stiftung Ludwig Wien, Vienna, 12 June – 31 Aug. 2003; Van Abbemuseum, Eindhoven, 22 Nov. 2003 – 1 Feb. 2004; eds. Eva Meyer-Hermann and Susanne Neuburger.

Martin Kippenberger: Das 2. Sein. Museum für Neue Kunst ZKM, Karlsruhe, 8 Feb. – 27 Apr. 2003; eds. Ralph Melcher and Andreas Schalhorn.

Hommage à Martin Kippenberger: Gitarren, die nicht Gudrun heissen. Galerie Max Hetzler, Berlin, 7 – 10 Mar. 2002; [59]p., col. illus.

Candidature á une Retrospective, Centre Georges Pompidou, Paris, 1993.

Kippenberger! 25.2.53 – 25.2.83: Abschied vom Jugendbonus! / vom Einfachsten nach House. Galerie Dany Keller, Munich, 25 Feb. – 26 Mar. 1983; [53]p., illus.

Der Kippenberger. Forum Kunst, Rottweil, 27 Feb. – 26 Mar. 1982; Studio f, Ulm, 31 Oct. – 28 Nov. 1982; 106p., illus.

Articles

'Obituaries: Martin Kippenberger', *Art in America,* vol.85, May 1997, p.142.

Gilmore, Jonathan: 'Thomas Bayrle at Gavin Brown's enterprise', *Art in America,* vol.94, no.10, Nov. 2006, pp.208–9.

Gingeras, Alison M: 'Performing the self: Alison M. Gingeras on Martin Kippenberger', *Artforum International,* 'Special Issue: Pop After Pop', vol.43, no.2, Oct. 2004, pp.253–5, 304–5.

*Rexer, Lyle: 'Martin Kippenberger at Nyehaus', *Art On Paper,* vol.9, no.6, July/Aug. 2005, p.63.

Verhagen, Marcus: 'Trash talking: how Martin Kippenberger found success in failure', *Modern Painters,* Feb. 2006, pp.67–9.

Jeff Koons

Books

Koons, Jeff and Robert Rosenblum: *The Jeff Koons handbook.* London: Thames & Hudson [published in association with the Anthony D'Offay Gallery], 1992; 174p., illus. (chiefly col.).

Sections of books

Weintraub, Linda: 'Honest: Jeff Koons' in Linda Weintraub: *Art on the edge and over: searching for art's meaning in contemporary society 1970s–1990s.* Litchfield, CT: Art Insights, 1996; 264p., col. illus.; ch.27, pp.197–204.

Exhibition catalogues

Jeff Koons: retrospective. Astrup Fearnley Museum of Modern Art, Oslo, 4 Sept. – 12 Dec. 2004; ed. Gunnar B. Kvaran; 256p., col. illus.; awards, biog. p.151, exhibs. pp.152–4.

Jeff Koons: pictures 1980–2002. Kunsthalle Bielefeld, 22 Sept. – 10 Nov. 2002; 112p., col. illus.; biog. pp.100–1, exhibs. pp.102–11.

Jeff Koons. Kunsthaus Bregenz, 18 July. – 16 Sept. 2001; ed. Eckhard Schneider; 134p., illus. (chiefly col.); bibl. pp.128–31.

Jeff Koons. San Francisco Museum of Modern Art, 10 Dec. 1992 – 7 Feb. 1993; Walker Art Center, Minneapolis, 10 July – 3 Oct. 1993; 132p., illus. (some col.).

Articles

'Collaborations: Jeff Koons', *Parkett,* no.19, 1989, p.28–69.

Avgikos, Jan: 'All that heaven allows: love, honor, and Koonst', *Flash Art,* no.171, Summer 1993, pp.80–3.

Burke & Hare: 'From full fathom five', *Parkett,* no.19, 1989, pp.44–7.

*Colman, David: 'K', *Interview,* Dec./Jan. 2009, pp.118–22, 201.

Koons, Jeff: [Art reproduction], *Art in America,* Nov. 1988, p.51.

Koons, Jeff: [Art reproduction], *Artforum International,* Nov. 1988, p.23.

Koons, Jeff: [Art reproduction], *Arts Magazine,* Nov. 1988, p.23.

Koons, Jeff: [Art reproduction], *Flash Art,* Nov./Dec. 1988, p.86.

Renton, Andrew: 'Jeff Koons: I have my finger on the eternal' (interview), *Flash Art,* vol.23, no.153, Summer 1990, pp.110–15.

Renton, Andrew: 'Jeff Koons and the Art of the Deal', *Performance,* no.61, Sept. 1990, pp.19–29.

Schjeldahl, Peter: 'Funhouse: A Jeff Koons retrospective', *The New Yorker,* 9 June 2008.

Siegel, Katy: 'Jeff Koons talks to Katy Siegel', *Artforum International,* Mar. 2003, pp.252–3, 283.

Sarah Lucas

Books

Robecchi, Michele. *Sarah Lucas: Supercontemporary* (*Supercontemporanei series*). Milan: Electa, 2007; 107p., col. illus.; bibl. pp.105–6, biog. pp.100–1, exhibs. pp.102–4;.

Exhibition catalogues

Sarah Lucas: exhibitions and catalogue raisonné 1989–2005. Tate Liverpool, 28 Oct. 2005 – 15 Jan. 2006; 195p., col. illus.; biog. pp.190–2.

Sarah Lucas: God is Dad. Gladstone Gallery, New York, 5 Feb. – 14 Mar. 2005; 39p., col. illus.; biog p.39.

Sarah Lucas: autoretrats I més sexe = autorretratos y más sexo = self-portraits and more sex. Centre Cultural Tecla Sala, Hospitalet de Llobregat, 9 Oct. 2000 – 7 Jan. 2001; 79p., col. illus.; bibl. pp.51–2.

Car park: eine Installation von Sarah Lucas im Museum Ludwig, Köln. Museum Ludwig, Cologne, 25 June. – 24 Aug. 1997; 23p., illus.; biog. and exhibs pp.22–3.

Sarah Lucas. Museum Boymans van Beuningen, Rotterdam, 4 Feb. – 31 Mar. 1996; 72p., illus.; bibl. p.69, biog. and exhibs. p.68.

Sarah Lucas: where's my moss. White Cube, London, 24 June – 10 Sept. 1994; 1p.

Articles

Adrichem, Jan Van; Freedman, Carl; Saltz, Jerry et al: 'Sarah Lucas' [5 article special section], *Parkett,* no.45, 1995, pp.76–115.

Bishop, C: 'Sarah Lucas: Sadie Coles HQ; Freud Museum, London' (exhibits.), *Artext,* no.70, Aug./Oct. 2000, pp.78–9.

Buck, Louisa: 'Sarah Lucas' (interview), *The Art Newspaper,* vol.11, no.102, 2000. pp.71–2.

*Falconer, M: 'Sarah Lucas : Zurich, Hamburg and Liverpool' (exhibit.), *The Burlington Magazine,* vol.148, Feb. 2006, pp.137–8

Gioni, Massimiliano: 'Sarah Lucas: au le jour = Sarah Lucas: hand to mouth' [inteview; translated by Jacques Demarcq], *Art Press,* no.321, Mar. 2006, pp.30–7.

*Harris, M: 'Sarah Lucas at St. John's Lofts and Sadie Coles HQ' (London; exhibits.), *Art in America,* vol.86, Jan. 1998, pp.106–7.

Kastner, Jeffrey: 'New York: fax' (exhibit.), *Art Issues,* no.55, Nov./Dec. 1998, pp.34–5.

Musgrave, David: 'Assuming positions', *Art Monthly,* no.209, Sept. 1997, pp.40–2.

Takashi Murakami

Sections of books

Brehm, Margrit (ed.): 'Takashi Murakami: A Lesson in Strategy (Morbid Double – Loop)' in *The Japanese experience – inevitable.* Ursula Blickle Stiftung Gallery, Kraichtal, 9 June – 14 July 2002; exhibs. pp.38–40; biog. p.37.

Brehm, Margrit (ed.): 'Art production now: HIROPON/ Kaikai Kiki Ltd.' in *The Japanese Experience – Inevitable.* Ursula Blickle Stiftung Gallery, Kraichtal, 9 June – 14 July 2002; pp.54–85.

Luna, Ian (ed.): 'Murakami Takashi', in *Tokyo life: art & design.* New York: Rizzoli, 2007; pp.334–43.

Murakami, Takashi: 'A theory of super flat Japanese art' in Takashi Murakami: *Superflat.* Tokyo: MADRA Publishing Co., 2000; 264p., illus. (some col.); pp.9–25.

Rothkopf, Scott: 'Takashi Murakami: company man' in Paul Schimmel (ed.): ©*MURAKAMI.* Los Angeles: The Museum of Contemporary Art, Los Angeles, 2007; pp.128–59.

Exhibition catalogues

©*MURAKAMI.* Museum of Contemporary Art, Los Angeles, 29 Oct. 2007 – 11 Feb. 2008; and touring to: Brooklyn Museum of Art, New York; Museum für Moderne Kunst, Frankfurt; Guggenheim Museum, Bilbao, until May 2009; 327p., col. illus. (some folded); bibl. pp.306–12, exhibs. list of works pp.300–5.

Little boy: the arts of Japan's Exploding Subculture. Japan Society Gallery, New York, 8 Apr. – 24 July 2005; ed. Takashi Murakami, 298p., col. illus.

Summon Monsters? Open the door? Heal? Or Die? Museum of Contemporary Art, Tokyo, 25 Aug. – 4 Nov. 2001; 168p., illus. (some col.); bibl. pp.154–9.

My reality: contemporary art and the culture of Japanese animation. Des Moines Art Center, 10 Feb. – 6 May 2001 and touring to: Brooklyn Museum of Art, New York; The Contemporary Arts Center, Cincinnati; Tampa Museum of Art; Chicago Cultural Center; Akron Art Museum, Ohio; Norton Museum of Art, West Palm Beach; The Huntsville Museum of Art, Alabama, until 4 Jan. 2004; 80p., col. illus.; biog., exhibs. pp.75–6.

Superflat. Parco Gallery, Tokyo, 2000; and touring to: Parco Gallery, Nagoya; Museum of Contemporary Art, Los Angeles; Walker Art Center, Minneapolis; Henry Art Gallery, Seattle, until 3 Mar. 2002; ed. Takashi Murakami; 264p., illus. (some col.); biog.; see pp.40–1.

Takashi Murakami: the meaning of the nonsense of the meaning. Center for Curatorial Studies, New York, 27 June – 12 Sept. 1999; 94p. (some folded), col. illus.; bibl. pp.92–3, exhibs. pp.90–1.

Articles

Buck, Louisa: 'Focus on Japan: the Louis Vuitton project is my urinal!' (interview), *Art Newspaper,* Oct. 2007, no.184, pp.35–6.

Cotter, Holland: 'Carving a pop niche in Japan's classical tradition', *New York Times,* 24 June 2001, section 2, pp.31–2.

Drohojowska-Philp, Hunter: 'Pop goes the usual boundaries', *Los Angeles Times,* 14 Jan. 2001, p.4, 79.

Heartney, Eleanor: 'A marriage of trauma and kitsch', *Art in America,* Oct. 2005, no.9, pp.56–61.

Itoi, Kay: 'The Wizard of Dob', *Art News,* vol.100, no.3, Mar. 2001, pp.134–7.

Kaplan, Cheryl: 'Takashi Murakami: lite happiness + the super flat', *Flash Art,* July/Sept. 2001, pp.94–7.

Marks, Peter: 'A Japanese artist goes global (email helps)', *New York Times*, 25 July 2001, p.B1, B5.

Nakamura, Eric: 'Takashi Murakami: Superflat's not dead', *Giant Robot*, no.45, Jan./Feb. 2006, pp.42–5.

Pagel, David: 'Paintings in the midst of generational conflict', *Los Angeles Times*, 1 Aug. 1997, p.F28.

Roberts, James: 'Magic mushrooms', *Frieze*, Oct. 2002, pp.66–71.

Rubinstein, Raphael: 'In the realm of the Superflat', *Art in America*, vol.89, no.6, June 2001, pp.111–15.

Siegel, Katy: 'Planet Murakami', *Art Review*, July 2003, pp.46–53.

Smith, Roberta: 'Takashi Murakami', *New York Times*, 5 Feb. 1999, p.B35.

Smith, Roberta: 'Takashi Murakami', *New York Times*, 6 Apr. 2001, p.B36.

Wilson, Glen: 'Takashi Murakami meet Japan's pop art Samurai', *Interview*, Mar. 2001, pp.188–90.

Peter Nagy

Articles

'Peter Nagy' (Galerie Georges-Philippe Vallois, Paris; review), *L'Oeil*, no.446, Nov. 1992, p.84.

'Peter Nagy' (International with Monument Gallery, New York; review), *Arts Magazine*, vol.59, April 1985, pp.38–9.

Frankel, David: 'Kim MacConnel, Jeff Perrone; Peter Nagy', *Artforum International*, vol.36, no.2, Oct. 1997, p.93.

Gookin, Kirby: 'Peter Nagy: Jay Gorney Modern Art' (New York; review), *Artforum International*, vol.27, no.6, Feb. 1989, pp.132–3.

Taylor, Paul: 'Peter Nagy: mapping time travel' (interview), *Flash Art*, vol.24, no.156, Jan./Feb. 1991 pp.106–9.

Richard Prince

Books

Brooks, Rosetta, Jeff Rian and Luc Sante: *Richard Prince*. London: Phaidon Press, 2003; 160p., col. illus.; bibl. pp.159–60, biog. and exhibs. pp.144–58.

Coetzee, Mark: *American dream: collecting Richard Prince for 27 years: Rubell Family Collection*. Miami: Rubell Family Collection, 2004; bibl. pp.78–110, colls., exhibs.

Newman, Michael: *Richard Prince: untitled (couple)*. London: Afterall, 2006; 165p. (incl. 10p. of plates), col. illus.; bibl.

Prince, Richard: *Second house*. New York: Gladstone Gallery; Cologne: Walther König, 2005; c.[224] p.: col. illus.

Prince, Richard: *Richard Prince: women*. Los Angeles and Ostfildern-Ruit: Regen Projects in association with Hatje Cantz Publishers, 2004; [176]p., col. Illus.

*Prince, Richard, and Taka Kawachi (eds.): *Richard Prince: 4 X 4*. Kyoto: Korinsha Press, 1997; [15]p., 88p. of plates, illus. (chiefly col.).

*Prince, Richard: *Richard Prince: adult comedy action drama*. New York: Scalo, 1995; 239p., col. illus.

Prince, Richard: *Inside world*. New York: Kent Fine Art: Thea Westreich, 1989; 85p., illus.

Prince, Richard: *War pictures*. New York: Artists Space, 1980; [12]p., 1 illus.

Prince, Richard: *Menthol wars*. Richard Prince, 1980; 22p., 1 illus.

Prince, Richard: *Menthol pictures*. Buffalo: GEPA Gallery, c.1980; [18]p., 1 illus.

Sections of books

*Prince, Richard: 'Standing In Line (With Mr. Jimmy)' in D'Orazio, Sante (ed.): *Pam: American Icon*. Munich: Schirmer/Mosel and Stellan Holm Gallery, 2005; pp.28–33.

Exhibition catalogues

Richard Prince: canal zone / words by James Frey. Gagosian Gallery, New York, 8 Nov. – 20 Dec. 2008; 91p., col. illus.

Richard Prince: America goes to war… swimming in the afternoon… Serpentine Gallery, London, 26 June – 7 Sept. 2008; [128]p., col. Illus.

Richard Prince. Solomon R. Guggenheim Museum, New York, 28 Sept. 2007 – 9 Jan. 2008; and touring to: Walker Art Center, Minneapolis; Serpentine Gallery, London, until Summer 2008; ed. Nancy Spectre; 371p., col. illus.; bibl. pp.362–71, colls., exhibs. pp.350–61.

Richard Prince. Sammlung Goetz, Munich, 22 Nov. 2004 – 7 May 2005; 168p., col. illus.; bibl., exhibs.

Richard Prince: nurse paintings. Barbara Gladstone Gallery, New York, 20 Sept. – 25 Oct. 2003.

Richard Prince: publicities: works from the Ophiuchus Collection (10 works). Hydra Workshop, Hydra, 19 July – 6 Sept. 2003; 15p.; col. illus.

Richard Prince: Zeichnungen 1989–1996. Museum Haus Lange and Museum Haus Esters, Krefeld, Feb – Mar. 1997; [15]p., col. illus.

Richard Prince. Jablonka Galerie, Cologne, 8 Nov. – 21 Dec. 1996; [8]p., 8p. of col. plates.

Richard Prince: photographien = photographs, 1977–1993. Kestner-Gesellschaft, Hanover, 3 June – 24 July 1994; eds. Carsten Ahrens and Carl Haenlein; 119p., col. illus.; bibl. and biog. pp.109–15, exhibs. pp.105–9.

Richard Prince. Whitney Museum of American Art, New York, 1 May – 12 July 1992; and touring to Kunstverein, Düsseldorf; San Francisco Museum of Modern Art; Museum Boijmans van Beuningen, Rotterdam, until 27 Nov. 1993; 192p., col. Illus.; bibl. pp.185–8.

Pamphlet. Le Nouveau Musée, Villeurbanne, 21 Jan. – 6 Mar. 1983; biog. p.32.

Articles

Ammirati, Domenick: 'Everyone knows this is nowhere' (interview), *Modern Painters*, Sept. 2007, pp.66–73.

*Appel, Brian: 'Interview: Richard Prince', *Photograph Collector*, 20 Nov. 2007, pp.1–9.

Crimp, Douglas: 'Crimp my style' (letter), *Artforum International*, Summer 2003, p.18.

Deitcher, David: 'Popisms: spiritual America: David Deitcher on pre-teen spirit', *Artforum International*, vol.43, no.2, Oct. 2004, pp.89–90.

Graw, Isabelle: 'Wiederaufbereitung: [Richard Prince]', *Wolkenkratzer Art Journal*, no.2, 1988, pp.34–7.

Halley, Peter: 'Richard Prince interviewed by Peter Halley', *ZG*, no.10, Spring 1984, pp.5–6.

Heartney, Eleanor: 'The strategist', *Art in America*, Mar. 2008, pp.144–51.

Hilty, Greg: 'Diamonds and dirt: Richard Prince's greatest hits', *Frieze*, no.1, 1991, pp.24–31; includes '20 questions', p.29, and reprinted interview with Richard Prince by J.S. Ballard from 1967, pp.30–1.

Lafreniere, Steve: 'Richard Prince talks to Steve Lafreniere', *Artforum International*, vol.41, no.7, Mar. 2003, pp.70–1, 264.

*Longo, Robert: 'Richard Prince', *Interview*, vol.17, no.11, Nov. 1987, pp.104–7.

*Nicholson, Geoff: 'Rare bits & pieces', *Bookforum*, Feb./Mar. 2009, p.6.

*O'Brien, Glenn: 'Richard Prince', *Interview*, Dec./Jan. 2009, pp.108–17, 201.

Prince, Richard: 'Liar liar' (reply to letter of Douglas Crimp), *Artforum International*, Summer 2008, pp.38–40.

Prince, Richard: 'Anyone who is anyone', *Parkett*, no.6, 1985; pp.67–70.

*Prinz, Eva: 'Richard Prince: photographer painter thief?', *Index Magazine*, Apr./May 2005, pp.36–43,

*Therond, Eve: 'Intimate Prince', *Whitewall*, Spring 2006, pp.90–103.

Wallis, Brian: 'Mindless pleasure: Richard Prince's imitation art', *Parkett*, no.6, 1985; pp.61–6.

Pruitt Early

Books

Rob Pruitt: 101 art ideas you can do yourself. [S.l.: s.n.], 1999

Articles

'Rob Pruitt: 09/16/2006 – 10/14/2006: Press Release' Gavin Brown's enterprise, New York, <http://www.gavinbrown.biz /exhibitions/view/rob-pruitt>.

Bussel, David: 'Pruitt-Early: 303 Gallery' (New York; exhibit.), *Flash Art*, vol.24, no.156, Jan./Feb. 1991, pp.134–5.

Dailey, Meghan: 'Rob Pruitt: Gavin Brown's Enterprise' in *Artforum International*, vol.39, no.9, May 2001, pp.177–8.

Fineman, Mia: 'Back in the arms of the art world', *New York Times*, 17 June 2001, p.30.

Gangitano, Lia : 'Home & away: Gavin Brown's enterprise, New York' in *C Magazine*, no.60, Nov. 1998/Jan. 1999, p.51.

Johnson, Ken: 'Pruitt and Early at Castelli' (Leo Castelli Gallery, New York; exhibit.), *Art in America*, vol.80, Apr. 1992, p.164.

*Mar, Alex: 'State of the arts', *Art Review* (London), vol.3, no.11, Nov./Dec. 2005, pp.45–6.

Martens, Anne: 'Robert Pruitt' in *Flash Art*, vol.41, May/June 2008, p.163.

Rimanelli, David: 'Pruitt-Early: Leo Castelli Gallery' (New York; installation), *Artforum International*, vol.30, Mar. 1992, pp.102–3.

Saltz, Jerry: 'So low can't get under it: Pruitt & Early's "Sculpture for teenage boys, (Pabst pyramid, 13 high)", early '90s', *Arts Magazine*, vol.65, Dec. 1990, pp.27–8.

Troncy, Eric: 'Being positive is the secret of the 90s: a comment on the politically correct epidemic', *Flash Art*, vol.25, no.164, May/June 1992, pp.96–9.

Weissman, Benjamin: 'Pruitt-Early: Stuart Regen' (Los Angeles; exhibit.), *Artforum International*, vol.29, Summer 1991, pp.120–1.

Yau, John: 'Pruitt-Early', *Arts Magazine*, vol.66, Apr. 1992, p.77.

David Robbins

Books

Robbins, David: *The ice cream social*. New York: Purple Books/Feature Inc., 1998; 58p.

Robbins, David: *The velvet grind: selected essays, interviews, satires (1983-2005)*. Zürich: JRP Ringier; Dijon: Les Presses du réel, c.2006; eds. Lionel Bovier and Fabrice Stoun; 319p.

Exhibition catalogues

Likeness: portraits of artists by other artists. CAA Wattis Institute for Contemporary Art, San Francisco, 27 Feb. – 8 May 2004; 71p., illus. (some col.); biogs.

Articles

Bankowsky, Jack: Group show (Metro Pictures, New York; exhibit.), *Flash Art*, no.135, Summer 1987, pp.107–8.

Budney, Jen: 'David Robbins: Feature', *Flash Art*, vol.28, no.182, 1995, p.113.

Decter, Joshua: 'New York in review' (American Fine Arts, Co, New York; exhibit.), *Arts Magazine*, vol.64, Feb. 1990, p.94.

Estep, Jan: 'Do you consider this a career?' (interview), *New Art Examiner*, vol.26, no.2, Oct. 1988, pp.26–31.

Rimanelli, David: [American Fine Arts Co, New York; exhibit.], *Artforum International*, vol.28, no.4 Dec. 1989, p.139.

Salvioni, Daniella: 'The David Robbins Show' (Nature Morte Gallery, New York; performance], *Flash Art*, no.130, Oct./Nov. 1986, p.77.

Sturtevant

Books

*Waters, John and Bruce Hainley. *Art: a sex book*. London: Thames & Hudson, 2003; 207p., illus. (some col.); bibl. p.200.

Exhibition catalogues

Sturtevant: the brutal truth. Museum für Moderne Kunst, Frankfurt-am-Main, 25 Sept. 2004 – 30 Jan. 2005; eds. Udo Kittelmann and Mario Kramer; 214p., illus. (some col.); bibl., pp.211–14, biog., colls., exhibs.

Sturtevant: shifting mental structures. Neuer Berliner Kunstverein, Berlin, 9 Mar. – 21 Apr. 2002. [105]p., col. illus.

Sturtevant: 1225 objects à Casino Luxembourg. Casino Luxembourg, 17 July – 22 Aug. 1999; [20]p., illus. (some col.).

Sturtevant. Galerie Thaddaeus Ropac, Paris, 9 Mar. – 6 Apr. 1991; [10]p., illus.; biog, exhibs., films.

Articles

Bader, Jeorg: 'Elaine Sturtevant: 'l'eternel retour des chefs-d'oeuvre = the eternal return of masterpieces' (interview), *Art Press*, no.236, June 1998, pp.31–5.

Cameron, Dan: 'A conversation: a salon history of appropriation with Leo Castelli and Elaine Sturtevant', *Flash Art*, no.143, Nov. – Dec. 1988, pp.76–7.

Hainley, Bruce: 'Sturtevant talks to Bruce Hainley', *Artforum International*, vol.41, no.7, Mar. 2003, pp.246–7.

Hainley, Bruce: 'Erase and rewind: Bruce Hainley on Elaine Sturtevant', *Frieze*, no.53, June/July. 2000, pp.82–7.

Lobel, Michael: 'Sturtevant: inappropriate appropriation', *Parkett*, no.75, Feb. 2006, pp.142–53.

Princenthal, Nancy: 'The other truth', *Art in America*, vol.93, no.11, Dec. 2005, pp.102–7, 167.

Wright, Karen: 'Déja vu: Sturtevant. Even better than the real thing?', *Modern Painters*, May 2005, pp.88–93.

Wulffen, T: 'Elaine Sturtevant: how the reference works' (interview), *Flash Art*, vol.25, no.166, Oct. 1992, p.128.

Gavin Turk

Books

Barrett, David and Lucy Head (eds.): *Gavin Turk (New Art Up-Close 2)*. London: Royal Jelly Factory, 2004; 48p., col. illus.; bibl. p.48, biog.

Sections of books

Millard, Rosie: *The Tastemakers: UK art now*; photographs by Geraint Lewis; artwork by Adam Dant. London: Thames & Hudson, 2001. 258p., col. illus.

Exhibition catalogues

Starstruck: contemporary art and the cult of celebrity. New Art Gallery, Walsall, 25 Apr. – 15 June 2008; 72p., col. illus.; biog. pp.9–10; see Turk pp.64–5,.

Gavin Turk: 'Me as him'. Riflemaker, London, 3 July – 1 Sept. 2007, 31p., col. illus.

The font project: Gavin Turk, 2006. Fine Art Society, London, 4 Oct. – 2 Nov. 2006; 155p., illus.

Copper Jubilee: Gavin Turk. The New Art Gallery, Walsall, 28 June – 1 Sept. 2002; 76p., col. illus.

Young British artists IV: John Frankland, Marcus Harvey, Brad Lochore, Marcus Taylor, Gavin Turk. Saatchi Collection, London, 1995; [14]p., illus.; bibl., exhibs.

Gavin Turk. Jay Jopling, London, 3 Dec. 1993 – 16 Jan. 1994.

Gavin Turk: collected works 1989–1993. White Cube, London, 3 Dec. 1993 – 16 Jan. 1994; [54]p., col. illus.

Articles

Bethemont, Hauviette: 'Gavin Turk: Centre d'art contemporain, 22 Sept. – 21 Jan. 2001', *Art Press*, no.264, Jan. 2001, pp.71–2

Bezzan, Cecilia: 'Gavin Turk: Le Magasin: 3 June – 2 Sept. 2007', *Art Press*, no.338, Oct. 2007, pp.88–9

Bezzan, Cecilia: 'Gavin Turk: Galerie Almine Rech, 5 Nov. – 23 Dec. 2005', *Art Press*, no.320, Feb. 2006, pp.88–9

Burrows, David: 'Exquisite corpses', *Art Monthly*, no.221, Nov. 1998, pp.24–5

*Coulson, Amanda: 'Diamond Dust Portfolio', *Art On Paper*, vol.8, no.4, Mar./Apr. 2004, pp.30–1.

Gavin, Francesca: 'The Youth of Today: 7 Apr. – 25 June, Schirn Kunsthalle', *Art Review*, no.1, July 2006, p.140.

Pollack, Barbara: 'Gavin Turk: Sean Kelly', *ARTnews*, vol.104, no.4, Apr. 2005, pp.128, 130.

*Preece, Robert: 'Gavin Turk' (interview), *Sculpture*, vol.24, no.3, Apr. 2005, pp.20–1.

Roberts, James: 'Last of England: Gavin Turk interviewed by James Roberts', *Frieze*, no.13, Nov. – Dec. 1993, pp.28–31.

Piotr Uklański

Exhibition catalogues

Piotr Uklański: Bialo-Czerwona. Gagosian Gallery, New York, 27 Mar. – 17 May 2008; 151p., col. Illus.

Piotr Uklański: the joy of photography. Musée d'Art Moderne et Contemporain, Strasbourg, 25 Oct. 2007 – 9 Mar. 2008; 103p., col. illus.

Superstars: das Prinzip der Prominenz von Warhol bis Madonna. Kunsthalle Wien, Vienna, 4 Nov. 2005 – 22 Feb. 2006; 319p., col. illus.; colls.

Nuit blanche. Festival, Paris, 2 Oct. 2004; 128p., col. illus., + 1 CD.

Piotr Uklanski: zimna wojna. Galleria Massimo De Carlo, Milan, 29 Sept. – 16 Nov. 2004; 48p., col. illus.

Piotr Uklanski: earth, wind, and fire. Kunsthalle Basel, 17 June – 22 Aug. 2004; 240p. (some folded), col. illus.; bibl. pp.222–33

Assuming positions: objects of art: lounge core, beige revolution. Institute of Contemporary Art, London, 12 July – 28 Sept. 1997; [30]p., illus. (some col.).

Articles

Cattelan, Maurizio and Piotr Uklanski: 'A Conversation: Uklanski/Cattelan: earth, wind, and fire', *Flash Art*, vol.37, no.236, May – June 2004, pp.92–4.

Moreno, Gean: 'Piotr Uklanski: Galerie Emmanuel Perrotin, Miami' (exhib. review), *ArtUS*, no.12 Mar./Apr. 2006, p.39.

Trembley, Nicolas: 'Piotr Uklanski: I wanted to go to Hollywood!', *Art Press*, no.302, June 2004, pp.40–5.

Meyer Vaisman

Sections of books

Weintraub, Linda: 'Humor: Meyer Veiserman' in Weintraub, Linda: *Art on the edge and over: searching for art's meaning in contemporary society 1970s–1990s*. Litchfield, CT: Art Insights, 1996; 264p., col. illus.; ch.28, pp.205–11.

Exhibition catalogues

Jump cuts: Venezuelan contemporary art: Colección Mercantil. Americas Society Art Gallery, New York, 24 Feb. – 21 May 2005; 156p., col. illus.; bibl., biogs., exhibs.

Meyer Vaisman. Galeria Camargo Vilaça, São Paulo, 4–27 Aug. 1999; [8]p. folded card.

Border crawl. Kukje Gallery, Seoul, 10 Feb. – 7 Mar. 1995; [44]p., col. illus.; awards, biogs., exhibs.

Dan Graham, Rodney Graham, Mike Kelley, Paul McCarthy, Danny Oates, Richard Prince, Meyer Vaisman, Jeff Wall. Gimpel Fils, London, 28 June – 3 Sept. 1994.

Meyer Vaisman: obras recientes. Centro Cultural Consolidado, Caracas, 16 Mar. – 9 May 1993; [10]p., col. illus.

Meyer Vaisman. Waddington Galleries, London, 1–24 Nov. 1990; [28]p., col. illus.; bibl., biog., exhibs.

Meyer Vaisman. Jablonka Galerie, Cologne, 1989; [20]p., col. illus.; bibl., biog., exhibs.

Articles

Cameron, Dan: 'Who is Meyer Vaisman?', *Arts Magazine*, vol.61, Feb. 1987, pp.14–17.

Cameron, Dan: 'Meyer Vaisman: a comedy of ethics' (Sonnabend Gallery, New York; exhibit], *Flash Art*, vol.23, no.153, Summer 1990, p.137.

*Dunlop, Jennifer: 'Meyer Vaisman at Patrick Painter', *Art Issues*, no.68, Summer 2001, p.54.

*Knode, Marilu: 'Ultrabaroque: aspects of post-Latin American art: Museum of Contemporary Art, San Diego', *Artext*, no.72 Feb./Apr. 2001, pp.83–4.

Leffingwell, Edward: 'Meyer Vaisman at Gavin Brown's enterprise [New York]', *Art in America*, vol.88, no.11, Nov. 2000, p.162.

Lewis, Jim: 'Poultryculturalism: Meyer Vaisman dresses the bird', *Artforum International*, vol.31, Nov. 1992, pp.90–1.

*Pagel, David: (Leo Castelli Gallery, New York; exhibit], *Artweek*, vol.19, 3 Dec. 1988, p.3.

Andy Warhol

Books

Bockris, Victor: *Warhol: the biography*. London: Frederick Muller, 1989; 528p., illus.; bibl. pp.502–3, exhibs. pp.496–502; see 'Andy Warhol's last loves 1982–85' [on his relationship with Basquiat], pp.460–70.

Bourdon, David: *Warhol*. New York: Harry N Abrams, 1989; 432p., illus. (some col.); bibl. pp.419–22.

*Colacello, Bob: *Holy terror: Andy Warhol close up.* New York: Harper Collins, 1990; 514p., illus.

Dalton, David (with photographs by David McCabe): *A year in the life of Andy Warhol.* New York: Phaidon, 2003; 239p., illus.; bibl. p.238.

Garrels, Gary (ed.): *The work of Andy Warhol: Discussions in Contemporary Culture, no. 3.* New York: Dia Art Foundation, in association with Bay Press, Seattle, 1989; 196p., illus.; see 'Warhol in context' by Charles F. Stuckey, pp.3–33.

Goldsmith, Kenneth (ed.): *I'll be your mirror: the selected Andy Warhol interviews: 1927–1987.* New York: Carroll & Graf Publishers, 2004; 427p., illus.; see 'Afterword: Warhol's interviews' by Wayne Koestenbaum, pp.395–7.

Hackett, Pat (ed.): *The Andy Warhol diaries.* New York: Warner Books, 1989; 807p., illus.

Hackett, Pat and Warhol, Andy: *Andy Warhol's party book.* New York: Crown Publishers, 1988; 148p. illus.

Koch, Stephen: *Stargazer: Andy Warhol's world and his films.* 1st ed., New York: Praeger, 1973; 155p., illus.; filmog. pp.143–51. (2nd ed., 1985)

*Koestenbaum, Wayne: *Andy Warhol.* New York: Viking Penguin, 2001; 196p., illus.; bibl. pp.190–6.

Pratt, Alan R. (ed.): *The critical response to Andy Warhol.* Westport, CA, and London: Greenwood, 1997; 306p.; bibl. pp.291–6.

Watson, Steven: *Factory made: Warhol and the sixties.* New York: Pantheon, 2003; 490p., illus.; bibl. pp.457–62.

Wiehager, Renate: *Andy Warhol: cars and business Art.* Stuttgart: DaimlerChrysler AG, 2002; 143p., col. illus.

Sections of books

Buchloh, Benjamin H.D: 'Andy Warhol's one-dimensional art: 1956–1966', in Michelson, Annette (ed.): *Andy Warhol (October files 2).* Cambridge, MA: The MIT Press, 2001; pp.1–46.

*James, David E: 'The unsecret life: a Warhol advertisement', in *Power Misses: Essays across (un)popular culture.* New York: Verso, 1996; ch. 7, pp.153–71.

Michelson, Annette: '"Where is your rupture?": mass culture and the *Gesamtkunstwerk*' in Michelson, Annette (ed.): *Andy Warhol (October files 2).* Cambridge, MA: The MIT Press, 2001; pp.91–110.

Exhibition catalogues

Warhol TV. La Maison Rouge Paris, 18 Feb. – 3 May 2009; ed. Judith Benhamou-Huet.

Warhol live: music and dance in Andy Warhol's work. Montreal: Montréal Museum of Fine Arts, 25 Sept. 2008 – 4 Jan. 2009; and touring to: Fine Arts Museums of San Francisco, de Young; Andy Warhol Museum, Pittsburgh, until 15 Sept. 2009; ed. Stéphane Aquin; 286p., illus. (some col.).

Andy Warhol. Queensland Art Gallery, Brisbane, 8 Dec. 2007 – 30 Mar. 2008; 319p., col. illus.

Andy Warhol: other voices, other rooms. Stedelijk Museum, Amsterdam, 12 Oct. 2007 – 13 Jan. 2008; and touring to: Moderna Museet, Stockhom; Hayward Gallery, London, until 18 Jan. 2009; ed. Eva Meyer-Hermann; 256p., ill. (some col.). see '"Oh when will I be famous; when will it happen?": Andy Warhol In The Picture: Self-Portraits and Self-Promotion' by Hubertus Butin, pp.47–55.

Andy Warhol: a guide to 706 items in 2 hours 56 minutes. Stedelijk Museum, Amsterdam, 12 Oct. 2007 – 13 Jan. 2008; Moderna Museet, Stockholm, 9 Feb. – 4 May 2008; ed. Eva Meyer-Hermann; 256p., illus. (some col.).

Cast a cold eye: the late work of Andy Warhol. Gagosian Gallery, New York, 25 Oct. – 22 Dec. 2006; 288p. (some folded), col. illus.

Andy Warhol: Supernova: stars, deaths, and disasters, 1962–1964. Walker Art Center, Minneapolis, 13 Nov. 2005 – 26 Feb. 2006; 111p., illus. (some col.).

Andy Warhol: the late work. Museum Kunst Palast, Dusseldorf, 14 Feb. – 31 May 2004; ed. Mark Francis; 3 vol., illus (some col.); bibl. pp.190–6; see 'Late Warhol' pp.8–9 and 'Horror vacui: Andy Warhol's installations' pp.10–20.

Andy Warhol: retrospective. Neue Nationalgalerie, Berlin, 2 Oct. 2001 – 6 Jan. 2002; and touring to: Tate Modern, London; Museum of Contemporary Art, Los Angeles, until 8 Aug. 2002; 319p., illus. (some col.); bibl. pp.314–18.

Andy Warhol: social observer. Pennsylvania Academy of the Fine Arts, Philadelphia, 17 June – 21 Sept. 2000; Corcoran Gallery of Art, Washington, 22 Dec. 2000 – 12 Mar. 2001; ed. Jonathan P Binstock; 64p., illus (some col.); bibl. p.64.

Andy Warhol: photography. Hamburger Kunsthalle, Hamburg, 13 May – 22 Aug. 1999; 398p., ill. (some col.), facsims; bibl. p.382–3, biogs; exhibs; see: '"Oh when will I be famous; when will it happen?": Andy Warhol's Society Photos'.

The Warhol look: glamour, style, fashion. Whitney Museum of American Art, New York, 8 Nov. 1997 – 18 Jan. 1998 and touring until spring 1999 to: Art Gallery of Ontario, Toronto; Barbican Art Gallery, London; Musée de la Mode, Marseille; Museum of Contemporary Art, Sydney; Andy Warhol Museum, Pittsburgh.

Andy Warhol: 1956–1986, mirror of his time. Museum of Contemporary Art, Tokyo, 17 Apr. – 23 June 1996 and touring to: Fukuoka Art Museum, Fukuoka; Hyogo Prefectural Museum of Modern Art, Kobe, until 17 Nov. 1996; 317p., illus. (some col.).

'Success is a job in New York…': the early art and business of Andy Warhol. Grey Art Gallery and Study Center, New York, 14 Mar. – 29 April 1989 and touring to: The Carnegie Museum of Art, Pittsburgh; University of Pennsylvania, Philadelphia; Institute of Contemporary Art, London; ed. Donna M. De Salvo; 92p., illus. (some col.).

Articles

Bankowsky, Jack: 'Words around Warhol', *Artforum International*, Apr. 1989, pp.142–3.

*Crimp, Douglas: 'Getting the Warhol we deserve', *Social Text 59*, vol.17, no.2, Summer 1999, pp.49–66.

James, David E.: 'The unsecret life: a Warhol advertisement', *October*, vol.56, Spring 1991, pp.21–41.

Pécoil, Vincent: 'Brand Art: Vincent Pécoil on art after Warhol', *Art Monthly*, no.265, Apr. 2003, pp.1–4.

Pendle, George: 'How unlike you: the phony Warhol and other artistic imposters', *Modern Painters*, vol.20, no.10, Dec. 2008/Jan. 2009, pp.68–73.

Prince, Richard: 'Guns and poses', *Artforum International*, Oct. 2004, p.143.

Young British Artists

Exhibition catalogues

In-a-gadda-da-vida: Angus Fairhurst, Damien Hirst, Sarah Lucas. Tate Britain, London, 3 Mar. – 31 May 2004; 111p., col. illus.

British contemporary. National Museum of Contemporary Art, Seoul, 28 Oct. 2003 – 31 Jan. 2004; 94p., col. illus.; biogs., exhibs.; see Hirst, pp.19–28, biog. p.86, Emin, pp.37–43, biog. p.88; Turk, pp.81–3, biog. p.95.

* *Distinctive elements: contemporary British art exhibition.* National Museum of Contemporary Art, Seoul, 28 Aug. – 20 Oct. 1998; 200p., col. illus.; bibl., biogs., colls., exhibs.

* *Pictura Britannica: art from Britain.* Museum of Contemporary Art, Sydney, 22 Aug. – 30 Nov. 1997; 238p., col. illus.; biogs.

Minky Manky. South London Gallery, London, 12 Apr. – 14 May 1995; [48]p. illus., (some col.); see Emin, pp.34–7; Hirst, pp.42–5; Lucas, pp.4–7.

Freeze. Docklands (PLA Building, Plough Way), London, 6 Aug. – 14 Nov. 1988; [48]p., illus. (some col.).

Articles

Bickers, P. 'Editorial: the usual suspects' [the YBAs in various exhibitions], *Art Monthly*, no.201, Nov. 1996, p.16.

Bush, Kate: 'Popisms: Young British Art: Kate Bush on the YBA Sensation', *Artforum International*, vol.43, no.2, Oct. 2004, pp.103, 105–6, 281, 283.

Elwes, Luke: 'At issue: look before you think' [contemporary British art scene], *Modern Painters*, vol.10, Winter 1997, p.107.

*Engberg, Juliana: 'Pictura Britannica', *Art/Text*, no.60, Feb./Apr. 1998, pp.80–1.

Ford, Simon: 'Myth making: Simon Ford on the phenomenon of the young British artist', *Art Monthly*, no.194, Mar. 1996, p.3–9.

Gaywood, James: '"YBA" as critique: the socio-political inferences of mediated identity of recent British art' [from the *Freeze* shows to 1997], *Third Text*, no.40, Autumn 197, pp.3–12.

Kino, Carol: 'Report from London: life after YBA-mania', *Art in America*, vol.90, no.10, Oct. 2002, pp.78–85.

Lamy, Frank: 'Pin-up, glamour and celebrity: star système' (exhibit.), *Beaux Arts Magazine*, no.224, Jan. 2003, p.32.

Legge, Elizabeth: 'Reinventing derivation: roles, stereotypes and "Young British Art"', *Representations*, no.71, Summer 2000, pp.1–23.

Shone, Richard: 'London: "Ant noises" and "Outthere"' (exhibits.), *The Burlington Magazine*, vol.142, no.1168, July 2000, pp.455–6.

List of Works

Dimensions are given in centimetres, height before width.

Not all works will be shown at all venues.

Ashley Bickerton
(born 1959)

Tormented Self-Portrait (Susie at Arles) 1987–8
Acrylic, bronze powder and lacquer on wood, anodised aluminium, rubber, plastic, Formica, leather, chrome plated steel, and canvas
227.1 x 174.5 x 40 cm
The Museum of Modern Art, New York. Purchased 1988
[pp.23, 110]

Still Life (The Artist's Studio after Braque) 1988
Mixed media construction with black leather covering
86.4 x 158.7 x 90.2 cm
Private collection, Courtesy Sonnabend Gallery, New York
[p.111]

Maurizio Cattelan
(born 1960)

Untitled 2009
Horse skin, fibreglass and resin
Dimensions variable
Courtesy the artist

Tracey Emin
(born 1963)

The Shop 1993
Ashes in wooden box
12.7 x 27.9 x 21.6 cm
Private collection

Hotel International 1993
Appliqué quilt
257 x 240 cm
Private collection, New York; courtesy the artist and Lehmann Maupin Gallery, New York
[p.152]

My Major Retrospective II 1982–92, 2008
Wire, canvas, card, pen, photographs, wooden shelves
Overall dimensions variable, each shelf 60 x 9 x 3.8 cm
Courtesy the artist and White Cube, London
[p.150]

**Tracey Emin
and Sarah Lucas**

*Lucas & Emin, Emin & Lucas
The Shop* January – July 1993
Mixed media
Various dimensions in two vitrines
Courtesy the artists
[pp.158–9]

*Tippi Hedren Suit
The Shop* 1993
Women's skirt suit, felt, thread, photograph on card, string, dummy
Dimensions variable
Courtesy the artists
[p.158, bottom left]

Cosey Fanni Tutti
(born 1951)

*Double-sided B/W
Model Z card* 1975
Print on card
21 x 15 cm
Courtesy the artist and Cabinet, London

*'Tessa from Sunderland' from
Park Lane*, no.12, 1975–6
Colour print on paper
44 x 119 cm
Courtesy the artist and Cabinet, London
[p.147]

Prostitution exhibition poster, Institute of Contemporary Arts 1976
Ink on paper
38.7 x 29.5 cm
Courtesy the artist and Cabinet, London
[p.146]

Cosey on ICA boxes c.1976
Colour photograph
21 x 29.5 cm
Courtesy the artist and Cabinet, London

*Single-sided B/W
Model Z card* 1977
Print on card
21 x 15 cm
Courtesy the artist and Cabinet, London
[p.147]

*'And I Should Be Blue' from
Knave*, vol.9, no.4, 1977
Print on paper
164 x 120 cm
Courtesy the artist and Cabinet, London
[pp.148–9]

**Associated with
Cosey Fanni Tutti**

Facsimile press cuttings from *Prostitution* exhibition, Institute of Contemporary Arts, London 1976
Courtesy the artist and Cabinet, London

Partner, vol.1, no.9, February 1980
Courtesy the artist and Cabinet, London

Paul Buck
Documentary photography of ICA *Prostitution* exhibition, Institute of Contemporary Arts, London 1976
Courtesy the photographer

Andrea Fraser
(born 1965)

Untitled 2003
Project and DVD, colour, no sound, 60 minutes
Woman in orange dress: Andrea Fraser. Man in blue sweater: anonymous. Camera set up by Peter Norrman. Produced by the Friedrich Petzel Gallery
Courtesy the artist
[pp.180–1]

Keith Haring
(1958–1990)

Pop Shop I 1987
Silkscreen ink on paper
30.48 x 38.1 cm
Keith Haring Foundation, New York

Pop Shop I 1987
Silkscreen ink on paper
30.48 x 38.1 cm
Keith Haring Foundation, New York

Pop Shop I 1987
Silkscreen ink on paper
30.48 x 38.1 cm
Keith Haring Foundation, New York

Pop Shop I 1987
Silkscreen ink on paper
30.48 x 38.1 cm
Keith Haring Foundation, New York

Untitled (Pop Shop Tokyo) 1987
Felt tip marker and sticker on paper
53.98 x 38.74 cm
Keith Haring Foundation, New York

Untitled (Pop Shop) 1989
Felt tip marker on paper
27.94 x 35.56 cm
Keith Haring Foundation, New York

Pop Shop [n.d.]
Dayglo and acrylic on foam core
121.29 x 81.28 x 63.5 cm
Keith Haring Foundation, New York

Pop Shop
Pop Shop recreation, including original
Pop Shop products
Keith Haring Foundation, New York

Damien Hirst
(born 1965)

Ingo, Torsten 1992
Gloss household paint on
wall, chairs and twins,
Dimensions variable
Original installation
at *Unfair*, Cologne
[p.156]

Aurothioglucose 2008
Household gloss and
enamel paint on canvas
172.7 x 274.3 cm
Private collection, courtesy
Sotheby's, London
[p.172]

False Idol 2008
Calf, gold, gold-plated
steel, glass, silicone, and
formaldehyde solution with
a Carrara marble plinth
and a stainless steel plinth
259.6 x 195 x 103.3 cm
Prada Collection, Milan
[p.179]

*Memories of / Moments
with You* 2008
Gold-plated steel and glass
with manufactured diamonds,
diptych
Each part 91 x 137.2 x 10 cm
Private collection, courtesy
Sotheby's, London
[p.174–5]

The Kiss of Midas 2008
Butterflies, manufactured
diamonds and enamel
paint on canvas
152.4 x 152.4 cm
Private collection, courtesy
Sotheby's, London
[p.178]

End of an Era 2009
Bull's head, gold, gold-plated
steel, glass, silicone, and
formaldehyde solution with
a Carrara marble plinth
213.4 x 170.9 x 97.2 cm
Edition of 3
Courtesy the artist
[p.176]

Martin Kippenberger
(1953–1997)

*Bitte nicht nach Hause
Schicken*
(Please Don't Send Me Home)
1983
Oil on canvas
120 x 100 cm
Private collection, Bonn
[p.129]

8. Preis 1987
Lacquer and
denim on canvas
180 x 150 cm
The Federal Republic of
Germany's Contemporary
Art Collection, Bonn
[p.133]

Pop It Out 1990
Portfolio of 30 posters
Various dimensions
Tate. Purchased 2005
Additional posters © Estate
Martin Kippenberger, Galerie
Gisela Capitain, Cologne
[p.126–7]

*Martin Kippenberger Is
Great, Tremendous, Fabulous,
Everything* 1990
Design by Jeff Koons
Screenprint on paper
94.7 x 68.8 cm
Tate. Purchased 2005
[p.128]

**Works assembled by
Martin Kippenberger
for his exhibition
*Candidature à une
Retrospective*, Centre
Pompidou 1993:**

Jörg Schlick
(1951–2005)
Lord Jim-Wallpaper 1992
Printed ink on paper
Dimensions variable
Artelier Contemporary, Graz

Bernard Buffet
(1928–1999)
Untitled 1958
Lithograph
54 x 39 cm (framed)
Private collection, Berlin

F.C. Gundlach
(born 1962)
Romy Schneider 1962/89
Black and white photograph
40 x 30 cm (framed)
Private collection, Vienna

Romy Schneider 1962/89
Black and white photograph
40 x 30 cm
Private collection, Berlin

Valeria Heisenberg
(born 1969)
*Portrait of Martin
Kippenberger* 1993
Oil on canvas
Approx. 85 x 60 cm
Estate Martin Kippenberger,
Galerie Gisela Capitain,
Cologne

Untitled 1991
Pencil on paper
29.5 x 21 cm
Private collection, Berlin

*Untitled (from the series
car portraits)* 1993
Oil on canvas
30 x 40 cm
Estate Martin Kippenberger,
Galerie Gisela Capitain,
Cologne

Martin Kippenberger
Martin Kippenberger, Galerie
Sylvana Lorenz, Paris 1990
Invitation card
15 x 10.5 cm
Estate Martin Kippenberger,
Galerie Gisela Capitain,
Cologne

*Schwer die Deckung
aufzugeben* 1983
Oil on canvas
90 x 75 cm
Private collection, Vienna

*We don't have problems with
people who look exactly like
us because they get our pain*
1986
Oil on canvas
180 x 150 cm
Estate Martin Kippenberger,
Galerie Gisela Capitain,
Cologne
[p.132]

Albert Oehlen
(born 1954)
Ewige Feile 1983
Collage on paper
30 x 30 cm (framed)
Estate Martin Kippenberger,
Galerie Gisela Capitain,
Cologne

Perschalla
Des Malers Ende 1928
Watercolour on paper
38 x 52 cm
Estate Martin Kippenberger,
Galerie Gisela Capitain,
Cologne

Stephen Prina
(born 1954)
Untitled
10 x 12.5 cm
Estate Martin Kippenberger,
Galerie Gisela Capitain,
Cologne

Tobias Rehberger
(born 1966)
Untitled 1993
Tempera on canvas
60 x 50 cm
Estate Martin Kippenberger,
Galerie Gisela Capitain,
Cologne

Untitled 1993
Tempera on canvas
81 x 59.5 cm
Estate Martin Kippenberger,
Galerie Gisela Capitain,
Cologne

Daniel Richter
(born 1962)
*Homage to Martin
Kippenberger* 2004
Oil on canvas
200 x 380 cm
Private collection, Berlin
[Later replacement for original
Paris Bar painting]
[p.131]

Chéri Samba
(born 1956)
Paris est propre
Offset
Approx. 70 x 40 cm
Private collection, Berlin

Anonymous
Paris (Hitchhiker sign) c.1980
Cardboard
Approx. 20 x 30 cm (framed)
Private collection, Berlin

Untitled
(from the series *Paris*) 2006
Approx. 32.5 x 21.5 cm
(framed)
Photograph by Peter Stöhr
Estate Martin Kippenberger,
Galerie Gisela Capitain,
Cologne

Jeff Koons
(born 1955)

Rabbit 1986
Stainless steel
104.1 x 48.3 x 30.5 cm
Ed. 1/3, plus artist's proof
Museum of Contemporary Art,
Chicago. Partial gift of Stefan
T. Edlis and H. Gael Neeson
[cover illustration and p.8:
The Eli and Edythe L. Broad
Collection, Los Angeles]

Made in Heaven 1989
Lithograph on
paper on canvas
314.5 x 691 cm
ARTIST ROOMS Tate and
National Galleries of
Scotland. Acquired jointly
through The d'Offay Donation
with assistance from the
National Heritage Memorial
Fund and The Art Fund 2008
[p.135]

*Bourgeois Bust –
Jeff and Ilona* 1991
White marble
113 x 71.1 x 53.3 cm
ARTIST ROOMS Tate and
National Galleries of
Scotland. Acquired jointly
through The d'Offay Donation
with assistance from the
National Heritage Memorial
Fund and The Art Fund 2008
[p.137]

Couch (Kama Sutra) 1991
Glass
49.5 x 59.7 x 40 cm
Collection of Rachel
and Jean Pierre Lehmann
[p.142]

Dirty – Jeff On Top 1991
Plastic
139.7 x 180.3 x 279.8 cm
Private collection
[p.137]

Exaltation 1991
Oil inks silkscreened
on canvas
152.4 x 228.6 cm
Courtesy Murderme, London
[p.139]

Glass Dildo 1991
Oil inks on canvas
228.6 x 152.4 cm
Collection of Rachel
and Jean Pierre Lehmann
[p.138]

Ilona's Asshole 1991
Oil inks silkscreened
on canvas
228.6 x 152.4 cm
Private collection
[p.141]

Manet 1991
Silkscreen ink on canvas
152.4 x 228.6 cm
Collection of Rachel and
Jean Pierre Lehmann
[p.145]

Violet-Ice (Kama Sutra) 1991
Glass
33 x 69.2 x 41.9 cm
Collection of Amalia Dayan
and Adam Lindemann
[p.144]

Wall Relief with Bird 1991
Polychromed wood
182.9 x 127 x 68.6 cm
Collection of Rachel and Jean
Pierre Lehmann
[p.140]

**Associated with
Jeff Koons**

Advertisement by Jeff Koons
Flash Art International,
no.143, November/
December 1988
Courtesy Flash Art
[p.116]

Advertisement by Jeff Koons
Artforum, vol.27, no.3,
November 1988
Courtesy the publishers of
Artforum
[p.117]

Advertisement by Jeff Koons
Art in America, vol.76, no.11,
November 1988
Courtesy Brant Publications
[p.117]

Advertisement by Jeff Koons
Arts 1988
Courtest the artist
[p.116]

*2007 Macy's Thanksgiving
Day Parade®, Featuring Jeff
Koons's 'Rabbit' Flying*, 29
November 2007
Balloon created by Macy's
Parade Studio in collaboration
with the artist
DVD, colour, sound, approx.
90 seconds
Macy's Parade &
Entertainment Group®
[p.6]

Sarah Lucas
(born 1962)

Mobile 1993
6 cut photographs, wire rods
Dimensions variable
Helen van der Meij Tcheng,
London

Octopus 1993
Tights, newspaper,
hair on band
76 x 46 x 23 cm
Courtesy Sadie Coles HQ,
London

Untitled (self-portrait #2) 1993
Colour copy on brown paper
183 x 162.5 cm
Courtesy Sadie Coles HQ,
London

Beer Can Penis 1999
Beer cans
22 x 17 x 10 cm
Courtesy Roddy Thomson

Beer Can Penis 2000
Carling beer cans
19 x 17 x 8 cm
Collection Pauline Daly

Beer Can Penis 2005
Heineken beer cans
17 x 12 x 9 cm
Collection Pauline Daly

Takashi Murakami
(born 1963)

Hiropon 1997
Acrylic, fibreglass and iron
180.3 x 104.1 x 121.9 cm
Ed. 3/3
Vanhaerents Art Collection,
Brussels
[p.13]

*Superflat Museum:
Convenience Store Edition*
2005
10 plastic figures with figure
assembly kits packaged
with gum, brochures and
certificates
Dimensions variable
Courtesy the artist

Collaboration Addiction
2009
Mixed media
Dimensions variable
Courtesy the artist

Peter Nagy
(born 1959)

EST Graduate 1984
Photocopy and acrylic
on canvas
100.3 x 61 cm
Collection of B.Z. & Michael
Schwartz, New York
[p.115]

Hypocrite Sublime 1984
Photocopy and acrylic on
canvas
63.5 x 63.5 cm
Collection of Alice Kosmin
[p.115]

Richard Prince
(born 1949)

Spiritual America 1983
Ektacolor photograph
in gold-painted frame
84 x 77 x 7 cm (framed)
Ringier Collection,
Switzerland
[p.123]

Pruitt Early

*Fear of a Black
Planet* early 1990s
Mixed media
299.7 x 67.3 cm
Collection of Daniella
Edelman. Courtesy of
Edelman Arts, Inc.

House of N.W.A. early 1990s
Mixed media
149.9 x 67.3 cm
Collection of Alexandra
Edelman. Courtesy of
Edelman Arts, Inc.

It Ain't No Fairy Tale early
1990s
Mixed media
269.2 x 299.7 cm
Collection of Lisa, Danielle
and Alexandra Edelman.
Courtesy of Edelman Arts, Inc.
[p.163]

Jackson 5 early 1990s
Mixed media
241.3 x 200.7 cm
Courtesy Gavin Brown's
enterprise, New York
[p.162]

Jungle Fever early 1990s
Mixed media
67.3 x 299.7 cm
Collection of Lisa Edelman.
Courtesy of Edelman Arts, Inc.
[p.161–2]

David Robbins
(born 1957)

Talent 1986
Portfolio of 18 black
and white photographs
Each 25.4 x 20.3 cm
Edition of 100
Courtesy the Dakis
Joannou Collection
[p.112]

Reena Spaulings

*Leggings (after Merlin
Carpenter)* 2009
Printed jersey
Size 'medium'
Edition of 100,
to be sold commercially
Courtesy the artist

Untitled (Flag) 2009
Mixed media and aluminium
pole, bracket, plastic eagle
Pole 182.9 cm high, flag
91.4 x 15.2 cm
Courtesy the artist

*Wallpaper (after Merlin
Carpenter)* 2009
Ink on paper
Dimensions variable
Courtesy the artist

Sturtevant
(born 1930)

Warhol Gold Marilyn 1973
Silkscreen ink and acrylic on
canvas 45.8 x 45.8 cm
Collection of the artist
[p.119]

Haring Tag, July 15 1981
1986
Acrylic on canvas
25 x 22.5 cm
Collection of L. Muzzey, Paris
[p.120]

Haring Tag 1986
Sumi ink and acrylic on cloth
25 x 22.5 cm
Private collection, Los Angeles
[p.120]

Haring Tag 1986
Sumi ink and acrylic on cloth
25 x 22.5 cm
Collection of the artist
[p.120]

Haring Tag, July 15 1981
1986
Sumi ink and acrylic on cloth
25 x 32.5 cm
Collection of the artist
[p.120]

Gavin Turk
(born 1967)

Pop 1993
Glass, brass, MDF, fibreglass,
wax, clothing, gum
279 x 115 x 115 cm
Collection of Frank Gallipoli
[p.155]

Cavey 1991–7
Ceramic laid on concrete
48.25 diameter x 5 cm
Courtesy Live Stock Market
[p.154]

Piotr Uklański
(born 1969)

The Nazis 1998
164 chromogenic,
black-and-white,
and colour photographs
Each 35.5 x 25.4 cm
Private collection, generously
provided by the Blavatnik
Family
[pp.56, 164–5]

Untitled (Pole-sploitation)
2009
Framed printed matter
(political propaganda, film
posters, drawings, press
clippings and other
memorabilia) dating from
1976–2009 assembled
from the artist's archives
Dimensions variable
Courtesy the artist

Meyer Vaisman
(born 1960)

In the Vicinity of History 1988
Process inks and
acrylics on canvas
243.8 x 438.2 x 21.6cm
Courtesy the Dakis Jounnou
Collection

Andy Warhol
(1928–1987)

*Tattooed Woman Holding
Rose* c.1955
Offset lithograph
on onion-skin paper
73.7 x 27.9 cm
The Andy Warhol Museum,
Pittsburgh. Contribution
The Andy Warhol Foundation
for the Visual Arts, Inc.
[p.23]

Self-Portrait
'Royaltone' album and wallet
sized photo set; Andy Warhol
at Columbus Hospital, New
York, June 1968, recovering
from bullet wounds inflicted
by Valerie Solanas 1968
Facsimile from an original
chromogenic colour print
8.9 x 15.2 cm
The Andy Warhol Museum,
Pittsburgh. Founding
Collection, Contribution
The Andy Warhol Foundation
for the Visual Arts, Inc.

*Factory Diary: Andy Warhol
at the Whitney* 1971
½ inch black and white reel-to-
reel videotape transferred to
digital files (DVD), sound,
22 minutes
Camera by Michael Netter.
With Andy Warhol, Bob
Colacello, Brigid Berlin,
Ultra Violet
The Andy Warhol Museum,
Pittsburgh. Contribution
The Andy Warhol Foundation
for the Visual Arts, Inc.

David Hockney 1974
Acrylic and silkscreen
ink on canvas
101.6 x 101.6 cm
Collection of David Hockney
[p.100]

David Hockney 1974
Acrylic and silkscreen
ink on canvas
101.6 x 101.6 cm
Collection of David Hockney
[p.100]

Gilbert and George 1975
Acrylic and silkscreen
ink on canvas; two panels
Each 101.8 x 101.8 x 2.1 cm
ARTIST ROOMS Tate and
National Galleries of
Scotland. Acquired jointly
through The d'Offay Donation
with assistance from the
National Heritage Memorial
Fund and The Art Fund 2008
[p.101]

Mick Jagger 1975
Acrylic and silkscreen
ink on canvas
101.6 x 101.6 cm
Private collection
[p.100]

Mick Jagger
1975
Acrylic and silkscreen
ink on canvas
101.6 x 101.6 cm
Private collection
[p.100]

*Phone Log: Calls Made
to the Factory in 1976* 1976
Ink and pencil on paper
with red leather cover
32.1 x 19.7 x 3.8 cm
The Andy Warhol Museum,
Pittsburgh. Founding
Collection, Contribution
The Andy Warhol Foundation
for the Visual Arts, Inc.

*Self-Portrait
Wallpaper* 1978
Ink on paper
Dimensions variable
The Andy Warhol Museum,
Pittsburgh. Founding
Collection, Contribution
The Andy Warhol Foundation
for the Visual Arts, Inc
[p.208]

Andy Warhol's BAD 1977
Screenprint on paper
76 x 101.4 cm
ARTIST ROOMS Tate
and National Galleries of
Scotland. Acquired jointly
through The d'Offay Donation
with assistance from the
National Heritage Memorial
Fund and The Art Fund 2008

*LeRoy Neiman and Andy
Warhol* c.1977
Lithograph on paper
49.5 x 68.6 cm
ARTIST ROOMS Tate and
National Galleries of
Scotland. Acquired jointly
through The d'Offay Donation
with assistance from the
National Heritage Memorial
Fund and The Art Fund 2008

Self-Portrait in Interview T shirt
1977–8
Photograph on paper
10.7 x 8.5 cm
ARTIST ROOMS. Tate and
National Galleries of
Scotland. Acquired jointly
through The d'Offay Donation
with assistance from the
National Heritage Memorial
Fund and The Art Fund 2008

*Factory Diary: Andy Warhol
on the Phone* 1978
½ inch black and white reel-to-
reel videotape transferred to
digital files (DVD), sound,
22 minutes
Camera by Vincent Fremont.
With Andy Warhol, Vincent
Fremont
The Andy Warhol Museum,
Pittsburgh. Contribution
The Andy Warhol Foundation
for the Visual Arts, Inc.

*Retrospective
(Reversal Series)* 1978
Acrylic and silkscreen
ink on canvas
203 x 203 cm
Bischofberger Collection,
Switzerland
[p.107]

Studio 54 VIP 1978
Acrylic and silkscreen
ink on canvas
20.3 x 35.6 cm
Holzer Family Collection

Studio 54 VIP 1978
Acrylic and silkscreen
ink on canvas
20.3 x 35.5 cm
Holzer Family Collection

*Black on Black Retrospective
(Reversal Series)* 1979
Acrylic and silkscreen
ink on canvas
195 x 241.5 cm
Private collection, courtesy
Galerie Caratsch, Zürich
[p.106]

*Four Multicoloured Self-
Portraits (Reversal Series)*
1979
Acrylic and silkscreen
ink on canvas
120 x 91.5 cm
Private collection, courtesy
Galerie Andrea Caratsch,
Zürich
[p.104]

Gem 1979
Acrylic, diamond dust and
silkscreen ink on canvas
137 x 218 cm
Galerie Andrea Caratsch,
Zürich
[p.96]

Gem 1979
Acrylic, diamond dust and
silkscreen ink on canvas
137 x 210 cm
Galerie Bruno Bischofberger,
Zürich

Gem 1979
Acrylic, diamond dust and
silkscreen ink on canvas
137.2 x 218.4 cm
Private collection, courtesy
Galerie Bruno Bischofberger,
Zürich

Gem 1979
Acrylic, diamond dust and
silkscreen ink on canvas
61 x 91 cm
Courtesy Galerie Bruno
Bischofberger, Zürich

Gem 1979
Acrylic, diamond dust and
silkscreen ink on canvas
81 x 107 cm
Private collection, Courtesy
Galerie Bruno Bischofberger,
Zürich
[p.97]

Gem 1979
Acrylic, diamond dust and
silkscreen ink on canvas
127 x 198 cm
Private collection, courtesy
Bruno Bischofberger, Zürich

Joseph Beuys 1980
Silkscreen ink and diamond
dust on acrylic on canvas
101.6 x 101.6 cm
Fondation Beyeler, Basel
[p.103]

Joseph Beuys 1980
Silkscreen ink and diamond
dust on acrylic on canvas
101.6 x 101.6 cm
Fondation Beyeler, Basel
[p.103]

*Twelve White Mona Lisas
(Reversal Series)* 1980
Silkscreen ink and
acrylic on canvas
202.9 x 202.9 cm
Mugrabi Collection
[p.105]

*Andy Warhol's TV on
Saturday Night Live* 1981
3 segments, 1 inch colour
videotape transferred to
digital files (DVD), sound,
1 minute each
Andy Warhol TV Productions
commissioned by Saturday
Night Live. Director, Don
Munroe; Producer, Vincent
Fremont; Associate Producer,
Sue Etkin. With Andy Warhol
The Andy Warhol Museum,
Pittsburgh. Contribution
The Andy Warhol Foundation
for the Visual Arts, Inc.

Myths 1981
Acrylic and silkscreen
ink on canvas
254 x 254 cm
Collection of Emily Fisher
Landau, New York
[p.99]

*Self-Portrait in Profile
with Shadow* 1981
Photograph on paper
7.2 x 9.5 cm
ARTIST ROOMS Tate and
National Galleries of
Scotland. Acquired jointly
through The d'Offay Donation
with assistance from the
National Heritage Memorial
Fund and The Art Fund 2008

Jean-Michel Basquiat 1982
Acrylic, silkscreen ink
and urine on canvas
101.6 x 101.6 cm
The Andy Warhol Museum,
Pittsburgh. Founding
Collection, Contribution
The Andy Warhol Foundation
for the Visual Arts, Inc.
[p.102]

*Andy Warhol's
TV (episode 5)* 1983
1 inch colour videotape
transferred to digital files
(DVD), sound, 30 minutes
The Andy Warhol Museum,
Pittsburgh. Contribution
The Andy Warhol Foundation
for the Visual Arts, Inc.

Keith Haring and
Juan Dubose 1983
Acrylic and silkscreen
ink on canvas
101.6 x 101.6 cm
Mugrabi Collection
[p.103]

Keith Haring and
Juan Dubose 1983
Acrylic and silkscreen
ink on canvas
101.6 x 101.6 cm
Mugrabi Collection
[p.103]

The New Portrait 1984
Screenprinted
poster on paper
88.6 x 56.8 cm
ARTIST ROOMS Tate
and National Galleries of
Scotland. Acquired jointly
through The d'Offay Donation
with assistance from the
National Heritage Memorial
Fund and The Art Fund 2008
[p.30]

Blackglama (Judy Garland)
from the portfolio Ads 1985
Screenprint on Lenox
Museum Board
96.5 x 96.5 cm
Regular ed. 190; exhibition
print: 4/5
Courtesy Ronald Feldman
Gallery, New York
[p.108]

Four Multicoloured Marilyns
(Reversal Series) 1979–86
Acrylic and silkscreen
ink on canvas
92 x 71 cm
Private collection, Courtesy
Bruno Bischofberger, Zürich
[p.109]

Andy Warhol's Fifteen
Minutes (episode 1) 1986
1 inch colour videotape
transferred to digital files
(DVD), sound, 30 minutes
The Andy Warhol Museum,
Pittsburgh. Contribution
The Andy Warhol Foundation
for the Visual Arts, Inc.

Grace Jones 1986
Acrylic and silkscreen
ink on linen
101.6 x 101.6 cm
The Andy Warhol Museum,
Pittsburgh. Founding
Collection, Contribution
The Andy Warhol Foundation
for the Visual Arts, Inc.
[p.101]

Grace Jones 1986
Acrylic and silkscreen
ink on linen
101.6 x 101.6 cm
The Andy Warhol Museum,
Pittsburgh. Founding
Collection, Contribution
The Andy Warhol Foundation
of the Visual Arts, Inc.

Grace Being Painted
by Keith 1986
Six stitched
photographs on paper
Each 35.3 x 72.5 cm;
overall size 69.5 x 80.5 cm
ARTIST ROOMS Tate
and National Galleries of
Scotland. Acquired jointly
through The d'Offay Donation
with assistance from the
National Heritage Memorial
Fund and The Art Fund 2008

Self-Portrait 1986
Acrylic and
screenprint on canvas
203.2 x 203.2 cm
Tate. Presented by Janet
Wolfson de Botton 1996
[frontispiece]

Self-Portrait with
Fright Wig 1986
Photograph on paper
9.5 x 7.2 cm
ARTIST ROOMS Tate
and National Galleries of
Scotland. Acquired jointly
through The d'Offay Donation
with assistance from the
National Heritage Memorial
Fund and The Art Fund 2008

Self-Portrait with
Fright Wig 1986
Photograph on paper
9.5 x 7.2 cm
ARTIST ROOMS Tate and
National Galleries of
Scotland. Acquired jointly
through The d'Offay Donation
with assistance from the
National Heritage Memorial
Fund and The Art Fund 2008

Self-Portrait with
Fright Wig 1986
Photograph on paper
9.5 x 7.2 cm
ARTIST ROOMS Tate
and National Galleries of
Scotland. Acquired jointly
through The d'Offay Donation
with assistance from the
National Heritage Memorial
Fund and The Art Fund 2008

Self-Portrait with
Fright Wig 1986
Photograph on paper
9.4 x 7.2 cm
ARTIST ROOMS Tate and
National Galleries of
Scotland. Acquired jointly
through The d'Offay Donation
with assistance from the
National Heritage Memorial
Fund and The Art Fund 2008

**Associated with
Andy Warhol**

Unknown photographer
Andy Warhol, 'Royaltone'
album and wallet-sized photo
set; Warhol is in bed, on the
telephone, at Columbus
Hospital, New York, June
1968, recovering from bullet
wounds inflicted by Valerie
Solanas 1968
Facsimile from original
chromogenic colour print
8.9 x 15.2 cm
The Andy Warhol Museum,
Pittsburgh. Founding
Collection, Contribution The
Andy Warhol Foundation for
the Visual Arts, Inc.

'Actress shoots Andy Warhol
/ cries "He controlled my
life"', New York Daily News,
4 June 1968
From Time capsule 1
Facsimile from an original
newsprint clipping
The Andy Warhol Museum,
Pittsburgh. Founding
Collection, Contribution The
Andy Warhol Foundation for
the Visual Arts, Inc.

'Andy Warhol fights for life',
New York Post, 4 June 1968,
p.3
From Time Capsule 40
Facsimile from an original
newsprint clipping
The Andy Warhol Museum,
Pittsburgh. Founding
Collection, Contribution The
Andy Warhol Foundation for
the Visual Arts, Inc.

Andy Warhol and Sonny
Liston for Braniff Airlines 1969
Printed ink on coated paper
73.7 x 27.9 cm
The Andy Warhol Museum,
Pittsburgh. Contribution The
Andy Warhol Foundation for
the Visual Arts, Inc.

Interview, vol.1, no.1, 1969,
First Issue Collector's Edition
© 1969 by Poetry on Film,
Inc., New York. Published by
Andy Warhol.
The Andy Warhol Museum,
Pittsburgh. Founding
Collection, Contribution
The Andy Warhol Foundation
for the Visual Arts, Inc.

Time, 16 February 1970
Cover artwork by Andy
Warhol, portrait of Jane,
Henry and Peter Fonda
Published by Time Inc.,
New York, NY
The Andy Warhol Museum,
Pittsburgh. Gift of Jay Reeg

Interview, December 1972
Courtesy Tate Library. © 1972
by Interview Enterprises, Inc.,
New York

Interview, May 1973
Courtesy Tate Library. © 1973
by Interview Enterprises, Inc.,
New York
[p.26]

Andy Warhol for Barney's
New York 1981
Page 50 from Small
Scrapbook no.12
The Andy Warhol Museum,
Pittsburgh. Contribution
The Andy Warhol Foundation
for the Visual Arts, Inc.

Andy Warhol for Sony
Beta Cassette Tapes 1981
Page 45 from Small
Scrapbook no.12
The Andy Warhol Museum,
Pittsburgh. Founding
Collection, Contribution
The Andy Warhol Foundation
for the Visual Arts, Inc.

New York, 29 December
1980–5 January 1981
The Andy Warhol Museum,
Pittsburgh. Founding
Collection, Contribution
The Andy Warhol Foundation
for the Visual Arts, Inc.

Headsheet, Zoli modelling
agency – photographs of 100
select male models including
Andy Warhol ('Special
Bookings Only') c.1981
From Time Capsule 416
The Andy Warhol Museum,
Pittsburgh. Founding
Collection, Contribution
The Andy Warhol Foundation
for the Visual Arts, Inc.
[p.21]

TDK Videotape
commercial 1983
1 inch colour videotape
transferred to digital files
(DVD), sound, 30 seconds
A production for TDK
Corporation, Tokyo. Director,
Mr Kamei; Director of
Photography, Mr Jumonji;
Creative Director, Mr Asaba;
Asatsu Advertising Agency,
Japan.
Collection of The Andy
Warhol Museum, Pittsburgh.
Contribution The Andy
Warhol Foundation for the
Visual Arts, Inc.

Andy Warhol for TDK
from Japanese magazine
Studio Voice 1983
Page 10 from Small
Scrapbook no.13
The Andy Warhol Museum,
Pittsburgh. Contribution
The Andy Warhol Foundation
for the Visual Arts, Inc.

Time, 19 March 1984
Cover artwork by Andy
Warhol, portrait of Michael
Jackson
Published by Time Inc.,
New York, 1984
The Andy Warhol Museum,
Pittsburgh. Founding
Collection, Contribution
The Andy Warhol Foundation
for the Visual Arts, Inc.

Absolut Warhol 1985
Page 89 from *Small Scrapbook no.15*
The Andy Warhol Museum, Pittsburgh. Founding Collection, Contribution
The Andy Warhol Foundation for the Visual Arts, Inc.

l.a. Eyeworks advertisement 1985
2 clippings from *InStyle* and *Interview*
Photograph by Greg Gorman
Courtesy l.a. Eyeworks
and
l.a. Eyeworks advertisement 1985
from *Interview*, December 1985
Collection of Jack Bankowsky

The Love Boat [episode 200] 1985
1 inch colour videotape transferred to digital files (DVD), sound, 49 minutes
Douglas S. Cramer Productions in association with Aaron Spelling Productions, Inc. Director, Richard Kinon
The Andy Warhol Museum, Pittsburgh. Contribution
The Andy Warhol Foundation for the Visual Arts, Inc.

Andy Warhol for Drexel Burnham 1985–7
From *Small Scrapbook no.15*
The Andy Warhol Museum, Pittsburgh. Founding Collection, Contribution
The Andy Warhol Foundation for the Visual Arts, Inc.
[title page]

'Become a Legend: with Andy Warhol and Aramis 900' from *Neiman Marcus Christmas Book* 1986
Neiman Marcus

'Pop Tarts! Andy Warhol & Debbie Harry slip a floppy disc with Cynthia Rose'
Cover story, *NME*, 11 January 1986
Courtesy Fiontán Moran

Andy Warhol for Vidal Sassoon 1984–6
Page 32 from *Small Scrapbook no.14*
Facsimile from an original advertisement
14 x 11.4 cm
The Andy Warhol Museum, Pittsburgh. Founding Collection, Contribution
The Andy Warhol Foundation for the Visual Arts, Inc.

'Andy Warhol Dead at 58'
New York Post, 23 February 1987
Published by The New York Post © News America Publishing, Inc.
The Andy Warhol Museum, Pittsburgh

Manhattan, Inc., vol.2, no.9, September 1985
Cover artwork by Andy Warhol
Published by Manhattan Magazine, Inc., New York, NY
The Andy Warhol Museum, Pittsburgh. Museum Purchase

Interview
Interview magazines 1976–87
Designed by Richard Bernstein. Various photographers
Courtesy Tate Library.

Photographs of Warhol

Bob Colacello
(born 1947)

André Leon Talley, Steve Rubell, and Andy Warhol at Bianca Jagger's Birthday Dinner, Mortimer's, New York 1981
Vintage gelatin silver print
20.3 x 25.4 cm
Courtesy Steven Kasher Gallery, New York

Diana Vreeland and Andy Warhol 1981
Vintage gelatin silver print
20.3 x 25.4 cm
Courtesy Steven Kasher Gallery, New York

Christopher Makos
(born 1948)

Andy and Liza Kissing 1978
Vintage gelatin silver print
40.6 x 50.8 cm
Collection of the photographer
[p.11]

Andy Kissing John Lennon 1978
Vintage gelatin silver print
40.6 x 50.8 cm
Collection of the photographer
[p.11]

Dalí Kissing Andy 1978
Vintage gelatin silver print
40.6 x 50.8 cm
Collection of the photographer
[p.11]

Andy Kissing Architect Philip Johnson 1979
P.W. gelatin silver print
40.6 x 50.8 cm
Collection of the photographer
[p.11]

Elizabeth Taylor and Andy Warhol 1981
Gelatin silver print
40.6 x 50.8 cm
Collection of the photographer

Andy Warhol and Jean-Michel Basquiat, 12 October, 1982
Gelatin silver print
40.6 x 50.8 cm
Collection of the photographer

Contact Sheet #100581–5 1982
Silver gelatin contact sheet print
21.5 x 27.8 cm
Collection of the photographer

Contact Sheet #M61882–1 1982
Vintage contact sheet with Makos grease pencil marks
25.5 x 20.5 cm
Collection of the photographer

Patrick McMullan
(born 1955)

Andy Warhol, 'Invisible Sculpture' March 1985, Area 1985, printed 2001
Kodak Endura metallic paper
50.8 x 71.1 cm
Patrick McMullan

Jean-Michel Basquiat, Tina Chow, Andy Warhol at Susan Blond's Dinner Party for Ozzy Osbourne at Mr Chow's, 21 April 1986
Kodak Endura metallic paper
50.8 x 71.1 cm
Patrick McMullan

Kenny Scharf, Andy Warhol, Keith Haring at Elizabeth Saltzman's Birthday Party at Il Cantinori, 16 June 1986
Kodak Endura metallic paper
50.8 x 71.1 cm
Patrick McMullan

Joint Works

Jean-Michel Basquiat and Andy Warhol

Sweet Pungent 1984–5
Acrylic and silkscreen ink on canvas
244 x 206 cm
Galerie Bruno Bischofberger, Zürich
[p.121]

Keith Haring and Andy Warhol

Untitled (Madonna: 'I'm Not Ashamed') 1985
Dayglo and acrylic on canvas
50.7 x 40.6 cm
Keith Haring Foundation, New York
[p.69]

Lenders

Public Collections

The Andy Warhol Museum,
Pittsburgh
ARTIST ROOMS Tate and
National Galleries of
Scotland
The Federal Republic
of Germany's
Contemporary Art
Collection, Bonn
Fondation Beyeler,
Riehen, Basel
Museum of Contemporary Art,
Chicago
The Museum of Modern Art,
New York
Tate, London
Tate Library, London

Private Collections and Galleries

Galerie Andrea Caratsch,
Zürich
Artelier Contemporary, Graz
Artforum
Jack Bankowsky
Bischofberger Collection,
Switzerland
Brant Publications Inc.,
New York
Galerie Bruno Bischofberger,
Zürich
Paul Buck
Bundesamt für Kultur
und Medien
Cabinet Gallery, London
Maurizio Cattelan
Pauline Daly
Amalia Dayan and
Adam Lindemann
Deste Foundation Centre
for Contemporary Art
Alexandra Edelman. Courtesy
of Edelman Arts, Inc.
Daniella Edelman. Courtesy
of Edelman Arts, Inc.
Lisa Edelman. Courtesy
of Edelman Arts, Inc.
Lisa, Danielle and Alexandra
Edelman. Courtesy of
Edelman Arts, Inc.
Tracey Emin
Galerie Emmanuel Perrotin
Cosey Fanni Tutti and
Cabinet, London

Emily Fisher Landau
Flash Art
Andrea Fraser
Frank Gallipoli
Gavin Brown's enterprise,
New York
David Hockney
Holzer Family Collection
Dakis Joannou Collection
Kaikai Kiki New York, LLC
Keith Haring Foundation,
New York
Estate of Martin
Kippenberger, Galerie
Gisela Capitain, Cologne
Alice Kosmin
Rachel and Jean Pierre
Lehmann
Live Stock Market
Sarah Lucas
Patrick McMullan
Macy's Parade and
Entertainment Group
Christopher Makos
Neiman Marcus
Helen van der Meij Tcheng,
London
Mugrabi Collection
Fiontán Moran
Murderme Ltd, London
L. Muzzey, Paris
Prada Collection, Milan
Private collection, generously
provided by the Blavatnik
Family
Private collection,
courtesy Galerie Bruno
Bischofberger, Zürich
Private collection, courtesy
Galerie Andrea Caratsch,
Zürich

Private collection, New York;
courtesy Tracey Emin and
Lehmann Maupin Gallery,
New York
Private collection, courtesy
Sonnabend Gallery,
New York
Private collection, courtesy
Sotheby's, London
Ringier Collection,
Switzerland
Ronald Feldman Gallery,
New York
Sadie Coles HQ, London
B.Z. & Michael Schwartz,
New York
Science Ltd, London
Reena Spaulings
Steven Kasher Gallery,
New York
Sturtevant
Roddy Thomson
Piotr Uklański
Vanhaerents Art Collection,
Brussels
Kanye West
White Cube, London

*and other private collectors
who wish to remain
anonymous*

Copyright

Photo Credits

Front cover, 8: Photo Douglas M. Parker Studio, Los Angeles

Frontispiece, 30, 101 (top left and right), 136: Tate Photography

6, 81: Getty Images

11: © Christopher Makos 1978 www.christophermakos.com

20 right, 104, 106: Courtesy Galerie Andrea Caratsch, Zürich. Photo © Roland Reiter, Zürich

23, 110: Museum of Modern Art, New York (MoMA) © 2009. Digital image, The Museum of Modern Art, New York / Scala, Florence

26: Courtesy Interview Enterprises Inc., New York

28, 64, 66–7, 125: Photo Tseng Kwong Chi, © 1986 Muna Tseng Dance Projects, Inc., New York

29: Photo © Oliviero Toscani

39, 116–17: Photo © Tate Photography, S. Drake

49: Scala, Florence / BPK, Bildagentur für Kunst, Kultur und Geschichte, Berlin

51: Photo Reiner Ruthenbeck

55 (right): Courtesy Anthony Reynolds Gallery

56, 152 (right), 164, 165: Courtesy Gagosian Gallery

70 (left), 158–9 (top row, left and middle; bottom row): Photo Carl Freedman

70 (right), p.159 (middle row, right): Photo © Pauline Daly

76, 84, 85: Photo: Miget

78: Photo Brian Forrest

82: Photo © David Valesco

83: GION

88: Courtesy of the artist and Marian Goodman Gallery, New York

89 (right): Gavin Brown's enterprise, New York

96, 97, 107, 109: Courtesy Galerie Bruno Bischofberger, Zürich. Photo: Roland Reiter, Zürich; Werner Schnueriger, Zürich

100 (bottom left and right): Photo © Tate Photography, A. Dunkley

102: Photo: Richard Stoner

103, (top left and right): courtesy Fondation Beyeler, Riehen / Basel

103 (bottom left and right): courtesy Mugrabi Collection

105: Photo Rob McKeever, courtesy Gagosian Gallery

108: Courtesy Ronald Feldman Fine Arts, New York / www.feldmangallery.com

100 (top left and right): Photo Richard Schmidt

111: Courtesy Sonnabend Gallery and Lhemann Maupin Gallery

112–13: Courtesy David Robbins

115 (left): Courtesy Collection of B.Z. & Michael Schwartz

120, (top right): Photo Fredrick Nilsen

121: Courtesy Galerie Bruno Bischofberger, Zürich. Photo: Phillips/Schwab

123: Courtesy Ringier Collection

124: Photo © Peter Cunningham

129: Photo Lothar Schnepf

130: Photo Ernst Arno Baur

133: Photo Herr Perter Oszvald

139: Courtesy Murderme

142, 145: Courtesy Collection of Rachel and Jean-Pierre Lehmann

150: Courtesy Emin Studio

153: Photo Steve Brown / courtesy White Cube

154: Courtesy White Cube

155: Photo Hugo Glendinning / Courtesy White Cube

166: Photo Markus Tretter

168: Photo Attilio Maranzano

169: Photo Axel Schneider

171: Photo Zeno Zotti

172–9: Courtesy Science

180, 181: Courtesy the artist and Friedrich Petzel Gallery

Supporting Tate

Tate relies on a large number of supporters – individuals, foundations, companies and public sector sources – to enable it to deliver its programme of activities, both on and off its gallery sites. This support is essential in order for Tate to acquire works of art for the Collection, run education, outreach and exhibition programmes, care for the Collection in storage and enable art to be displayed, both digitally and physically, inside and outside Tate. Your donation will make a real difference and enable others to enjoy Tate and its Collection both now and in the future. There are a variety of ways in which you can help support Tate and also benefit as a UK or US taxpayer. Please contact us at:

Development Office
Tate
Millbank
London SW1P 4RG

Tel: 020 7887 4900
Fax: 020 7887 8098

American Patrons of Tate
1285 6th Avenue (35th floor)
New York, NY 10019
USA

Tel: 001 212 882 5119
Fax: 001 212 882 5571

Donations, of whatever size, are gratefully received, either to support particular areas of interest, or to contribute to general activity costs.

Gifts of Shares
We can accept gifts of quoted share and securities. All gifts of shares to Tate are exempt from capital gains tax, and higher rate taxpayers enjoy additional tax efficiencies. For further information please contact the Development Office.

Gift Aid
Through Gift Aid you can increase the value of your donation to Tate as we are able to reclaim the tax on your gift. Gift Aid applies to gifts of any size, whether regular or a one-off gift. Higher rate taxpayers are also able to claim additional personal tax relief. Contact us for further information and to make a Gift Aid Declaration.

Legacies
A legacy to Tate may take the form of a residual share of an estate, a specific cash sum or item of property such as a work of art. Legacies to Tate are free of inheritance tax, and help to secure a strong future for the Collection and galleries. For further information please contact the Development Office.

Offers in lieu of tax
Inheritance Tax can be satisfied by transferring to the Government a work of art of outstanding importance. In this case the amount of tax is reduced, and it can be made a condition of the offer that the work of art is allocated to Tate. Please contact us for details.

Tate Members
Tate Members enjoy unlimited free admission throughout the year to all exhibitions at Tate, as well as a number of other benefits such as exclusive use of our Members' Rooms and a free annual subscription to *Tate Etc*. Whilst enjoying the exclusive privileges of membership, you are also helping secure Tate's position at the very heart of British and modern art. Your support actively contributes to new purchases of important art, ensuring that the Tate's Collection continues to be relevant and comprehensive, as well as funding projects in London, Liverpool and St Ives that increase access and understanding for everyone.

Tate Patrons
Tate Patrons share a strong enthusiasm for art and are committed to giving significant financial support to Tate on an annual basis. The Patrons support the acquisition of works across Tate's broad collecting remit, as well as other areas of Tate activity such as conservation, education and research. The scheme provides a forum for Patrons to share their interest in art and to exchange knowledge and information in an enjoyable environment. United States taxpayers who wish to receive full tax exempt status from the IRS under Section 501 (c) (3) are able to support the Patrons through the American Patrons of Tate. For more information on the scheme please contact the Patrons office.

Corporate Membership
Corporate Membership at Tate Modern, Tate Britain and Tate Liverpool offers companies opportunities for corporate entertaining and the chance for a wide variety of employee benefits. These include special private views, special access to paying exhibitions, out-of-hours visits and tours, invitations to VIP events and talks at members' offices.

Corporate Investment
Tate has developed a range of imaginative partnerships with the corporate sector, ranging from international interpretation and exhibition programmes to local outreach and staff development programmes. We are particularly known for high-profile business to business marketing initiatives and employee benefit packages. Please contact the Corporate Fundraising team for further details.

Charity Details
The Tate Gallery is an exempt charity; the Museums & Galleries Act 1992 added the Tate Gallery to the list of exempt charities defined in the 1960 Charities Act. Tate Members is a registered charity (number 313021). Tate Foundation is a registered charity (number 1085314).

American Patrons of Tate
American Patrons of Tate is an independent charity based in New York that supports the work of Tate in the United Kingdom. It receives full tax exempt status from the IRS under section 501 (c)(3) allowing United States taxpayers to receive tax deductions on gifts towards annual membership programmes, exhibitions, scholarship and capital projects. For more information contact the American Patrons of Tate office.

Ruth and Stuart Lipton
Anders and Ulla Ljungh
The Frank Lloyd Family Trusts
London & Cambridge
 Properties Limited
London Electricity plc,
 EDF Group
Mr and Mrs George Loudon
Mayer, Brown, Rowe & Maw
Viviane and James Mayor
Ronald and Rita McAulay
The Mercers' Company
The Meyer Foundation
The Millennium Commission
Anthony and Deirdre Montagu
The Monument Trust
Mori Building, Ltd
Mr and Mrs M D Moross
Guy and Marion Naggar
Peter and Eileen Norton,
 The Peter Norton Family
 Foundation
Maja Oeri and Hans
 Bodenmann
Sir Peter and Lady Osborne
William A Palmer
Mr Frederik Paulsen
Pearson plc
The Pet Shop Boys
The Nyda and Oliver
 Prenn Foundation
Prudential plc
Railtrack plc
The Rayne Foundation
Reuters
Sir John and Lady Ritblat
Rolls-Royce plc

Barrie and Emmanuel Roman
Lord and Lady Rothschild
The Dr Mortimer and
 Theresa Sackler Foundation
J. Sainsbury plc
Ruth and Stephan Schmidheiny
Schroders
Mr and Mrs Charles Schwab
David and Sophie Shalit
Belle Shenkman Estate
William Sieghart
Peter Simon
Mr and Mrs Sven Skarendahl
London Borough of Southwark
The Foundation for
 Sports and the Arts
Mr and Mrs Nicholas Stanley
The Starr Foundation
The Jack Steinberg
 Charitable Trust
Charlotte Stevenson
Hugh and Catherine Stevenson
John Studzinski, CBE
David and Linda Supino
The Government
 of Switzerland
Carter and Mary Thacher
Insinger Townsley
UBS
UBS Warburg
David and Emma Verey
Dinah Verey
The Vintners' Company
Clodagh and Leslie
 Waddington
Robert and Felicity
 Waley-Cohen
Wasserstein, Perella
 & Co., Inc.

Gordon D Watson
The Weston Family
Mr and Mrs Stephen
 Wilberding
Michael S Wilson
Poju and Anita Zabludowicz

*and those donors who wish
to remain anonymous*

Donors to Transforming Tate Modern

Lauren and Mark Booth
The Deborah Loeb Brice
 Foundation
James Chanos
Paul Cooke
Tiqui Atencio Demirdjian
 and Ago Demirdjian
Lydia and Manfred Gorvy
Noam and Geraldine
 Gottesman
Alison and Howard Lutnick
Anthony and Deirdre Montagu
Alison and Paul Myners
The Dr Mortimer and Theresa
 Sackler Foundation
John Studzinski, CBE
Tate Members
The Thistle Trust
Nina and Graham Williams

*and those donors who wish
to remain anonymous*

Tate Modern Benefactors and Major Donors

We would like to acknowledge
and thank the following
benefactors who have
supported Tate Modern in the
period 01 May 2008 to 30
April 2009.

29th May 1961
 Charitable Trust
Agnew's
Alexander and Bonin
 Publishing, Inc.
Mr R Allan
American Patrons of Tate
Klaus Anschel
John H Armstrong
The Art Fund
Art Mentor Foundation Lucerne
Charles Asprey
Professor John Ball
Gerald Bauer
Luis Benshimol
Black Rat Press
Steve Blatt
Mel Bochner
The Charlotte Bonham-Carter
 Charitable Trust
Charles Booth-Cliborn
Ruth Boswell
Louise Bourgeois
Mrs John Bowes
Mr Gordon Bowyer
Pierre Brahm
John Brodzky
Melva Bucksbaum and
 Ray Learsy
Mark and Katie Cecil
James Chanos

Henry Christensen III
Pepe Cobo
Mr Michael Compton
Mr Christopher Cone
John Cox
Michael Craig-Martin
Paula and Jim Crown
 in honour of Jim Gordon
Anthony d'Offay
The D'Oyly Carte
 Charitable Trust
Thomas Dane
Manny and Brigitta
 Davidson and the Family
Department for Culture,
 Media and Sport
Department for Innovation,
 Universities & Skills
Simon C Dickinson Ltd
Sir Harry and Lady Djanogly
Jeanne Donovan Fisher
Jytte Dresing
Carla Emil and
 Richard Silverstein
Mrs Teresa Fairchild
The Estate of Maurice
 Farquharson
Marilyn & Larry Fields
Doris and Donald G Fisher
The Flow Foundation
Sarah Fox-Pitt
James Franco
Mildred and Martin Friedman
Frith Street Gallery
Kathy Fuld
Galeria Luisa Strina
Galerie Lelong, New York
Kate Ganz and Daniel N Belin
Gapper Charitable Trust

Henrietta Garnett
Luke Gertler
The Getty Foundation
Ingvild Goetz
The Horace W. Goldsmith
 Foundation
Nicholas and Judith Goodison
Marian Goodman
Lydia and Manfred Gorvy
Professor Jonathan Gosling
Penny Govett
David and Susan Gradel
Arthur and Helen Grogan
Mr Irving Gross
Agnes Gund
Mimi and Peter Haas Fund
Bruce T. Halle Family
 Foundation
Jane Hamlyn
Mrs Sue Hammerson OBE
Viscount and Viscountess
 Hampden and Family
Help a London Child
Mr Anthony Hepworth
Damien Hirst
John A. Smith and
 Vicky Hughes
Gary Hume
The Idlewild Trust
Inhotim Centro de Arte
 Contemporânea
Daniel Katz Ltd
Peter Kennard
Leon Kossoff
David and Amanda Leathers
Eduardo Leme
Mrs Caro Lloyd-Jacob
Mrs Sylvia Lynton
Joshua Mack
The Michael Marks
 Charitable Trust

Henry McNeil
Stavros Merjos
Marisa Merz
Mr and Mrs Michel
 David-Weill
Sir Geoffroy Millais
The Estate of Paul Edwin
 Millwood
Victoria Miro and
 Glen Scott Wright
Mondriaan Foundation,
 Amsterdam
The Monument Trust
The Henry Moore Foundation
Pat Moss
The Estate of Juan Munoz
Alison and Paul Myners
National Heritage
 Memorial Fund
Elisabeth Nay-Scheibler
David Page
Maureen Paley
Julie Panting
Catherine Petitgas
Patricia Phelps de Cisneros
PHG Cadbury Charitable Trust
Austin and Hope
 Pilkington Trust
Heather and Tony Podesta
Pro Helvetia,
 Swiss Arts Council
Beatriz Quintella and Luiz
 Augusto Teixeira de Freitas
The Radcliffe Trust
Jamie Reid
Anthony Reynolds Gallery
Jill Richards
Ruth Richards
The Michael Harry Sacher
 Charitable Trust
Mrs Lily Safra

Alex Sainsbury
The Estate of Simon Sainsbury
Doris Salcedo
The Basil Samuel
 Charitable Trust
The Sandra Charitable Trust
Mr Lee Saunders
Stuart Shave
Neville Shulman
Thomas J. Sikorski
 Charitable Trust
Randy Slifka Philanthropic
 Foundation
The Estate of Keir Smith
The Stanley Foundation
Jeffrey Steele
Norah and Norman Stone
Diane Symons
Tamares Management LLC
Tate American Acquisitions
 Committee
Tate Asia-Pacific
 Acquisitions Committee
Tate International Council
Tate Latin American
 Acquisitions Committee
Tate Members
Tate Patrons
Tim and Helen Taylor
David Teiger
Jannick Thiroux
The Sir Jules Thorn
 Charitable Trust
Henry Tillman, Jill Bradford
 and Henry T's Entertainment
Nicholas Tresilian
Allan and Lucy Turner
The Estate of Joyce Valentine
Chloe Veale
Paulo A W Vieira
Derek von Bethmann-Hollweg

Alin Ryan von Buch
The Weinstock Fund
White Cube
Wilkinson Gallery
Iwan and Manuela Wirth
Albertine Wood
Aroldo Zevi
Uzi Zucker Philanthropic Fund

and those donors who wish
to remain anonymous

Platinum Patrons
Ghazwa Mayassi Abu-Suud
Mr Shane Akeroyd
Beecroft Charitable Trust
Rory and Elizabeth Brooks
Lord Browne of Madingley,
 FRS, FREng
Melanie Clore
Pieter and Olga Dreesmann
Tania Fares
Mrs Wendy Fisher
Mr David Fitzsimons
The Flow Foundation
Hugh Gibson
The Goss-Michael Foundation
The Charles S. and Carmen
 de Mora Hale Foundation
The Hayden Family Foundation
Vicky Hughes (Chair)
Mrs Gabrielle Jungles-Winkler
Maria and Peter Kellner
Mr and Mrs Eskander Maleki
Panos and Sandra
 Marinopoulos
Nonna Materkova
Mrs Megha Mittal
Alison and Paul Myners
Mr Mario Palencia

Mr and Mrs Paul Phillips
Ramzy and Maya Rasamny
Mr and Mrs James Reed
Simon and Virginia Robertson
Mr and Mrs Richard Rose
Sally and Anthony Salz
Mr and Mrs Jake Shafran
Poju and Anita Zabludowicz

and those who wish to
remain anonymous

Gold Patrons
Ms Thoraya Bartawi
Pierre Brahm
Alla Broeksmit
Arpad Busson
Beth and Michele Colocci
Alastair Cookson
Haro Cumbusyan
Christian Dinesen
Eykyn Maclean LLC
Flora Fraser and Peter Soros
Nanette Gehrig
Mr and Mrs A Ramy Goldstein
Mr Michael Hoppen
Mrs Petra Horvat
Anne-Marie and
 Geoffrey Isaac
Mr Eugenio Lopez
Fiona Mactaggart
Elena Bowes Marano
Sir Robert McAlpine Ltd
Mrs Bona Montagu
Catherine and Franck Petitgas
Mathew Prichard
Mr and Mrs James Reed
Mr David Roberts
Mrs Rosario Saxe-Coburg
Carol Sellars
Sophie and David Shalit
Mr and Mrs Malek Sukkar
Mrs Celia Forner Venturi

Michael and Jane Wilson
Manuela and Iwan Wirth
Barbara Yerolemou

and those who wish
to remain anonymous

Silver Patrons
HRH Sheikha Lulu Al-Sabah
HRH Princess Alia Al-Senussi
Mr Abdullah Al Turki
Agnew's
Helen Alexander
Ryan Allen and Caleb Kramer
Harriet Anstruther
Toby and Kate Anstruther
Mr and Mrs Zeev Aram
Edward Ariowitsch Foundation
Mr Peter Arkell
Mr Giorgio Armani
Kiran Arora
Edgar Astaire
Daphne Warburg Astor
Mrs Jane Barker
Mr Oliver Barker
Mr Edward Barlow
Victoria Barnsley
Jim Bartos
Mrs Nada Bayoud
Mr and Mrs Paul Bell
Ms Anne Berthoud
Madeleine Bessborough
Janice Blackburn
Mr and Mrs Anthony Blee
Elena Bonanno Di
 Linguaglossa
Mr Andrew Bourne
Alan Bowness
Mrs Lena Boyle
Mr Daniel Bradman
Ivor Braka
Alexander Branczik

Mr Simon Alexander Brandon
Viscountess Bridgeman
The Broere Charitable
 Foundation
Mr Dan Brooke
Ben and Louisa Brown
Mr and Mrs Charles Brown
Michael Burrell
Mrs Marlene Burston
Canvas Magazine
Mrs Elizabeth Capon
Laurent and Michaela Caraffa
Peter Carew
Mr Francis Carnwath
 and Ms Caroline Wiseman
Veronica Cazarez
Lord and Lady Charles Cecil
John and Christina Chandris
Frank Cohen
Mr and Mrs Paul Collins
Terrence Collis
Mr and Mrs Oliver Colman
Carole and Neville Conrad
Giles and Sonia Coode-Adams
Mr and Mrs Paul Cooke
Cynthia Corbett
Mark and Cathy Corbett
Mr and Mrs Bertrand Coste
The Cowley Foundation
James Curtis
Ms Michelle D'Souza
Ms Carolyn Dailey
Mrs Isobel Dalziel
Sir Howard Davies
Sir Simon Day
Ms Isabelle De La Bruyère
The de Laszlo Foundation
Mr Jan De Smedt
Anne Chantal Defay Sheridan
Marco di Cesaria
Simon C Dickinson Ltd

205

Overleaf:
Detail
Andy Warhol
Self-Portrait Wallpaper 1978
The Andy Warhol Museum, Pittsburgh.
Founding Collection, Contribution The Andy
Warhol Foundation for the Visual Arts, Inc

207

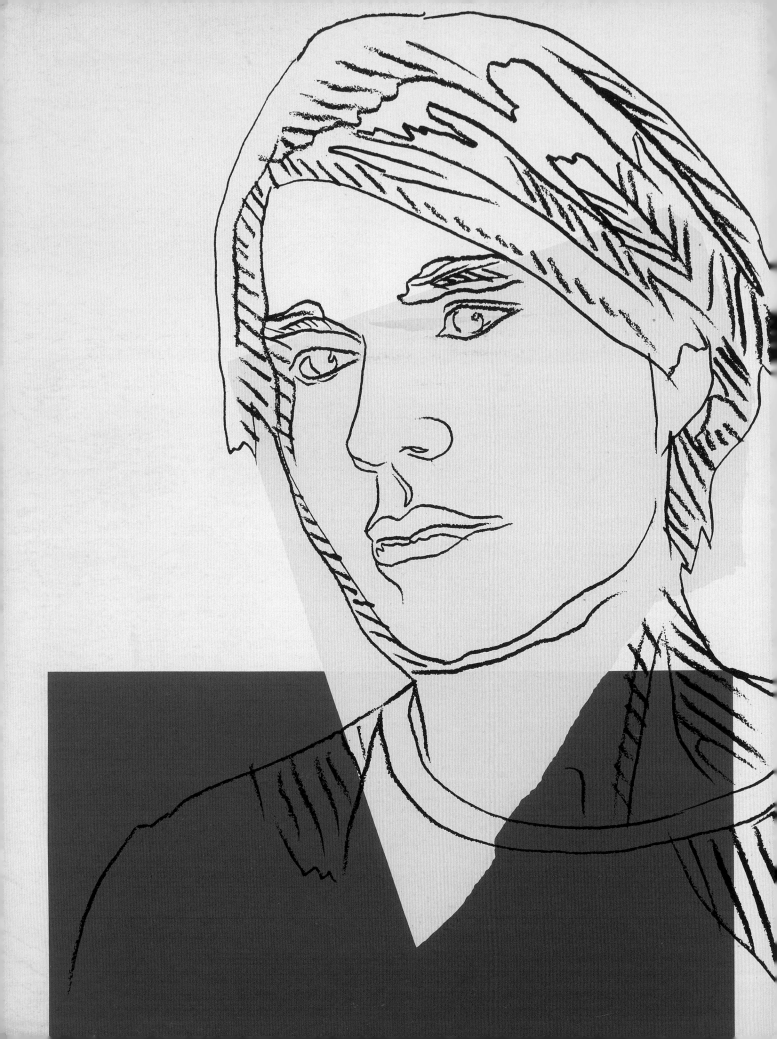